100 More Canadian Heroines

100 more
CANADIAN HEROINES
FAMOUS AND FORGOTTEN FACES
Foreword by Julie Payette

MERNA FORSTER

DUNDURN
TORONTO

Editor: Nicole Chaplin
Design: Courtney Horner
Printer: Webcom

Library and Archives Canada Cataloguing in Publication

Forster, Merna
 100 more Canadian heroines : famous and forgotten faces / by Merna Forster ; foreword by Julie Payette.

Includes bibliographical references.
Issued also in electronic formats.
ISBN 978-1-55488-970-9

 1. Women--Canada--Biography. 2. Canada--Biography. I. Title.
II. Title: One hundred more Canadian heroines.

FC26.W6F68 2011 920.720971 C2011-902574-4

1 2 3 4 5 15 14 13 12 11

We acknowledge the support of the **Canada Council for the Arts** and the **Ontario Arts Council** for our publishing program. We also acknowledge the financial support of the **Government of Canada** through the **Canada Book Fund** and **Livres Canada Books**, and the **Government of Ontario** through the **Ontario Book Publishing Tax Credit** and the **Ontario Media Development Corporation**.

Care has been taken to trace the ownership of copyright material used in this book. The author and the publisher welcome any information enabling them to rectify any references or credits in subsequent editions.

J. Kirk Howard, President

Printed and bound in Canada.
www.dundurn.com

Front cover images: Top left to right: Victoria Cheung (They Came Through, Public Domain), Kathleen Parlow (Kathleen Parlow: A Portrait, Public Domain), Molly Kool (painting by unknown artist). Bottom left to right: Ethel Catherwood (Courtesy of Bedford Road Collegiate), Demasduit, 1819 (Painting by Lady Hamilton/Library and Archives Canada, Acc. No. 1977-14-1), and Maud Allan (Courtesy of Dance Collection Danse).

Dundurn	Gazelle Book Services Limited	Dundurn
3 Church Street, Suite 500	White Cross Mills	2250 Military Road
Toronto, Ontario, Canada	High Town, Lancaster, England	Tonawanda, NY
M5E 1M2	LA1 4XS	U.S.A. 14150

For Annie Davis and Annie Forster

Help me search the meaning
Written in my life,
Help me stand again
Tall and mighty.

— Rita Joe, "Expect nothing else from me," 1978

Contents

Q

R

S

T

W

Foreword
by Julie Payette

Can you imagine running a 100-metre dash, starting 20 metres behind the other competitors, and remaining convinced that you can win the gold medal? Picture yourself climbing Mount Everest in a skirt, petticoat, and bonnet. How do you stay confident in the fact that your chances of making it to the summit and back safely are as good as anybody else's?

And how do you maintain the steadfast belief that you can finish at the top of your pilot-training class even though the standard issue flight gear does not fit and you need a telephone book behind your back just to reach the rudder pedals?

These are the kinds of images that come to mind reading the stories of the exceptional women Merna Forster introduces in *100 More Canadian Heroines*, the sequel to *100 Canadian Heroines*. Beating the odds while chasing a dream has been the lot of many women throughout history. Their stories are rarely told, let alone remembered. But not in this book! Defying probabilities and presumptions, the women featured here have managed to follow their passions and fulfill their ambitions, even if it meant shaking up the prevailing social order. They have marked — and made — Canadian history, and their stories are riveting.

In *100 More Canadian Heroines*, Forster presents a collection of short and lively biographies that celebrate the talent and achievements of women from all walks of life. Their stories range from the time before

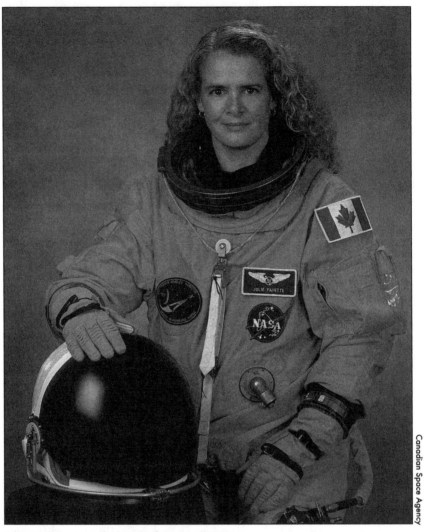

Julie Payette, prior to the launch of mission STS-127.

the European conquest to the present, touching the worlds of science, health, sports, politics, war and peace, exploration, business, social reform, arts, entertainment, and public service. Some of these women are well-known, but most are not. Some were affluent, born or married into privilege, but many were poor or faced other unfavourable odds. Some operated behind powerful and supportive male partners; many despite them. Some chose to remain single to circumvent society's historical requirement that a woman give up her career upon marriage.

All of these women rose above the preconceived notions associated with their condition.

This pool of trailblazers is impressive. Meet journalists, artists, entrepreneurs, settlers, civil rights advocates, war veterans, scientists, Olympic athletes, and a Native chief. Despite their varied backgrounds, it is striking to see how much these women have in common in their determination and fortitude. Stubborn, resourceful, creative, and courageous, all are very inspiring. After reading their tales, it is humbling to realize how little we know about the women who have contributed to Canada's development.

The road to gender equality in modern societies has been long and arduous, dotted with many setbacks. Numerous issues still exist and not all women have benefited from recent advances in employment equity, politics, and social relations. Women remain largely responsible for childcare, domestic chores, and unpaid work in the community, and women who are employed earn on average far less than men. Gender discrimination affects women at all stages of life, and women are more likely to suffer the most poverty.

Much progress is still required, particularly in developing countries, to ensure that women enjoy equal access to wealth, education, health services, employment, and political positions, but there is no doubt that we live in an era where opportunities for women are unsurpassed. A Canadian girl born today can be all she wants to be. With an unprecedented ability to direct, influence, and effect change, her possibilities are infinite. There is no position unattainable, no field out of reach, no task too difficult, and no goal too high for the ambitious, the bold, the tenacious, and the passionate. Indeed, with a bit of effort, even the Earth can be at her feet.

Dare to dream.

Julie Payette
Canadian Astronaut

Introduction

The first and only great Canadian woman I remember hearing about as a child was Nellie McClung. She knew my grandmother, Grace Latimer, a pioneer schoolteacher who died in her thirties in Calgary and left seven young children. But no stories of how she knew the famous Nellie. Many women left few records of their lives, and even those that did are often forgotten. This book is a tribute to great women in Canadian history as well as the persistent researchers, family members, filmmakers, and others who've worked to keep their memories alive.

When I began doing radio and television interviews after the release of volume one in the Canadian Heroines series, I was inundated with suggestions for the "next book" — before some readers had even had the chance to track down the first one. Both men and women sent congratulatory emails, lists of names of notable Canadian women, and packages with newpaper clippings, photographs, and a variety of other material. One reader wrote, "I am a man and I loved your book. As odd as this may seem I am inspired by the content and can't help but wonder why as Canadians we know so little about these heroines that have altered our lives in so many ways?"

His point was reinforced by the contest launched by CBC Television to select the greatest Canadian in our history, the results of which were determined just as *100 Canadian Heroines* hit bookstores. People across the country named ten men (including colourful sportscaster Don

Cherry) as the final contenders for The Greatest Canadian and only six women made the top fifty. These included historical figures Laura Secord, Nellie McClung, and Mary Maxwell of the Baha'i faith, along with popular singers Shania Twain (the highest ranked female at number eighteen), Avril Lavigne, and Céline Dion. Presumably, many people who voted weren't familiar with the countless other women in Canadian history they could have added.

As a result of the overwhelming response to the first volume, this book presents another 100 Canadian heroines who I believe should be recognized and celebrated for their impressive achievements.

Who qualifies as a heroine? I like the concept of heroines proposed by the acclaimed legal scholar Constance Backhouse, who suggested a definition that "captures the lives of women who represent resistance, strength, courage, persistence, and fortitude"[1] as they face oppression or other challenges — a definition that is inclusive of the experiences of a wide variety of women and does not require perfection.

The book features the stories of a selection of historical heroines from many periods of Canadian history. You'll find notables from diverse ethnic backgrounds from coast to coast. I've included women who made significant achievements in different fields and demonstrated amazing courage and perseverance — from Beothuk captive Demasduit to the biochemist behind the polio vaccine, Canada's first female chief, the only woman leader in the Winnipeg Strike, feminist activist Madeleine Parent, our first prima ballerina, and the best dairywoman in North America. The profile of the adventurous goldseeker Catherine Schubert was written by Emily Zheng, the winner of a heroines essay contest for students sponsored by Dundurn.

Many of the women profiled were born in Canada and lived here throughout their lives. But in this nation of immigrants, other notable women settled here, some passed through, and some moved to other countries to pursue their dreams. I've included Canadian heroines who made important contributions here in Canada, as well as those who made their mark on the international stage. Sadly, many of these inspiring women have been largely forgotten — even buried in unmarked graves.[2] I hope that this volume will help rescue them from obscurity.

Journalist Andrew Cohen once wrote, "In celebrating ourselves, modesty is no virtue and moxie is no vice."[3] In a nation that is often reluctant to name heroes and heroines, I hope that the achievements of the remarkable women in this book will be more widely recognized. Some academic studies have shown that while people identify more male than female public heroes, just reading about the exploits of women increases the likelihood of recognizing female heroism.[4]

We can all play a role in celebrating notable women in Canadian history — from featuring them in educational programs in classrooms, libraries, museums, and historic sites to organizing special events during Women's History Month each October. We can make movies about amazing women, suggest commemorative stamps, or encourage art galleries to collect — and display — artworks produced by talented female artists. Right now, less than 10 percent of the collection of the National Gallery of Canada is attributed to women.[5]

And wouldn't you like to see some female worthies join the famous men immortalized in stone? The tenacious Frances Wright and the Famous 5 Foundation engineered a campaign that circumvented the rules for statuary on Parliament Hill. In October 2000, the figures of the Famous Five became the first females (aside from Queen Elizabeth II) to stand tall with male parliamentarians.

You can also nominate someone to be recognized by the Historic Sites and Monuments Board of Canada (responsible for commemoration of people, places, and events of national historic significance). Since the 1990s, the board has been trying to include more women in the system, which in the early years focused on commemorating white Anglo-Saxon men (often military and political leaders perceived as nation builders); but it currently recognizes just seventy-six women as national historic persons along with 567 men.[6] In Canada there is still a reluctance to give heroic status to individual women and a preference to recognize them collectively, as nurses or pioneers for example.[7]

This book tells the remarkable true stories of 100 inspiring trailblazers — great Canadians to be celebrated.

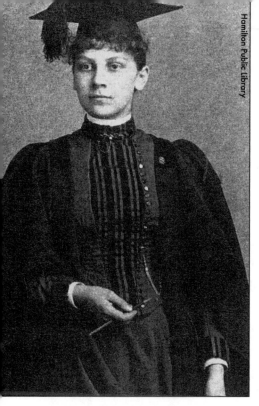

A New Wave in Education

Mary Electa Adams
1823–1898

She revolutionized the education system for women, setting the stage for universities to open their doors to them for the first time.

Mary E. Adams, graduation from the Wesleyan Ladies' College.

Since the primary role of girls in the Victorian era was to become wives and mothers it was expected they should only be taught "ornamental" subjects like art, music, and needlework. Educator Mary Electa Adams dared to suggest otherwise, insisting that females learn strenuous subjects just like male students. She introduced a curriculum in the "female branch" of the Wesleyan Academy at Mount Allison in Sackville, New Brunswick, which included science, mathematics, moral philosophy, and Latin.

Women were barred from attending university when Mary was growing up, but she was raised in a Methodist family that believed in the value of higher education for both girls and boys. The daughter of Loyalist parents and a descendant of American president John Adams, Mary was born in Westbury, Lower Canada (now Quebec), in 1823. The family soon moved to Upper Canada (Ontario), where Rufus and Maria Adams initially taught their five children at home. Though they were a family of modest means, both parents had a classical education and Mrs. Adams received some higher education at an American college.

When she was seventeen, Mary began attending the same institution as her mother, the Montpelier Academy in Vermont. There she studied such subjects as mathematics and classics. Mary continued her education at the Cobourg Ladies' Seminary, where she earned the diploma Mistress of Liberal Arts and then became an instructor. When the school moved to Toronto and became the Adelaide Academy, Mary continued to teach and study there.

Soon recognized as a skillful educator, Mary was invited to become the lady principal at Picton Academy in 1848. She subsequently became the chief preceptress at four notable ladies' colleges: the Albion Seminary in Michigan, Mount Allison Academy (Sackville, New Brunswick), Wesleyan Ladies' College (Hamilton), and the Ontario Ladies' College (Whitby, Ontario). In 1872, feeling renewed after two years of travel in Italy, she established the Brookhurst Academy at a site near Victoria College in Ontario. Writing in her diary about her enthusiasm for opening her own school for girls, Mary also noted what she would need to succeed: "Courage! Patience! Hope! Perseverance!"[1]

Having developed an international perspective on women's education through her work in the United States and a trip to Great Britain, Mary introduced demanding academic curricula in the influential institutions where she taught, proving that women could excel in subjects assumed to be masculine. She played a significant role in reforming women's education in New Brunswick, Ontario, and throughout British North America, and also brought in new approaches to studying modern languages and literature for both sexes.

Her leadership role is remarkable given the barriers to women at the time. Mary developed high-calibre women's institutions and programs where females could demonstrate their worthiness to pursue university educations. The women's colleges eventually closed as students were able to pursue their studies in co-ed universities.

Significant progress had been made by the time Mary retired in 1892 (approaching her seventieth birthday), after nearly fifty years of leadership at prestigious women's colleges. She moved west to help her nephew establish cattle ranches in what is now Alberta, and perhaps to enjoy her favourite pastimes of painting and writing poetry.

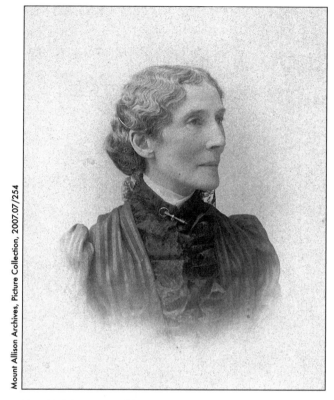

Mount Allison Archives, Picture Collection, 2007.07/254

Mary E. Adams as an older woman.

Mary was a determined educator who had a profound influence on individuals, as well as the educational system. Peers, such as Nathanael Burwash of Victoria College, recognized her outstanding achievements, noting that "no Canadian educator of Canadian women has surpassed Miss Adams either in the perfection of her work or in her far-reaching influence in the development of larger opportunities for higher education for the women of Canada."[2] In 2004, the Historic Sites and Monuments Board designated Mary Electa Adams as a national historic person due to her outstanding and lasting contribution to Canadian history.

Quote:

"I dread the idea of living uselessly."[3]

She Fought the Law and the Law Won

Sally Ainse
circa 1728–1823

As settlers moved west, one brave Indian woman fiercely defended her land.

Sally Ainse was a Native woman ahead of her time — a prosperous trader, landowner, and diplomatic courier in the borderlands between what would become the United States and Canada. She fought for her property in both the American republic and the British Empire. In the eighteenth century and the early nineteenth, she was widely known and respected by many notable figures of her day.

Sarah Ainse, often referred to as Sally, was probably an Oneida. She was the half-sister of the famous Chief Skenandon who was a Conestoga adopted by the Oneida. Sally grew up on the Susquehanna River in what is now New York State and may have learned English at a colonial school. She also mastered a multitude of Native languages, and was able to understand and read most of them. Sharp-witted as well as striking, the tall and graceful woman soon captivated a flamboyant colonial adviser named Andrew Montour.

At age seventeen, sometime before 1753, Sally became Mrs. Montour, wife of the influential interpreter, scout, and Indian Agent. An Oneida

chief, Montour had both French and Native blood. During their short and tumultuous marriage, the couple lived through the turmoil of the French and Indian War (1754–1763), as Great Britain and France fought for control in North America. The Montours lived in what would become New York, Pennsylvania, and Ohio while Andrew advised the British. They camped with George Washington at the Battle of Fort Necessity in 1754; Washington referred to Sally in some correspondence.

Despite their comfortable life together — Sally owned luxury items, including eleven pairs of stockings — Andrew was a big drinker and his young bride left him in about 1756. Montour placed their two older children, Polly and Andrew Jr., with colonial families in Philadelphia. After the split, Sally gave birth to their third child, Nicholas. She and the baby went to live with some of her Oneida relatives in Kanonwalohale.

When the British established a post at nearby Fort Stanwix in 1758, Sally became a fur trader. In 1762, she convinced the Oneida to grant her a good piece of land near the fort; they trusted her to help protect it from settlers. But Sally couldn't compete with the powerful friends of Sir William Johnson, her ex-husband's employer, who also saw the commercial potential of the property. In 1772, he gave the land to a cartel of his buddies, which included the governor of New York.

With the end of the French and Indian War in 1763, the British gained control of North America. Sally soon began trading in the Great Lakes country, buying furs from the Mississaugas on the north shore of Lake Erie, and then moving north to Michilimackinac at the entrance to Lake Michigan.

By late 1774, Sally Ainse had moved to Detroit, where she became a prosperous trader with a large-scale business, a town lot, and several slaves. She eventually owned two houses in Detroit, as well as cattle and horses and a good supply of flour for trading. With the American Revolution raging, the successful entrepreneur wanted to make sure she had refuges on both sides of the new border. Sally arranged to purchase a prime piece of land along both banks of the lower Thames River in what is now Chatham, Ontario. She paid £500 in goods to her friends, the local Ojibwa, for this 150-square-mile tract. At this time she married an English trader, John Wilson.

After the end of the American Revolution and creation of the United States, Sally moved onto her land along the Thames. She built a house, planted an orchard, and fenced in a field, and thrived as a farmer while continuing to trade. She intended to use some of the land to grant private property rights to individuals of her choice, but the Detroit land board rejected her right to do this. Squatters invaded her land, and the board granted them legal deeds of ownership.

Sally began a legal battle for her land that continued for decades, showing that while attempting to develop a form of Native land ownership within settler society, she could function in the systems of that society. However, she had two strikes against her: not only was she Native, but she was a woman entering colonial society where only men could own property.[1] And she was claiming ownership of the most valuable piece of land in the region.

In 1790, the British Crown purchased land from the Chippewas in the area in a transaction called the McKee purchase, excluding the tract sold to Sally Ainse. Based on this exemption, as well as her Chippewa deed, Sally petitioned numerous times for the title to at least some of her land. As many as eighteen Indian chiefs confirmed her purchase with the Chippewas and many influential men supported her case, including Lieutenant Governor Simcoe, Sir John Johnson (who managed Indian Affairs), and Mohawk Chief Joseph Brant. Sally was related to Brant through marriage, and helped him in his efforts to unite Aboriginal people by enabling communication between tribes in various areas. A skillful negotiator, she obtained information, provided advice, and carried Brant's messages to Natives in the Detroit and Thames valleys.

The support of these powerful men was not enough to withstand the growing demand of white settlers for land, and the fear that allowing a Native to keep her land would set a dangerous precedent that would threaten settler land titles. In 1792, Sally had so impressed Simcoe that he directed the Detroit land board to award her 1,600 acres (about 1.7 percent of her original petition); the board delayed implementing his ruling. They also launched a smear campaign, writing letters to discredit her character, land claim, and improvements. When the frustrated Simcoe ordered that Sally Ainse be issued her deed, the necessary survey was delayed. The surveyor insisted that Sally did not

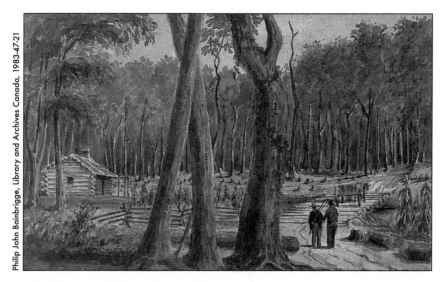

Philip John Bainbrigge, Library and Archives Canada, 1983-47-21

A bush farm near Chatham, Ontario, 1838.

exist, though there was a Sarah Wilson. She was told she couldn't claim the property because common law prevented a married woman from holding legal title to real estate.[2]

In 1798, the Detroit land board dismissed Sally's reduced claim to just 200 acres. Tragedy struck when a fire destroyed her barn — and the entire harvest stored there. The Moravian mission provided her with shelter and the Christian faith, reporting that she began attending daily meetings. She relied on charity to survive.

Sally may not have known that her son, Nicholas Montour, had become a prosperous fur trader, businessman, and owner of a seigneury in Trois-Rivières, Quebec. The feisty Sally Ainse outlived him, settling in Amherstburg and continuing to fight for her rights; however, she had resigned herself to asking only for compensation in wild land for the property she lost. She submitted claims in 1808, 1809, 1813, and again in 1815, demonstrating such amazing persistence and longevity that, at the time of the last claim, the Executive Council insisted she had to be dead.

Deemed by the *Dictionary of Canadian Biography* to be "a clearly exceptional person,"[3] Sally Ainse was almost ninety when she died in 1823. A historical plaque in Chatham, Ontario, commemorates the life of this tenacious woman.

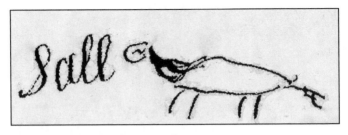

Sally Ainse's signature, featuring a horse.

Quote:

"Though I am an Indian Woman (& guilty of great indecorum in presuming to write to you in this manner), I see no reason why I should be openly plundered of my property."[4]

— Sally Ainse writing to the surveyor general for the Detroit land board.

The Dancer
Maud Allan
1873–1956

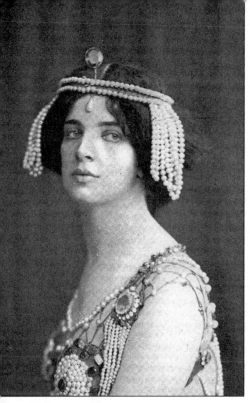

Maud Allan in costume for *The Vision of Salomé*, 1908.

She didn't create modern dance. But her artistry, imagination, and musicality helped usher in a dance revolution.[1]

A sex symbol of the Edwardian age,[2] Maud Allan was a Canadian-born dancer and choreographer who defined her art as poetical and musical expression. A pioneer in modern dance, Maud developed a distinctive style that both enthralled and shocked audiences. In her famous *Salomé* dance she performed barefoot, midriff bare, in scanty costumes of gauze, strings of pearls, and bejewelled breastplates. Maud Allan was a talented dancer who dared to be different and helped make theatrical dancing a respectable occupation.

Though this gifted performer gained much of her worldwide celebrity for her provocative dance, *The Vision of Salomé*, Maud choreographed over fifty dances and toured in many countries. She became famous for her dance interpretations, in which she brought to life the music of Chopin, Rubinstein, Beethoven, Schubert, and Mendelssohn. While Isadora Duncan, her contemporary, gained enduring fame for both dancing and personal tragedies, Maud was considerably more popular in the prime of her career during the first two decades of the twentieth century.

Born Maud Durrant in Toronto in 1873, she was the daughter of shoemaker William Allan Durrant and his wife Isabella Hutchinson (who was adopted in Ontario but assumed to be the love child of Adolph Sutro, a flamboyant German-Jewish engineer and arts patron who was mayor of San Francisco from 1894 to 1896). Maud spent her early childhood in Toronto, taking piano lessons from the accomplished musician Clara Lichtenstein. When she was six, the Durrants moved to San Francisco. There they connected with Sutro; Isabella hoped that her daughter would become a world-famous concert pianist.

In February 1895, Maud left San Francisco to study piano in Germany, expecting her beloved brother Theo to join her for his post-graduate studies. By April, however, she received the horrifying news that Theo had been accused of brutally murdering two young women in the church where he taught Sunday school. The sensational media coverage of Theo's "crime of the century," and his execution in 1898 changed Maud forever. At her family's urging, she stayed in Europe throughout the ordeal. She concealed her relationship to Theo by using her father's middle name and adopting the stage name Maud Allan.

Maud stayed in Germany to continue her musical education. She was strongly influenced by her mentor Ferruccio Busoni, the famous composer and pianist, and his colleague Marcel Remy, who later composed the music for her *Salomé*. Maud soon abandoned the idea of being a concert pianist, deciding instead to become a dancer. After several years of research and experimentation to develop her unique mode of expression — Maud always boasted she had no formal dance training — she had her debut at Vienna's Conservatory of Music in December 1903. It was a gutsy move: a thirty-year-old woman just beginning her life in theatrical dancing.

Her career was launched by none other than King Edward VII, who was entranced by her performance at a spa in Marienbad. Thanks to his support, Maud soon made her debut at London's Palace Theatre, where she was promoted as Alfred Butt's latest discovery. He was the city's leading impresario and the man who had managed the debuts of stars like Maurice Chevalier and Fred Astaire. Hailed as the personification of grace and elegance, Maud Allan was a hit.

The London Observer raved about Maud: "She is a reincarnation of the most graceful and rhythmic forms of classic Greece … music turned into moving sculpture … in *The Vision of Salomé* her writhing body enacts the whole voluptuousness of Eastern feminity."[3]

Other critics echoed their praise, and Maud Allan became the darling of the social, political, and cultural elite of London. Prime Minister Asquith and his wife became close personal friends; Margot Asquith even paid for Maud's luxurious apartment. The dancer's eighteen-month engagement at the Palace Theatre was the height of her career, bringing her wealth and celebrity. She earned £250 per week and enjoyed a lavish lifestyle.

Maud was a dedicated and determined artist at a time when theatrical dancing was widely considered "a form of female erotic display performed by women of questionable moral status."[4] She dared to depict an aggressively sexual woman (albeit an Eastern woman, which made it a bit more acceptable to her audience). As a respectable middle-class female, bearing a stamp of approval from the cultural elite, Maud helped bring greater acceptance of women on the stage.

Maud's performances drew women of all ages and backgrounds, from schoolgirls to matrons, working girls to aristocrats. Maud was so popular with women that the Palace Theatre ran special matinee performances of her dancing — banning smoking, as the women preferred. Many admirers watched Maud to learn her movements and then try them out at home. Wealthy women held parties at which they dressed in replica's of Maud's *Salomé* costumes and practised her movements. Even the *Woman Worker* encouraged its trade-union supporters to attend Maud's performances and emulate her movements to build "the Body Beautiful."[5] She helped encourage greater body awareness, an acceptance of expressing female sexuality, and participation in social dancing.

While Maud became a celebrity, she also had critics. Her *Salomé* made her notorious. Many condemned Maud Allan as a sensual temptress, labelling her performances in scanty costumes (that she designed herself) as scandalous.

Her career was damaged irrevocably when she dared challenge a British member of parliament who had slandered her in an intentionally provocative article called "The Cult of the Clitoris,"[6] near the end of the First World War. The article suggested that a private showing of Oscar

Wilde's controversial play *Salomé*, starring Maud, would be attended by members of a group of prominent, sexually perverse Brits who were at risk of blackmail and treason. The MP insinuated that Maud was a lesbian, and that her knowledge of the word *clitoris* demonstrated moral depravity. She sued him in 1918; the revelation that her brother was a murderer ruined her reputation.

After the trial, Maud performed in India, the Far East, Australia, Canada, the United States, Europe, South America, and Africa but did not receive the critical acclaim she had enjoyed at the height of her career in London. For a 1916 tour in North America, she performed with The Maud Allan Symphony Orchestra, a company of forty directed by Ernest Bloch. Maud also starred in the silent movie *The Rugmaker's Daughter* (1915). She established a dance school for slum children in London in 1928.

For a ten-year period ending in 1938, Maud lived with her secretary Verna Aldrich, who was rumoured to be her lover. During the Second World War, Maud drove an ambulance for the Red Cross and worked for an aircraft factory. She died in poverty in Los Angeles in 1956, at the age of eighty-three.

Years after her sensational success, some still remembered Maud Allan. English art critic Sir Herbert Read recollected that Maud "was the Marilyn Monroe of my youth."[7] Now recognized primarily by dance historians, Maud Allan was an extraordinary performer whose significance in modern dance continues to be debated in a multitude of publications. *The Canadian Encyclopedia* praises Maud as a pioneer of modern dance. Dance Collection Danse, a private archives in Toronto, has a collection of Maud Allan memorabilia, including several of her famous Salomé costumes.

Quote:

"While I am dancing I know nothing but the surge of the music."[8]

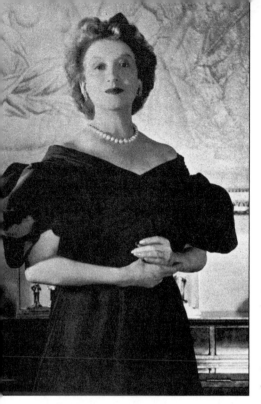

Behind the
Red Door

Elizabeth Arden
1881–1966

She became one of the richest and most powerful self-made women in the world.[1] A multimillionaire who revolutionized the cosmetics industry, she landed on the cover of *Time* magazine as the queen of horse racing.

Elizabeth Arden, 1947.

Florence Nightingale Graham often took the reins of her father's horse-drawn cart when they went to sell vegetables and flowers at his stall in Toronto's St. Lawrence Market; there she honed her haggling skills. The Grahams lived on a tiny farm in Woodbridge, Ontario. After her mother died of tuberculosis when Florence was just four, she and her siblings tried to support their father as he struggled to feed and clothe his family while fighting depression. She never forgot the days of shivering in their cold house, or stuffing newspapers in her shoes to keep her feet dry. Florence dreamed of becoming "the richest little girl in the world"[2]; when she did, she lined her handmade shoes with newspaper and lived in overheated homes.

Forced to drop out of school to work, Florence nurtured her dreams with images from romantic novels and films. She held some clerical jobs in Toronto and tried nursing, but dropped out because she hated the sight of blood. In 1907, when she was twenty-six, Florence decided to follow her brother to New York City, where she found a job working as

a cashier in a beauty parlour on Fifth Avenue. She soon convinced her employer to teach her the beauty treatments she performed.

Excited by both New York and the potential of the booming beauty business, Florence partnered with beautician Elizabeth Hubbard to set up a salon in 1909. Within six months, she took over the bustling shop. She renamed it (and herself) Elizabeth Arden, likely because of her admiration for Queen Elizabeth I (who was known to use cosmetics) and Arden, after the country estate of a rich railway baron who raised horses.[3]

Since it would have been unlikely for a bank to loan money to a single woman, Arden's biographer speculated that her uncle, James Liberty Tadd, may have provided the start-up funds.[4] Whatever the source, Elizabeth Arden seized the opportunity to carve a niche for herself in the beauty industry by developing her own products, procedures, and exclusive salons. Painting the door of her first beauty salon a rich red, she attached a brass nameplate with the name Elizabeth Arden in script. The famous red doors would mark the more than 100 salons she established worldwide.

When she established herself in New York in the early twentieth century, women were just emerging into public life, demanding the vote, and expressing themselves with bobbed hair and shorter skirts. Prior to the 1920s, only actresses and whores dared wear much make-up in public. Elizabeth offered the opportunity for respectable women to discover their inner beauty through good skin care and cosmetic products, as well as a healthy lifestyle involving nutritional food and exercise. Passionate about body toning through yoga, she made a sound recording explaining yoga techniques back in the 1920s and still loved standing on her head during her eighties.

Elizabeth helped create the global beauty industry and became one of the first women to run an international business.[5] She was a tenacious and visionary entrepreneur, working up to eighteen hours a day to build and run her beauty empire. By the time of her death in 1966, she was the sole owner of a corporation doing $60 million in business a year. She operated exclusive beauty salons (decorated in pink) and wholesale outlets around the world, from London and Paris to Rome, Madrid, Asia, Australia, South America, Africa, and Canada.

During the Depression, Elizabeth dared to expand her New York salon to seven floors and employed more than 1,000 staff in various countries. By

1944, her customers could purchase almost 1,000 different beauty products that she'd developed through scientific experimentation and testing for safety, get their hair done in an Elizabeth Arden salon, and purchase something from the popular lingerie collection. Even British royalty were among her fans: both the Queen Mother and Queen Elizabeth II sent letters of thanks for gifts from the collection.[6] When she decided to incorporate a fashion line in her business, she recognized the potential of an assistant designer, thereby launching the career of the legendary Oscar de la Renta.

In addition to the salons, Elizabeth opened America's first luxury health and beauty farm in 1934 in Maine and later added another in Phoenix. Women checking into the exclusive Main Chance resort were encouraged to eat a light diet and required to drink a pint of fresh vegetable juice, consisting of cabbage and celery, each day. The clients participated in yoga, tennis, water-skiing, sailing, riding, archery, and aerobic workouts, as well as enjoying seaweed baths and deep-tissue massage. *Vogue* reported that the spa was "like no other place under the sun, where you lived a charmed and incredible life in Sybaritic surroundings, trained as rigorously as any athlete."[7]

A brilliant and creative innovator in product development, promotion, and packaging, Elizabeth was also a genius in marketing, customer service, and public relations. She hired talented people to develop cutting-edge advertising, mastered corporate sponsorship, and was the first to adopt lifestyle promotion with her products.[8] She demonstrated makeup application on one of the first television shows to air in America. Elizabeth methodically developed her place in society, cultivating friendships with royalty and the likes of J. Edgar Hoover and First Lady Mamie Eisenhower, dining with Prime Minister Jawaharlal Nehru of India, sponsoring cultural activities, and supporting charities. She received many awards, including an honorary doctorate and the Lighthouse Award from the New York Association for the Blind for subcontracting work to the blind.

During her busy life, Elizabeth married twice. She divorced her first husband in 1934 after a private detective discovered his numerous infidelities, and the second (masquerading as a Russian prince) in 1943 after she found out he was a homosexual who'd married in hopes of paying off his huge debts.

Elizabeth had better luck with her hobby: horse racing. She loved horses and participated in races from the early 1930s until her death in 1966. She had property in Kentucky for her horses and stables. In 1945, her stables were the most profitable in America, with winnings of $589,170. Elizabeth's horse Jet Pilot, trained by "Silent" Tom Smith of Seabiscuit fame, won the Kentucky Derby in 1947.

She never forgot her Canadian roots, and returned twice in the 1950s to open the Black Creek Pioneer Village and then Dalziel Pioneer Park, where she once lived. In 2003, the Canadian Horse Racing Hall of Fame honoured Elizabeth for her contributions to the racing industry. Many publications recognize her important position as a role model: "Since Elizabeth Arden founded her international business empire, Canadian women cannot claim to be neophytes in private enterprise."[9]

After Elizabeth died in a New York hospital, she was dressed in burial clothes fit for a wealthy beauty queen: a ruffled pink gown designed by Oscar de la Renta. More than 1,000 people attended the funeral of the poor little rich girl from Canada whose enduring legacy is Elizabeth Arden, Inc., which now operates in 100 countries with sales in excess of $1.3 billion.

Quote:

"There are only three American names that are known in every corner of the globe: Singer Sewing machines, Coca-Cola and Elizabeth Arden."[10]

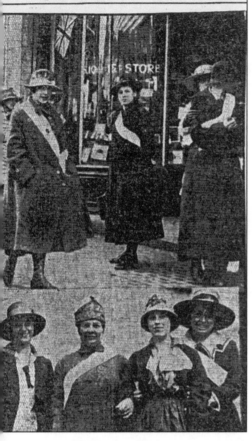

Wild Woman of the West

Helen Armstrong
1875–1947

Even prison bars didn't stop Helen Armstrong, the lone female leader of the famous Winnipeg General Strike.

Newspaper clipping from December 1917, showing Helen Armstrong at far left in the top picture, and second from the left in the bottom photo.

Police considered jailed activist Helen Armstrong such a danger during the 1919 Winnipeg Strike that she was denied bail for days before being released. Newspapers in eastern Canada later dubbed the scrappy striker the Wild Woman of the West.

Helen Armstrong (née Jury) was born in Ontario, the eldest daughter among ten children. She was strongly influenced by her father, Alfred Fredman Jury, a successful tailor, prominent labour leader, lobbyist, and organizer of the Knights of Labour. While working as a seamstress in his Toronto shop, Helen witnessed boisterous political discussions during the many gatherings held there. She met a young radical socialist named George Armstrong, who shared her passion for social reform and helping workers.

Helen married George in 1897 in Butte, Montana, where he had gone in search of work. The Armstrongs would move many times in search of employment. When they lived in New York City, Helen was active in the National Women's Suffrage Association; she was jailed after chaining herself to a fence at the White House during a campaign to win the vote. By the time they moved to the booming Winnipeg in 1905, she was the mother of three girls, and gave birth to their son Frank several years later. Helen was a devoted mother, focusing on the family while George quickly became a leader in the local labour movement. The Armstrongs took in boarders to help make ends meet.

A devoted mother, Helen was devastated when all four children came down with scarlet fever at the same time. All suffered severe hearing loss. Exhausted and depressed, Helen collapsed and was hospitalized. As the children grew older, Helen was able to join her husband more frequently in efforts to improve the lives of the working class in Winnipeg. Helen wasn't a socialist and didn't believe in revolution, but she was a feisty feminist who would stop at nothing to help people in need.

Both Helen and George opposed Canada's involvement in the First World War. Helen was often the only woman who spoke against conscription in open-air platforms in Winnipeg. One newspaper reported she would often "place herself between the soldiers and the other speakers and was attacked and bruised from head to toe because of her courage."[1] Helen also took food and clothing to men imprisoned at Stony Mountain for refusing to enlist. She was arrested for handing out anti-conscription pamphlets.

Helen became a women's labour organizer, fighting for equal pay for equal work, higher wages, healthy working conditions, and shorter working hours. She championed the thousands of women in Winnipeg who were struggling to support themselves and their families in a wide variety of low-paying jobs; she voiced their concerns in the provincial legislature, newspaper articles, police courts, and on the picket line. Helen challenged the notion that women didn't need the same wages as men because they weren't the main breadwinners.

Helen became president of the Women's Labour League (WLL) in Winnipeg, helped educate working girls and women about their rights, and fought for a minimum wage. She founded the Retail Clerks' Union

and served on the Mother's Allowance Board. In May 1917, she organized a union for female workers at Woolworth's Department Store and led them to a strike. The company paid the women just $6 a week for working twelve hours per day, six days a week. Many of them were living on coffee and cake because they couldn't afford anything else. Under Helen's leadership the women demanded — and won — a raise of $2 per week.

Helen was at the forefront of the fight for a living wage when Manitoba and British Columbia became the first two provinces to pass minimum wage legislation for women in 1918. By this time, she'd earned a reputation as a radical labour leader, and was a woman admired by one female journalist as a "very striking personality ... a woman whose ideals are pure and broad."[2]

When veterans of the First World War returned to Winnipeg in 1918, they discovered few job opportunities; labour unrest grew along with inflation, poverty, and malnutrition. Helen was among those voicing demands for the right to collective bargaining, as well as better wages and working conditions. She was a member of the General Strike Committee, which organized the Winnipeg General Strike. With 50,000 workers off the job, the city shut down on May 15, 1919. Helen organized a soup kitchen in the Labour Temple, serving up to 1,500 patrons a day.

She also organized peaceful demonstrations, regular strike reports, and the maintenance of some essential services, while taunting scabs, defying police, and rallying strikers. She was arrested at least four times during the strike, and the Royal Canadian Mounted Police carted her husband off to jail after raiding the Armstrongs' home. She would later lead children in singing "Solidarity Forever" outside the prison walls.

Helen marched with strikers on June 21, 1919, when provocation of the crowd resulted in a violent confrontation between demonstrators, the Royal Canadian Mounted Police, and special police: "Bloody Saturday." Shots were fired, two protesters were killed, and many brutally beaten. As law enforcers attacked the crowd, which included women and children, with batons, baseball bats, and wagon spokes, Helen urged the women around her to stick their hat pins in the rumps of the Mounties' horses. After the riot, George Armstrong was sentenced to a year in prison along with other key leaders, the strike was called off, and Helen was arrested for inciting violence.

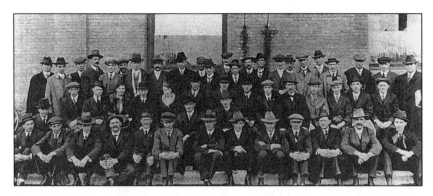

The Winnipeg Strike Committee, with Helen Armstrong in the second row, fourth from the left.

Authorities kept the woman the press called "the dangerous Mrs. Armstrong" in prison for four days before finally granting bail. As the press reported, "The Attorney General has refused bail for Mrs. Geo. Armstrong, he says that is the duty of our judges. For some reason inexplicable to ordinary mortals, this woman is refused bail and must spend day after day in jail."[3]

After being released and acquitted, Helen looked after her family during George's incarceration and went on an extensive public speaking tour in eastern Canada to raise money to cover the legal costs of the jailed strike leaders. Praised by the press for her indomitable spirit, she attracted considerable media coverage. She campaigned twice for election as a city alderman in Winnipeg, but didn't win. When George had trouble finding construction work in the 1920s, the Armstrongs moved to Chicago in 1924. Helen had been corresponding with feminist social worker Jane Addams (who later won the Nobel Peace Prize) and immediately began working with her at Hull House.

When the Armstrongs returned to Winnipeg after the 1929 stock market crash, Helen plunged back into her efforts to improve the lives of women. She'd endured public criticism, arrest, and prison to stand up for her ideals. Helen sometimes wore a medallion engraved with the word *courage*, a gift from the parents of a boy she saved from drowning in a lake, even though she couldn't swim.

Helen Armstrong's significant contributions to the labour movement — particularly her involvement in the Winnipeg strike — were largely overlooked for many years.[4] Film producer Paula Kelly was

among those who bemoaned the fact that "Helen Armstrong nearly disappeared off the radar of twentieth-century history" until recently; she released a documentary about Helen in 2001.[5]

Quote:

"Women's vote has given us the club. Now we want women to use it."[6]

Should Parenthood Be Planned?

Elizabeth Bagshaw
1881–1982

A crusader for birth control rights in Canada, she devoted her life to women's health.

Dr. Bagshaw after graduation from the University of Toronto, 1905.

According to Catholic bishop John F. McNally, Dr. Elizabeth Bagshaw's clinic was run by heretics and devils. Funny thing was, the more he preached his opposition to the birth control clinic in Hamilton, Ontario, the more women appeared on the doorstep for help. Many women hadn't heard about the facility until he unwittingly spread the news.

Dr. Bagshaw, an experienced physician, served as medical director of Canada's first — illegal — birth control clinic for more than thirty years. Eager to help women plan their families, she courageously accepted the unpaid position in 1932, despite strong objections to the facility from religious leaders and some members of the medical community. Though it was illegal to provide birth control in Canada until 1969, Dr. Bagshaw and her team of nurses and volunteers did just that. How did they manage to avoid the long arm of the law? They kept quiet about the clinic. News spread by word of mouth.

The clinic provided advice about birth control and distributed condoms, jellies, and pessaries to married women. Dr. Bagshaw also

inserted diaphragms and provided the necessary information about their use. During the first year of operation, Dr. Bagshaw assisted 390 women. Women who visited the clinic in the early years were married and already had children, and for financial or medical reasons worried about expanding their families.[1]

In later years, methods of birth control changed with advances in contraception and unmarried women began seeking advice at the clinic. The centre was not an abortion clinic, though on a few occasions Dr. Bagshaw performed abortions for medical reasons.

Born and raised on a farm in Victoria County, Ontario, Elizabeth Catharine Bagshaw was the youngest of four girls. She was a spunky child who remembered being frequently strapped at school because she was saucy. A tomboy who relished riding cows and standing up on horses' backs, as she'd seen in the circus, she was an independent thinker. At the age of sixteen, she decided to become a doctor.

With the support of her father John, (and the disapproval of her mother), Elizabeth attended the Women's Medical College in Toronto. Before she graduated, tragedy struck the family. John Bagshaw fell from a ladder and broke his neck — as Elizabeth watched. He died the next day; Elizabeth had to manage the farm. After facing more sexism from the hired men than she had ever encountered at medical school, the young woman eventually fired them all and sold the farm.

Elizabeth graduated as a doctor in 1905, but still had to gain practical experience to obtain her licence. As it was difficult for women to find a hospital in Canada where they would be accepted for the required one-year internship, she hoped to complete the program in Detroit. She gave up her plans, though, because of her mother's pleas not to be left alone. Instead, Elizabeth completed a one-year, unpaid preceptorship with a female physician who focused on maternity patients.

Dr. Bagshaw settled in Hamilton after filling in for a woman doctor there; she began a lengthy career, primarily caring for women. Most of her work was in obstetrics, and in three consecutive years in the 1920s, she signed more birth certificates than any other physician in Hamilton. She delivered most of those babies at their parents' homes. In the early years of her practice she rented a horse and buggy for transportation in the mornings, using her bicycle to attend to patients

in the evenings. During her career, Dr. Bagshaw brought more than 3,000 babies into the world.[2]

By the time she was forty, her hopes of long-term romance had literally died with the death of two suitors, Lou Honey and Jimmy Dickinson. At forty-five, Dr. Bagshaw adopted the baby of a distant relative who suddenly died. Afraid that her dream of motherhood would die if Children's Aid got involved, she quietly hired a good lawyer and became a single parent. Her son, John, eventually became a doctor, and, beginning in 1954, both practised in the same building.

Dr. Elizabeth Bagshaw maintained an active medical practice in addition to serving as the medical director of Canada's first birth control clinic until 1966. She helped change public opinion on the issue of planned parenthood. When she reluctantly retired at age ninety-five, still serving fifty patients, Dr. Bagshaw was the country's oldest practising physician. She celebrated her ninety-ninth birthday with the release of a National Film Board movie about her life.[3] She died at the age of 100.

A trailblazer in Canadian medical history, Dr. Bagshaw received widespread recognition for her accomplishments before her death. The lengthy list of honours includes the Order of Canada, the Governor General's Persons Award, Hamilton's Citizen of the Year (1970), the naming of the Elizabeth Bagshaw Elementary School, a guest lectureship in her name at Hamilton Academy of Medicine, and an honorary doctorate from McMaster University. In 2007, Dr. Elizabeth Bagshaw was inducted into the Canadian Medical Hall of Fame.

Quote:

"There was no welfare and no unemployment payments, and these people were just about half-starved because there was no work, and for them to go on having children was a detriment to the country. They couldn't afford children if they couldn't afford to eat. So the families came to the clinic and we gave them information."[4]

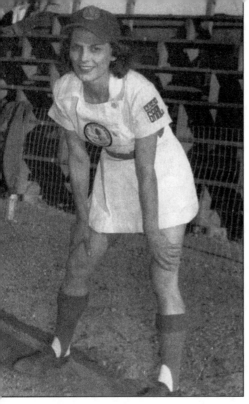

Mary "Bonnie" Baker.

Bonnie at the Bat

Mary "Bonnie" Baker

1918–2003

She stole fans' hearts as deftly as she stole bases, becoming the face of women's professional baseball and helping shatter the notion that only men could play in the big leagues.

Baseball was in Mary Baker's blood. When scouts for the All-American Girls Professional Baseball League (AAGPBL) came calling, she jumped at the chance to play ball. Not only did she love the game, but the league paid an incredible $55 to $100 a week at a time when women in the workforce were earning as little as $10 a week. Not to mention that a few top players, like Mary, were said to have received at least one $2,500 signing bonus.[1]

Mary Geraldine Baker (née George) was born in Regina on July 10, 1918, to parents of Hungarian descent. Baseball was hot on the Prairies when she was growing up; the star athlete remembered that there wasn't much to do "except play ball and chase grasshoppers."[2] By the time she was in elementary school, Mary had set a record for throwing a baseball 105 metres.

After Mary married Maury Baker she continued to play softball on a team sponsored by the Army and Navy department store where she worked. At the outbreak of the Second World War, her husband joined the Royal Canadian Air Force and left to fight overseas. Meanwhile,

American chewing gum magnate P.K. Wrigley — the owner of the Chicago Cubs — came up with the idea of creating a women's professional baseball league to fill the stadiums during wartime.

Mary Baker was astounded to read about the league in the Regina newspaper one morning, and thrilled to receive a call from scout Hub Bishop that same afternoon. She'd already passed up a chance to play pro softball for a Montreal team in 1942, because her husband refused to let her sign up. But this time Maury was on the other side of the world, and Mary's mother-in-law encouraged her to go to the tryouts at Wrigley Field in the spring of 1943.

Mary was chosen as one of the sixty players who would make up the four founding teams in the league, and the first women to play professional baseball. Of the 600 young women from across North America who would eventually play in the league, more than 10 percent were Canadian, half of those from Saskatchewan, like Mary.

Many of the new recruits were shocked to discover the stylish, but impractical, uniforms they'd be wearing: one-piece skirted tunics with satin shorts worn underneath the short skirts preserved modesty but did nothing to prevent painful "strawberries" when the players slide into base on bare skin.[3] Wrigley and his staff made it clear that they wanted the women to play ball like men, but look feminine and stylish.

There were many rules and regulations for team members. The "girls" — the common term of the era — would be strictly chaperoned. They were forbidden to smoke or drink hard liquor in public. A curfew required them to be in bed within two hours after the games, and all social activities had to be approved in advance.

Eager to hire attractive girls who would draw fans, the AAGPBL insisted on femininity.[4] During the spring of 1943, Mary and the other new recruits were required to attend charm school, conducted by beauty salon founder Helena Rubenstein. Even after the charm school was discontinued in later years, the women still received a beauty kit and a manual that explained the ideal for players: "The All-American girl is a symbol of health, glamor, physical perfection, vim, vigor and a glowing personality."[5]

According to sports historian M. Ann Hall, Mary was the most outstanding Canadian player because of her skill and longevity as well

as her enthusiasm for the game.[6] She was a natural beauty, as well as charming and well-groomed, and quickly became a popular cover girl and spokesperson for the league; the press often referred to her as Pretty Bonnie Baker. In 1945, she was featured in *Time* magazine, the Canadian who became the embodiment of the All-America girl, playing professional ball. Mary's husband returned from the war that same year, proud of her success. He had initially accepted her career with the condition that she quit when he came home; he changed his tune when he realized how miserable she would be.

Though initially hired to play softball, the "girls" were soon playing baseball like their male counterparts. The schedules for the women were gruelling: games six nights a week, as well as double-headers on Saturday or Sunday. The talented and feisty Mary "Bonnie" Baker was a fan favourite and played more games than any other player in the league: 930 regular games and eighteen playoff games.

Mary was an outstanding catcher and baserunner, stealing 504 bases during her nine seasons with the league. With a career fielding average of .953, she was one of the top backstops in women's baseball. A two-time All Star, she played backcatcher for Indiana's South Bend Blue Sox from 1943–50. Fifty years after the Blue Sox disappeared, she still dominated fans' memories: "Remember Bonnie Baker …"[7]

In 1950, she was traded to Michigan's Kalamazoo Lassies as a manager, becoming the only woman in the league to ever work full-time as a manager. She missed the 1951 season to give birth to her daughter, Maureen. Mary spent the following year toting the baby to practices while playing with the Lassies, after the league introduced a sexist motion to prohibit women managers. The AAGPBL disappeared in 1954, but not before the first professional women's baseball league had made history and entertained nearly a million fans a year at its peak.

Back in Regina, Mary managed the local curling club for twenty-five years and became Canada's first female sports broadcaster at Regina's CKRM from 1964 to 1965. The gutsy baseball pioneer was inducted into both the sports and baseball halls of fame in Saskatchewan. In 1998, the Canadian Baseball Hall of Fame honoured the Canadian members of the AAGPBL, and its American counterpart finally recognized the league after relentless lobbying by Mary Baker and some of her teammates. The

movie *A League of Their Own* paid tribute to the women with characters inspired by the remarkable true story, featuring Geena Davis in the starring role of Dottie Hinson — who resembled the famous Pretty Bonnie Baker.

When Mary "Bonnie" Baker died in December 2003, she was remembered as "one hell of a woman."[8] Mourners celebrated her by singing "Take Me Out to the Ball Game."

Quote:

"I was ecstatic. I knew I was on my way to what I'd dreamed of."[9]

— Mary's reaction on being invited to try out for the AAGPBL.

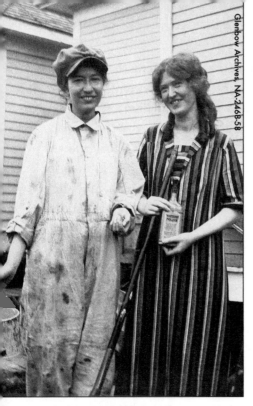

Adventures in Hostelling

Catherine Barclay
1902–1985

Mary Barclay
1901–2000

They turned their passion for travel and the outdoors into building hostels.

Mary and Catherine Barclay working on hostels, 1920–1923.

Travellers who explore Canada and stay in hostels can thank the Barclay sisters, Mary and Catherine. The Calgary schoolteachers established the first youth hostel in North American in 1933, then worked together with family and friends to develop Canadian hostelling.

Having spent much of their early childhoods in the country, Mary and Catherine liked tramping around the Alberta foothills and the Rockies. The Barclay children were all born in Illinois: Mary in 1901, Catherine in 1902, and their brother, George, the following year. When their father's business failed, George Barclay and his ailing young wife, Elsie, decided to homestead in Canada. In 1905, after a long journey in a crowded Canadian Pacific Railway colonist car, the Barclays arrived near Lacombe, Alberta.

Despite the hardships of homesteading, the girls loved country life and their long walks to school through the woods and meadows. Times were tough and the Barclays went bankrupt. After the foreclosure of their home in 1913, they settled in Calgary, where they rented a house at

212 12th Avenue North West; the building would later also serve as the headquarters of the Canadian Youth Hostelling Association.

Mary and Catherine completed their schooling in Calgary, attending a high school whose principal, William Aberhart, would one day become premier of the province. Mary always felt overshadowed by Catherine, who was charming and witty, beautiful as well as intellectual. But both girls followed the same career path, attending Normal School to become teachers, then working in country schools at the outset of their careers.

Mary, always eager to improve her skills, studied at the University of Chicago for a year. During the Second World War, she obtained a degree from the University of Toronto. She worked as a principal at several schools, pioneering what is now called outdoor education.[1]

Once Catherine could afford to continue her education, she attended the University of Alberta, where she studied English literature and French. She was very enthusiastic about learning and teaching French, becoming a champion of bilingualism in Canada decades before it became official government policy. She also helped create student exchanges between Quebec and Alberta.[2] She attended courses at the Sorbonne to improve her French, and later received her master's degree at Columbia. It was Catherine's interest in travel, student exchanges, and foreign languages that led her to the idea of youth hostels.

"We actually blundered into it," remembered Catherine.[3] She thought it was beneficial for young people to have the opportunity to travel, but the costs were often problematic. She met a man in Calgary who promised discount travel rates to England if twenty young people would sign up. He suggested that running an essay contest, with a free trip as the prize, would be an incentive. After the man disappeared, Catherine and the other contest organizers had $19 in contest entrance fees, but faced the formidable task of raising money to pay the winner's trip costs.

Catherine read about the English youth hostel system, which seemed to present an ideal means of providing low-cost accommodation for the contest winner. The youth hostels were named after the German *Jugendherberge*, which had been established by Richard Schirmann in 1907. The concept was to provide a system of carefully placed shelters where young people could stay while cycling or hiking between them.

By 1919, German's first hostelling committee had been organized, and the International Youth Hostel Federation was created at a conference in Amsterdam in 1932.

With some knowledge of the growing hostel movement overseas, Mary, Catherine, and some other single, working women in Calgary decided to form a hiking club in 1933. After the group had spent a few weekends in the nearby Bragg Creek area at a small lodge, Mary decided to create a hostel by pitching a tent and charging users twenty-five cents a night. She was excited about this means of providing city folks with an inexpensive place to enjoy the great outdoors. As Mary had hoped, her sister provided the $19 from the essay contest as a start-up fund; the fees paid for transporting hikers to the hostel.

On July 1, 1933, Mary, Catherine, and their friends loaded up the Barclay's Model T with supplies. Mary later dubbed the car Faith, explaining that she needed "a lot of faith to drive her, and her passengers certainly needed it too."[4] By nightfall, the team had constructed the first official hostel in North America at Bragg Creek.

It consisted of a twelve-by-fourteen-foot tent, which George Barclay had managed to rent for $7.50 for the month, complete with straw mattresses, a small stove, and dishes. There was a broken-down toilet nearby, with no door. Nothing fancy, but "it stood for an ideal," Mary later wrote. "A right idea that once seen could never be destroyed."[5] By the fall, the team had purchased a permanent tent from Eaton's department store for $49 and installed a wooden floor. Membership fees of $1, and the twenty-five-cent nightly charges, provided revenue.

By the end of their first summer, the hostel team had big plans. Mary and Catherine, along with friends Ivy Devereux and Dorothy Allen, created the Canadian International Youth Hostelling Committee. They began offering recreational opportunities, such as horseback riding, to hostel guests, and, the following year, began planning the expansion of Canadian hostels based on new information about the system in Europe. The two sisters worked together, along with a growing network of supporters, to build more hostels between Calgary and Banff and in southern Alberta. By 1939, there were sixteen hostels in the province. After the Second World War, Mary managed to get huts from the Kananaskis prisoner-of-war camp moved to Banff to be used as hostels.

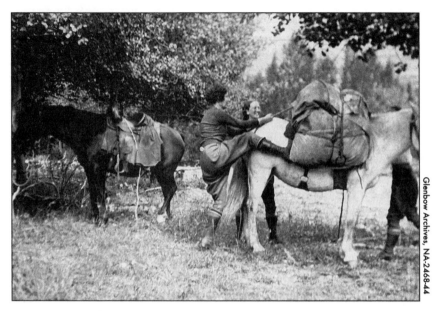

Glenbow Archives, NA-2468-44

Mary Barclay (at left) tying a pack horse for a trail-blazing trip in the Seebe area, Alberta.

The Canadian Youth Hostel organization was created in the Barclay's Calgary home, and a national system slowly developed in the following years thanks to hundreds of keen hostellers across Canada. Mary and Catherine ceased active involvement in 1941, once the groundwork for a national organization was in place, but they remained supportive of the movement. The Canadian Hostelling Association, as it is now called, has hostels in every province and territory, which attract families as well as young adventurers.

In 1975, the International Youth Hostel Federation presented the sisters with the Richard Schirrmann medal, acknowledging them as the co-founders of youth hostelling in Canada. Both Mary and Catherine had long teaching careers and remained single. They enticed many of their pupils into hostelling, including activist and author Doris Anderson, who spent many an afternoon picking wool to make comforters for the hostels.[6] The sisters lived together in their Calgary home until Catherine passed away in 1985.

The E. Catherine Barclay Scholarship was established at the University of Calgary to support students interested in studying in France. Mary received the Order of Canada in 1987 in recognition of her achievement

as co-founder of the Canadian Youth Hostelling Association. At the age of ninety-six, Mary attended the unveiling of an impressive $1.7-million addition to the Banff Hostel in 1998, which was named the Mary Belle Barclay Building in honour of the pioneer conservationist.

Quote:

"This is a far cry from sleeping on a plank of wood with canvas walls and apple box cupboards."[7]

— Mary Barclay at the Banff Hostel, 1998.

Bound for Uncharted Waters

Frances Barkley

1769–1845

The first European woman to explore the coast of British Columbia, she circumnavigated the globe twice.

It was a whirlwind courtship. Just six weeks after Captain Charles Barkley sailed into Ostend, Belgium, he wed Frances Hornby Trevor. Less than a month later, the fair young bride with long reddish-blond curls set sail for the Pacific coast of America with her new husband.

Frances Barkley was born in Somerset, England, in 1769 — the same year as Napoleon. Her mother died when she was an infant, and her father, the Reverend Doctor John Trevor, moved the family to London, then Hamburg. Reverend Trevor became the minister of the Protestant Chapel in Ostend in 1783. Frances was educated in a Roman Catholic convent somewhere on the Continent. A brilliant student of French, the young woman completed her studies and joined her father in Belgium.

When she married British mariner Captain Charles William Barkley, a fur trader, he was twenty-seven and she was seventeen. The Barkleys departed November 24, 1786, on the *Loudoun*, which had been renamed the *Imperial Eagle*, flying the Austrian flag, to avoid conflict with the British East India Company's trading monopoly.

Courtesy of Mark Heine

Frances Barkley, depicted by Harry Heine.

During the first few months of the voyage across the Atlantic, the Barkleys survived many storms. Crashing seas swept away some of their fresh food, including turkeys, chickens, and ducks. When Captain Barkley got rheumatic fever in December, it seemed that there was little hope of recovery without proper medical attention. The young bride cared for her husband while fending off unwanted attentions: "My situation was very critical at that time from the unprincipled intentions of the Chief Mate supported by the second Mate, who being a Lieutenant in his Magesties service ought to have had more honor."[1]

Fortunately for Frances, Captain Barkley's health improved and he resumed control of the ship. The *Imperial Eagle* stopped in Brazil before tackling the trecherous passage around Cape Horn. The Barkleys replenished their supplies in the Sandwich Islands (now Hawaii) and arrived on the west side of Vancouver Island in June 1787. They moored in Nootka Sound at Friendly Cove — just nine years after Captain James Cook became the first European to explore the area.

Captain Barkley traded with Natives in both Nootka and Clayoquot sounds, obtaining about 800 sea-otter furs. Frances wrote favourably about her meetings with Chiefs Maquina and Callecum, and noted that the local climate seemed similar to that of Scotland. After spending about a month in Friendly Cove, the Barkleys sailed south along the coast; Captain Barkley named a very large sound after himself. Frances explained that, "several coves and bays and also islands in this sound were named. There was Frances Island — after myself: Hornby Peak — also after myself — Cape Beale after our purser."[2]

The *Imperial Eagle* then sailed into a large strait to the east, which Barkley named after Greek mariner Juan de Fuca who claimed to have discovered it. After six of the crew were killed on a nearby island — Barkley named it Destruction Island — the ship departed for Macao to sell the otter pelts. They loaded new cargo before the *Imperial Eagle* continued to Mauritius, where Frances gave birth to her first child, a son named William Andrew Hippolyte, in 1788. Barkley lost the ship when his investors backed out: the East India Company was displeased about the threat to their monopoly. He was forced to turn over his charts to a disreputable fellow called John Meares. Armed with Barkley's information, Meares would later claim some of the discoveries as his own — a claim that Frances's diary and other writings would refute.

Frances and her husband and baby eventually headed back to England on an American ship, which was wrecked off the coast of Le Havre, France. Despite being deserted in the night by the captain and crew as the ship sank, the threesome were rescued. They arrived safely back in Portsmouth, England, on November 12, 1789.

Two years after departing on the voyage, Frances Barkley was home and had circumnavigated the globe. While Jeanne Baret, a French woman disguised as a man, holds the distinction of being the first female to complete a circumnavigation,[3] young Frances was likely the first woman to accomplish the task without hiding her sex.

The Barkleys spent about seven months in England before setting sail for India. Frances gave birth to her daughter, Martha (Patty), during a gale as they rounded the Cape of Good Hope. They arrived safely in Calcutta in August 1791. At the end of December 1791, the Barkleys sailed off to trade in Sitka Sound, Alaska, then headed to the Sandwich

Islands, China, and Mauritius. During the voyage, Captain Barkley and Patty both became seriously ill. Captain Barkley miraculously survived, but little Patty died the day before her first birthday.

On arriving in Mauritius, the Barkleys discovered it was occupied by the French (now at war with the British); their ship was confiscated and the captain and crew imprisoned. Eventually, the Barkleys returned to England after a journey of four and a half years. Frances Barkley was home by November 1794, where she remained for the rest of her life.

Several relatives recounted the story of how Frances's golden-red hair had saved the family from danger when hostile Natives believed she was a goddess. She was considered to be a courageous woman, absolutely devoted to her husband, as he was to her; his affectionate letters to Frances referred to her in terms such as "the best of women" and "my ever dear Love."[4]

And how is Frances Hornby Trevor Barkley remembered today? Trevor Channel was named as a tribute to her in 1931, and author Beth Hill published a biography after years of research. In England, Frances's story was included in a publication called *Somerset's Forgotten Heroes*.[5] In 2009, the University of Auckland, New Zealand, established the Frances Barkley Scholarship for Maori and Pacific students. The *M.V. Frances Barkley*, a Norwegian-built vessel now carrying passengers on the west coast of Vancouver Island, was named in honour of the courageous adventurer.

Frances Barkley is a notable woman in Canadian history for being the first European woman to arrive in British Columbia, and recording important information about the Barkley's voyages. While images of her father and husband have been preserved, no drawings or paintings have been found that show her face. We can only imagine a beautiful young woman, standing on deck below the billowing sails of the *Imperial Eagle*, a graceful figure with long golden-red hair blowing in the wind.

Quote:

"... I made up my mind to brave every danger rather than separate, thereby at any rate securing his [Captain Barkley's] peace of Mind, as

well as my own; but we both imbarked with heavy hearts, two Infants to share all risks, the Youngest at the breast. She, poor little creature, became the Victim of our folly."[6]

— Frances reflecting on the decision to accompany her husband on a sea voyage from Calcutta, 1791.

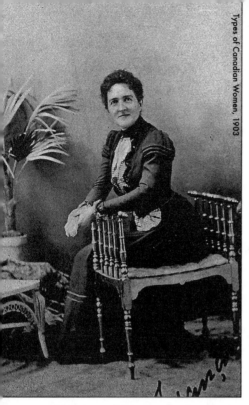

Robertine Barry.

A Feminist Rebel

Robertine Barry
1863–1910

The first woman in Quebec to earn her living as a journalist, she battled for women's rights despite being publicly insulted by both sexes for her radical ideas.

It's a good thing that Robertine Barry didn't give up easily: it took nine long years before an editor accepted any of her articles. One editor had offered to print a story years earlier — on the condition that her name be excluded — but the aspiring journalist refused. Her perseverence eventually earned her acclaim as a great writer; she was compared favourably with the likes of Balzac, George Sand, Guy de Maupassant, and Henry James.[1]

From the time Robertine was a child, writing was her passion. Born in L'Île-Verte, Quebec, she was fortunate to come from a privileged family. Her mother, Aglaé Rouleau, once created a stir in church by daring to wear a dress with a crinoline; she was denied communion. Robertine's father, John Edmond Barry, a well-educated Irishman, became prominent in the Saguenay region and held administrative positions ranging from mayor to vice-consul of Sweden and Norway.

Robertine grew up in a bustling household with a dozen siblings and a wealth of books and music. Unlike many children at the time, she

received the best education available despite frequent visits to the Mother Superior for bad behaviour. Robertine loved to learn but felt stifled in the strict convent schools she attended in Trois-Pistoles and Quebec City. By the time she graduated at age twenty, the young woman was thrilled to regain her freedom.

Though she was expected to marry and have children, the fiercely independent and strong-willed Robertine had other ideas: "I am not among those who consider marriage as the goal to which must be devoted a lifetime of noble efforts."[2] She dreamed of becoming a full-time journalist; inspired by the success of French journalist Séverine, Robertine began submitting articles to newspapers. She viewed journalism as a noble profession whose purpose was to encourage discussions of social issues and important events. She was eager to express her opinions and influence society.

After approaching Honoré Beaugrand, editor of the influential radical Montreal newspaper *La Patrie*, Robertine finally got the opportunity she'd dreamed of. On April 30, 1891, the paper published her provocative article about the importance of education for young women — on the front page of the paper. She suggested that radical reforms were necessary, and that schooling should be removed from the Catholic Church's control. Writing under her pen name Françoise, Robertine showed remarkable courage as her first major piece challenged the majority of Quebec's population (including the powerful clergy, ultramontanes, and anti-feminists). Henri Bourasssa, a politician and the founder of *Le Devoir*, shared the common belief that women should stay quietly in the home; he called Robertine a monster for living her life in the public eye.[3]

La Patrie published four of Françoise's articles about women's education. From the fall of 1890 until 1900, she was a regular staff member at the paper, writing a weekly column called "Chronique du lundi." She also introduced women's pages in Quebec through *Le Journal de Françoise*, the bimonthly magazine she founded in 1902 and published until 1909. The review included literary works, allowing her to showcase her friends' writing, including Laure Conan and the talented, but tormented, poet Émile Nelligan (whose relationship with Robertine inspired several of his poems). Robertine published two books — a

collection of short stories and her collected weekly columns — while also writing for a variety of publications in Montreal. She was one of the founders of the Women's Press Club of Canada, and served as president.

Robertine became an accomplished professional writer, publisher, journalist, and an excellent lecturer. A vocal and influential feminist, she championed women's rights and promoted access to education and the establishment of libraries. She viewed employment for single and married women as the key to emancipation. She inspired other women by setting an example as a single, independent career woman who spoke her mind on important issues, travelled internationally by herself (which was considered quite scandalous), and dared to do things like go underground in a mine or jump into the Lachine Rapids.

The Canadian government appointed Robertine Barry (along with Josephine Dandurand) to represent Canada at the 1900 Paris International Exhibition, for which she also contributed to a publication about women in Canada and participated in the International Women's Congress. In 1904, the government of France honoured Robertine by naming her *officier d'académie*. Robertine represented Canada at the Universal Exposition in Milan in 1906. In 1910, Quebec Premier Sir Lomer Goulin named her inspector of women's working conditions in industry, but she died suddenly a few months later of a stroke. She was forty-seven.

Quebec's unofficial poet laureate, Louis Fréchette, considered Robertine to be the most remarkable woman in Canada.[4] Though a journalism prize, a street in Montreal, and a township in Abitibi, Quebec, bear her name, biographer Sergine Desjardins suggests that few people remember this pioneer journalist, and those who do underestimate her role as an important Canadian feminist in the nineteenth century.[5]

Quote:

"I dream … of chairs of universities occupied by women."[5]

The Heroine of Long Point

Abigail Becker

1830–1905

Unable to swim, she plunged into Lake Erie to save the crew of the schooner *Conductor*.

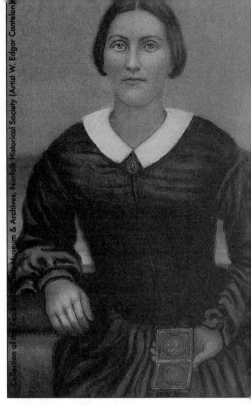

Painting of Abigail Becker with her gold medal, based on a daguerreotype.

Abigail Becker was once more famous that Laura Secord.[1] When she died in 1905, even the *New York Times* noted the passing of this woman, "famed in song and story throughout Canada."[2]

On November 24, 1854, a vicious storm blew in on Lake Erie, bringing snow and raging winds. The three-masted schooner *Conductor*, bound for the Welland Canal with a heavy load of grain, sought shelter at Long Point, a narrow peninsula known for its shifting sandbars and dangerous currents. The vessel foundered on a sandbar and most of it was quickly submerged. Throughout the night Captain Hackett, his six sailors, and the cook clung to the frozen rigging.

Abigail Becker lived in poverty in a shanty on Long Point, with her husband Jeremiah and their many children; he already had five when Abigail Jackson wed him at seventeen, and she bore eight more during their marriage. The storm was still raging in the morning when twenty-four-year-old Abigail went to fetch some water. The young mother and two of her sons set about rescuing the drowning men. The three gathered

driftwood and set a fire on the beach.

She was said to be six feet tall, a strong and powerful woman; she would need every ounce of that strength for the ordeal ahead. As she had no boat to reach the ship, the courageous Abigail dashed into the crashing waves and waded toward it with outstretched arms, trying to encourage the men to risk swimming to shore. She waded deeper and deeper, risking her own life as she plunged into the icy waters up to her shoulders. Captain Hackett was the first to leap into the lake.

Hackett got caught in an undertow, so Abigail Becker struggled farther out to grab him. She pulled the drowning man to shore, where he huddled by the warmth of the bonfire with hot tea. Then she coaxed the second mate to swim through the storm, and again she dragged him to safety. An exhausted but determined Abigail rescued the remaining sailors in the same fashion, but the cook (who couldn't swim) remained lashed to the rigging until the following day, when he, too, made it to shore thanks to her help and a raft built by the other men.

Abigail was credited with single-handedly saving the lives of the eight men, and news of her heroism spread. Sailors and merchants from Buffalo, New York, presented her with a purse of money. The New York Lifesaving Benevolent Association presented her with a gold medal, which she wore proudly for special occasions. Abigail was particularly pleased with the congratulatory letter she received from Queen Victoria, along with £50. Governor General Lord Aberdeen also sent her a letter, and the Royal Humane Society gave her a bronze medal.

With the money she'd received, Abigail purchased fifty acres north of Port Rowan, settling there with her husband and children. After he froze to death during a hunting trip, she struggled to support her family on the farm. She later married Henry Rohrer. During her lifetime, she raised a total of seventeen children.

Abigail also saved a boy who had fallen into a well and assisted six other shipwrecked sailors. Some called her "The Heroine of Lake Erie," others "The Angel of Long Point." They praised the "unparalleled exploit of good, strong-bodied, simple-minded, warm-hearted Abigail Becker."[3] Tributes included a lengthy poem written by Miss Amanda T. Jones (published in 1885),[4] which was included in the Ontario High School Reader,[5] as well as an article in *Atlantic Monthly*.[6]

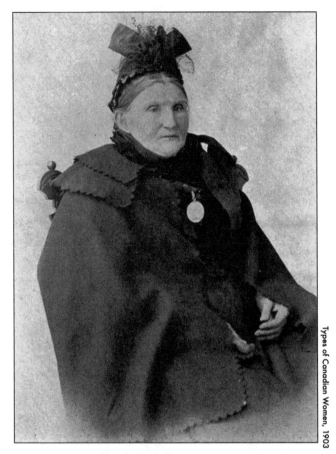

Types of Canadian Women, 1903

Portrait of Abigail Becker, taken at the G.P. Perry Studio in Simcoe.

In 1958, an Ontario provincial government plaque commemorating Abigail's heroism was erected in Port Rowan. In 1992, the folk band Tanglefoot recorded a song called "The Angel of Long Point." Though the story of Abigail Becker is no longer widely known, the Abigail Becker Conservation Area remains.

Quote:

"I don't know as I did more 'n I'd ought to, nor more'n I'd do again."[7]

— Abigail Becker talking to a Captain Dorr soon after the rescue.

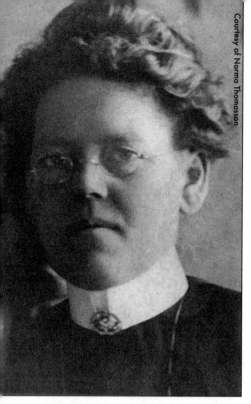

Margret Benedictsson.

The Power of Freyja

Margret Benedictsson

1866–1956

This Icelandic feminist fought to get the vote for women in Manitoba. And created the country's major suffrage journal — named after a Norse goddess.

Born on a peasant farm in the Víður valley of northern Iceland in 1866, Margret Jonsdottir had a lonely childhood. She was the daughter of harness-maker Jon Jonsson and Kristjana Ebeneserdottir, the servant who cared for his elderly, leprosy-afflicted wife Margret. Enraged at the birth of the baby, the ailing woman was placated only when the newborn was named after her and Kristjana was sent away. The child received no affection after her mother left, remembering only that someone once patted her hand.[1]

Following the death of her father, Margret was alone. At thirteen, she became a shepherdess in the mountains of Iceland. She grew up accustomed to equal rights for women and was inspired by reading about patriot Jon Sigurdsson's fight for Icelandic independence. Knowing that, as a peasant, she would find few opportunities for advancement in her homeland, Margret borrowed money to emigrate to an Icelandic settlement in the Dakota Territory in 1887. Penniless, the twenty-one-year-old couldn't speak a word of English.

She worked as a domestic servant to pay off her loan, as well as high-school education and two years of study at Bathgate College. Around 1890, she packed her bags and headed north to Winnipeg to join other Icelanders.

Margret took a business course so she could support herself by doing typing and bookkeeping. When the young woman arrived in Manitoba, women didn't have the right to vote in provincial or federal elections. The Elections Act lumped together all second-class citizens denied the right to vote in a clause stating "no woman, idiot, lunatic, or criminal shall vote." Margret fought for Canadian women to have equal rights to men in politics as well as all other spheres of their lives. By 1893, she was lecturing about women's rights to Icelanders in Winnipeg.

While other Manitoba suffragists were already actively campaigning for the vote, many Icelanders were insulted that English-speaking women hadn't tried to involve foreigners, such as themselves. That didn't stop Margret from getting into the act. After she married Sigfus Benedictsson, the couple founded *Freyja*. It would become Canada's most important women's suffrage newspaper, as well as one of the few Icelandic literary journals in North America.[2] With Margret as editor, the couple published the influential paper from 1898 to 1910. The name of the publication means woman or goddess, from the name of a Norse goddess responsible for love, fertility, battle, and death.

Margret noted the primary objective of the paper: "At the top of the agenda will be progress in the women's rights movement. It will support abstinence and all that is good and pure."[3] The Benedictssons published monthly issues of *Freyja* in Icelandic, comprised of an average of forty pages with information about the struggle for women's rights, as well as stories, poems, literary reviews, profiles of notable people, and material for children. Margret wrote much of the content and included her translations of the writings of American and European suffrage leaders. Icelanders were generally sympathetic to equal rights for women, and the publication had a large circulation.

By day, Margret looked after her three children and filled the traditional role of wife and mother. In the evenings she devoted herself to *Freyja,* as well as giving suffrage lectures in the Icelandic community. This committed and energetic activist was the primary motivator behind various Icelandic suffrage organizations in Manitoba.[4] In 1908,

she created what she called the "first Icelandic Suffrage Association of America"[5] in Winnipeg, serving as president. She then linked it with the Canada Suffrage Association (and was invited to several meetings), and the International Woman Suffrage Alliance.

Icelandic suffragette groups soon sprung up in other communities, all of which sent petitions to the government of Manitoba in 1910. The organizations also submitted a joint petition in 1912. Margret deserved some of the credit when — on January 28, 1916 — Manitoba became the first province to grant women the right to vote and hold office in the government. Acting Premier T.H. Johnson, who co-introduced the bill, was the son of an Icelandic suffragist.

But Margret had already left Manitoba by then. She and Sigfus had often shared their differing opinions about divorce and marriage in *Freyja*: Sigfus argued that married women were dependents and Margret wanted them to be equal partners. The simmering discord escalated to the point that Sigfus locked up the printing press in 1910.[6] That ended *Freyja* and the marriage. Margaret divorced Sigfus and moved to Washington State with her children in 1912.

While Margret was overshadowed by nationally prominent suffragists like Nellie McClung, Professor Anne Brydon has suggested that she merits greater recognition as "a symbol of Icelandic fortitude."[7] Overcoming the challenges of her humble origins in Iceland, the ambitious immigrant became an influential champion of women's rights in Canada.

Quote:

"Angry and distressed I read the laments of oppressed persons, unhappily married women, and the misfortunes of young girls. And it is this evil that aroused in me ... a yearning to break down all the fetters that tie people to evil and distress."[8]

Florence Nightingale of the North

Myra Bennett

1890–1990

The British nurse brought desperately needed medical care to isolated outports in Newfoundland. Even when there was no money to pay her.

Courtesy of Trevor Bennett

Myra Grimsley in England.

"I have been wonderful lucky that I could help a woman like that," Angus Bennett said of his wife Myra.[1] Residents of the rugged northwest coast of Newfoundland were equally fortunate. For half a century the heroic nurse Myra Bennett (née Grimsley) provided nursing and medical services there.

The daughter of an interior decorator, Myra grew up in a family of nine children in London, England. By the time she was fourteen, she was working as a tailor and chatting in Yiddish to German Jewish customers. She saved money to train as a nurse at the British Hospital for Mothers and Babies, and later took courses at the famous Clapham School of Midwifery. The classes in anesthesia and operative midwifery would prove to be particularly useful in the years ahead. By the time the young woman decided to serve in the Canadian wilderness, she had a decade of solid nursing experience, including working through the air raids and blackouts of the First World War and dealing with the horrors of North London slums.

The sensitive nurse decided to apply for a posting in Saskatchewan after reading the tragic account of a woman who died in childbirth there due to the absence of medical assistance. Persuaded by Lady Harris (wife of the governor of Newfoundland) that the need for her services was even more pressing on The Rock, Myra boarded a ship for St. John's on April 13, 1921. She accepted a two-year contract with a monthly payment of $75, and was posted to work by herself at Daniel's Harbour. Bursting with enthusiasm for the adventures ahead, the well-trained nurse and midwife arrived in the tiny hamlet on the Great Northern Peninsula, tasked with caring for residents of a 200-mile stretch of lonely coast. The community was very isolated, accessible only by a coastal steamer that operated in the summer. The nearest hospital was Dr. Grenfell's mission at St. Anthony, several hundred miles north and impossible to reach.

"The need for medical help is beyond my power of description," Myra wrote soon after her arrival in Daniel's Harbour. [2] Appalled at the widespread poverty, harsh living conditions, and low levels of education, Myra nevertheless marvelled at the resourcefulness of the Newfoundlanders who soon began shyly approaching her about their illnesses. She settled into the community, marrying an ex-merchant mariner, Angus Bennett, who was a fisherman, trapper, and woodsman. She prided herself on learning local customs and the skills of independent living. She baked bread from scratch, grew vegetables, sheared sheep and wove clothing, milked cows, hooked rugs, and made seal-skin boots and garments.

In 1922, the newlyweds moved into their two-storey wooden house; it would serve as the home for their three children, as well as her clinic. When her two-year contract expired, the government informed her it was broke and couldn't pay her. Unwilling to abandon those in need, Myra worked for free until 1934 when she began receiving a token annual salary of $250.

Myra served not only as a nurse and midwife, but also as dentist, veterinarian, and educator. She delivered more than 700 babies and pulled at least 3,000 teeth, without anesthetic. Nurse Bennett tried to teach her patients that tuberculosis was contagious, breastfeeding was preferable to non-pasteurized milk, and that toothaches could not

be cured with charms. When her brother-in-law Alex cut off his foot while sawing lumber, she miraculously sewed the severed foot back onto the leg.

Nurse Bennett devoted her life to caring for the residents in her area. She often operated on her kitchen table and kept patients in her home for long periods. Sometimes she'd be away from Daniel's Harbour for weeks delivering babies and tending to patients. She travelled to her patients by boat, dogsled, or horse-drawn sleigh, and always found a way to help the sick. A mistress of improvisation, she often came up with novel ways to treat people in desperate situations. For keeping a broken limb in traction, for example, Nurse Bennett created her own device using beach rocks as weights.

Once her boat crashed into a rocky shore during a squall, and she had to be pulled up a cliff before speeding off in a horse-drawn sled to an expectant mother. Another time, the dedicated nurse risked her life to set out by schooner in a raging storm to save a dying woman. The woman had recently given birth, and was severely swollen and convulsing after being unconscious for two days. "God help me! A case of eclampsia in a two-roomed cottage," Myra remembered.[3]

Her exploits were legendary: she became known as The Florence Nightingale of Newfoundland. Even after officially retiring in 1953, she continued to provide nursing care. Myra's selfless service was recognized in many ways, including the King George V Jubilee Medal, Coronation Medals from George VI and Elizabeth II, the Member of the British Empire Medal, the Order of Canada, and an honorary doctorate from Memorial University. A CBC documentary celebrated this heroic nurse, and author H. Gordon Green wrote a book about her. "I've had a wonderful life," she told Green. "I went where I wanted to go and I stayed because the need was there."

Myra Bennett died in 1990 at the age of 100. Her longtime home in Daniel's Harbour is now preserved as a provincial heritage home. Robert Chafe's play, *Tempting Province,* brings to life the remarkable story of this Canadian heroine.[4] As pioneer medical officer Dr. Noel Murphy noted, "there will never be another Nurse Bennett, we hope there will never be such dire need and deplorable conditions."[5]

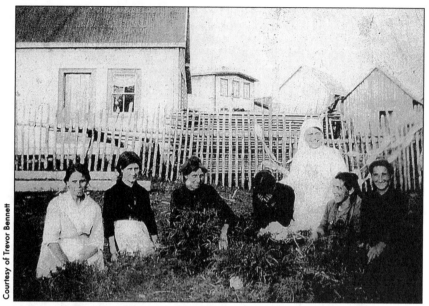

Courtesy of Trevor Bennett

Nurse Bennett (back) with women in Daniel's Harbour, 1921.

Quote:

"There are people, you know, who are rather happier when they can move into the eye of the hurricane. I suppose I was always one of them."[6]

The Not-So-Promised Land

Mary Bibb

circa 1820–1877

A zealous anti-slavery leader, she helped black fugitives who dreamed of a better life.

There is no image of Mary Bibb. This is her husband Henry Bibb, 1849.

Mary Bibb fought to end slavery and believed that black people should seek freedom in Canada. But she also knew that it was not the promised land, and that the desperate (and destitute) refugees faced great challenges despite the absence of legalized racism.

Mary Elizabeth Miles was born free in Rhode Island, one of the fortunate few black people of her time to be so privileged. Her parents were free black Quakers who encouraged her education. Mary graduated from a normal school in Lexington, Massachusetts, where she was strongly influenced by the abolitionist principal's promotion of black education and women's rights. She became one of the first black women in North America to become a teacher and devoted most of her life to the emancipation and advancement of her race.

Mary supported herself by teaching in black schools in Albany, Boston, and Cincinnati. As she moved from place to place, she got involved with anti-slavery activities, including an 1847 meeting in New York at which she met her future husband. Henry Bibb, an escaped slave

and prominent abolitionist, remembered his pleasure at being introduced to Miss Miles: "a lady whom I had frequently heard very highly spoken of, for her activity and devotion to the anti-slavery cause, as well as her talents and learning, and benevolence in the cause of reform generally."[1]

Mary was an independent woman of twenty-eight when she married Henry in 1848 and moved to Boston. When the Fugitive Slave Law was passed in the United States in 1850, the Bibbs and thousands of other black people fled to Canada, terrified by the knowledge that runaways and even free blacks could be re-enslaved. The couple first settled in Sandwich, and later Windsor, in Canada West. Windsor was a major terminus of the Underground Railroad, and the Bibbs often sheltered destitute fugitives in their home. They began working together on a number of initiatives intended to help refugees make the transition to permanent citizenship by equipping them with literacy, land, and information.

In January 1851, the Bibbs began publishing the *Voice of the Fugitive*, the first major newspaper created by and for African Canadians. With the well-educated Mary Bibb as co-editor, they developed an important communication tool that raised black consciousness and provided an international forum for discussion of issues related to abolition of slavery and settlement. The publication reported on events, promoted education, and countered racist articles in the mainstream press.

Some historians consider Mary Bibb as the first female black journalist in Canada due to her important role in the *Voice*.[2] Mary frequently supervised production of the newspaper on her own, and this was certainly the case during most of 1851 when her husband was away lecturing. An excellent writer, she penned articles on a wide variety of topics, including women's rights, anti-slavery activities for women, fashion, and style — she also managed a dressmaking business. As Mary had many important contacts with influential abolitionists in the United States, she also played a vital fundraising role for the newspaper.

Voice of the Fugitive served as the official communication tool of the Refugee Home Society (RHS), an organization established to secure land for former slaves who settled in an all-black community. Mary and her husband were among the leaders of the society, which succeeded in providing twenty-five-acre plots for more than 200 families near Sandwich, Canada West, as well as building two schools and several churches. The

Bibbs also played key roles in organizing the North American Colored Convention, which was held in Toronto on September 11, 1851.

Advancing education for black people was probably Mary's primary goal, and she taught school for at least twenty years.[3] While involved with the *Voice*, she struggled to establish a number of schools for black children who were barred from attending regular schools due to opposition from white parents. She ran a school for children in her home in Sandwich, and created another after settling in Windsor in 1852. Mary taught reading and writing to adults at Sunday schools. She supported herself by teaching in schools after her husband died suddenly in the summer of 1854. The couple was childless.

Mary later remarried and managed a shop from approximately 1865 to 1871 before moving to Brooklyn, New York. Though her many achievements are often overshadowed by those of her famous first-husband, she was a notable figure in her own right — accomplished as well as beautiful, according to abolitionist William Wells Brown, whom she met in 1861.[4] A prominent and influential anti-slavery advocate, a pioneer teacher, and a journalist, Mary Bibb was recognized as a person of national historic significance by the Historic Sites and Monuments Board of Canada in 2002.

Quote:

"What shall we say of those who have again taken their lives in their hands and escaped to this desolate, cold country, where they are again strangers in a strange land ... Is not the person who can improve under such circumstances a hero ...?"[5]

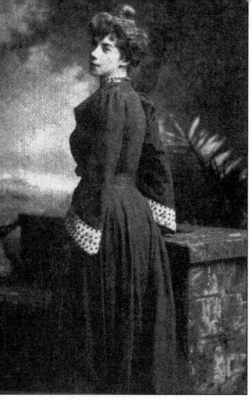

Georgina Binnie-Clark in Dorset.

Homesteads for Women?

Georgina Binnie-Clark

1871–1947

She showed that a single lady could succeed as a wheat farmer. And demanded that women have the right to free land — just like men.

Her friends and family thought she was mad. What else could explain the British writer's plan to move to Saskatchewan and become a wheat farmer, with no agricultural experience?

Born in Dorset in 1871, Georgina Binnie-Clark was a well-educated gentlewoman with limited options for supporting herself in England; a one million surplus of women made marriage unlikely and there were few suitable job opportunities for those of her class. In her early thirties, she visited her brother on his farm in Fort Qu'Appelle, Saskatchewan. She loved the untamed West and penned a travel book called *A Summer on the Canadian Prairie*. After observing how poorly her brother was doing as a farmer, Georgina decided she could do better. She moved to the Prairies in 1905, but as a single woman she was not eligible for the 160 acres of free land like her sibling had been. Married women were also excluded.

Unlike the more equitable homestead laws in the United States, the Canadian West's policies allowed only widows, divorcees, or abandoned

women with children to qualify for the same land grant as men. While men were only required to pay $975 in fees and could acquire an additional 160 acres at minimal cost, Georgina had to come up with $5,000 to purchase the same amount of land.[1] Though she bought an established farm with machinery, two cows, and three horses, Georgina still needed capital to operate it. She managed to get bank loans, as well as some financial support from her father.

As a wheat farmer, Georgina faced the same challenges as men, but resented the fact that she and other single women could not start off on equal footing. She chronicled her experiences during her first three years of farming in a book entitled *Wheat and Woman*, which was published in 1914 as a guide to other potential female homesteaders. Georgina hoped that her advice would encourage other British women to become homesteaders. She advised her readers that women could achieve independence, and eventually wealth, as farmers — if they didn't have to pay extra for their land:

> She may be the best farmer in Canada, she may buy land,
> work it, take prizes for seed and stock, but she is denied
> the right to claim from the Government the 160-acres of
> land held out as a bait to every man.[2]

In the fall of 1908, Georgina went on a one-woman mission to Ottawa but achieved nothing. She joined others who had already been fighting for the cause, including Winnipeg journalists Cora Hind and Isabel Graham, who was the influential leader of the campaign.[3] Georgina became an important advocate in the feminist battle to change the Homestead Act.

In 1909, after a meeting with Georgina, Isabel Graham wrote a passionate article about homestead rights in the *Grain Growers' Guide*. The article exemplified Georgina as a modern farmer: "an English woman of moderate means, considerable culture, unusual enterprise, and rare pluck … continues to make a brilliant success of [farming in the West]."[4] The publication encouraged a flood of inquiries to Ottawa about homesteads for women, but the rigid policies remained — even after the government received a petition signed by 11,000 men in 1913 and organized by Isabel.

The homesteads-for-women movement reached peak activity between 1909 and 1913, but continued until 1930. That year, the three Prairie provinces gained control of their public lands, which did not include a lot of land for homesteading. Many solo women had become farmers despite inequalities in the homestead laws; one study showed that there were more than 283 women landowners in southwestern Manitoba at the time Georgina farmed.[5]

In 1910, Gerogina started training prospective women farmers from England, earning some welcome cash to pay her bills. From 1929 to 1935, the ever-persistent Georgina worked in Saskatchewan on the Union Jack Farm Settlement (UJFS). The plan proposed helping British immigrants by teaching them to farm and helping them find jobs. It was launched at the onset of the depression, but never fully materialized despite the considerable effort she put into it.

During the First World War, the British government appointed Georgina and six other agriculturalists to train women to work the land; she was assigned the Yorkshire and Lincolnshire districts. During the war years, she wrote a book for children and donated the proceeds to help wounded soldiers and their horses. She also managed a small shop selling patterns for dresses and hats in London until the 1930s. From at least the beginning of the Second World War until her death in 1947, Georgina kept a flat in Chelsea, London, on the poor side of Cheyne Walk by the Thames. When she wasn't living there, Georgina depended on the rent money to help run her farm in Canada.

Georgina assisted some families and continued to solicit funds for the UJFS until 1937, but by then she was back living in London and had joined the Lyceum Club for female writers and artists. She died in her flat on Cheyne Walk in 1947; her sister, Ethel, scattered her ashes on the Fort Qu'Appelle farm that she had loved.

Quote:

"If I'd wanted to be dictated to by a man, I'd have married one and let him keep me."[6]

Quest for Freedom

Lucie Blackburn

circa 1804–1895

The Blackburns' landmark case set a precedent, establishing Upper Canada as a safe refuge for fugitive slaves.

She was once a slave girl named Ruthie,[1] who worked as a nursemaid for two young children of merchant George Backus and his wife, Charlotte, in Louisville, Kentucky.

Of mixed black and white parentage, Ruthie — later known as Lucie Blackburn — was born in the West Indies about 1804. She was perhaps bought at auction in New Orleans by the Backus family. Her beauty and fair skin saved her from hard labour in the cotton fields and the heavy chores of a cook or housemaid. As the only slave to live in the Backus's home, she was treated with a certain amount of respect and even had her own tiny room in the attic. When she married fellow slave Thornton Blackburn, Ruthie had probably received the black silk wedding dress as a gift from Charlotte Backus. This fine dress would play an important role in Ruthie's great escape.

In June 1831, Mr. and Mrs. Backus and their daughter died unexpectedly; Ruthie was sold to a slave trader for $300. The Blackburns feared that she would soon be sold in the Deep South: an attractive

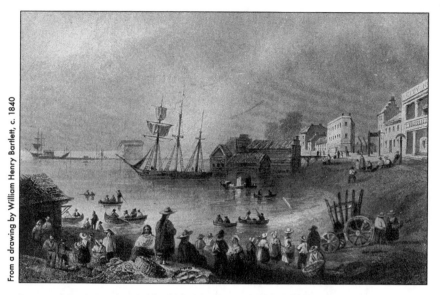

From a drawing by William Henry Bartlett, c. 1840

Toronto about 1838, showing the fish market, Front and Wellington Streets.

"yellow girl" would likely end up a sex slave for a master or in a brothel. They also worried that they would never see each other again.

Within two weeks the young couple was standing on the Louisville dock dressed in their finest attire, audaciously posing as free blacks. "The woman was a fine looking mulatto, handsomely dressed and was called the wife of the man. She was dressed in a superior piece of black silk goods,"[2] recalled one of the men duped by the masquerade.

Armed with forged papers documenting their status as free African Americans, the Blackburns managed to board a Cincinnati-bound steamship and continue by stagecoach to Detroit. Feeling fairly safe in the Michigan Territory, where slavery was outlawed, Ruthie and her husband settled in the city and Thornton found work as a stonemason. But after two years of freedom, a white clerk from Kentucky recognized Thornton. Because of the Fugitive Slave Act, the Blackburns were thrown in jail in mid-June 1833. They were sentenced to be returned to their owners.

Ruthie got lucky. A female visitor switched places with her, enabling the runaway slave to slip out of jail and cross the Detroit River to Upper Canada. A crowd staged a riot outside the Detroit prison and forcibly rescued Thornton. He also fled to safety across the river. Though fugitive slaves were officially welcomed in Upper Canada, the Blackburns were

imprisoned in Sandwich when their owners demanded their return.

The Fugitive Offenders Act protected slaves who reached Upper Canada, but the Blackburns' owners demanded extradition on the grounds that they were escaping justice for their crimes in the jail escapes and riots. In this first test of the law, Lieutenant Governor Sir John Colborne ordered Ruthie and Thornton released after a month in prison. Their courageous defiance of slavery, and the resulting case, established that fugitive slaves would not be returned if they hadn't committed crimes punishable as capital offences under Canadian law. This important legal precedent affected all future slave extradition cases until the American Civil War ended slavery in the United States.[3] It also influenced Canada's current policy regarding conditions for extradition of immigrants.[4]

After Ruthie and Thornton Blackburn were released in late July 1833, they spent about a year with friends in Amherstburg before moving to Toronto. Mrs. Blackburn (she would never have been accorded that honorific while a slave) celebrated her freedom by discarding the name she bore as a slave and calling herself Lucie. She was about thirty years old when they settled in Toronto, and Thornton was twenty-two.

The Blackburns spent the remainder of their lives in Toronto. Miraculously, they had reunited with Thornton's brother Alfred (who was working as a carpenter). Thornton also brought his mother, Sibby, to join them; he risked his life to rescue her. Thornton worked as a waiter in the dining room at Osgoode Hall before he and Lucie established Upper Canada's first cab company in 1837. They had a specially built horse-drawn carriage. Though Lucie was an excellent money manager and Thornton was an enterprising man, they were both illiterate. They remained childless.

In 1848, the Blackburns were able to purchase the large double lot they'd been renting on South Park Street. They constructed an 800-square-foot bungalow, a classic African-American "shotgun house."[5] These structures were common in southern cities and originated in West Africa and the Caribbean: a long, narrow house with three rooms in a row, and a short, gabled end. Theirs faced Lake Ontario. Though they lived a modest lifestyle, Lucie and Thornton were successful entrepreneurs who profited from their cab company.

The Blackburns also assisted newly arrived fugitive slaves by housing them at nominal rates in rental properties and sometimes in their own

home. They helped improve conditions for the new arrivals by creating jobs and contributing funds for settlements, such as the Buxton Mission, established near Chatham in 1849. Thornton was one of four men, including newspaper publisher George Brown, who contributed a total of £750 to create mills there. While there is little information about Lucie's involvement in anti-slavery activities, she did attend the Convention of Coloured Freemen in Toronto in 1851.

Thornton retired from the cab business after the Civil War. The affluent couple lived on their savings and investment income for three decades. Thornton died in 1890 and was buried in the Toronto Necropolis in the family's plot. Lucie inherited their home, six rental properties, and cash for a total estate of $18,000. By the time she died in 1895, the onetime slave was a prosperous moneylender, earning 6 to 7 percent on the mortgages she held. Lucie Thornton was buried beside her husband. One of the city's most prominent physicians, Dr. Frederick Lemoine Grassett, signed her death certificate.

In 2002, a Quest for Freedom celebration marked Lucie and Thorton Blackburn's harrowing escape. The joint American-Canadian project commemorated their journey from Louisville, Kentucky, to Toronto, Ontario, by installing historic markers in both cities. The Historic Sites and Monuments Board of Canada recognized the couple as persons of national historic significance, and erected a plaque at the site of their longtime home in Toronto.

This site was excavated by archaeologist and historian Karolyn Smardz Frost in 1985, sparking her nearly twenty-year quest to piece together the story of the couple, runaway slaves who left no written records nor any descendants to preserve their memory. Karolyn Smardz Frost's award-winning book, *I've Got a Home in Glory Land,* is the result of her research, and a poignant tribute to them: "Every American slave who found refuge in Canada before the Civil War had reason to be thankful to Thornton and Lucie Blackburn."[6]

Quote:

[I am a] "full blooded Creole from the West Indies."[6]

Sparks on the Lucky Mosdale

Fern Blodgett
1918–1991

Fern Blodgett.

Determined to fight the Germans in the Second World War, she served at sea during the Battle of the Atlantic.

Fern Blodgett was the first Canadian woman to become a wartime wireless radio operator, and the first to serve at sea with the merchant marines during the Second World War. She jumped at the opportunity to work on a foreign vessel since females were forbidden from serving on Canadian ships. The idea horrified Canadian officials: "Good God no, we have enough trouble on ships now without having women on board!"[1]

Fern was born in Regina but grew up in Cobourg, Ontario. She loved watching the steamships on Lake Ontario and dreamed of becoming a sailor. After the outbreak of the Second World War, she thought there might be a slim chance of going to sea and helping the war effort if she became a wireless operator — or "Sparks," named after the spark-gap radios used to transmit Morse code. While working as a stenographer in Toronto she found a school that trained women as wireless operators. Fern received her second-class wireless operator's licence after about eighteen months of attending night school while working her day job.

Opportunity knocked on her graduation day: June 13, 1941. Knowing that Fern wanted to work on a ship, her principal phoned with the news that there was an urgent need for a Sparks on a Norwegian Merchant Navy vessel, the *Mosdale*, sailing out of Montreal. She caught the train that night. The ship's master wasn't expecting F. Blodgett to be a woman. After days of delay waiting for a qualified radio operator, Captain Gerner Sunde was desperate to depart so he accepted Fern for the job. (They married a year later.)

The *Mosdale* was a modern, 3,000-ton ship carrying a crew of thirty-five and twelve passengers. During the war, it played a vital role in transporting provisions across the Atlantic to England. It also carried passengers, such as servicemen, correspondents, and seamen who'd been torpedoed. The *Mosdale* was a fast ship, capable of 15 knots, and often travelled alone since it could usually outrun submarines. Despite the hazards of crossing the Atlantic during the Second World War, the *Mosdale* miraculously made ninety-eight wartime crossings, with Fern in charge of radio communications for seventy-eight. Of the half-dozen Norwegian fruit carriers operating during the Battle of the Atlantic, only the *Mosdale* survived.

Fern's expertise was essential for the vessel's safety. From the first day she sailed on the *Mosdale*, the newly minted Sparks was in charge of the Telefunken radio station; later, she had an English 2nd and a Norwegian 3rd to assist. From the moment the ship hit open seas, Fern became violently seasick, but as the only operator she stuck to her duties with a bucket beside her. She often witnessed the horrors of lost ships and crews after torpedo attacks, and guided the *Mosdale* through many close calls, escaping enemy subs, German bombers, or uncharted minefields. Fern quickly earned the respect and admiration of the ship's captain and crew, and a secret letter from the Admiralty commended the *Mosdale* for its exemplary use of wireless instructions to escape dangers.

After the *Mosdale's* fifty-first Atlantic crossing, in 1942, crew members were honoured by a visit from Norway's King Haakon and Crown Prince Olav. The king presented an award to Captain Sunde and the Norwegian War Medal to his wife, Fern, for her wartime service as the chief wireless operator. She was the first woman to ever receive this decoration. Fern continued to serve on the *Mosdale* for the duration of

the war. She admitted that "there was always the threat of danger and toward the end of the war our nerves got pretty frayed."[2]

Fern remained on the ship for six months after the war before leaving to start a family with Captain Sunde in Norway. His sudden death from a heart attack left her with two young daughters to raise on her own. She remained in her adopted homeland for the remainder of her life, earning a medal from the city of Farsund in 1988 for the distinction she brought to it. The courageous Canadian heroine died in 1991.

Fern Blodgett's role as a Sparks in the Second World War seems virtually unknown in Canada. Groups such as the Radio Amateurs of Canada, YLRadio, and the Canadian Ladies Amateur Radio Association are trying to ensure that the contributions of early women radio operators are not forgotten. The Norwegian book *Lykkelige Mosdale* (*Lucky Mosdale*) by Eiliv Odde Hauge includes Fern's story.

Quote:

"Why should I not risk my life when millions of men are risking theirs. Is a woman's life more precious than a man's?"[3]

Secret Identities

Esther Brandeau

circa 1718–unknown

The key to remaining in Canada was simple: become a Catholic. Yet she refused.

An imaginary portrait of Esther Brandeau, by artist Julia Bell.

The schooner *St. Michel* sailed into the port of Quebec in mid-September 1738 following a long journey across the Atlantic from La Rochelle in France. When a young sailor, Jacques La Farge, aroused suspicion, authorities in New France arrested the well-mannered and comely fellow claiming to seek work in the colony. Under interrogation by the marine commissioner, Jacques revealed that he was actually a she: twenty-year-old Esther Brandeau. She had successfully hidden her sex for five years.

Esther was the daughter of Jewish refugees who'd fled the Portuguese Inquisition. She was born in Bayonne, France, where her father, David Brandeau, was a merchant in Saint-Esprit. Shipwrecked at age fifteen en route to visit her aunt and older brother in Amsterdam, the girl was taken in by a kindly woman in Biarritz on the French coast. Esther soon decided to see some of the world.

Esther shocked colonial authorities with the tales of her subsequent adventures. She had disguised herself as a boy, calling herself Pierre

Alansiette, to work as a ship's cook in Bordeaux. The freedom-loving girl then posed as a man with a string of different names to explore France, working as errand boy for a tailor, messenger in a convent, baker's helper, and footman for an ex-infantry captain. After being mistaken for a thief and spending a miserable twenty-four hours in jail, Esther signed on as a ship's boy on the *Saint-Michel*.

The presence of a young Jew in New France presented Intendant Hocquart with a big problem. Adherence to Catholicism was strictly enforced in the French colony and he could make no exceptions. There was a dire shortage of young, marriageable women in New France, so authorities decided to let Esther stay on one condition: she had to become a Catholic. But she stubbornly refused to abandon her own religion and learn about Catholicism.

The embarrassing case required consultation with the highest officials in France, including Hocquart's cousin the king. After a year in the colony, Esther still resisted all efforts to persuade her to convert. The intendant advised the minister in France about the lack of progress: "Her conduct has not been wholly bad, but she is so frivolous that at different times she has been both obedient and obstinate with regard to the instruction the priests desired to give her. I have no other alternative than to send her back."[1]

Esther was the first Jewish immigrant to Canada[2] — and the first to be deported. On direct orders from King Louis XVI, colonial authorities shipped the young immigrant back to France in the autumn of 1739; the French government paid for her passage. Esther's fate is unknown, but the incredible story of this heroic woman continues to be remembered in Canada. Though details of her life are scanty, the intriguing adventures of Esther Brandeau have been depicted in a multitude of history books, as well as a novel for young adults and a performance installation by Heather Hermant.[3]

Quote:

"[the woman in Biarritz] made her eat pork and other kinds of meat that

were forbidden to the Jews, and she resolved in due course never to return to the house of her father and mother, in order to enjoy the same liberty as the Christians."[4] — Esther's explanation of why she concealed her sex, 1738. Excerpt from interrogation report of the marine commissioner.

Brown is Beautiful[1]

Rosemary Brown
1930–2003

She challenged oppression and prejudice throughout her life, changing the face of Canada by shattering colour and gender barriers.

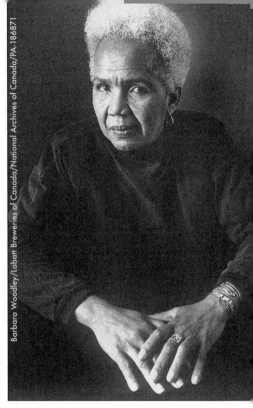

Rosemary Brown, 1990.

"To be Black and female in a society which is both racist and sexist is to be in the unique position of having nowhere to go but up,"[2] Rosemary Brown quipped in a 1973 speech. The other strikes against her were being an immigrant and a socialist living in a capitalist country. Despite these obstacles, this passionate feminist became the first black woman to win a seat in a provincial legislature.

Rosemary Brown (née Wedderburn) was born in Jamaica in 1930. She grew up in the home of her grandmother — a prosperous woman whose shrewdness in real estate ensured the family's financial stability. Rosemary was surrounded by high-achievers, including her Uncle Karl (one of Jamaica's leading surgeons), and a multitude of strong, well-educated, independent women who were all politically active.

These accomplished female elders both terrified and inspired the young Rosemary. These religious women served the community as volunteers and activists; they set high standards and had great expectations for Rosemary. While some of her relatives had attended universities

overseas, they feared that racism in both the United States and England made those countries too dangerous for her to continue her studies. The family decided to send Rosemary to McGill University in Canada.

When the eager student arrived in Montreal, she faced the ugliness of racial prejudice for the first time in her life. Most of the other students shunned her and white girls refused to share a dorm room with her. Landlords wouldn't rent to her and potential employers wouldn't hire her. She joined the West Indian Society where she met an American student named Bill Brown. The couple wed in 1955 after Rosemary completed her bachelor's degree. The Browns moved to Vancouver.

Rosemary worked and raised their three children while Bill trained as a psychiatrist. The couple became active members of the British Columbia Association for the Advancement of Coloured Peoples, fighting racism in the province.

Once finances permitted, Rosemary returned to university to become a social worker, but felt frustrated at her lack of power as a woman. After reading Betty Friedan's book, *The Feminine Mystique*, and monitoring the progress of The Royal Commission on the Status of Women, she became a committed feminist determined to fight both racial injustice and sexism. At a time when many black women felt that feminism was a white-only movement, Rosemary courageously encouraged her black sisters, and women of many races, to join the fight.

Rosemary was a founding member of the Vancouver Status of Women Council and ombudswoman on the implementation of some of the commission's recommendations. Provincial NDP leader Dave Barrett invited her to run as a candidate in the next election. In 1972, Rosemary made political history when she was elected to British Columbia's legislature. She held a seat until 1986, despite the reservations of those who were uncomfortable with her close ties to the women's movement. Rosemary was disappointed that the premier refused to create a ministry focusing on the needs of women, and didn't give her a cabinet position.

During her years in politics, Rosemary played an important role in introducing legislation that prohibited discrimination due to marital status or sex as she strived to help many disadvantaged groups. She was proud that British Columbia's provincal government was the first in

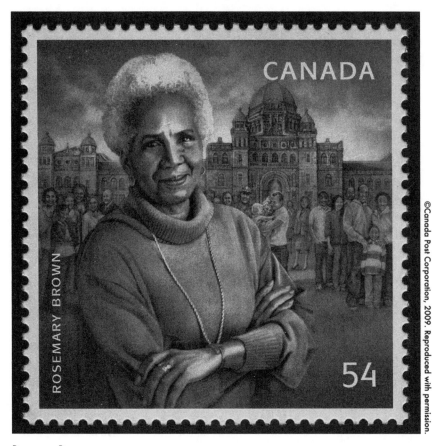

Rosemary Brown.

Canada to fund shelters for battered women and rape relief centres. Her work led to many changes, including an increase in the number of women appointed to boards and government commissions, and the establishment of a committee to eliminate sexism and racism in school textbooks and curricula. In 1975, she became the first Canadian woman to run for leadership of a federal political party, losing to Ed Broadbent on the final ballot. She prided herself on having brought the topic of feminism into public debate across the country.[3]

After Rosemary left politics in 1986, she accepted a position as professor of women's studies at Simon Fraser University. She served on the board of the Canadian Security Intelligence Review and became chief commissioner of the Ontario Human Rights Commission.

As director of the Match International Centre, she promoted the advancement of women in developing countries.

She received many honours before her death at seventy-two, including the United Nations Human Rights Fellowship, the Order of Canada, the Order of British Columbia, and fifteen honorary doctorates. In 1999, Canada Post celebrated her achievements with a commemorative stamp. The Rosemary Brown Award promotes social justice and equality for women.

Ever true to the women who raised her, Rosemary Brown was a principled leader who was passionate about inclusion, equality, peace, and social justice. A symbol of strength throughout her life, she opened doors to people of colour and continues to be an inspirational role model for female politicians.

Quote:

"Electoral politics touches our lives in a sufficient number of profound ways that no matter what the cost, it cries out for the presence and involvement of women."[4]

A Legacy of Blooms

Jennie Butchart

1866–1950

She transformed an ugly lime quarry into one of the most famous gardens in the world.

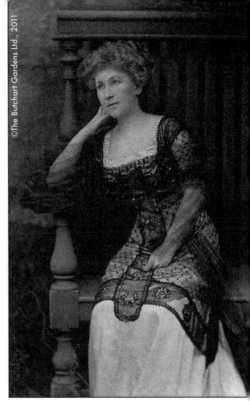

Jennie Butchart.

"I sat there having our picnic and crying with loneliness. I wanted to go home to Ontario,"[1] Jennie Butchart remembered. In 1902, she accompanied her husband to the site of their future home and factory on Tod Inlet, travelling in a horse-drawn buggy over a rough trail from Victoria. Within a few years, a limestone quarry was in full operation and business was booming at the new Vancouver Island Portland Cement Company.

Born in Toronto to Irish parents, Jeanette Foster Kennedy was orphaned at fourteen and sent to live with an aunt in Owen Sound. She thrived in the family of seven children, enjoying outdoor activities such as skating and horseback riding. The adventurous Jennie even went up in hot air balloons and flew with pioneer French aviator Louis Blériot, the first person to fly across the English Channel. She attended Brantford Young Ladies' College and her artistic talents earned her a scholarship to study in Paris. Love won over art, though, and Jennie married R.P. Butchart when she was eighteen.

Jennie had a certificate in chemistry, and after the couple and their two daughters moved to British Columbia she worked in the laboratory of the cement plant for awhile. She soon adored the West Coast and its luxuriant vegetation. Jennie had no gardening experience, but decided to plant a rose bush and some sweet peas around their cottage.

Jennie started her first major gardening project in 1906: a Japanese garden by the sea, above Butchart Bay. As a middle-class woman of means, she was able to hire Isaburo Kishida — a Japanese designer — to plan the site. They transformed an area of brush and stumps into a sophisticated garden, including traditional Japanese garden features along with others added by Jennie. She preferred to have more flowering plants and fewer areas of rock. Among the most exquisite features of the garden was the exotic Tibetan blue poppy, a rare flower that Jennie introduced after obtaining seeds from Kew Gardens in London.

Though Jennie Butchart was proud of her husband's successful quarry business, she was less pleased with the environmental impact: "You're ruining the country, Bob, just to get your old cement."[2] When the limestone quarry was depleted and shut down in 1909, after five years of extraction, Jennie looked with despair at the silent and ghastly tomb of the industrial site. It was an ugly pit, scraped of soil. The rough quarry floor was scattered with hundreds of rocks, broken and rusting machinery. Jennie envisioned something else: "Like a flame, the limestone pit burst into imaginary bloom. A flame for which I shall ever thank God."[3]

Over a period of ten years, Jennie oversaw the creation of the Sunken Garden in the abandoned quarry. Labourers no longer needed at the quarry were seconded to the project, and the arduous task of hauling away rocks and debris, and bringing in soil by horse and cart. Jennie sometimes suspended herself over the edge of the quarry in a bosun's chair, to carefully plant ivy and dwarf trees in the cracks of the stone walls. She had a row of Lombardy poplars planted to conceal the old cement factory.

Jennie and the crew transformed a leftover rock tower into an attractive viewpoint for the Sunken Garden, and created a lovely pond

from a muddy crater in the quarry floor. Hugh Lindsay, the Butchart's first head gardener, helped Jennie plan the Sunken Garden and plant the breathtaking array of trees, shrubs, and flowers that still awe visitors. While the garden itself is remarkable, it is even more amazing that Jennie created it from an ugly scar on the land.

After the development of the Sunken Garden, Jennie added other features to what is now known as the Butchart Gardens: the Italian Garden (1926), the Rose Garden (1928–29), the Star Pond (1928), and the private garden (1928). Each demonstrates a distinctive character, creating an exceptional example of an early-twentieth-century estate garden. Though Jennie was an amateur designer, she was the mastermind behind the gardens, overseeing development for over thirty years, supported by landscapers, architects, and gardeners. Over the years, the Butcharts added new plants, sculptures, ornaments, and fountains collected during their travels around the world.

Jennie Butchart loved sharing the beauty of her gardens with visitors. Often they stayed for tea, enjoying the family's gracious hospitality. Jennie refused to charge visitors, even when, by 1915, about 18,000 people a year toured the Butchart Gardens. By the 1920s, she was popular in horticultural circles and frequently invited to judge shows in Canada and the United States.

In 1931, the City of Victoria named Jennie Butchart "Best Citizen of the Year" and the *Colonist* noted that, "There is no lady in this quarter of the Empire better known throughout the continent than Mrs. Butchart."[4] At the end of the 1930s, advancing age meant Jennie and her husband were less involved in the gardens, and in 1939 they transferred ownership to their grandson Ian Ross. He transformed the Butchart Gardens into a successful family business, featuring fifty-five acres of gardens that are a prominent tourist attraction, visited by about a million people each year. Jennie continues to be an inspiration to those who know her story, and in 1995 an MLA in B.C. suggested that "while Mrs. Butchart is remembered all over the world for the beauty she created, perhaps at home we should honour her today as the world's most dedicated recycler."[5]

In 2004, the Historic Sites and Monuments Board of Canada designated the Butchart Gardens as a national historic site, noting

Butchart Gardens commemorative stamp.

that the "transformation of a limestone quarry into a sunken garden of massive dimensions and dramatic aesthetic qualities represents an exceptional creative achievement in gardening history."[6] Garden historian Edwinna von Baeyer wrote, "the reclamation of an industrial site was highly unusual for its time and has a unique treatment."[7] The gardens are Jennie's legacy.

Quote:

"I had a small garden and I think it was that first horticultural venture, and seeing the marvelous way things grow out here where there were no cold winters, which started my enthusiasm."[8]

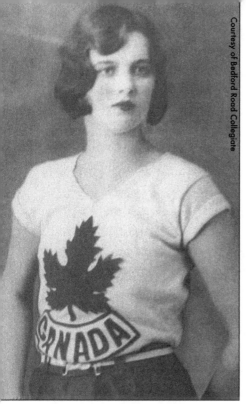

Ethel Catherwood, circa 1928.

The Saskatoon Lily

Ethel Catherwood

1908–1987

Propelled by her goal of being the best in the world, she brought home the first gold medal for a woman high jumper.

It was a great moment in sports history — and quintessentially Canadian. A tall, athletic beauty dropped the red Hudson's Bay blanket from her shoulders. Clad in red shorts and a white T-shirt emblazoned with a red maple leaf and *Canada* in bold letters, she raised both arms and waved to the crowd. She ran and slipped effortlessly over the bar, setting a new world record in high jumping. The media darling known as the Saskatoon Lily won a gold medal at the 1928 Olympics in Amsterdam, and no Canadian woman has matched her achievement since.

Ethel Catherwood was a natural athlete. She was born in North Dakota while her mother was visiting family, but her parents had a homestead in Scott, Saskatchewan. Ethel's family moved to Saskatoon in 1925. Joe Catherwood was an athletic man who encouraged his nine children to participate in sports. Ethel excelled in track and field, as well as hockey, basketball, and baseball.

The young girl loved to jump in the high-jump pit in the Catherwoods' backyard, where, at fifteen, she amazed her father by clearing a height

of five feet four inches — though neither realized it, no woman had ever made such a jump. When E.W. "Joe" Griffiths, physical education director at the University of Saskatchewan, heard about Ethel's huge jump, he realized she had the potential to become a world champion. With Griffiths coaching her, Ethel set an unofficial world record at a provincial meet in Regina in 1926. By the summer of 1927, there were no more challenges in the West to motivate her.

The aspiring athlete headed east to compete in the Canadian Women's Track and Field Championships. Wearing a purple cape trimmed with white fur (from her sponsor, the Saskatoon Elks Club) over a white athletic uniform, the attractive young woman drew as much attention for her appearance as her athleticism. Ethel stunned the crowd with her jumping, winning her event and setting a Canadian high-jump record despite having a sore leg. She also set a Canadian record in javelin throwing.

The famous Toronto sportswriter Lou Marsh wrote that astonished fans roared with delight as Ethel scissored over the bar: "The crowd knew a high jumper when they saw one and the Saskatoon Lily was one."[1] The nickname stuck.

Multimillionaire Teddy Oke offered Ethel the chance to work and train in Toronto, the hub of women's sports. Oke sponsored the Parkdale Ladies' Athletic Club, enabling many promising athletes to earn a living while developing their athletic skills. Ethel jumped at the opportunity. With her older sister Ginger along for support, she moved to Toronto in January 1928. The sisters attended a business college and worked in Oke's brokerage company, and Ethel joined the athletic club to train with acclaimed coach Walter Knox.

After a rigorous selection process in Halifax, Ethel joined six other talented athletes for the first Canadian women's Olympic track team in 1928. Though many people worried that women might be an embarrassment at the international competition, Ethel Catherwood, Jane Bell, Myrtle Cook, Bobbie Rosenfeld, Ethel Smith, and Jean Thompson proved they were champions. The team became known as the Matchless Six; they made Canada proud, earning two golds, two silvers, and a bronze.

Even before she won her gold medal, Ethel was a celebrity at the games: the media was wowed by her beauty. The most photographed

female athlete at the games, she was hailed as the most beautiful by the *New York Times*. The quiet and extremely shy young woman hated the media frenzy, and spent much of her time in her room to avoid it.

When Ethel won an Olympic gold medal, setting a world record for the high jump, she and her teammates were hailed as "conquering Canadian heroines."[2] Almost half the city of Toronto turned out to cheer the team's return. The Matchless Six inspired girls across Canada to dream of becoming top-notch athletes and helped ensure that women's track and field would be a part of future Olympics.

After turning down offers to make movies, Ethel studied piano at the Toronto Conservatory of Music and completed her business course. She participated in a few athletic competitions, but lost her competitive spirit due to a lack of new challenges as well as to injuries. The press pounced on her after discovering that she had been secretly married to a Toronto bank clerk and later sought a divorce in Reno. The sensational coverage of Ethel's private life hurt her deeply.

Desperate to escape her celebrity, Ethel moved to the United States. She remarried and died in California in 1987. The once-famous Olympian has been honoured in the Canadian Olympic Hall of Fame and the Sports Hall of Fame. In 1966, Canada Post issued a commemorative stamp depicting her legendary jump at the 1928 Summer Olympics.

Quote:

"I'd rather gulp poison than try my hand at motion pictures."[3]

Between Two Worlds

Victoria Cheung

1897–1966

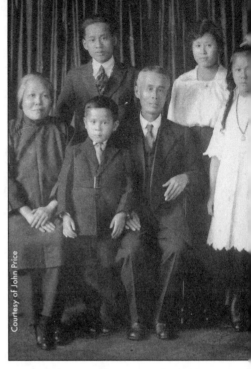

Courtesy of John Price

She was born in Canada, where many believed she belonged to China.

Victoria Cheung (back right) with her family in Victoria.

Victoria Cheung was the first female Chinese-Canadian doctor.[1] When she graduated from the University of Toronto in 1922, the university newspaper noted that she was going to China as a medical missionary because it was "her own country."[2] Dr. Cheung's story provides a glimpse of the challenges faced by Chinese Canadians in the early twentieth century, as well as her accomplishments in introducing modern Western medical care to South China.

Victoria was born in Victoria, British Columbia, in 1897. Her parents were proud to live in Canada, eager for their children to adopt the culture of their new homeland and become successful Canadians. But at the time, anti-Chinese sentiments and institutional racism presented many obstacles to their dreams. Chinese families faced prejudice, persecution, and exclusion.

Contractors for Canada's transcontinental railway had lured Victoria's father Sing Noon Cheung from his South China village. Lucky to have survived the perils of working on the Canadian Pacific

Railway, he settled in Victoria after the last spike was driven in 1885. Sing Noon Cheung started a small business with his savings and became one of the fortunate few who could afford to bring his wife from China.

Mrs. Cheung had converted to Christianity while enrolled at a mission school in Guangzhou, and her husband joined the faith in Victoria. He became one of the first Chinese converts to the Methodist mission. After Victoria and her brother were born, their mother became a midwife to help support the family. When Victoria was five or six, she was sent to kindergarten at the Oriental Home, operated by the Woman's Missionary Society, while her mother was working.

Popular among both students and teachers, Victoria was soon recognized as a strong, intelligent, and witty girl. She taught Sunday school and participated in girls' groups while attending the mission school in Chinatown. She resolved to become a medical missionary in China, to the amazement of her classmates who considered it preposterous that a poor Chinese girl could get a university education.

The president of the Presbyterian Woman's Missionary Society (WMS) offered Victoria a university scholarship. As legislation in the province prohibited Chinese people from entering professions, she attended the University of Toronto. During the first two decades of the twentieth century, it was the only medical school in Ontario that accepted female students. In 1917, Victoria joined young men and women who were primarily the children of businessmen — most of whom were white.

Victoria graduated in 1922. After she interned at Toronto General Hospital, the WMS appointed her to the Marion Barclay Hospital for women and children, part of the South China Mission. Dr. Cheung began work in Kongmoon in 1923. Her parents and younger brother soon joined her. Dr. Cheung confidently took charge of the hospital, where she became highly respected as a skillful surgeon and efficient administrator. She also taught at the nursing school and worked in the medical dispensary. Dr. Cheung introduced modern medical practices, drugs, supplies, and equipment to South China, startling rural residents with an ambulance in 1932.[4]

Known to be quiet, self-controlled, personable, and a "contagious Christian,"[3] Dr. Cheung worked in China for forty-three years, aside

from occasional breaks to return to Canada, travel, and study. During a break in 1936–37, she attended the School of Tropical Medicine in London for three months; a decade later she worked with Chinese Canadians in British Columbia and attended a missionary conference in Washington, D.C.

Dr. Cheung stayed in China despite political upheavals and the Japanese invasion in 1937. When other Canadian doctors were ordered home, she took charge of the men's hospital. After the first bombings in Kongmoon, she and her staff courageously cared for the wounded, and sheltered refugees. When the city fell to the Japanese in March 1939, she and her only remaining helpers (two graduate nurses) managed the hospital and had vegetables planted on the hospital grounds to provide food.

Dr. Cheung also provided medical care for three or four other refugee camps which depended on her for vaccinations against smallpox, inoculations for typhus and cholera, and treating malaria and dysentery. Times were so tough that one day a starving middle-aged woman tried to sell her two daughters to the doctor. When the Japanese invaders finally took over the mission and its hospital, Dr. Cheung could have returned to Canada with the other missionaries, but her mother was still alive and the Chinese Exclusion Act made it impossible for her to return to Canada. Her daughter would not leave her.

Dr. Cheung ended her official connection with the WMS in 1952, when the Communists took charge of mainland China, so she could continue to practice medicine. She remained in China until her death in 1966.

"We are youth without a country,"[5] some educated young Chinese Canadians claimed in the 1930s. We do not know if Dr. Cheung shared their concern — that they were Canadian in thoughts, feelings, and attitudes, yet not quite Canadians — or if it motivated her move to China. As one observer of the group wrote later, "There is a general feeling among Canadian-born Chinese that they *go back* to China even though they have never been before. No doubt they would feel differently if they were really accepted by all citizens of this country, for what they are and wish only to be — Canadians."[6]

Courtesy of John Price

Dr. Cheung with patients in China.

Quote:

"Under no circumstances do anything which will give a clue to the fact that you are writing to me, much less sending me funds. I am in a dangerous position, and the Japanese would make it very difficult for me and my friends"[7]

— Dr. Cheung writing to the treasurer of the South China Mission in 1942.

The First Lady of Folklore

Helen Creighton

1899–1989

She helped define Maritime culture and brought traditional music to modern recording studios and folk festivals.

Maclean's Magazine, 1952

Jack Turple singing "Ben Dean" for Helen Creighton.

Pirates ignited Helen Creighton's passion for folklore. At a 1928 clambake in Halifax Harbour, she interviewed some fishermen who knew songs and stories from the pirate days. "Ain't many remember those old songs these days," said one oldtimer. "When I die, a lot of them will die with me."[1]

Helen realized there was a lot of folklore that would soon disappear if it wasn't recorded. She spent the next sixty years of her life collecting folksongs, ghost stories, and witches' tales throughout Nova Scotia, New Brunswick, and Prince Edward Island. Helen became an internationally recognized folklorist, gathering about 40,000 items. She collected and recorded more than 4,000 songs and stories in English, French, Micmac, Gaelic, and German. Her legacy of sound recordings, photographs, texts, and movies forms the largest private collection in the Nova Scotia Archives, and is one of the most important cultural resources in the province.

Helen Creighton was born in Dartmouth, Nova Scotia, in 1899. She received a music diploma from McGill University in 1915 and graduated from Halifax Ladies' College in 1916. As a young woman, she served as a

driver with the Royal Flying Corps in Toronto in 1918, and an ambulance driver for the Red Cross in Nova Scotia in 1920. Helen studied social work in Toronto until 1923, but a physical breakdown prevented her from graduating. She worked stints as a teacher in Mexico and as a journalist. In 1926, she began her broadcasting career as Aunt Helen, the host of a children's radio program in Halifax.

After hearing the pirate tales in 1928, Helen began travelling around Nova Scotia collecting more songs and stories. She was a self-trained folklorist, covering 3,000 to 4,000 miles a year in the province: by car, foot, boat, and an ox-team taxi. She even pushed her melodeon — a heavy miniature organ she used to pick out tunes — across sand dunes in a wheelbarrow. When she started on her folklore quest she had no income. But her father, who believed in its importance, paid Helen's bills and lent her his car.

Helen initially made recordings on wax cylinders, then acetate discs, before switiching to tapes in 1949. She collected Acadian songs from Cheticamp, Mi'kmaq songs from Chief William Paul at the Shubenacadie Reserve, German songs from Lunenburg County, English songs from the black community. She preserved ancient British ballads, including a thirteenth-century ballad called "The False Knight Upon the Road." Sea captains sang shanties for her and William Riley of Cherrybrook shared his slavery songs.

Helen collected dances, cures, children's folklore, and games. She became best known for her work on the supernatural, collecting a wealth of material on ghosts, buried treasure, witchcraft, and superstitions. In 1933, she recorded "The Nova Scotia Song," sung by Ann Greenough of Petpeswick; it was later popularized by Catherine McKinnon as "Farewell to Nova Scotia" and became the unofficial anthem of the province.

Helen compiled the songs she had collected into a book; *Songs and Ballads from Nova Scotia* was published in 1932. The book established her reputation as a folklorist and brought speaking engagements across Canada and the United States. She eventually wrote thirteen books of stories, folk songs, and ballads. The Rockefeller Foundation invited her to represent English-speaking Canadians at a folklore conference in the United States in 1942. She was then invited to collect and record Maritime folklore for the Library of Congress (1943–44 and 1948), receiving a number of

fellowships from the Rockefeller Foundation. The National Museum of Canada hired her to gather material in 1947; she stayed until 1965.

Helen was also enthusiastic about folk performances, organizing the Nova Scotia Folk Singers. In 1938 and 1939, she hosted a weekly program on the CBC that featured folksingers, along with folk tales. She was frequently heard on both CBC radio and television long afterward.

The works she collected have been used in folk festivals, operas, symphonies, a ballet, plays, films, and professional recordings by musicians like Ashley MacIsaac and Mary Jane Lamond. The songs Helen preserved are now sung in schools and on stages, as groups such as the Nova Scotia Mass Choir and Men of the Deeps (North America's only coal miners choir) perform the music that would have been lost without her efforts.

Helen collected folklore until she died in 1989. Nova Scotians enthusiastically shared their songs and stories with the popular folklorist while she was alive, and they have not forgotten her. In addition to her enduring legacy of music, Helen Creighton has been widely honoured in a multitude of ways. There are three documentaries about her life, and she received six honorary doctorates and awards, such as the Order of Canada, the Queen's Medal, Fellow of the American Folklore Society, Honorary Life President of the Canadian Authors' Association, Distinguished Folklorist of 1981, and the Canadian Music Council Medal. In 2011 she was inducted into the Canadian Songwriters Hall of Fame.

The Helen Creighton Folklore Festival in Dartmouth and the Helen Creighton Foundation are dedicated to preserving the memory of this remarkable Canadian heroine. Each year at the East Coast Music Awards a talented performer receives the prestigious Dr. Helen Creighton Lifetime Achievement Award for lasting and profound influence on the Atlantic-Canadian music industry.

Quote:

"Was it prophetic that I was born with a caul? This thin membranous tissue that sometimes covers the face of a newborn baby is universally known in folklore, and folklore was to become my life's work."[2]

Battle at Montgomery's Tavern, 1837.

The Original De Grassi Kids

Charlotte De Grassi
1823–1872

Cornelia De Grassi
1825–1885

Armed rebels were threatening Toronto. Two teenage girls helped save the city.

The Canadian TV franchise *Degrassi* is probably our most successful TV export, licensed in at least 147 countries from Saudia Arabia to North Korea.[1] Some fans of the popular teen drama, which began with *The Kids of Degrassi Street* in 1987, may know that the shows were filmed in Toronto. The name comes from De Grassi Street in Riverdale. The street was named after Captain Filippo De Grassi,[2] an Italian immigrant who served in the British Army, whose England-born daughters were heroines during the Upper Canada Rebellion.

The De Grassi family settled near the Don River Valley in Toronto in 1831, where Filippo received a land grant of 200 acres; he later bought an additional 200 acres in 1833. Even with income from their sawmill, the De Grassis struggled to survive. When their house burnt to the ground in the spring of 1833, they lost everything they had, including money, jewellery, and provisions for six months. The De Grassi couldn't afford to pay the expenses for the sawmill, so they leased it out — but the renter ran away without paying his bill.

The De Grassis were still facing hardships when the 1837 Rebellion broke out. A group of disgruntled reformers, led by Toronto's first mayor, William Lyon Mackenzie, became increasingly discontented with the government and the officials who dominated administration and control in the colony. Mackenzie persuaded radicals to draft a constitution based on the American model, and to forcibly seize Toronto when all the troops in the colony had been sent to Lower Canada in early December 1837.

When rumours of rebellion spread, Captain De Grassi stood behind the government led by Sir Francis Bond Head. De Grassi recollected, "after the fire I managed amidst great trials and difficulties to struggle on until that unfortunate rebellion broke out in 1837 when Mr. W.L. Mackenzie thought to take upon himself more than regal functions and declared that my property with that of many other loyal men should be parceled out among his followers."[3] Charlotte and Cornelia De Grassi soon showed they were equally loyal to the government.

It was a winter night — Monday, December 4 — when De Grassi heard about the rebellion. Eager to investigate and help the loyalists, he left home at 11:00 p.m. along with his daughters, fifteen-year-old Charlotte and thirteen-year-old Cornelia. They encountered rebel troops at Helliwell's Place, a brewery. Scared that her father would be taken prisoner, Charlotte distracted the men while her father and sister slipped past. De Grassi made it to Government House, where he joined the Scarboro militia forces under Colonel McLean. Charlotte and Cornelia returned home safely, managing to evade the armed rebels.

On Tuesday, December 5, the De Grassi sisters headed into Toronto, where they conveyed information about the rebels at the Don River (Cornelia had spied on the rebel camp at Gallows Hill) and checked on their father. That same day, a group of 500 to 700 rebels (armed with pitchforks, staves, and rifles) marched south on Yonge Street to confront a small force of about 200 to 250 volunteers and militia. A battle broke out when a group of loyalists opened fire on the rebels, who quickly fled after the poor evening light led them to believe the front ranks of their force had been killed; in fact just two rebels and one loyalist died. There is no record of whether the sisters came close to this skirmish.

Governor Head didn't know how many rebels there actually were, which was critical information for determining government strategy.

On Wednesday, December 6, Cornelia was asked to spy on the rebels, so she rode on her horse to their headquarters at Montgomery's Tavern. At the nearby wheelwright's shop, she feigned interest in a sleigh, but the rebels took her prisoner. When Mackenzie arrived with the news that the rebels had taken the Western Mail, the teenager saw her opportunity to escape. Cornelia jumped on her horse and rode off in a storm of bullets. Back in Toronto, she told Governor Head the number and condition of the rebels. Realizing the rebels numbered in the hundreds rather than thousands, and that they were poorly armed, Head decided to suspend negotiations.

Cornelia's information was considered crucial to the outcome of the 1837 Rebellion. Mackenzie himself wrote: "Dr. Rolph then advised us not to go into the city till towards dark — told us that Dr. Horne had employed a woman as a spy (De Grassi, I think he called her) who we had let pass, and Dr. H. had persuaded Head to hold out, assuring him our numbers were less than supposed."[4]

While Cornelia was spying on the rebels, Charlotte was relaying secret messages behind enemy lines. Loyalists had detained Charlotte at the market, and begged her to deliver an important dispatch, as there was no horseman available. She carried it along Kingston Road and returned safely to the city with an answer. But as she was heading home, she was spotted by a large group of rebels before Sinclair's Clearing. Shots rang out. Both Charlotte and her pony were hit; one account noted that one ruffian fired at her face. Wounded, she raced home.

On Thursday, December 7, the fearless Cornelia followed loyalist forces to Yonge Street, to observe cannons thundering and guns firing. She reported the situation to the chief justice. On attempting to return home, Cornelia discovered that the rebel Matthews had set fire to the Don Bridge. She raced back to the city to sound the alarm. At 11:00 p.m., she tried to return home again, this time on foot.

A few days later, the short-lived rebellion was quashed. On Friday, December 8, a force of 1,000 to 1,500 loyalists confronted the die-hard rebels remaining at Montgomery's Tavern and won. Charles Duncombe later led a small outbreak near Brantford, but the rebels were quickly dispersed; both Duncombe and Mackenzie fled to the United States. Two of the original rebels, including Peter Matthews, were executed.

Captain Philip De Grassi.

While Charlotte and Cornelia's heroic exploits may not necessarily have changed the course of history, the *New York Albion* acknowledged that "all who were witnesses of the conduct of these extraordinary girls spoke of it in terms of unqualified admiration. They became the topic of conversation, and were pointed out as bright examples of loyalty and courage."[5]

Little is known of the sisters after the 1837 Rebellion. Both Charlotte and Cornelia married Americans and moved to the United States. Unforunately, their heroism has not been widely recognized, unlike Laura Secord, who warned of an American attack in the War of 1812, and Madeleine de Verchères who defended her family's fort.

The *Globe and Mail* published an article[6] on Cornelia De Grassi in 1954, and *The Canadian Encyclopedia* notes that Cornelia carried messages through enemy lines. Part of the original De Grassi homestead is included in the Charles Sauriol Conservation Reserve, where a plaque mentions Captain De Grassi. While the De Grassi name lives on through the popular television shows, it is unfortunate that few — if any — viewers know the story of the remarkable De Grassi sisters.

Quote:

"Amidst the general excitement and joy of the rebels my little girl had the presence of mind to urge her horse and ride off at full speed, amidst discharge of musketry. A ball went through her saddle, and another through her riding habit. Arrived in Toronto, she was taken before Sir F.B. Head, the Governor, to whom she gave valuable information as to the numbers and condition of the rebels — Thus the loyalists were encouraged, measures were taken to meet Mackenzie's attack, and my poor child was the means of saving Toronto...."[7]

— An account of Cornelia's escape from the rebel camp,
by Philip De Grassi.

A Beothuk Captive

Demasduit

1796–1820

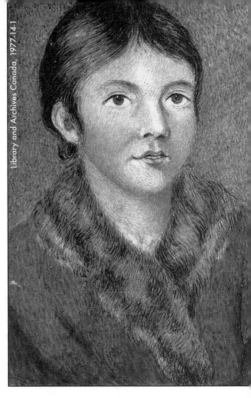

Captured by English settlers, this heroic woman provided invaluable information about her people. But it was too late to save the Beothuks.

Portrait of Demasduit by Lady Hamilton, 1819.

Today it seems like a bad idea. To "open a friendly intercourse with the tribe,"[1] English colonists in Newfoundland decided to capture some of the Beothuk. Among them was a young woman called Demasduit.

The plan was to release the Beothuk captives once they'd been treated kindly and given presents, so they'd be keen to promote peaceful relations and trade. This cruel strategy was undertaken a number of times in an effort to curtail the violence that erupted from the competition between Natives and Europeans for fish, furs, and other resources. There were rewards for anyone who could bring a live Beothuk back to St. John's, Newfoundland.

In 1819, John Peyton Jr., a merchant in Exploits, obtained permission from Governor Charles Hamilton to pursue the Beothuks who'd cut the moorings of one of his boats. Hamilton encouraged Peyton to take a captive.

During late winter that year, Peyton's armed band of furriers, eager for revenge, stormed a Beothuk camp on Red Indian Lake. There were thirty-

one people camped in three *mamateeks* (winter wigwams) on the shore. Most of the startled Natives fled to the forest, but Demasduit — who had recently given birth — was too weak to escape. The attackers surrounded the fallen woman as her husband, Chief Nonosabasut, rushed back to rescue her. Someone in Peyton's party shot him, and a witness watched him die on the ice: "His eyes flashed fire and he uttered a yell that made the woods echo."[2] The raiders also murdered Nonosabasut's brother.

Despite the remaining Beothuks' efforts, Demasduit's baby died two days after she was abducted. The raiding party took Demasduit to Twillingate and the grieving widow was placed in Anglican missionary John Leigh's home. She quickly learned some English and worked with Leigh to compile a list of about 200 Beothuk words — an important record that helped preserve the language. For the first time, their actual name became known: the Beothuks.

Demasduit significantly changed public opinion about the people previously known as the Red Indians. She was transported to St. John's in May, where she became known as Mary March, denoting the month of her capture. She was a frequent guest of Governor Hamilton, who noted she was "of a gentle and interesting disposition and acquiring and retaining without much difficulty any words which she was taught."[3] Lady Hamilton painted her portrait and the personable young woman was regarded with affection by all who met her.

Until Demasduit's arrival, the local residents had generally considered the island's Natives savages, murderers bent on preventing the settlers from earning an honest livelihood. The Europeans failed to recognize they were pushing the Natives from their traditional territory, depriving them of a means of survival. Demasduit transformed some of the hostility felt toward Beothuks into understanding of their situation. One anonymous writer recognized this important shift in an article published on May 27, 1819:

> In consequence of the habitual persecution and cruelty which every well informed person in this island knows to have occurred, we could not but believe that the Red Indians were the most ferocious and intractable of the savage tribes. And it is with no less astonishment than

pleasure that we find in the young woman which has been brought amongst us a gentle being, sensibly alive to every mild impression and delicate propriety of her sex. Is it not horrible to reflect that at the very moment, while we set down at our fire sides in peace and composure, many of her country men ... are exposed to wanton cruelty.... We might remember that as far as priority possession can convey a right of property, the Red Indians have the better title to the Island.[4]

Some well-intentioned citizens in St. John's decided to help Demasduit by raising money for her return home. They didn't realize that in Beothuk culture anyone who had contact with white people (who belonged to the bad spirit) was considered corrupt and would face rejection and death if he or she came back.[5] Several attempts to return Demasduit to her people failed when they couldn't find any Beothuk camps. A final attempt was being made when she died of tuberculosis onboard the *HMS Grasshopper* on January 8, 1820.

Her body was carried back to Red Indian Lake where she had been captured the year before. Her niece Shanawdithit and a few surviving Beothuks watched in the nearby woods as Demasduit's pine coffin was placed inside a tent. After the spring thaw, the Beothuks placed her body in the nearby cemetery beside Chief Nonosabasut and their infant.

One of the last survivors of the Beothuk people, Demasduit was recognized as a national historic person. She has also been commemorated by the Mary March Regional Museum and Mary March Provincial Park.

Quote:

"Kaw-injemeesh."

— A Beothuk phrase meaning "Let us shake hands."[6]

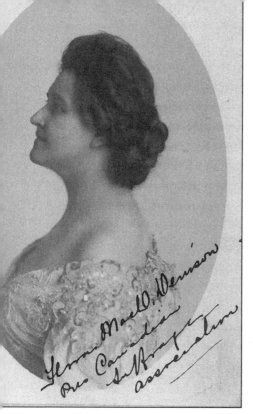

Flora MacDonald Denison, circa 1911.

Born a Rebel[1]

Flora MacDonald Denison

1867–1921

She was a radical feminist who became a powerful voice for women's suffrage. And created the wilderness retreat that would become Bon Echo Park.

Flora was so passionate about women's rights that she served guests at Bon Echo with suffragist dinnerware, featuring slogans such as "Votes for Women." Flora MacDonald Denison (née Merrill) played an important role in obtaining the vote for women in Canada and New York. She was an accomplished businesswoman, journalist, spiritualist, labour activist, suffragist, and an ecofeminist before the term was coined.[2]

Flora's independent lifestyle was no doubt nourished by her childhood. The daughter of a genteel family who'd fallen on hard times, she was born in a shanty in the Ontario bush where her adventurous father, George Merrill, was prospecting. Her mother, Elizabeth, supported the close-knit family of eight children in Belleville when George's mining venture failed and he turned to drink when he couldn't find steady work. The family believed in the supernatural; some of them had psychic powers, including Flora's older sister, Mary, who she wrote about in her novel *Mary Melville, the Psychic.*

Flora's upbringing made her open to new ideas and opportunities, and gave her a tendency to question accepted beliefs and institutions. She found orthodox Christianity stifling, preferring mysticism to churches where "most women were given such a miserable position within its sacred portals."[3] Flora had to leave school at fifteen to work. After a brief stint of school teaching, which she found "little more enticing ... than solitary confinement,"[4] she did office work in Toronto. In the mid-1800s, she joined relatives near Detroit where she began her journalism career.

There she also met a travelling salesman named Howard Denison, with whom she had a marriage of sorts in 1892. Their relationship was complicated by the fact he was already married, though they might have had a legal ceremony after his first wife died in 1904. Their union wasn't a successful one, aside from the birth of her beloved son Merrill in 1893. The couple eventually separated. One biographer suggests that she may have had a secret lesbian lover.[5]

Like her mother before her, Flora had to be the breadwinner since her husband wasn't successful. They settled in Toronto, where she began work as a dressmaker; it would become the primary source of income during her lifetime. She became well known as a clothing designer for wealthy women, first as manager of the custom dress department at the Robert Simpson Company and, as of 1905, the owner of a profitable business of her own. Flora combined this with a writing career, starting with articles in *Saturday Night* magazine and a regular column in the *Toronto Sunday World* from 1909 to 1913.

As a journalist, Flora became a vocal advocate for women's independence, supporting controversial topics, such as divorce, birth control, and free love. She encouraged economic and political equality for women, state-funded daycare, respect and improved conditions for working women, vegetarianism, and saner clothing — no tight corsets, pointed toes, and high heels. Pioneer suffragist Emily Howard Stowe introduced her to the women's movement in 1903, and Flora blossomed into a self-confident leader. She soon became a key figure in the suffragist movement in Toronto as well as a player on the international stage.

Flora brought enthusiasm to the national suffrage association. She promoted the women's movement through her newspaper articles and

speaking engagements, made significant financial contributions to the suffrage cause, and brought prominent speakers to Toronto from the United States and Britain.

She gave her first suffragist speech to an audience of more than 5,000 at the Lily Dale spiritual resort in New York, becoming such a successful speaker that she made vocal feminist Augusta Stowe-Gullen jealous.[6] Flora was the Canadian Suffrage Association's secretary before becoming president in 1911. She represented Canada, at her own expense, at two world conventions of the International Suffrage Alliance, in Copenhagen in 1906 and Budapest in 1913. Flora also led the Canadian delegation to a suffrage rally in Washington, D.C., that year.

Flora admired and befriended suffrage leaders in other countries, including Americans Susan B. Anthony and Charlotte Perkins Gillman, as well as the English militant Emmeline Pankhurst. While in England in 1913, Flora participated in the London Pavillion protest, and concluded that militancy was sometimes necessary. She joined the Women's Social and Political Union there, and spoke at a Caxton Hall meeting. She was more radical than many of her Canadian sisters and was one of the few activists in the country who was a self-proclaimed feminist.[7]

Flora was often critical of her conservative colleagues and, perhaps because of her lower social status, she was never fully accepted. She was forced to resign from the CAS in 1914. Her talents were still appreciated south of the border: the president of the National American Woman Suffrage Association hired her as a full-time lecturer in the campaign that brought the franchise to New York State in 1917.

In 1910, Flora purchased the rustic Bon Echo Inn on the shores of Lake Mazinaw, Ontario. After she returned from New York, she focused on the wilderness property. She hoped to transform Bon Echo into a nature retreat for artists, reformers, spiritualists, and socialists — a haven dedicated to Walt Whitman's ideals of democracy, freedom, and the love of nature. Active in the Theosophical Society, the Whitmanite movement, and the Association for Psychical Research of Canada, she attended seances that made contact with both her sister, Mary, and Old Walt. As a tribute to the poet, she arranged to have the massive granite cliff along Mazinaw Lake dedicated to Whitman on the centennial of his birth, in August 1919.

The dedication to "Old Walt" in 1919. Flora is sitting below the P.

Flora died of pneumonia on May 23, 1921, at the age of fifty-four. Her devoted son, Merrill, continued to manage Bon Echo. He ensured that the beautiful natural area was preserved in perpetuity for everyone to enjoy. Many authors, photographers, and artists — including Group of Seven members — found inspiration there. Merrill eventually transferred ownership to the province of Ontario. His gift became Bon Echo Provincial Park in 1965, at which time the nature reserve was dedicated to Flora MacDonald Denison and Merrill's first wife.

Quote:

"It is easy to conform: it is easy to avoid criticism: just be nothing, say nothing: but there will be whole worlds that you will never enter and exquisite joys that you will never know the meaning of."[8]

On Trial for Being Black

Viola Desmond

1914–1965

Her defiance of segregation galvanized the black community, inspiring others to fight racial discrimination in Canada.

Portrait of Viola Desmond by David MacIntosh, 2010.

Viola Desmond's car broke down on February 8, 1946, in New Glasgow, Nova Scotia. Stranded for the night, the young lady decided to see a movie. The shocking events that followed changed her life — and ushered in a new era of race consciousness in Canada.

At just thirty-two, she was already the owner of a prosperous beauty salon in Halifax. She asked to buy a ticket at the Roseland Theatre and found a seat on the main floor; she was quickly asked to move upstairs, since the lower level was reserved for white people. Her offer to pay the extra penny tax for her seat was rejected, but Viola politely and firmly refused to budge. The petite woman (under five foot, weighing less than 100 pounds) was dragged from the theatre by a burly white policeman, arrested, and taken to jail. She was forced to spend the night in a cell with male prisoners. The charge? Tax evasion under the provincial Theatres, Cinematographs, and Amusements Act.

The next morning, the local magistrate convicted Viola Desmond and fined her $26. The fact that theatre patrons were assigned seats

according to their race wasn't discussed during the short trial; in fact, race wasn't mentioned at all. Provincial legislation was used to support racial discrimination. Viola didn't have a lawyer; she wasn't advised of her rights to seek adjournment or have counsel. As one newspaper would later write, she wasn't actually tried for a felony, but for being a negress.[1]Angry and humiliated, Viola paid the fine and went home.

Viola Desmond (née Davis) was the daughter of a prominent black family. She was married to a successful barber named Jack Desmond. Growing up in Halifax she attended racially segregated schools. Eager to pursue a career as a beautician, she had to train in Montreal because beauty schools in Halifax weren't open to black people. Viola also went to New York and Atlantic City to study. She established Vi's Studio of Beauty Culture in 1937 in Halifax — where her clients included the legendary classical singer Portia White — and created a line of beauty products.

Viola travelled around Nova Scotia to provide beauty supplies and services to black communities. She also started the Desmond School of Beauty Culture, which attracted black students from around the province, as well as New Brunswick and Quebec. An ambitious and prosperous entrepreneur, she dreamed of setting up a franchise of beauty parlours for black people across the country. She was a strong, highly respected woman, touted as a model of success.

When Viola returned home after the trial, her husband was understandably concerned, but urged her to forget the ordeal: "Take it to the Lord with a prayer."[2] Among those who encouraged her to take action were Pearleen Oliver and her husband Reverend William Oliver. The influential black couple were strong proponents of racial equality. They convinced the bruised and battered Viola to get medical attention for the injuries she suffered when she was dragged out of the theatre. Viola also decided to contact a lawyer, and the Nova Scotia Association for the Advancement of Coloured People (NSAACP) agreed to raise funds to support the costs and hold public meetings to bring attention to the case.

Unfortunately, her laywer mishandled the case. He missed an important appeal deadline and failed to directly attack racial segregation. The legal actions failed, and Viola never received public vindication for the discrimination she had endured. While some black people in Halifax objected to her activism and feared a backlash, Viola's courageous legal

challenge resulted in a major growth in racial consciousness. Viola's lawyer did not charge the NSAACP for his legal fees, so the funds were used to fight other cases of racial discrimination. Reverend Oliver saw the significance of the case: "Neither before or since has there been such an aggressive effort to obtain rights. The people rose as one and with one voice. This positive stand enhanced the prestige of the Negro community throughout the Province."[3]

As for Viola, she was "bitterly disappointed."[4] The case took a heavy toll on her personal life. Her husband, who thought she was stirring up trouble, refused to support her. They eventually separated. Viola's business suffered and she lost her enthusiasm for the national franchise. She closed her shop, and moved to Montreal and then New York, hoping to work as a consultant in the entertainment industry. She died suddenly in New York in 1965, at fifty, from a gastro-intestinal hemorrhage.

A civil rights icon, Viola Desmond is recognized by many as a heroic leader in the fight against racism in Canada. Her story has been well-documented by legal historian Constance Backhouse[5] and retold in articles, stories, and radio dramas. In April 2010, the government of Nova Scotia granted Viola Desmond a free pardon — a rare act, acknowledging that the courageous woman was innocent of the crime she was convicted of. She would no doubt have been pleased to know that the pardon was signed by Lieutenant Governor Mayann Francis, a black woman.

Quote:

"I didn't realize a thing like this could happen in Nova Scotia — or in any other part of Canada."[6]

The Prima Donna

Pauline Donalda

1882–1970

She dazzled audiences in the world's major opera houses. Then returned home to make Montreal a city of great opera.

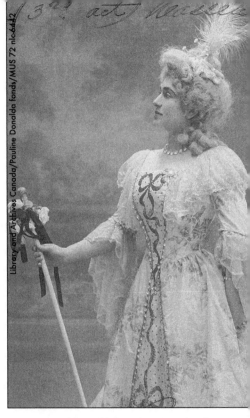

Pauline Donalda's debut in the title role of Jules Massenet's *Manon* in Nice, 1904.

Singer Pauline Donalda got her big break at London's Covent Garden in June 1905. Legendary opera singer Nellie Melba was playing the lead role in the hit production of *La Bohème* when she suddenly fell ill. The twenty-three-year-old Canadian soprano, her understudy, came to the rescue. She had just four days to master the opera in Italian — though she knew it in French — and the audience loved her performance opposite Enrico Caruso.

Born and raised in Montreal, Pauline grew up in a Jewish family with eleven children. She was the daughter of Russian immigrant Michael Lichtenstein (anglicized to Lightstone) and his Polish wife, Fanny Goldberg. Michael, a hatter, worked hard to give the children a good education, including musical training. Pauline won a singing prize at the age of ten; her remarkable voice drew considerable attention after she sang a solo in a choral performed for the Jewish Zion Congress in 1901.

Recognizing Pauline's potential, the choir director arranged for an audition with the acclaimed musical director at the Royal Victoria College, Clara Lichtenstein (no relation). "I think the diamond has been found,"[1] she

remarked after hearing the young woman. Pauline got a full scholarship to the college, but Miss Lichtenstein recommended that she develop her talent in Europe. After experts at the Metropolitan Opera confirmed that Pauline had great potential, she departed for France in 1902, thanks to the financial support of arts patron Lord Strathcona (Sir Donald A. Smith). He awarded her a scholarship of $50 per month to cover tuition and living expenses.

Pauline adopted the stage name Pauline Donalda in honour of her sponsor. Thrilled to be in Paris, and anxious to live up to great expectations, Pauline began taking voice lessons with Edmond Duverney at the Paris Conservatoire. She also studied stage technique with Paul Lhérie, improved her French with Pierre Breton, and took Italian lessons with Babette Rosen. After two years of study, she made her debut in Nice on December 30, 1904, playing the leading role in *Manon*.

"Pauline Donalda dared to appear for the first time before the public in the role of *Manon*," wrote one critic. "Only Pauline Donalda could have had that boldness and succeed. She possesses an unusually exquisite physique; a strong, brilliant, flexible and wide-ranged voice; a finesse and intelligence underlined by remarkable acting and sparkling eyes that open to life or are full of love."[2]

Encouraged by the praise, Pauline courageously approached Covent Garden, one of the world's greatest opera houses. Astonished to be offered a three-year contract, Pauline debuted there in May 1905 as Micaela in *Carmen* and began winning leading roles. Covent Garden was Pauline's base for nine years, but she also performed at Théâtre de la Monnaie in Brussels, the Opéra-Comique in Paris, and the Manhattan Opera House in New York, where she received an impressive $5,000 a month. After a six-month illness and threat of tuberculosis, she wed baritone Paul Seveilhac in 1906 despite her family's strong opposition to her marrying outside the Jewish faith.

In a stellar career that lasted from 1905 until 1922, Pauline toured Canada, the United States, Russia, Hungary, Holland, Germany, Ireland, Wales, and Scotland. In addition to her public performances, she also gave private concerts in the homes of London's elite. Pauline performed with the greatest opera stars, conductors, and musicians of her time, including conductor Sir Landon Ronald, violinist Mischa Elman, pianist Ignaz Jan Paderweski, and composer and violinist Efrem Zimbalist. She made several recordings, but few remain.

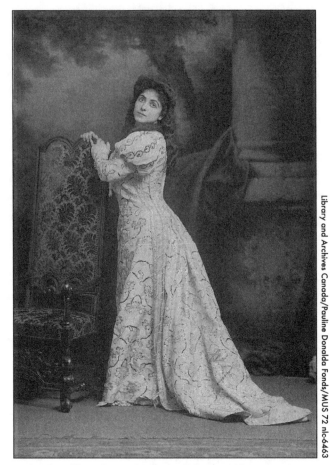

Library and Archives Canada/Pauline Donalda Fonds/MUS 72 nlc-6463

Pauline Donalda in Covent Garden's production of *Romeo and Juliet*, 1905.

At the outbreak of the First World War, her Australian tour was cancelled, and Pauline spent the war years in Canada. With her husband and three brothers on the front, she gave many performances (including the Donalda Sunday Afternoon Concerts) to support the war effort through the War Relief Fund, the Patriotic Fund, and the Red Cross. During the war, she even tried vaudeville in New York, where she shared billing with Harry Houdini.

She returned to Europe in 1917 and, after her marriage ended in divorce, she wed a Danish tenor named Mischa Léon; this marriage also ended in divorce. Pauline continued to sing in the great opera

houses of Europe for five more years, before retiring at the age of forty due to exhaustion.

Pauline opened a studio in Paris in 1922. There she taught hundreds of gifted singers before moving back to Montreal in 1937. Eager to stimulate excellence in operatic performances in the city of her birth, Pauline founded the Opera Guild in 1942 and directed it until 1969. Under her leadership, the Guild produced twenty-nine operas and provided performance opportunities for notable Canadian singers, such as Maureen Forrester, Clarice Carson, and Robert Savoie. Pauline was still teaching in her eighties when she died in 1970.

Pauline Donalda received a multitude of honours, from an honorary doctorate to the Order of Canada and Montreal's Outstanding Citizen Award. She is still widely recognized for her brilliant career as an international opera singer, in addition to her dedication to the development of opera in Montreal. As the *Montreal Star* wrote, she was "a commanding figure in the history of Canadian music."[3]

Quote:

"From my own personal experience, I most certainly do not think a singing career and marriage mix well at all. If a career is to be successful … one must be ready to simply give everything, sacrifice everything to it, *everything*."[4]

The Lady in Black

Onésime Dorval
1845–1932

The first certified teacher in Saskatchewan, she laid the groundwork for a system of French and English education in the province.

Onésime Dorval (at right) with Georgine d'Amours.

How could a woman deemed too frail to become a nun survive the hardships of the northwestern wilderness? With great courage and determination.

Onésime Dorval was a petite farm girl, born in Ste-Scholastique, Quebec, in 1845 to Esther Brunette and Ignace Dorval, a farmer and carpenter. She attended convent schools in the Laurentians and earned a first-class teaching certificate. Onésime was intensely religious and wanted to devote her life to God by becoming a nun.

She joined the Sisters of Good Shepherd in New York. There she learned English, but was not permitted to make her final vows because she was too frail. Never robust, she eventually grew stronger. When she heard that Bishop Vital Grandin, Oblates of Mary Immaculate, was looking for resourceful women to work as teachers and housekeepers, the adventurous Onésime jumped at the chance to travel west and serve in the Roman Catholic missions.

In the summer of 1877, thirty-two-year-old Onésime arrived at Fort Garry in Red River, accompanied by Marie Giroux, a young orphan girl

she'd adopted. Onésime taught English for several years and established a school at Baie St. Paul for Métis and French-Canadian children. In 1880, Onésime moved on to Saskatchewan, travelling west on a demanding two-and-a-half-month trek by Red River cart. Despite the rigours of the trip, she often walked ahead of the nineteen carts in the brigade, marvelling at what she considered "this beautiful nature which had the power to charm the saddest of hearts."[1]

Onésime devoted her life to serving the Oblate missions of the northwest. She became a member of the Order of St. Francis, formally signing over her income for the regular rights of the order. She taught in Manitoba for more than forty years, and also established schools and taught in Saskatchewan at St-Laurent-Grandin, Battleford, Batoche, and Duck Lake. While working in St-Laurent, she helped create a grotto to Our Lady of Lourdes. In 1913, St. Michael's School in Duck Lake celebrated Mademoiselle Dorval's fifty years of teaching, even though she didn't retire until 1921.

She faced many challenges during her early years on the Prairies, including physical hardships and poverty at the rudimentary missions. During the North-West Rebellion in 1885, Onésime and thirty-two others sought safety in Fort Battleford, fearful at news of hostilities such as the Frog Lake Massacre.

Onésime was the first certified schoolteacher in Saskatchewan, and one of the few bilingual educators in the West. She played an important role in sustaining the bilingual system through the 1875 North-West Territories Act. Though she shared the popular notion that she should be converting the Aboriginal peoples, this zealous Roman Catholic teacher also loved and respected her Métis students, and they admired her for it.

Onésime was always smiling; she even allowed a bit of mischief in the classroom. Fond of children, she adopted a second daughter, Georgine d'Amours, a Métis orphan. The esteemed teacher was also a talented painter, woodworker, and carpenter; she helped construct the schoolhouse at Battleford, and household furniture.

When she retired, Onésime continued serving the community and working on her memoirs. As always, she lived a modest life and dressed conservatively in black. She died at eighty-seven. The pioneer teacher was buried in Duck Lake, Saskatchewan, at the St. Michael's school

cemetery. "She was admired by all who came in contact with her, for her remarkable memory, sound judgment, her cheerful disposition and edifying piety."[2]

The Historic Sites and Monuments Board of Canada recognized Onésime as a person of national historic significance in 1954. That same year, the Saskatchewan government named four small islands in the North Saskatchewan River in her honour. Visitors to the Duck Lake Regional Interpretive Centre will find a little harmonium that Onésime once used to teach music, and in Batoche National Historic Site they can see one of her paintings on display.

Quote:

"Austere poverty was evident everywhere; not far from the church a miserable structure serving as a kitchen, classroom, dining hall."[3]

— Onésime's first impressions of the mission at Saint-Laurent de Grandin, 1881.

An Astronomical Success

Allie Vibert Douglas
1894–1988

A renowned astronomer and astrophysicist, she paved the way for women to study sciences at university.

Allie Vibert Douglas.

There was a definite chill in the air when Allie Vibert Douglas was studying for her Ph.D. at Cambridge University. Women had to sit at the back of the lecture room at Trinity College, while the first two rows — beside the stove — were reserved for men. While the cold made concentration difficult, she was more concerned that, as a woman, she wouldn't receive a degree from Cambridge, despite fulfilling the academic requirements.

Allie's path toward scientific distinction was long and winding. She was born in Montreal in 1894 to accountant John Vibert and Alice Douglas. Alice died soon after giving birth and John was struck with tuberculosis. Allie and her brother, George, were raised by their grandmother, Marie Pearson Douglas, and two unmarried aunts, Mary and Mina, in London, England, and Montreal.[1]

Allie was always interested in science. She faced her first gender barrier when a high-school club refused to accept her because she was a girl. Her brother helped her circumvent the exclusion by leaving the door ajar during the lectures she wanted to hear so she could listen from the

hallway. Allie decided to fight women's inequality with determination and a little creativity.

In 1912, Allie enrolled at McGill University in honours mathematics and physics. When her studies were interrupted by the Second World War, she went to London to work in the War Office. She received the silver cross as Member of the Order of the British Empire for her work before returning to McGill to complete her B.A. and M.Sc.. Allie then studied at the Cambridge Observatory and the Cavendish Laboratory in England. There she worked on radioactivity with Ernest Rutherford before getting hooked on astronomy.

Allie volunteered at an observatory in Wisconsin, then returned to McGill. She completed her doctorate in physics in 1926, and was the first woman in Canada to become an astrophysicist. A popular lecturer, she was once told that "if you were a man I would say that that was a damn fine lecture, you took them by storm."[2]

Though Dr. Vibert Douglas gave lectures in astrophysics at McGill, she was "never offered a proper academic position."[3] In 1939, she accepted the position of dean of women at Queen's University, eventually becoming a full professor in astronomy and astrophysics. She taught there until 1960. Dr. Vibert Douglas played an important role in facilitating women's entrance into science programs, particularly engineering and medicine. She was an inspirational role model and mentor to countless young women, including Member of Parliament Pauline Jewett.

Anxious to help scholars in Europe who'd been displaced after the wars, Dr. Vibert Douglas joined the International Federation of University Women. She served as president from 1947 to 1950. She was also president of the Royal Astronomical Society of Canada (the first woman to hold the position) and attended more conferences of the International Astronomical Union than any other Canadian astronomer. A widely published scientist, she wrote an acclaimed biography of the famous astronomer Arthur Stanley Eddington, with whom she studied at Cambridge. At a time when there were few female astronomers in the world, she attained an international reputation.

An adventurous woman who explored many countries, Allie was fondly remembered by family and friends as unique and intrepid. She

was passionate about her work and dedicated to ensuring women's access to educational opportunities.

Allie received honorary doctorates from Queensland, Queen's, and McGill Universities. Queen's University created the Dr. A.Vibert Douglas Scholarship to commemorate her life and career — as a scholar, humanist, and champion of women in the sciences. The Canadian Federation of University Women recognized her as a twentieth-century heroine and set up a fellowship in her name. A crater on Venus and an asteroid were also named after the acclaimed astrophysicist.

Quote:

"Why are women not equally accepted at Queen's?"[4]

Set My Sisters Free

Mary Two-Axe Early[1]

1911–1996

Her relentless crusade for equal rights for Aboriginal women improved thousands of lives. Mary Two-Axe Early.

When Mary Two-Axe Early's friend died of a heart attack in 1966, it was a case of death by discrimination. Her friend had been forced to leave the Kahnawake Reserve and sell her house because she'd lost her Native status. Mary knew that the stress of the situation was behind her death. Mary channelled her anger into a crusade to regain equal rights for Aboriginal women who'd lost their Indian status after marrying non-Natives.

Born on the Kahnawake Reserve in Quebec in 1911, Mary Two-Axe was the daughter of a Mohawk named Dominic Onenhariio Two-Axe and his wife, Juliet Smith, an Oneida teacher and registered nurse from Wisconsin. When the marriage dissolved, Mary lived with her mother in North Dakota until Juliet died during the Spanish flu epidemic. Mary grew up with her Mohawk grandparents in Kahnawake.

After moving to Brooklyn, New York, as a young woman, Mary married an Irish-American electrical engineer named Edward Early. Mary and their two children, Edward and Rosemary, spent every summer in Canada on the Kahnawake Reserve. Though she was no

longer considered an Aboriginal under the law, Mary was young and in love and didn't think much about her status.

Like all other Aboriginal women who married non-Natives, Mary had lost her status under the provisions of the Indian Act of 1876. Unlike Aboriginal men who married non-Natives, the women were denied all rights and benefits of Aboriginal status, such as health and education services, and the right to live, own property, vote in band elections, and be buried on reserves. After her friend's death in 1966, and her public-awareness campaign about this gender discrimination, Mary's anguish grew. She travelled across Canada, listening to stories from Native women who'd been exiled and robbed of their cultural identities. "They were no longer considered persons — it was as though they were dead," she recalled.[2]

Mary was fifty-five when she became a political activist, writing letters to politicians and the press, giving presentations, and making submissions to the federal government. After consulting with women's rights advocate Senator Thérèse Casgrain, she led a group of thirty Quebec Mohawk women to submit a brief to the Royal Commission on Women in Canada. Male First-Nations leaders, among the strongest opponents she faced, expressed their reservations about the high cost of extending rights to deregistered Aboriginal women and their offspring. Mary continued fighting for the birthrights that she and her sisters had lost.

After her husband died in 1969, Mary moved back to Canada to live in the log house she'd inherited from her grandmother. Band leaders reluctantly permitted her to live on the reserve, but when she had to turn ownership over to her daughter (who had married a Mohawk man), Mary became "a guest in her own house."[3] The Kahnawake band council was still displeased with the arrangement and, in 1975, announced plans to evict Mary.

The 1970 report from the Royal Commission on the Status of Women in Canada recommended that some sections of the Indian Act be repealed to ensure that Aboriginal women and men had equal rights and privileges. In 1975, Mary brought national and international media attention to the discrimination of Aboriginal women after sharing news of her eviction notice at the International Women's Year conference in Mexico.

With Quebec premier René Lévesque's support, Mary pleaded her case to reluctant ministers at the 1983 constitutional conference. When

the Canadian Charter of Rights and Freedoms took effect in 1985, the government of Canada passed Bill C-31, which restored Aboriginal status and rights to the many First Nations women who had married non-Indians, as well as to their children. The change in legislation made about 16,000 women and 46,000 descendants eligible for status.

Mary Two-Axe Early played a major role in the revision of the Indian Act. On July 5, 1985, Mary became the first woman to regain her Aboriginal status at a special ceremony in Toronto. David Crombie, minister of Indian Affairs and Northern Development, presented the seventy-three-year-old lady with a document recognizing her achievement: "I could find no greater tribute to your long years of work than to let history record that you are the first person to have their rights restored under the new legislation."[4]

The battle was not over and Mary continued to fight. Some bands refused to accept Aboriginal women who had regained their status. Mary spoke out in 1993 when she testified before the Federal Court of Canada after some powerful First Nations groups challenged the right of the federal government to decide on band membership. At eighty-three, the tenacious activist helped win another legislative victory.

Mary lived in Kahnawake until her death. As journalist Janice Kennedy observed in 1991, "Heroism lives in improbable places. Sometimes it settles modestly at the end of a quiet road, in a wooden frame house painted blue."[5]

Mary Two-Axe Early is remembered as an inspirational leader. She received considerable recognition for her achievements, including the Governor General's Award in Commemoration of the Persons Case, the Order of Quebec, a National Aboriginal Achievement Award, and an honorary Doctorate of Laws degree from York University. The heroic modern-day warrior was buried on the Mohawk reserve where she was born. It was her final victory.[6]

Quote:

"Please search your hearts and minds, follow the dictates of your conscience, set my sisters free."[7]

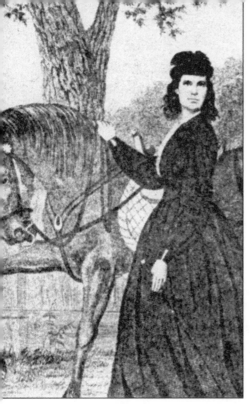

Just Call Me Franklin

Sarah Emma Edmonds

1841–1898

A fearless Canadian soldier, spy, and nurse, she survived some of the bloodiest battles of the Civil War.

Portrait of Sarah Emma Edmonds, as depicted in her book.

A visiting peddler gave young Emma Edmonds a book about a female pirate captain called Fanny Campbell, a brave, swashbuckling heroine who shot panthers and rode wild horses. Told that she was so courageous and noble that she "shouldst have been a man,"[1] tomboy Fanny cut her hair, dressed as a man, and hit the road. Enthralled by the book and inspired by Fanny's exploits, Emma would follow a similar path.

From the day she was born, Emma (who later changed her last name) was a disappointment to her father, Isaac Edmondson. A tyrannical Scot, he wanted sturdy sons to help on his farm near Magaguadavic Lake, New Brunswick. In December 1841, he was enraged when his Irish wife, Betsy, gave birth to their fifth daughter. Emma became proficient at milking cows, planting potatoes, chopping wood, firing a shotgun, hunting, fishing, and riding even the wildest horses. She took classes at a one-room school and attended an Anglican church with her family.

When Emma was fifteen, her father insisted she accept a marriage proposal from an older man. But, with her mother's help, the teenager

ran away, renamed herself Sarah Emma Edmonds, and learned how to make hats. She met the Perrigo family, who believed in educating all their children well, not just the boys. Emma and Henriette Perrigo became partners in a millinery shop in Moncton, New Brunswick.

Around 1858, Emma faced a crisis of some sort and disappeared. She disguised herself as a young man named Franklin Thompson, and reappeared in Saint John as a Bible salesman with short, curly auburn hair. The new arrival was saving money to move to the United States to train for missionary service. Franklin was such a successful salesman that the publisher told the young man they'd never had anyone who could sell Bibles so well. Franklin earned a good income, dressed in fine clothes, and drove a handsome horse and buggy.

In the fall of 1860, Emma (as Franklin) travelled west to Flint, Michigan. She continued to work as a salesman. One friend noted that Franklin was "glib of tongue, thoroughly businesslike, and had an open, honest, persuasive manner that was particularly attractive."[2] Franklin became friends with William R. Morse, captain of the Flint Union Greys. She joined the Greys and quickly demonstrated skill as a marksman. When the Civil War broke out that year, a wave of patriotic fever swept through Flint. Emma, now comfortable masquerading as a man and enjoying her freedom, felt a sense of loyalty toward her adopted country and decided to join the Union Army as a male nurse.

Franklin was initially rejected for being too short, at five-foot-six. Then, in the spring of 1861, Captain Morse came to sign up more recruits; he allowed Franklin to enlist for a period of three years. Franklin joined Company F, Second Michigan Volunteer Infantry, as a male nurse with the rank of private. With the many skills she'd learned on the farm, Franklin performed well in basic training. She also found it easy to stand guard, build roads and fortifications, and take her turn at police duty.

Private Thompson was soon heading for the front, facing enemy fire in the First Bull Run in July 1861. Emma later wrote about the appalling sight of the battlefield: "Men tossing their arms wildly calling for help; there they lie bleeding, torn and mangled; legs, arms and bodies are crushed and broken as if smitten by thunderbolts; the ground is crimson with blood."[3]

Franklin saw combat at Williamsburg and Fair Oaks. In the Seven Days Battles, she carried messages by horseback through the fighting because she was such an adept rider. Always under fire, the daring soldier rode "with a fearlessness that attracted the attention and secured the commendation of field and general officers."[4]

In addition to serving as an army nurse, Franklin worked as the regiment's postmaster and later the Second Michigan's mail carrier. For the dangerous job, she travelled fifty or sixty miles by horseback with up to three bushels of mail. Emma spent many nights sleeping by the roadside, always on the lookout for the bushwackers who had murdered other carriers. Whatever the challenge, Emma faced the hazards of the Civil War. Her fellow soldiers admired the skillful and determined fellow who was a "whole-souled, enthusiastic youngster, frank and fearless."[5]

During the Battle of Fair Oaks, Emma's arm was severely mangled when her horse suddenly kicked her and bit her arm. Despite serious injuries, she bandaged herself up and returned to caring for the wounded while fighting chills, fever, and pain.

Later, Private Franklin Thompson served in the Federal Secret Service as a spy, working for General George B. McClellan. On her first mission she disguised herself as a black boy, painting her skin and wearing a curly black wig; she slipped into rebel territory at Yorktown. Armed with a revolver and a southern drawl, she soon worked with a pick and shovel on rebel fortifications. With blistered hands, Emma sketched the fortifications and recorded detailed information about the guns, concealing the report under the sole of her shoe. She gleaned more useful details about the rebels from gossip and even managed to see Confederate General Robert E. Lee.

The physical and emotional challenges of serving in the Civil War eventually wore down the adventurous heroine. Near the beginning of the war, she'd fallen in love with a young assistant surgeon named Jerome John Robbins. When she later revealed that she wasn't really a man, he confessed that he was already betrothed. She later fell for Assistant Adjutant General James Reid, who probably shared her feelings but was married. Heartbroken and injured, she was also suffering from malaria and requested a leave of absence. The request was denied and, in April 1863, she deserted.

Sarah Emma Edmonds dressed as Franklin Thompson.

Emma was cared for by a doctor in Oberlin, Ohio. About a month later, she reclaimed her true identity and wrote a book about her Civil War adventures, *Unsexed; or The Female Soldier*. It was published in 1864 by the publishing house for which she had sold Bibles, though it didn't reveal that the author had disguised herself. The book was a bestseller, with 175,000 copies sold by 1882. Emma donated the proceeds to an organization that assisted the soldiers with whom she had served, while she worked as a nurse and enrolled in Oberlin College.

In 1867, Emma married Linus Seely (later changed to Seelye), a carpenter from New Brunswick. She gave birth to three children, but all three died, so the couple adopted two sons.

Emma later decided to apply for a much-needed pension. She contacted some former comrades, revealing that she was actually Franklin Thompson. Once they got over their shock, each veteran she approached provided an affidavit on her behalf. In 1884, Congress, recognizing that Franklin Thompson and Sarah Emma Edmonds Seelye were one and the same, granted her a pension of $12 per month. She is the only woman from the Civil War to receive a federal veteran's pension. Congress eventually removed the charge of desertion from her record and, in 1889, she was granted an honourable discharge plus back pay and bounty.

When she died, Sarah Emma Edmonds Seelye was buried beside fellow veterans with full military honours at Washington Cemetery in Houston. She was the most widely known female Civil War soldier, having left the only verifiable written records of her military experiences.[6] Near the site of her childhood home in New Brunswick, a plaque recognizes the heroic Canadian.

Quote:

"I could only thank God that I was free and could go forward and work, and I was not obliged to stay at home and weep."[7]

— On enlisting for the Civil War.

Fighting Polio

Leone Norwood Farrell

1904–1986

With limitless energy and a passionate devotion to her research, she helped save millions from a terrifying disease.

Dr. Farrell.

Boys and girls were suddenly unable to walk, and some died within days of being stricken. Polio was one of the most dreaded diseases of the twentieth century, with widespread epidemics sweeping many countries. In 1953, at least 9,000 Canadian children were infected with the virus, as were many of their caregivers. Some of the survivors ended up in iron lungs, others were crippled for the rest of their lives.

Though American scientist Dr. Jonas E. Salk had discovered a potential polio vaccine in 1952, it was still untested; there was no method to develop enough of the vaccine to conduct large-scale tests to determine its efficacy and safety. Connaught Medical Research Laboratories at the University of Toronto received funds to support its polio research from the National Foundation for Infantile Paralysis in the United States. A senior researcher at the lab, Dr. Leone Farrell, developed the "Toronto technique," which enabled mass production of the vaccine.

Dr. Farrell was an experienced researcher by the time the polio field trials started. In 1934, she had joined the staff at Connaught, which was a

leader in the production of vaccines, penicillin, and insulin. The team had developed a synthetic medium, Medium 199, which had proven suitable for rapid multiplication of the polio virus. Farrell was charged with discovering a way to produce the vaccine in bulk, and the pressure was on.

Dr. Farrell developed a technique, using a machine she designed, which produced large enough quantities of the polio virus to conduct large-scale trials. When Dr. Farrell's process proved successful, Connaught received the contract to produce almost all of the 3,000 litres of virus fluids needed for the testing.

Dr. Farrell planned the building of the labs and incubators, and trained staff. She supervised the entire production process at the Connaught facility on Spadina Avenue during the winter of 1953–54. Dr. Farrell and her team were "working round-the-clock to produce large volumes of the live virus … they were so dedicated."[1]

Every Thursday, a station wagon would pull up to the door to collect the priceless cargo, carefully packed in ice in milk pails, and transport it to pharmaceutical companies in Detroit and Indianapolis. The virus was inactivated and transformed into polio vaccine. Dr. Salk praised the staff at Connaught for pulling off the Herculean task of supplying the virus.

Thanks to Dr. Farrell and her team, in spring 1954, about two million children participated in successful field trials of Salk's polio vaccine. Surplus vaccine was sent to Canada, enabling additional testing in Manitoba, Alberta, and Nova Scotia. Connaught received the contract to provide vaccine for the Canadian vaccination program. Mass immunization swept across North America.

Dr. Salk and his fellow scientists continue to be lauded by the *Journal of the American Medical Association* for their role in "one of the greatest achievements of the 20th century."[2] Yet, Dr. Farrell's role in eradicating polio has not been widely recognized. Few have ever heard of Dr. Leone Farrell, who author Paul Engleman called "Polio's unsung hero."[3]

Little is known about Leone Farrell's personal life. She was born in 1904 in a farming community near Ottawa and raised in Toronto. She received her Ph.D. in biochemistry from the University of Toronto in 1933 before being hired by Connaught Labs, where she worked for more than thirty-five years. During her distinguished career, she conducted research on fungi, antibiotics, whooping cough, cholera, and diptheria.

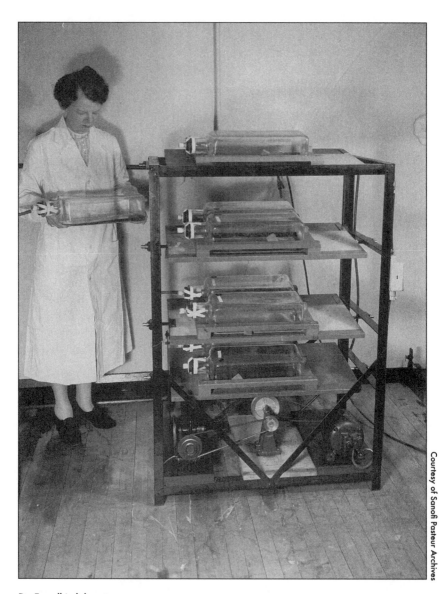

Courtesy of Sanofi Pasteur Archives

Dr. Farrell in laboratory.

Colleagues remembered her as a disciplined scientist devoted to her work, as well as being a well-dressed, elegant lady who favoured silk blouses, business suits, and high heels.

Farrell's employment files summarized her career as follows: "The breadth of these accomplishments bears testimony to the knowledge

and mental fertility enjoyed by Dr. Farrell. Never was she lacking in basic ideas of how to accomplish her scientific goals."[4] While her important role in the eradication of polio has been acknowledged on *science.ca* and promoted in Harry Black's book *Canadian Scientists and Inventors*,[5] her achievements have gone largely unrecognized; she worked in "relative obscurity."[6]

Dr. Leone Farrell died on September 24, 1986. She was buried in Toronto's Park Lawn Cemetery in an unmarked grave in Lot 707. After Daly's 2005 newspaper article appeared, relatives engraved Dr. Farrell's name on a family headstone and erected a slab outlining her accomplishments.

Quote:

"You will want to know why and when and where, and whether pigs have wings…. You must let your imagination take flight, while you keep your feet on the ground."[7]

— Advising women on the qualities required to become a good medical researcher, 1959.

The Secret Life of Alice Freeman

Faith Fenton

1857–1936

She dared to be a journalist, inspiring her female readers to follow new paths.

Faith Fenton in her mid-thirties.

Students knew her as Miss Freeman, a plain, spinster schoolteacher in Toronto. But to thousands of Canadians — from housewives to prime ministers — she was investigative journalist Faith Fenton.

Alice Matilda Freeman was born in Bowmanville, Ontario, in 1857. At the age of ten, the daughter of struggling British immigrants was suddenly sent to live with Reverend Thomas Reikie and his wife, Margaret. She spent four years with the childless couple. Alice thrived under the love and attention of her devoted foster mother (who secretly wrote poetry), and received an excellent education. After Margaret's death, Alice continued her studies and trained for one of the few occupations open to respectable young ladies: teaching.

At eighteen, Alice became a teacher for the Toronto School Board, earning less than $300 a year (about half what male teachers earned). She taught for the next nineteen years. Praised as an inspirational teacher, Miss Freeman endured the restrictive environment of the school system and the close scrutiny that female teachers were subjected to. She pursued

her secret passion by night, transforming herself into a journalist under the pseudonym Faith Fenton.

Alice — as Faith — led a double life to protect her position in society (and at the school board) and create a professional journalistic identity. She was one of the first women journalists in Canada and one of the most celebrated. Her articles were published in Barrie's *Northern Advance* and Toronto's prominent *Empire*. She finally gave up teaching in 1894 and devoted herself exclusively to journalism, working as editor at the *Canadian Home Journal* for two years.

While working for the *Empire,* Faith wrote a popular weekly column called "Woman's Empire." Newspapers wanted to expand their markets by including content that appealed to female readers. She provided just that, writing everything from travel pieces that nurtured national pride[1] to features on politics, child abuse, wages, suffrage, sensational murder trials, fashion, and the theatre. Faith prowled Toronto's seediest streets; she slept in a homeless shelter one night for an article. Urging readers to help the disadvantaged, she wrote, "There is a way of escape for every woman, a door into the larger life, of which she alone holds the key."[2]

Faith was a feminist before the term was coined. She openly expressed her views, even when her editor disagreed. Her columns touched a chord with women, with insights into new places, people, and issues; she interviewed American suffragist Susan Anthony, opera diva Emma Albani, and poet Pauline Johnson. Faith played an active role in the National Council of Women, and, in 1893, she covered the International Council of Women at the Chicago World's Fair. Dubbed the head of lady journalists,[3] Faith was well-respected, and attracted a large readership in Canada, as well as abroad. She even socialized with John A. Macdonald, Wilfrid Laurier, and Lady Aberdeen, the liberal-leaning reformer who was the governor general's wife.

Faith set out on her greatest adventure after gold was discovered in the Klondike. She joined the Yukon Field Force bound for the goldfields as the *Toronto Globe's* correspondent. She scandalized the expedition commander by wearing a long skirt without bloomers, revealing shapely calves. Faith agreed to conceal the offending body parts, sewing a piece of black satinette around the hemline.

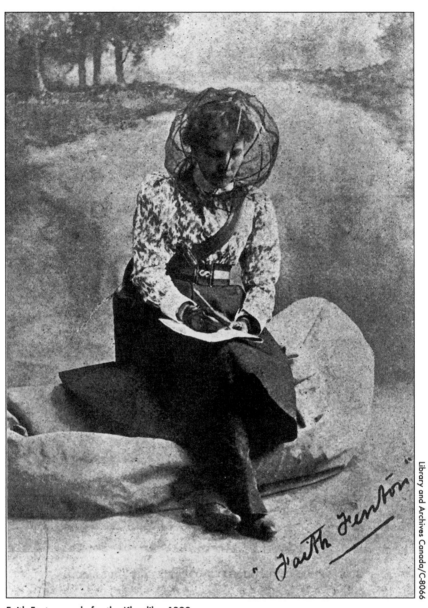

Library and Archives Canada/C-8066

Faith Fenton ready for the Klondike, 1898.

Faith entertained a legion of devoted readers and new fans with her tales of the trail, as she trekked into the wilderness. She wasn't the first woman reporter in the goldfields, but new arrivals such as Laura Berton remembered that Faith's were the only good reports on what to expect.

Welcomed in Dawson City as a brilliant and famous writer, Faith fell in love in the land of the midnight sun and stayed for five years.

On New Year's Day 1900, Miss Alice Freeman married Dr. John Brown, a young doctor from Toronto. Dr. Brown worked as the Yukon Medical Officer of Health and Territorial Secretary, while Alice devoted herself to being "the wife of her husband."[4] When the couple moved back to Toronto in 1904, she gave up her career.

Faith continued writing freelance occasionally, but mainly focused on married life. She died in 1936, a few days after she and her husband John celebrated their thirty-sixth wedding anniversary. John soon horrified many in the family by marrying Faith's pretty niece Olive Freeman, a woman twenty-eight years his junior.

Faith was a determined pioneer journalist who helped shape a generation of women. Her great-niece Phyllis MacKay devoted herself to preserving Faith's memorabilia, with author Jill Downie's help. Concerned that Faith Fenton's story had "all but completely disappeared from the history of her country,"[5] Downie published her biography in 1996.

Quote:

"Stories in this world tell themselves by halves. There is always a silent side, and none may know the life of another."[6]

Heroine in Sumatra

Joan Bamford Fletcher

1918–1979

She commanded a force of machine-gun-toting Japanese soldiers in the jungles of Sumatra on a perilous rescue.

Joan Bamford Fletcher, circa 1940.

"One Woman Ordered — The Enemy Obeyed — 2000 Were Saved."[1] News reports hailed Canadian lieutenant Joan Bamford Fletcher for her courage during the daring rescue of prisoners in Sumatra after the Second World War.

Born in Regina in 1918, Joan grew up on a dairy farm. The Fletchers were prosperous British cotton merchants, and sent Joan and her sisters to boarding school in England. Joan completed her studies in Belgium and France, before returning to Canada to work for the Prairie Farm Rehabilitation Administration.

Joan was eager to play an active role in the Second World War. After completing a mechanics course and training as a driver for the Canadian Red Cross, Joan paid her own fare to Britain. She joined the First Aid Nursing Yeomanry (FANY), a civilian service whose volunteers were uniformed. They drove vehicles, operated hospitals, worked as interpreters or decoders, and served as secret agents. During the war, Joan was stationed in Scotland, where she drove vehicles for the Polish army.

After the Japanese surrendered in 1945, Joan was reassigned to the Far East to assist in the evacuation of Allied captives. Joan was first posted to India with the British Red Cross, then to Malaysia to tend the sick in prison camps. She was named as assistant to the commander of the brigade, with the rank of lieutenant.

Now twenty-seven, Joan was sent to evacuate nearly 2,000 women and children detainees from the prison camp in Bangkinang to the city of Padang on the Indian Ocean. The mission was extremely dangerous since Indonesia was in chaos: defeated Japanese soldiers remained, and a bloody battle for independence had erupted as armed rebels were attacking Dutch prisoners in some areas of the Dutch East Indies.

Lieutenant Fletcher needed troops to protect the civilian internees and convinced the Japanese army to provide forty soldiers, vehicles, and a translator.[2] As she commanded her reluctant troops, convoys began transporting the ailing women and children through the mountainous jungle terrain. Joan monitored each of the journeys, driving back and forth to check for problems — everything from blown-up bridges, to road barricades, and treacherous driving conditions.

Once, a rebel truck struck her down, but she was back in action a few hours later. The four-inch slice in her scalp was pulled together and bandaged; stitches had to wait. Another time Joan raced after Indonesians who'd stolen one of the vehicles and taken its Dutch passengers captive. She saved the day.

As hostilities escalated with each convoy, the number of guards was increased to seventy Japanese soldiers armed with machine guns. When Allied troops finally arrived at Padang, she was supposed to be relieved of her rescue duties, but the brigadier-general recognized her commitment to the mission and permitted her to complete it. In six weeks, she commanded a total of twenty trips through the Sumatran jungle.

"It shook the Japanese a bit to find themselves under the command of a woman,"[3] Joan reported. This remarkable Canadian earned the respect and admiration of her unlikely contingent of soldiers. As a token of his esteem, the Japanese officer in the group presented her with his own Samurai sword, which had belonged to his family for 300 years.

CWM 19800177-001, ©Canadian War Museum

The Canadian War Museum has the Samurai sword that Joan received as a gift.

Following her jungle adventures, Joan was sent to Hong Kong where she was hospitalized with a severe case of swamp fever. She eventually lost half of her lower teeth and some of her jaw, which was replaced with a piece of plastic. When she had recovered, Joan was posted to Warsaw in the Information Section at the British Embassy. In 1946, the British ambassador to Poland presented her with the prestigious Member of the Order of the British Empire (MBE) medal for her heroism. Joan eventually rejoined her family in Canada, where she died in 1979.

When news spread about the expedition in Sumatra, the press (including *Time* magazine) praised Lieutenant Fletcher as a heroine. In 2005, her incredible mission was depicted in the documentary *Rescue from Sumatra*. As historian Dean Oliver remarked, "this is a woman who in extraordinary times put her life on the line to save several thousand people ... by anybody's definition that is heroism of the highest grade."[4]

Quote:

"It was fatal to stop. I just loved every minute of it."[5]

Mother of the Jewish People in Canada[1]

Lillian Freiman

1885–1940

One of the most outstanding women in the Zionist movement, she was praised by Golda Meir as "a symbol of what a proud Jewish woman should be."[2]

Lillian Freiman

An excited young woman strode down the gangplank of the *Scandinavian* after it docked in Quebec City in August 1921. Lillian Freiman was surrounded by more than 100 children — orphans from the Ukraine. She and another woman had cared for the young immigrants from the time they boarded the ship in Antwerp, and would ensure that they were placed in Jewish homes in Canada.

Their arrival was the culmination of the campaign Lillian Freiman launched through the Jewish War Orphans' Committee. It brought 150 Jewish orphans to Canada. At the time there were serious concerns about orphaned Jewish girls being pulled into slavery. Lillian adopted one girl to raise alongside her three other children.

The rescue mission was a remarkable achievement during a time when prejudice against Eastern European immigrants was widespread and Canada limited the number of Jewish immigrants. For this, and other projects, Lillian Freiman was considered the leading Canadian Jewish figure of her generation.[3] "A saintly woman whose heart knew

no bounds,"[4] Lillian was a dedicated community worker, a talented organizer, and a generous philanthropist. She effectively used her wealth, social position, and political connections to help those in need. An important leader in the Canadian Zionist movement, she was the most prominent Jewish woman in the country during the years between the First and Second World Wars. In addition to spearheading Jewish causes, she forged ties with all Canadians through her community service.

Born Lillian Bilsky, she grew up in Ottawa in a large Jewish family that thrived on public service and Zionism. Her father, Moses, was an eminent member of the community and their home on Nicholas Street became the focus of Jewish life in the city. By the time she was sixteen, Lillian was involved in philanthropy, joining her mother at the Ladies Hebrew Benevolent Society.

At eighteen, Lillian married Archibald Freiman, the prosperous owner of a furniture and clothing store. He shared her devotion to community work and Zionism. The couple led Canadian Zionism, with Archie the head of the Zionist Organization of Canada and Lillian president of the Canadian Hadassah-WIZO (Women's International Zionist Organization).[5] The latter supported the settlement of Jews in Palestine, and the health and well-being of women and children in the Jewish diaspora.

While president of Hadassah, from 1919–40, Lillian transformed it into a strong national organization, raising substantial funds to support a variety of institutions in Palestine. Under her leadership, Hadassah supported the reconstruction of Jewish settlements in Palestine as well as many public health and education initiatives. In 1927, she convinced the board of Hadassah-WIZO to take on full financial responsibility for the first agricultural college for women in Palestine. The initiative provided training in a traditionally male occupation, encouraging female independence and equality.

One of Lillian Freiman's first projects as president of Hadassah was to launch (at her own expense) a national fundraising campaign to support impoverished Palestinians. She managed to raise $160,000 and $40,000 in clothing donations. As noted by H.M. Caiserman, first secretary-general of the Canadian Jewish Congress, she "revolutionized the measure of contribution in Canada for Palestine."[6] Lillian also focused Hadassah on

women's issues, and made it the "strongest, most coherent, and best-led national organization on the Canadian Jewish scene."[7]

Under Lillian's leadership, Hadassah supported Youth Aliyah when it was formed in 1933 to save Jewish youth in Nazi Germany and Austria. Before the outbreak of the Second World War the group rescued about 5,000 teenagers, bringing them to safety in Palestine.

Hadassah is one of Lillian's most notable legacies. Today the Hadassah-WIZO is the leading Jewish women's philanthropic organization in Canada, with 10,000 members.

Lillian Freiman was very active in both the Jewish and non-Jewish communities. During the First World War, she created a Red Cross sewing circle that became the Disraeli Chapter of the Daughters of the Empire. In 1917, she participated in the creation of the Great War Veterans Association, a precursor of the Canadian Legion. She also raised funds for the Institut Jeanne d'Arc, and assisted the Protestant Infants Home, the Ottawa Women's Canadian Club, the Canadian National Institute for the Blind, Girl Guides, the Ottawa Day Nursery, and the Ottawa Welfare Bureau.

When a flu epidemic swept through Ottawa in 1918, the young woman accepted the mayor's plea to lead the campaign against it. With the support of the city medical officer, she supervised 1,500 volunteers, developed a filing system to monitor all patients and volunteers, arranged for local newspapers to distribute epidemic reports, and planned and managed three temporary hospitals. Lillian was a born caregiver, eager to help anyone in need.

Lillian died in Montreal in 1940. Her funeral was attended by many dignitaries, including Prime Minister William Lyon Mackenzie King, Mayor Stanley Lewis, Canadian Legion President Alex Walker, and Canadian Jewish Congress President Samuel Bronfman. Golda Meir gave a moving eulogy at a memorial service in Tel Aviv.

Lillian received considerable recognition during her lifetime. In 1934, she became the first Jewish Canadian to be awarded the Order of the British Empire. She also received the King George VI Coronation Medal in 1937, and the Vimy Medal, for her work with ex-soldiers. Poet Abraham M. Klein wrote a poem in her honour, while the Royal Canadian Legion dedicated a memorial plaque and made her an honorary lifetime

member. Lillian had the rare privilege of having a settlement in Israel named after her: Moshav Havatselet HaSharon (based on her Hebrew name). While Lillian Freiman may not be well-known across Canada today, in 2008 the Historic Site and Monuments Board of Canada recognized her as a person of national significance.

Quote:

"As a daughter of an ancient race I must not look back on the past and be overwhelmed by unhappiness, but from our long history I must derive strength to go on. Courage is the lesson that the Jewish past teaches every member of our race."[8]

Getting Girls in the Game

Alexandrine Gibb

1891–1958

Guided by her slogan "girls' sports run by girls,"[1] she changed the leadership of women's sport in Canada.

Alexandrine Gibb.

When women were first permitted to compete in sports such as track and field at the 1928 Olympics, some people thought Alexandrine Gibb was just a chaperone. Turns out, she was the women's team manager and one of the most influential leaders in the organization and promotion of women's sport in Canada.

An accomplished athlete, Alexandrine Gibb managed several teams that competed internationally. She was also the most prominent female sports journalist in Canada during the 1920s and 1930s. Throughout her life, she fought to advance women's participation, training, and development with female coaches for all types of sports.

Alexandrine was born in Toronto in 1891, to dairy farmer John Gibb and his wife, Sarah. They encouraged her involvement in sports: her mother was the type of woman who ignored disapproving looks to row, which was considered unladylike. Alex attended Havergal College, a private girls school and a leader in athletic opportunities. Havergal offered a well-equipped gym and pool, as well as instruction

in everything from basketball and cricket to hockey and golf.

Alex, a dark young lady with beautiful brown eyes and a great mass of hair,[2] worked as a secretary after graduation. In her free time she was a member of the women's basketball league in Toronto. Before the First World War, she enjoyed a growing number of opportunities to play sports, which were largely organized by men. But with many men away, the women got involved in organizing the activities, and staged competitions to raise money for the war effort. It is believed that Alex was engaged to Lieutenant Harry Dibble, but he was killed in France in August 1918.

After the war, Canadian women had more opportunities to be active as citizens, which included participation in sports. Alex became increasingly involved in sport, as an athlete, administrator, organizer, and promoter. In addition to being an avid golfer and tennis player, she played basketball for the Maple Leafs until 1925.

By the fall of that year, Alexandrine had launched her long career in sports journalism. From May 1928 to November 1940, Alex wrote an influential daily sports column for the *Toronto Daily Star* called "No Man's Land of Sport: News and Views of Feminine Activities." Deemed a role model, she would later be hailed as the dean of women sportswriters. Some said she was a lousy writer, but a gutsy journalist who knew how to get a story. Alex continued writing for the *Star* until 1956.

She coined the slogan "girls' sports run by girls," and helped establish both the Ontario Ladies' Basketball Association and the Toronto Ladies Athletic Club (and served as its first president). When the Canadian Amateur Basketball Association was formed in 1922, Alex was the only woman on the executive. She was elected president of the Ontario Ladies' Basketball Association in 1925. When she became the first woman appointed to the Ontario Athletic Commission in 1934, the highly respected sports editor Lou Marsh defended her selection by noting that "Miss Gibbs knows sport better than any other woman in the country and any other man whose name was mentioned in the tentative line-ups."[3]

In 1925, the Amateur Athletic Union of Canada (AAU of C) offered Alex a challenging assignment: select a team of Canadian women athletes within a week to depart for a major international track and field competition in England. An experienced male coach had been named to the position first, but Alex's controversial appointment went through

since the Brits were paying the tab and insisted on an all-female group. Alex quickly selected her team and travelled overseas as the manager. Impressed by the British Women's Amateur Athletic Association, she returned to Canada determined to establish a similar organization.

Alex worked with other sports leaders in Toronto to start the Women's Amateur Athletic Federation of Canada. The attitude of male advisers such as John DeGruchy wasn't always positive. He commented that "the important thing is not so much athletics for women as that they are the mothers of the coming nation."[4]

Alex ensured that Canadian women participated in some other major international competitions during the interwar years, including the Olympics and the Women's World Games. She managed the amazing Matchless Six who competed in the 1928 Amsterdam Olympics; they brought home two gold medals, a silver, and a bronze. Alex also convinced teenager Marilyn Bell to attempt her swim across Lake Ontario in 1954.[5]

According to sportswriter Bruce Kidd, "[few] Canadian women have advanced the cause of girls and women in sport more than Alexandrine Gibb,"[6] yet she seems to be largely forgotten. Gibb should be recognized as an inspirational figure who contributed to the golden era of women's sports during the interwar years.

Quote:

"Men have had years and years of experience in sport organizations and the girls have only been in the game for the past ten years. So we have lots to learn, girls. But we want a chance to learn it."[7]

Hilwie Hamdon.

Building Al Rashid

Hilwie Hamdon

1905–1988

One important thing was missing from her life: a place of prayer for the Muslim community.

Hilwie Hamdon led a group of Muslim women determined to build a place to pray in their new homeland. Despite prejudice and the Great Depression, they succeeded. The Al Rashid Mosque opened its doors in Edmonton in 1938, becoming Canada's first mosque. For the first time since Muslim immigrants began arriving in Alberta at the turn of the twentieth century, they would be able to celebrate their faith in a mosque.

Hilwie Taha Jomha was born in 1905 in Lala in the Baka'a Valley of Lebanon. She received little formal education. When she was about seventeen, Hilwie married Ali Hamdon, a forty-two-year-old man who had saved up to travel back to Lebanon from Alberta in search of a bride.

The couple sailed for New York in 1922, where Ali bought Hilwie a full-length fur coat for the cold winters ahead. The Hamdons travelled across the continent by train to Fort Chipewyan, a remote fur trading post in northern Alberta. It was there that Ali had settled to earn his living, trading with the Natives.

When Hilwie arrived, she couldn't speak English; one can only imagine the culture shock she experienced in the early years in the isolated post, which was primarily inhabited by Cree. Hilwie gave birth to the Hamdon's six children in Fort Chipewyan. There were no other Muslims at the post, though by the late 1920s there were a handful of Muslim families in Alberta. Most worked as merchants, mink ranchers, and fur traders.

With temperatures dropping as low as 69 degrees below zero some years, Hilwie must've appreciated her fur coat. During the winter, she travelled around the country by dogsled. One frigid winter their first baby became seriously ill, so the Hamdons went all the way to Edmonton to find a doctor. It took them seven days to make the 500-kilometre journey to Fort McMurray, where they boarded the train to the city. Hilwie was always glad to return to Edmonton for their annual summer vacations.

The young mother became a respected member of the settlement, but found it difficult to raise her children as Muslims in a community where no one shared her faith. When the Hamdons decided to move to Edmonton in the 1930s, the local chief presented Hilwie with a beautiful fox skin, a gift for a person he considered "the finest white woman of the north."[1]

Once settled in her new home, Hilwie played a prominent role in the establishment of the Muslim community in Alberta. When the Arabian Muslim Association was registered in Edmonton on January 4, 1938, she was one of six women among the thirty-two charter members. She also organized the Ladies Muslim Society and served as president a number of times. The Hamdons were often the first to welcome new Lebanese immigrants into their home. But building Canada's first mosque was Hilwie's crowning achievement.

Hilwie motivated Edmonton's Muslim community to build the mosque and energized the campaign to raise the necessary money.[2] Hilwie and other Muslims convinced the city's mayor, John Fry, to provide land. Lila Fahlman, who was a teenager at the time and went on to found the Canadian Council of Muslim Women in 1982, remembered that Hilwie's vibrant personality could win over anyone.

The women managed to get contributions from many city merchants on Jasper Avenue — including Christians and Jews, as well as Muslims — and other donors from as far away as Saskatchewan. After years of

perseverance, Hilwie and her team raised the money and contracted a Ukrainian man named Mike Dreworth to start construction. Though the building had a curious resemblance to a Russian Orthodox church, the Muslim community was thrilled when its mosque opened on December 12, 1938.

"This could not have happened in some lands," said Mayor Fry at the opening ceremonies. "It is significant that people of many faiths are sitting friendly together."[3] At Hilwie's insistence, the master of ceremonies had to be fluent in both English and Arabic. So a Christian Arab, I.F. Shaker, presided over the dedication, which was conducted by Allamah Abdallah Yusef Ali, Pakistani translator of the Qur'an.

When the Al Rashid Mosque was completed, it served the needs of about twenty Muslim families, most from Lebanon's Baka'a Valley. The mosque was a focal point for Edmonton Muslims and Arabs of all faiths for decades, as a community centre as well as a place of worship. With a growing number of Muslims in Edmonton (nearly 16,000 by 1980), it was replaced by a larger mosque in 1981. A few years later the original crumbling red brick building faced demolition. Members of the Canadian Council of Women, including Hilwie's granddaughter, Karen Hamdon, and grand-niece, Evelyn, set out to save the old Al Rashid Mosque.

Thanks to this new generation of Muslim women, the first Al Rashid Mosque was transported to a new home in Fort Edmonton in 1991, despite opponents saying it would be a historical intruder in the heritage park. As Karen Hamdon reflected, "it's important to our history and our future to acknowledge that it has a place in this living history museum."[4]

The old Al Rashid Mosque was restored and now stands as a lasting tribute to Hilwie Hamdon and the other Muslim women who built it. Their story is told in the *Alberta Online Encyclopedia*. Hilwie was also recognized in the CBC documentary *100 Years in Alberta*, which celebrates the history of the Hamdon family since they became pioneers on the prairie.

Quote:

"[I] entered with zest into this rugged pioneering life."[5]

The Soldiers' Song

Harriet Rhue Hatchett

1863–1958

A daughter of escaped slaves, she penned the official marching song of Canadian soldiers in the First World War.

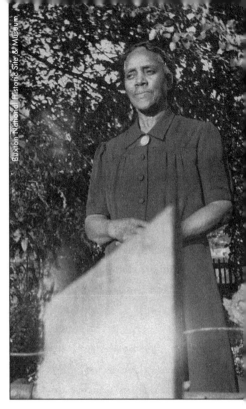

Hattie Rhue Hatchett.

While the upbeat song "It's a Long Way to Tipperary" was popular during the First World War, Canadian soldiers marching along muddy roads to the front often sang another tune, "That Sacred Spot." Written by Canadian Harriet (Hattie) Rhue Hatchett, the poignant hymn referred to the sacred spot where fallen Canadian soldiers were buried when they died on the battlefields. The song "applies to the feeling of a mother and her hope that if her son was killed, it would be a sacred spot and God would be looking over it."[1] None of Hattie's relatives fought in the First World War, but she wanted to write a song to ease the soldiers' pain.

Hattie was born in Canada during the American Civil War. Her father, escaped slave William Isaac Rhue, met his future wife, Jane Serena Lewis, another fugitive slave from Kentucky, while travelling the Underground Railroad. The couple moved to the growing settlement at Buxton in southern Ontario established by Reverend William King as a haven for black refugees. The Rhues raised sixteen children.

Hattie's family life revolved around religion and music. She attended a one-room school beside the Rhue farm, before graduating from nearby Chatham Collegiate Institute at seventeen. Always musically talented, she played a second-hand melodeon, then took piano lessons (and learned needlework) from Reverend King's wife, Jemima.

After graduation, Hattie taught school in the Chatham area. At eighteen, encouraged by Reverend King and her mother to help meet the urgent need for teachers in the southern United States, Hattie headed to Kentucky to teach former slaves and their children. There she met her future husband, Millard Hatchett, who she taught to read and write. They married in 1892, and Hattie continued teaching as they began a family. After a number of moves, the Hatchetts, with their three daughters and one son, moved permanently to North Buxton in 1904.

Tragically, all three girls became ill and died. The grief-stricken Hattie poured her heart and soul into music and her faith. Despite obtaining a music-teaching certificate, Hattie couldn't find a job as a music teacher;[2] racism and sexism may have limited her opportunities. Teaching jobs weren't open to married women, and churches with white congregations may not have wanted to hire a black organist.[3]

An active community leader, Hattie organized a choir for white churches in the area. She also welcomed local children into her home to share her love of music, teach them to play instruments, and prepare them for concerts and competitions. As one neighbour remembered, "she was willing to teach anybody anything that she knew without charging them."[4]

The extraordinary pianist was a popular performer; she frequently sang and played at church, conferences, and meetings. In addition to playing classical and popular songs and hymns, Hattie composed the words and music for many hymns, spirituals, and children's songs. Unfortunately, most copies that existed were lost in fires.

Hattie copyrighted three of her most popular compositions and sold sheet music for them: "Jesus, Tender Shepherd Lead Us" (more than 1,000 copies purchased around the world), "That Land Beyond The Sky," and "That Sacred Spot." Canon Frederick G. Scott, a poet and senior chaplain of the 1st Canadian Division during the First World War, selected "That Sacred Spot" as the official marching song for Canadian troops.[5] He felt its images and religious tone made it a fitting choice for

soldiers marching to war. As former War Amps president, Lieutenant-Colonel Sidney Lambert remembered, "it made the soldiers think of home; it had a good beat which enlivened marching in-step; it was a tribute to those who had gone before, and an ever-present thought that if they were killed, their grave site would be remembered."[6]

Hattie Rhue Hatchett died in 1958 at ninety-four, outliving her husband and children. She is remembered as a gifted musician, a smart lady with a lively sense of humour and a positive attitude, and a composer whose identity was probably unknown to the many Canadian soldiers who marched along to "That Sacred Spot."

Quote:

"In foreign fields apart or in a row
There lies a soldier's lonely grave so low.
Tremendous cost wherever it may be
Keep that Sacred Spot in living memory."[7]

Trailblazer

Satinder Hawkins

1958–2010

The first Indo-Canadian woman to hold a cabinet post in a provincial government, Sindi was an inspirational nurse, lawyer, and politician.

Sindi Hawkins, after being appointed as deputy speaker for the Legislative Assembly of British Columbia in 2005.

Satinder Kaur Ahluwalia was born in New Delhi, India, in 1958 to a Punjabi Sikh family. Her father, Manohar Singh Ahluwalia, taught at the University of Delhi and served as a communications officer under Prime Minister Jawaharlal Nehru. When Sindi was just five, she immigrated with her family to Canada.

The Ahluwalias settled in the small town of Sturgis, Saskatchewan, where her father taught high-school social studies and English. The family was involved in many community activities. Sindi was active in ice hockey, curling, choir, the student council, badminton, the 4-H Club, and the debating society. She was chosen as queen of the Winter Ice Carnival in 1974. After graduating from high school, Sindi moved to Saskatoon with her family. Here she met and married Dr. Ralph Hawkins; the couple divorced in the 1990s.

Sindi began her professional life as a registered nurse, earning her degree in Calgary, where she worked in intensive care, management, education, and consulting. For more than a decade she treated cancer

patients as head nurse at Calgary's Baker Cancer Centre. One of the first nurses to be certified in neuroscience nursing, Sindi became the head nurse of neurosurgery at Calgary's Foothills Hospital. Sindi also earned a law degree from the University of Calgary in 1994; she set up her own private practice specializing in legal issues related to medicine.

After settling in Kelowna, Sindi decided to enter provincial politics, winning her first election with a huge margin of 7,000 votes in 1996. In her inaugural speech the onetime immigrant remarked, "It gives me a great sense of pride, as well, that the voters have given me the opportunity to be the first Punjabi woman to be elected to a legislature in Canada."[1] She was re-elected in 2001 and 2005.

Sindi was a high-profile Liberal member of the legislative assembly under Premier Gordon Campbell. She rapidly rose in the ranks, serving as deputy speaker, minister of state for intergovernmental relations, and minister of health planning. She was a workaholic with a 1,000-watt smile, a kind and caring woman with a promising political career that was tragically cut short.

She worked on an anti-racism committee and assisted a non-profit society for visible minority and immigrant women. She focused on following the path of "sewa" or service, as encouraged by her Sikh faith.[2] In 1997, on the occasion of the hundredth anniversary of Sikhs in Canada, she said, "Sikhs have contributed a lot to this province and to this country. I'm proud of my heritage."[3]

A longtime crusader in the fight again cancer, Sindi initiated the annual Sindi Hawkins and Friends Charity Golf Classic for Cancer Care in 1996. In January 2004, she was diagnosed with acute myeloid leukemia, eventually receiving two bone-marrow transplants from her younger sister, Seema. During Sindi's courageous battle, she urged others to donate blood and to register as bone-marrow donors, particularly Asian Canadians. Despite her illness, she continued to raise money for cancer research and was proud to bring Lance Armstrong to Vancouver in 2007 for the Tour of Courage. She helped raise more than $20 million and inspired other cancer sufferers.

Sindi died in her eldest sister's home, surrounded by family, in 2010. She was fifty-two. Hours before her death, longtime colleague Gordon Campell announced that a cancer facility in Kelowna would be renamed

the Sindi Hawkins Cancer Centre — "a lasting legacy of her kindness, her passion for helping others and her generosity of spirit."[4] She is remembered as a humanitarian who served her community as a nurse, lawyer, cancer crusader, and MLA.

Quote:

"I lived the Canadian dream."[5]

The Maverick Painter

Prudence Heward

1896–1947

She was an original,
presenting new images of
women to Canadian art:
"powerful, confident, even
heroic figures."[1]

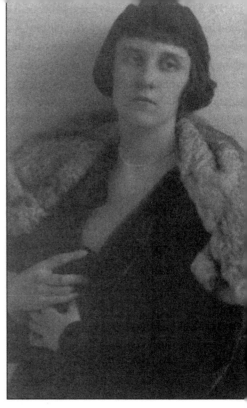

Prudence Heward.

"In my opinion, [Prudence Heward] was the very best painter we ever had in Canada and she never got the recognition she richly deserved in her lifetime. I wanted her to join the Group of Seven, but like the Twelve Apostles, no women were included,"[2] A.Y. Jackson said.

While artist Prudence Heward was not invited to join the boys' club, she was offered the rare privilege of exhibiting in several of their shows. Though Prudence didn't join A.Y. Jackson's co-ed Beaver Hall Group when it formed in 1920, she became a member of the informal network of women that continued to exist afterward. Prudence was among the ten most prominent women in the group, whose existence helped them find exhibit space and provided support and comraderie in the male-dominated art world.

Prudence was born in Montreal to respected members of the English establishment.[3] Due to her severe asthma, she was educated at home and began art lessons at twelve. Her comfortable world was shattered in 1912 when her father and two sisters died and her mother struggled to support

eight children. During the First World War, Prudence volunteered with the Red Cross in England with her mother. She returned to Montreal in 1918, determined to pursue an artistic career despite her ill health.

Prudence studied at the Art Association of Montreal, then the Académie Colarossi, École des Beaux Arts, and the Scandinavian Academy in Paris. She set up a studio in the family's Montreal home where she did most of her work, but she also went to the countryside to paint. Though Prudence produced many impressive still-life and landscape paintings, her most powerful works were figures (a term she preferred over "portraits").

Using bold colours, angular lines, and expressive brushstrokes, Prudence portrayed strong and serious women. She painted real women and children with a remarkable depth of feeling, conveying the misfortunes and sorrows of life. Her painting *Girl Under a Tree* (a nude female figure) is considered one of her most compelling works, a masterpiece.[4]

Prudence was at the height of her career in the 1920s and 1930s. She earned significant recognition for her 1928 exhibit with the Group of Seven as well as for her win the next year of the National Gallery's Willingdon Prize, which brought national attention. In 1930, a Toronto critic singled out her paintings *At the Theatre* and *Rollande* as noteworthy works that "resemble no one else in their individual form of expression."[5] The National Gallery purchased *Rollande* for $600, a considerable price at the time. Her works were selected for numerous international expositions (including the Tate Gallery in London).

In addition to developing her own artistic expression, Prudence devoted herself to redefining the role of women in art and developing new opportunities for showcasing their works. In addition to being an active member of the Beaver Hall Group, she was a founding member of the Canadian Group of Painters and the Contemporary Arts Society. She hosted meetings at her Montreal home and painted picnics in the country, which were often attended by her friend and mentor A.Y. Jackson.

Though male art critics often considered female painters as society hobbyists, Prudence was a professional artist. She was a quiet, witty, and fashionable woman known for her elegant attire and flashy cars: the first one yellow and the second a blue Hudson. Unfortunately, the gifted artist's flare for life was no match for her lifelong battle with asthma.

Rollande, oil on canvas painted by Prudence Heward in 1929.

In the late 1930s, she was hospitalized for asthma, injured in a car accident, and traumatized by the deaths of both a close friend and her sister. As her health deteriorated, she had less energy to paint. In 1947, Prudence died in Los Angeles while seeking treatment. She was just fifty. Following her death, the National Gallery of Canada put on a memorial exhibition of her work. In the *Saturday Night* review of the exhibit, Paul Duval wrote that Prudence was "one of the most sensitive painters this country has ever known."[6]

Prudence Heward was a great Canadian painter. Perhaps the growing number of publications and exhibitions focusing on Canadian women artists will bring more appreciation of her contribution to

Canadian art. In 2010, Canada Post paid tribute to Prudence by issuing commemorative stamps featuring two of her paintings.

Quote:

"I think that of all the arts in Canada painting shows more vitality and has a stronger Canadian feeling"[7]

The Invasion of Architecture

Esther Hill
1895–1985

Trained to design great buildings, she ended up weaving and making gloves.

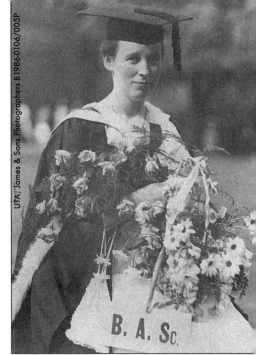

Esther Hill at her graduation from the University of Toronto, 1920.

"The Canadian woman has invaded one more profession and Miss Esther Marjorie Hill is blazing the trail."[1] It turned out this particular invasion, reported by the *Globe and Mail* in June 1920, was more difficult than the determined Miss Hill had ever imagined.

Born in Guelph, Esther Hill was raised in Edmonton by progressive-minded parents. Her father, a teacher and chief librarian for the Edmonton Public Library, staunchly supported his daughter's ambitions; Esther's mother was one of the first women to study at the University of Toronto and a member of the National Council of Women. Esther began studying architecture at the University of Alberta, but transferred to the University of Toronto after the program was cancelled.

When Esther graduated in 1920, she became the first woman in Canada to receive a university degree in architecture. While the convocation audience applauded and the *Globe and Mail* gushed, some of her male colleagues weren't as supportive. The university's chairman of architecture, C.H.C. Wright, boycotted the convocation ceremony in protest.

The enthusiastic grad soon discovered that it wouldn't be easy to start her career, and accepted the only job she could find: interior decorating for Eaton's. Esther returned to Edmonton to find more challenging employment. She tried to register with the Alberta Association of Architects, but the organization quickly changed its requirements to make her ineligible by demanding one year of full-time experience in an architecture firm.

Determined to succeed despite the discrimination, Esther managed to get a short stint as a draftsman with MacDonald and Magoon in Edmonton. She took a post-graduate course in town planning at the University of Toronto, studied at Columbia University, and worked for architect Marcia Mead in New York. Esther then reapplied to the Alberta Association of Architects. In 1925, she became the first Canadian woman to be a registered architect.

When offered architectural work in New York by another female architect, Esther returned to the United States and stayed there until 1928. Back in Edmonton, she again managed to get short-term work with MacDonald and Magoon, but with the onset of the Great Depression there were no other opportunities. Esther turned to weaving, teaching, and making gloves and greeting cards.

She continued with these occupations when she moved to Victoria in 1936 with her parents. Once the economy improved after the Second World War, she set up her own architectural practice. Esther found many of her clients through weaving. A longtime member of the Victoria Weavers' Guild who wore her own homespun clothing, she taught both weaving and spinning and won first prize for her work at Toronto's Canadian National Exhibition in 1942.

Esther successfully registered with the Architectural Institute of British Columbia in 1953. She served on the city planning commission for five years and worked as an independent architect in Victoria until she retired in 1963.

Struggling to develop a career in the male-dominated field of architecture, Esther had a lonely professional existence. She worked by herself on all her projects, often designing on a drafting table in her parents' living room. During her years in Victoria, she designed houses, kitchen renovations, an addition to a church, several apartment buildings, and a senior citizens home.

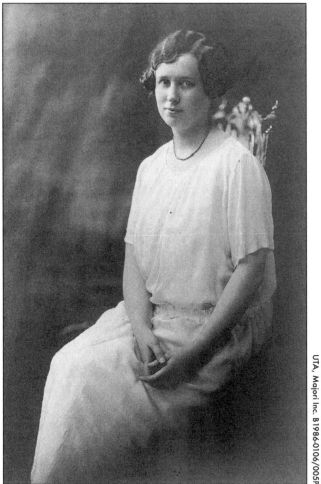

UTA, Majori Inc. B1986-0106/005P

Esther Hill, 1920s.

Esther Hill died in 1985. Many of the buildings she designed have been demolished, and for those that remain, men often took the credit.[2] As Professors Annmarie Adams and Peta Tancred noted, we can only imagine what this pioneer architect might have achieved had she entered the profession half a century later.[3]

Quote:

"One must have artistic talent, practical experience, professional knowledge, good business and executive ability, resourcefulness, and a determination to persevere. With these assets there is no reason why a woman should not be as successful as a man."[4]

The Atomic Mosquito

Lotta Hitschmanova

1909–1990

The face of hope to millions around the globe, she inspired Canadians to help the world's most vulnerable.

Lotta Hitschmanova, 1940s.

Dr. Lotta Hitschmanova was one of Canada's greatest humanitarians and among the most prominent Canadian women of her time. From the 1940s to the 1970s, she was one of the most widely recognized figures in the country because of her annual fundraising appeals and public service announcements on TV and radio.

The small woman with flaming red hair, dressed in an olive-green uniform and cap and speaking passionately with a Czech accent, was unforgettable. Her pleas always ended with the same message: please give generously to the Unitarian Service Committee (USC) and send your contribution to 56 Sparks Street, Ottawa. The address was as well known as that of the prime minister's.

Lotta was born in Prague, where she grew up in a prosperous and happy Jewish family. She deeply admired her father and adopted his belief in honesty and hard work, charity, wisdom, and education as a key to independence. She obtained a Ph.D. from Prague University in languages and literature. Earning diplomas in five languages (French,

English, German, Spanish, and Czech), she also studied political science and journalism at the Sorbonne in Paris and acquired a Red Cross nursing diploma. After a stint working for the largest daily newspaper in France, she established herself as a political journalist in Czechoslovakia.

When Hitler's troops prepared to invade, the openly anti-Nazi journalist fled to Paris and then Brussels in the summer of 1938. She was on the run for years, experiencing the horrors of the Second World War in France and Belgium and helping refugees. Her parents died in a Nazi concentration camp and Lotta was determined to make sure that their deaths hadn't been in vain.

When she collapsed from hunger in Marseilles, Lotta was cared for at a medical clinic run by the American USC. The chance visit introduced her to the organization that would become her life's focus. When she finally escaped Europe in July 1942, Lotta was asked to deliver a report on the refugee situation to USC headquarters in Boston. From there she went to Montreal. When she arrived, she weighed less than 100 pounds, had $60 in her pocket, and was completely alone in a strange country. She was thirty-two.

Within four days, Lotta landed a job and settled in Ottawa. In 1945, she established an independent USC in Ottawa to help children and other refugees in war-ravaged European countries. The work she did with the USC became her all-consuming passion; she worked seven days a week, from dawn until midnight. The United Nations initially required aid workers to wear a uniform, so Lotta began wearing a military-style uniform. The "Soldier of Peace"[1] only hired women for the USC office, preferring single women prepared to work long hours.

Lotta was the heart of the organization for thirty-six years, involving the USC in projects around the world, from Africa to Asia and Latin America. The USC became a successful non-profit, non-denominational organization dedicated to helping people suffering as a result of war, drought, disease, or poverty. She believed in empowering local people to help themselves and treating them respectfully. Under Lotta's leadership, the USC worked with local partners (most of them women) who could become leaders in their communities. She felt that women should be at the heart of all aid projects; many aid programs provided educational opportunities once basic needs were taken care of.

Courtesy of USC Canada

Lotta Hitschmanova in Korea, 1954.

Each year, Lotta travelled across Canada for about three months to solicit food, clothing, and cash. During one of these treks in 1949, she covered 17,000 kilometres, giving ninety-six talks in thirty-six communities. She raised an impressive $50,000. Haunted by the suffering she'd witnessed, she could easily move audiences and her own employees to tears with her words. Dubbed the "atomic mosquito" because of her small size and persistence, Lotta knew how to create a media buzz and convert it into support for the poorest people in the world.

Dr. Lotta, as she was affectionately called by many, also regularly visited affected areas. True to her journalism background, she asked many questions and took copious notes. She used the trips to assess needs and ensure accountability for the projects. Known for her excellent judgment, she inspired those she met with her warmth and compassion. Between 1948 and 1972 she produced promotional films of her annual trips overseas.

Lotta poured her considerable energy into the USC until she reluctantly retired in 1982, as Alzheimer's disease claimed the last decade

of her life. She died in 1990. Dr. Lotta received many awards from around the world, including the Medal of Gratitude from France, Greece's Athena Messolora Gold Medal, Rotary International Award for Human Understanding, and 1975 Woman of the Year for India by Prime Minister Indira Gandhi.[2] Following her death, Agriculture Canada released a new variety of oat seed called *AC Lotta* in her honour.[3] To recognize the 100th anniversary of her birth, the City of Ottawa declared November 28, 2009, as Dr. Lotta Hitschmanova Day.

Dr. Lotta's legacy is the USC Canada, which continues to help people in need around the world. She played a major role in awakening Canadians to the sufferings of people in other countries and fostering a commitment to international humanitarianism.

Quote:

"Scientists tell us there is no longer any excuse for human starvation, yet 2/3 of mankind remain hungry, while the world spends 150-billion dollars a year on armaments. Won't you invest a constructive dollar in the fight against need and poverty?"[4]

The Stars Belong to Everyone

Helen Hogg

1905–1993

She expanded our knowledge of stars in the Milky Way — and hooked thousands of university students, kids, and their parents on astronomy.

Helen Hogg at Harvard.

A total eclipse of the sun turned Helen Sawyer on to astronomy: "the glory of the spectacle seems to have tied me to astronomy for life, despite my horribly cold feet as we stood almost knee deep in snow."[1]

It was 1925 when Helen Sawyer, a student at Mount Holyoke College, switched majors from chemistry to astronomy. Born in 1905 in Lowell, Massachusetts, her parents had encouraged her to appreciate the world around her. After graduation, Helen went to work with the renowned astronomer Harlow Shapley at the Harvard Observatory. She married Frank Hogg in 1930 and obtained her doctorate the following year. Though her studies were completed at Harvard, the university wouldn't grant science degrees to women, so both her master's and Ph.D. were issued by Radcliffe College.

The Hoggs moved to Victoria, British Columbia, when Frank had a job at the Dominion Astrophysical Observatory. There was no hope of Helen getting hired there, because the federal government wouldn't employ both a husband and wife during the Great Depression. So Dr.

Helen Hogg volunteered as her husband's assistant. There was, however, one benefit of being the spouse: Helen was allowed to do her research and photography at night, because her husband was there to chaperone her. She was thrilled to have access to the second-largest telescope in the world. And once their daughter was born, Helen faced no opposition to bringing the baby along as she studied the night sky.

While in Victoria, Helen began studying the variable stars in globular clusters. After the Hoggs moved east in 1935 so Frank could accept a position at the University of Toronto, Helen continued her research while working as an assistant at the David Dunlop Observatory (DDO), using what is still the largest telescope in the country. In 1936, she gave birth to a son and managed to get her first paid position as a researcher; from then on, Helen worked full-time. She gave birth to her third child in 1937.

With men away during the Second World War, Helen got more career opportunities. She became the acting chairman of Mount Holyoke's astronomy department from 1940 to 1941, and accepted a teaching position at the University of Toronto when she returned to the DDO. She became an assistant professor in 1951 (her husband died suddenly of a heart attack that year), an associate in 1955, and finally a professor from 1957 to 1976.

As an expert on variable stars in globular clusters, Helen promoted greater understanding of our galaxy. She used the 2,000 photographs she'd taken of clusters to identify thousands of variable stars and compile a series of three catalogues, which are still cited by astronomers. She published more than 200 scientific papers and presided over several Canadian scientific and astronomical organizations, and also served as director of the American National Science Foundation's astronomy program. Her work set the groundwork for later studies on the Milky Way and earned her international respect.

Beginning in 1951, she wrote a weekly astronomy column in the *Toronto Star* for thirty years. Some of the material was included in her popular book *The Stars Belong to Everyone: How to Enjoy Astronomy*. In 1970, she hosted an astronomy series on TV Ontario. After Helen died in 1993, the president of the Royal Astronomical Society of Canada noted that "perhaps her greatest memorial is the appreciation

of a larger universe which her popular writing instilled in thousands of ordinary Canadians."[2]

Sometimes referred to as a "first lady of science,"[3] Dr. Hogg succeeded when women in science were often ridiculed. Professor Christine Clement noted that in the early days of Hogg's career "it was very unusual to see a woman working in the physical sciences, a woman who had the respect of her male colleagues and students."[4] Even after she retired from her regular duties at the University of Toronto, Helen actively encouraged young women to enter scientific fields.

Dr. Helen Sawyer Hogg was widely recognized for her achievements as a great scientist, a gifted educator, and an inspirational role model. Throughout her impressive career she received a multitude of national and international awards and honours, including medals, honorary degrees, Fellow of the Royal Society of Canada, and Companion of the Order of Canada. In 1972, an International Astronomical Union Colloquium was held to honour the work of one of Canada's foremost astronomers. An asteroid, an observatory, and a telescope were also named after Dr. Hogg — fondly remembered as one of a kind.[5]

Quote:

"Make your hours count."[6]

P. Stafford. The Atlantic Advocate, January 1981

Ann Hulan's schooner *Industry*.

The Queen of St. George's Bay

Ann Hulan

1750s–1840s

She made her mark in Newfoundland – and survived being captured by privateers in the War of 1812.

When the War of 1812 broke out, Newfoundland businesswoman Ann Hulan still had to get her goods to market. She hardly expected to be taken a prisoner of war by an American privateer.

After the United States declared war on Great Britian, armed vessels became a common sight off the coast of Newfoundland. Though British boats were on patrol, there were many private armed vessels engaged in lawful looting. In August 1812, Ann Hulan and one of her daughters set sail on her schooner *Industry*, with Captain Renneaux at the helm.[1] They were bound for St. John's with 152 barrels of cured salmon and twenty fox furs.

Just south of St. Mary's Bay, an American privateer commanded by Captain Ingersoll captured the schooner. The *Benjamin Franklin*, a one-ton vessel carrying eight guns and 120 men,[2] took the crew prisoner and sailed to New York. During a marine court of inquiry in September that year, the determined Ann Hulan convinced Commissioner Nathaniel Davis that she was not a threat to the United States and depended on the

earnings from her cargo. The fiftyish widow won the investigators' hearts; Davis pleaded for her release in a letter to American Secretary of State James Monroe, writing that Ann and her crew shouldn't be considered prisoners of war.

She was eventually released. The government made sure that only she could bid at her schooner's auction and returned her valuable cargo, worth about $2,000. Armed with a safe conduct pass, Ann arrived back in Newfoundland by Christmas.

Ann was a successful trader and experimental farmer who owned and operated Newfoundland's first commercial farm in the late 1700s. Born Ann Cyril, she was the daughter of a couple who had emigrated from Jersey in the Channel Islands. By the early 1760s, the young girl and her family had settled along St. George's Bay on the west coast of Newfoundland.

Ann and her husband, James Hulan, established a farm and fish exporting business in St. George's Bay. After his death, Ann expanded the business while looking after her family. Several notable nineteenth-century travellers wrote about meeting Ann and were impressed by her. Edward Wix, a clergyman and missionary who visited her in 1835, called her "the mother of the settlements."[3] The explorer William Eppes Cormack stayed at her farm on the second Barasway River in 1822, noting that Mrs. Hulan was "indefatigably industrious and useful" and "commanded a remarkable degree of maternal influence and respect" over the population of St. George's Bay.[4]

Ann was an accomplished farmer who managed an efficient business. Cormack was amazed by the cleanliness of her dairy and the excellence of the cheese and butter, which she sold to bay residents and to trading vessels. She had a good stock of domestic poultry, and a cellar full of potatoes and other vegetables. Ann experimented with growing different kinds of potatoes. She also grew oats, barley, and wheat, and her fur business included martens, foxes, otters, beavers, muskrats, bears, wolves, and hares.

Often referred to as the Queen of St. George's Bay, Ann managed a thriving fishing and farming enterprise when many women were usually relegated to more traditional roles. She is featured in a series of educational posters, developed for classroom use in Newfoundland and

Labrador, to celebrate notable people in the history and culture of the province.[5] The Hulan House, built by Ann's grandson on her farmland, was designated a Registered Heritage Structure in 1991.

Quote:

"She speaks with lively gratitude of the very humane attentions which were uniformly paid her while she was detained in New York."[6]

— Edward Wix, relating comments made by Ann Hulan.

The Queen of Comedy

May Irwin
1862–1938

She sang, she danced, she made jokes. And became one of the most beloved comediennes.

Strobridge Lith. Co., ca.1898

May Irwin.

"There cannot be too much laughter in the world," said the jovial Canadian entertainer Mary Irwin.[1] Laughter would be her legacy after nearly fifty years on the stage.

Before May Irwin became a Broadway star, she was a youngster named Georgina May Campbell in Whitby, Ontario. When her father died, leaving the family destitute, her mother encouraged eleven-year-old May[2] and her younger sister Flora to audition for a variety theatre in Rochester, New York. They began performing as the "Irwin Sisters," and in December 1875 worked at Buffalo's Adelphi Theatre. The duo debuted in New York City in January 1877.

By the fall of that year, May Irwin had landed a spot in Tony Pastor's New York Music Hall. She performed in his vaudeville and burlesque company for six years. After joining Augustin Daly's stock company in 1883, she made her first dramatic appearance in the play *Girls and Boys*. While employed by Daly, she sailed in 1884 for London, England, where she debuted in *Dollars and Sense* and performed at

Toole's Theatre for several seasons. By this time the young woman was busy working and caring for her two toddlers; she had married Frederick Keller, a theatre employee, when she was sixteen and they had started a family the following year.

May often played widows in the burlesques, plays, and musical revues that made her famous. At twenty-five she became a widow herself, when her older husband died of tuberculosis in 1886. The ever-jovial single mother continued to smile through her tears and support her sons as an actress and vaudevillian. Her gift was farce-comedy and audiences loved the buxom, blue-eyed blonde who helped make the 1890s gay and full-figured women fashionable. As one of her contemporaries wrote, "Miss Irwin is a famous fun-maker; of jolly, rotund figure, and with a face that reflects the gaiety of nations, she is the personification of humour and careless mirth, a female Falstaff ... refined and recast in a nineteenth-century mould."[3]

Beginning in 1887, May toured with Howard Athenaeum's vaudeville troupe, then switched to a notable farce-comedy company called the City Directory. She returned to New York to do some burlesque and then legitimate stage work. After years of developing her skills, May became a Broadway star in 1895, performing a lead role in the hit of the season, *The Widow Jones*. The comic songstress was a great success and a series of farce-comedies followed. One of the most popular entertainers of her time, she gave her last performance on Broadway in 1922.

When Thomas Edison was experimenting with moving pictures, he convinced May and her co-star John C. Rice to re-create their kissing scene from *The Widow Jones* for film. *The Kiss*, a mere twenty-two-second segment, was the first cinematic kiss — scandalizing preachers and other guardians of morality. It was also the first movie shown in Canada. May appeared in another silent film, *Mrs. Black Is Back*, in 1914.

May was one of the pioneering women in comedy, when men dominated the profession and many people doubted that women had a sense of humour. She gave a command stand-up comedy performance for American President Woodrow Wilson during the First World War and he jokingly appointed her the Secretary of Laughter. During this time, she also marched to support the suffragists' campaign.[4]

Poster for *The Widow Jones*.

Strobridge Lith. Co., ca. 1895

May wrote lyrics for some of her songs and had a talent for picking out winners. She paid aspiring composer Irving Berlin $1,000 for rights to one of his songs. The famous tune "After the Ball" was produced after she heard a guitar player picking out the music and encouraged him to complete it and add lyrics. May introduced ragtime songs on Broadway,

though she never appeared in blackface. Her songs sold well as sheet music and she recorded a few on the Victor and Berliner labels.

One of the top-paid female actresses and singers of her time, May earned as much as $2,500 a week by the age of twenty-five and daringly established her own theatre company in 1897. She was a shrewd investor and made more than a million dollars (the equivalent of $20 million today) by selling her extensive Manhattan holdings.

May retired to her private island, Irwin Isle in the Thousand Islands, where she lived happily with her second husband, Kurt Eisenfeldt. She built a pink-granite mansion (with a stained glass window featuring May as the Statue of Liberty), and raised cattle, chickens, and racehorses. May frequently entertained on her island; she played softball with Babe Ruth, listened to Irving Berlin play the piano, and passed on the now-famous recipe for Thousand Island Dressing to the owner of the Waldorf Astoria Hotel. A renowned cook, she also published a popular cookbook that included poems and jokes.

May died in 1938, donating much of her wealth to theatrical charities.[5] The Whitby Central Library proudly developed the May Irwin Collection as a tribute to the girl who went from rags to riches.

Quote:

"It is hard enough being penniless in places like New York or Camden, New Jersey, but nothing to jingle in Whitby, Ontario, is something terrible. Being penniless, my sister, Flo, and I were what you might call in reduced circumstances."[6]

Making Bitter Butter Better

Eliza M. Jones

1838–1903

A leader in scientific agriculture, she was the best known dairywoman in North America.

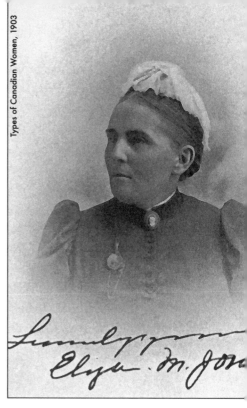

Eliza Jones.

Even a large basket couldn't hold all the medals Eliza Jones won for her purebred Jersey cattle, let alone the silver cups and services from competitions in the United States.[1] The prominent dairywoman from Brockville, Ontario, earned international acclaim for her herd and bestselling butter. She was one of the most successful stock-raisers and horse breeders on the continent.

Born in Maitland, Ontario, in 1838, Eliza Maria Harvey was educated in Scotland and Montreal. She cared for her five siblings after her mother's death and helped on the family farm. A great animal lover, she was thrilled when Chilion Jones gave her a black horse as an engagement gift. The couple wed in 1859. When the Prince of Wales laid a cornerstone for Ottawa's first Parliament Buildings, designed by Chilion Jones's firm Fuller & Jones, the new bride rode horseback in the welcome procession.

The young couple settled in Brockville, where John A. Macdonald would join them for a supper whenever he was in town. During the

1860s, Eliza gave birth to four of their seven children and began a dairy farm. Though the Joneses only owned a small piece of property, she also rented two farms. Her income became a vital source of money for the family.[2]

She purchased an outstanding purebred Jersey from the Royal Herd at Windsor and eventually built a large herd. Her model farm incorporated gas lights, steam-powered equipment, sanitary conditions, and carefully rationed feed that maximized milk production. She managed every aspect of the operation, and hired three male labourers to assist her. Every morning, after rising at 6:00 a.m., eating breakfast, and reviewing her accounts, Eliza donned her cap and inspected the barns and stables.

At the time, most of the butter produced by small farms in Ontario was poor-quality and best-suited for axle grease; Eliza experimented until she developed the best butter on the market. She sold it at a premium price to prestigious clients in Canada and the United States, including Ottawa's Rideau Club and the CPR's dining cars. By the 1890s, she was shipping more than 7,000 pounds of butter a year. In 1893, the now-famous farmer served as a judge of butter for the World's Columbian Exposition in Chicago.

Beginning in the 1880s, Eliza began showing her purebred cattle at fairs and exhibitions in Ontario, Quebec, and New York state. She won numerous awards and sold her prize-winning stock throughout North America. Eliza was an active member of the Canadian Jersey Cattle Breeders' Association and wrote for agricultural publications such as the *Farmer's Advocate*. After her rented farmland was sold in 1896, she kept half her herd and began diverting her energy to raising racehorses and carriage horses and writing short stories.

Unable to respond to the flood of letters from farmers seeking her advice, Eliza wrote *Dairying for Profit; or, The Poor Man's Cow*, first published in 1892. It became an instant bestseller and was acclaimed by the *Farmer's Advocate* as the "best book ever written."[3] The Ontario Department of Agriculture purchased 50,000 copies.

Eliza was an accomplished farmer, breeder, butter producer, and writer with widespread recognition. Her son, F.P. Jones, established the Eliza M. Jones Award at McGill University in her honour. Her descendants continue to demonstrate their love of animals as owners of

Brockville's Franklands Farm, which supports the Canadian Equestrian Team. Granddaughter Prudence Heward (also featured in this book) became a gifted painter.

Quote:

"This little book is dedicated — to my sisters in toil, the tired and over-tasked women, who are wearing their lives away in work which has little hope and less profit."[4]

Dr. Kelsey in a laboratory with Dr. E.M.K. Geiling, late 1930s.

Thalidomide Heroine

Frances Oldham Kelsey

born 1914

Defying a powerful drug company, she prevented thousands of babies from being born severely deformed.

From the time she was a little girl on Vancouver Island, Frances Kathleen Oldham knew she wanted to be a scientist. "To this day, I do not know if my name had been Elizabeth or Mary Jane, whether I would have had that first big step up,"[1] she mused. Read on to hear the story of mistaken identity.

Frances was born in 1914 on a farm at Cobble Hill, British Columbia. Her mother encouraged her to go to college. Frances attended St. Margaret's School in Victoria before continuing at Victoria College in Craigdarroch Castle. She obtained a bachelor's degree in science from McGill University in 1934, and her master's the following year.

The young graduate was thrilled to be accepted to a fellowship under the renowned pharmacology researcher E.M.K. Geiling at the University of Chicago, but noticed that her acceptance letter was addressed to "Mr. Oldham." Geiling had assumed the applicant was male because of her name. Frances was concerned that "when a woman took a job in those days, she was made to feel as if she was depriving a man of the ability to support his wife and child."[2]

Her professor at McGill urged her to accept the job, despite the gender confusion; Frances signed the offer (and added "Miss" in brackets before her name). Professor Geiling was appalled when he discovered that he'd hired a woman, but Frances soon proved her worth as she worked on synthetic cures for malaria.

Frances earned her Ph.D. in pharmacology from the University of Chicago in 1938 and subsequently taught there. After marrying fellow faculty member Dr. Fremont Ellis Kelsey, she earned her medical degree and gave birth to two daughters. In 1960, the Kelseys moved to Washington, D.C., following her stints teaching pharmacology and practising medicine at the University of South Dakota. In Washington, she began her distinguished career with the Food and Drug Administration.

Dr. Kelsey's first assignment for the FDA was supposed to be a straightforward review of a harmless sleeping pill that was already being used around the world. Pregnant women were also taking the drug to relieve morning sickness. From her malaria research, she knew that drugs could pass through the placenta from a mother to her unborn child. Her concerns about this, and other safety issues, led her to demand further testing of the drug being marketed as Kevadon, now know as thalidomide.

Despite intense pressure from the drug company, eager to get Kevadon distributed throughout America, Dr. Kelsey stood firm. She was worried about possible dangerous side effects in patients who used it repeatedly. Her refusal to approve the drug sparked a two-year battle with manufacturer William S. Merrell Company of Cincinnati. The FDA ended up banning thalidomide in the United States.

Her worst fears about thalidomide were confirmed by reports that some users experienced numbness in their toes and fingers. Cases emerged in the United Kingdom and Germany of pregnant mothers who gave birth to babies with severe birth defects after taking the drug. In Canada, about 115 such infants were born before the abnormalities were linked to thalidomide. It's estimated that more than 100,000 deformed babies were born in forty-six countries.[3] Because Dr. Kelsey kept the harmful drug out of America, she prevented thousands of babies from being born without arms or legs, or with other severe birth defects.

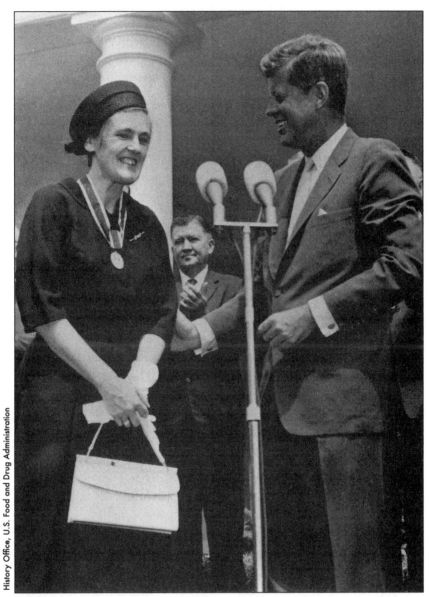

History Office, U.S. Food and Drug Administration

Dr. Kelsey receiving the President's Award for Distinguished Federal Civilian Service from President John F. Kennedy, 1962.

A front page story in *The Washington Post* on July 15, 1962 — "Heroine of FDS Keeps Bad Drug Off of Market" — thrust Dr. Kelsey into the limelight. President John F. Kennedy presented her with the President's Award for Distinguished Federal Civilian Service, the highest

honour available to a civilian. President Kennedy noted that "her exceptional judgement in evaluating a new drug for safety for human use has prevented a major tragedy of birth deformities in the United States. Through high ability and steadfast confidence in her professional decision she has made an outstanding contribution to the protection of the health of the American people."[4]

Dr. Kelsey continued to work for the FDA, helping develop and enforce tough drug regulations that ensured patient protection. Though she retired when she turned ninety, she continues to be recognized as a role model in public health and was inducted into the National Women's Hall of Fame in the United States.

In September 2010, Dr. Kelsey became the first recipient of the FDA's first Kelsey Award, named in recognition of her "excellence and courage in protecting public health." As the *New York Times* noted in announcing the latest honour, "though her story is nearly forgotten, she was once America's most admired civil servant — celebrated for her dual role in saving thousands of newborns from the perils of the drug thalidomide and in serving as midwife to modern pharmaceutical regulation."[5]

Here in Canada, students at Frances Kelsey Secondary School in Cobble Hill, British Columbia, are proud of the woman who is its namesake. Dr. Kelsey attended the school's groundbreaking ceremony in 1994. Canadians still like to claim her as one of their own.[6] The Canadian-born heroine "helped write the rules that now govern nearly every clinical trial in the industrialized world."[7]

Quote:

"They gave it [the review of Kevadon] to me because they thought it would be an easy one to start on. As it turned out, it wasn't all that easy."[8]

The Newfoundland Planter

Lady Sara Kirke

circa 1611–1683

The first female entrepreneur in English Canada, she ran the most successful plantation in Newfoundland.

For close to three decades, Lady Sara Kirke was a planter who operated the Poole Plantation on Newfoundland's Avalon Peninsula. Plantations in seventeenth-century Newfoundland were waterfront properties for fishing operations. And a planter was a European settler who owned boats and plantations. Lady Sara was a fish merchant — a wealthy one.

Sara Andrews came from Middlesex, England. In 1630, at nineteen, the daughter of Sir Joseph Andrews married thirty-three-year-old Dieppe-born Englishman David Kirke. The eldest son of a family of prosperous wine merchants, he was also an adventurer, trader, and colonizer. Under commission from Charles I, he'd led an expedition that resulted in the conquest of the French in Quebec in 1629, and the capture of his onetime hunting buddy, Samuel de Champlain. Kirke was knighted in 1633, and Sara became Lady Kirke.

When Lady Kirke was twenty-seven, she arrived in Newfoundland with Sir David, their children, and about thirty servants. Sir David Kirke became the first governor of Newfoundland, brought over about

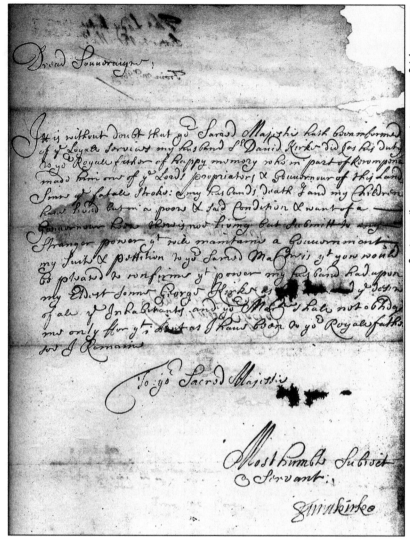

Letter written by Lady Kirke.

100 colonists, built forts, and shrewdly developed a highly lucrative business. This included trading salt-dried fish for wine and fruit in Spain, Portugal, and Italy, and selling these for a significant profit in British and Dutch ports. Sir David was a big fish in a very big pond.[1] As a royalist, he supported Charles I in the English Civil War. After the Puritan government took control and Charles lost his head, Sir David was recalled to England to face tax-evasion charges. The recall was also

an attempt to ensure that he wouldn't launch a counter-revolution from Newfoundland. He died in prison in 1654.

During the years that her husband had been away on his many overseas adventures, during the war, and through the legal wrangling, Lady Sara had already superintended the family business in Newfoundland and abroad. A strong and resourceful woman, Lady Sara's literacy helped her run the business.

After her husband died, Lady Sara could have returned to England. She also might have considered remarrying in Newfoundland, but given her social standing and the small population, the odds of finding a suitable match on the island weren't good. Lady Sara never remarried, and decided to remain on the Avalon Peninsula and continue managing the Poole Plantation.

The business prospered under Lady Kirke's leadership, despite the many obstacles she faced. After Sir David died, Sara still had to deal with a debt of £60,000 and a challenge from the heirs of Ferryland's first owner, Lord Baltimore. In 1660, she wrote an eloquent letter to King Charles II, pleading for her husband's powers and titles to be transferred to her oldest son, George. Her petition wasn't granted. Lady Sara ignored the second Lord Baltimore's successful claim to her plantation, even though the threat of eviction remained. She also faced the threat of attacks on her business from England's enemies. In 1673, Ferryland was bombarded by a Dutch squadron and the plantation was plundered and much of it burned. The Kirkes rebuilt.

Lady Sara managed Poole Plantation until she retired in 1679. She was the most prosperous fish merchant on the English shore and the largest planter in all of Newfoundland.[2] Lady Sara's sons and her sister supported her, but she ran the operation independently.

The plantation included an impressive quay, a forge, a cobblestone street, and a large slate-roofed warehouse on the waterfront. The holdings varied with the years, but in 1675 she had five boats and a crew of twenty-five men. Artifacts discovered in the mansion where Lady Sara lived included a silver thimble and silver pins, exquisite decorative dishes, and expensive ceramics. Ferryland was considered "the pleasantest place in the whole island."[3]

Lady Sara died in 1683 and locals believe she was buried east of Poole Plantation. Her role in Newfoundland's history is highlighted on

the Heritage Newfoundland website, where it is noted that the Kirke family are much underrated players on the stage of Canadian history. The Canadian Advanced Technology Alliance recognizes her as the first and foremost woman entrepreneur in North America through the Sara Kirke Award for Woman Entrepreneurship. This award is presented annually to "celebrate innovation, entrepreneurship and create positive role models for women."[4]

Quote:

"Dread Sovereign: It is without doubt that your Sacred Majesty hath been informed of the loyal services my husband Sir David Kirke did (as his duty) to our royal father of happy memory, who in part of recompence made him one of the Lords Proprietors and Governor of this Land."

— Lady Sara's letter to King Charles II, 1660.[5]

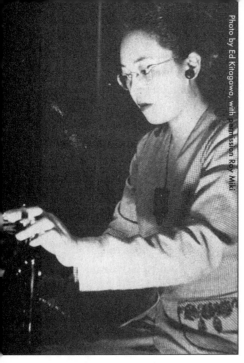

Betrayed

Muriel Kitagawa
1912–1974

Muriel Kitagawa, 1943–44.

When Canada imprisoned its own citizens after the bombing of Pearl Harbor, she refused to hide her outrage.

Muriel Kitagawa was twenty-nine when Japan bombed Pearl Harbor on December 7, 1941, and her world began to crumble. "War came to tear out the roots of our lives and we were washed down helter skelter on the roaring flood,"[1] she wrote. Muriel, a passionate journalist and activist, openly protested the racist pressures that resulted in all Japanese Canadians being branded enemy aliens and potential threats to national security.

Tsukiye Muriel Fujiwara was born in Vancouver in 1912, a second-generation Japanese Canadian (Nisei). During her childhood, the Fujiwaras moved frequently as her parents struggled to support their family. When they lived in Sidney on Vancouver Island, Muriel's father worked in a mill while his wife made dresses. Muriel remembered they "were so poor it did not seem possible to become any poorer and still retain … self-respect and independence."[2] She was ten years old when the family split up for several years: her mother worked as a live-in housekeeper in Vancouver while Muriel and two of her siblings lived in the Oriental Home in Victoria. The family reunited in 1924.

Muriel was troubled by the racial discrimination she sensed, but was enthusiastic about school. Her English teacher encouraged her to develop her writing. She attended the University of British Columbia for a year before dropping out because of financial problems. In 1933, Muriel married Ed Kitagawa, a banker and the star of the famous Asahi baseball team.

Muriel helped develop the short-lived *The New Age*, the first regular journal for Nisei. By 1939 she was a regular contributor to a Japanese-Canadian community newspaper called *The New Canadian*. She wrote about a wide range of topics — from arranged marriages to liberation of Nisei women— as well as short stories, poems, and historical vignettes. Prolific and provocative, Muriel was an outspoken advocate for her community during and after the Second World War.

When Japan attacked Pearl Harbor, Muriel had two small children and had been bedridden for months because of a difficult pregnancy. Her twins arrived in early January 1942. As Japanese Canadians were uprooted during the Second World War, Muriel wrote long letters to her brother, Wes Fujiwara, chronicling the courage these people showed as they struggled to survive harsh and discriminatory policies. Twenty-one-thousand Japanese Canadians faced expulsion from their homes, dispersal across the country, seizure of property and belongings, internment, family seperations, even deportation.

During the war, Muriel's younger sister, Kay, and her mother were in Japan; government regulations prohibited them from returning to Canada. To avoid a concentration camp, her brother, Doug, signed up to go to the internment camp near Schreiber, Ontario, in April of 1942. Muriel, her husband, and four children were among the fortunate few to receive a special permit to relocate to Toronto. The Kitagawas boarded a train on June 1, 1942.

Muriel contributed articles and served as managing editor for *Nisei Affairs* in Toronto, continuing to defend the innocence of Japanese Canadians and affirm their loyalty to Canada. She also vociferously expressed her views in letters to government officials, as well as in public lectures. "You, who deal in lifeless figures, files, and statistics could never imagine the depth of hurt and outrage dealt out to those of us who love this land," she wrote to the Custodian of Japanese Properties. "It is because we are Canadians that we protest the violation of our birthright."[3]

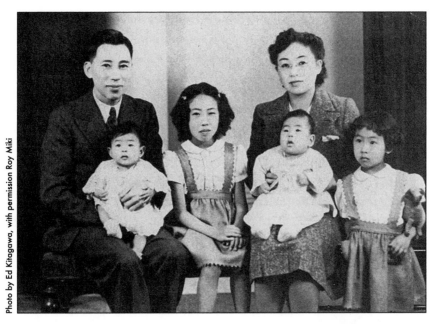

Photo by Ed Kitagawa, with permission Roy Miki

Ed and Muriel Kitagawa with children Shirley, Carol, and twins Jon and Ellen, 1942.

Following the war, Muriel called the deportation order of Japanese nationals a human rights violation and expressed her sense of betrayal at the federal government's failure to compensate people for destroying their lives. After 1949 she focused on other things in her life, though the bitterness remained. That same year, Japanese Canadians were allowed to return to the West Coast and vote in provincial elections, but the Kitagawas had nothing to go back to. Muriel lived the rest of her life in Toronto.

In 1985, Roy Miki published a collection of Muriel's letters and some other writings. Her protests against the forced dispersal and internment of Japanese Canadians inspired many people voice their feelings about the tragic events. Randy Enomoto, onetime president of the National Association of Japanese Canadians, said the movement for redress began with her work in the 1940s.[4] Muriel's writing jolted many people into awareness of this history, including author Joy Kogawa who wrote the novel *Obasan*, and Robin Engleman, who composed a musical tribute to the internees.

When Brian Mulroney gave a speech in 2008 on the twentieth anniversary of the federal government's official apology to the Japanese com-

munity, he referred to Muriel. Quoting from her writings, Mulroney acknowledged Muriel's contributions to her country: "For her life, and the lives of other Japanese Canadians in wartime, Canada can be grateful."[5]

Quote:

"Who is the Custodian of my freeborn rights, if not the government of my native land? ... God! God! Were my soul 'so dead' I could not thus agonize for the land betrayed!"[6]

The Chief

Elsie Knott

1922–1995

Elected as the first female Indian chief in Canada under the Indian Act, she led the way for other First Nations women to become more politically active.

Chief Elsie Knott.

When Elsie Knott pulled up to your door in a hearse, she wasn't there to take you to a funeral — she was giving you a ride to school. Elsie only completed grade eight at the Mud Lake Indian Reserve School; high school was never suggested, and there was no way to get there anyway. Elsie's converted hearse was the first step toward establishing the Knott Bus Service, which enabled local children to continue their education off the reserve. For thirty-one years, Elsie drove the school bus.

Elsie Taylor grew up in a family of seven on the Mud Lake Reserve, on a peninsula northwest of Peterborough, Ontario. She only spoke Ojibway when she started attending the reserve school administered by the Department of Indian Affairs, where anyone "caught talking Indian"[1] had their name written on the blackboard along with a capital *X*. When she was just fifteen, her parents arranged for her to marry Cecil Knott, a man from the reserve who was twelve years her senior.

By twenty, Elsie was living in poverty with her three children; her tuberculosis-afflicted husband could not support the family. Desperate

to improve their living conditions, Elsie struggled to earn money by driving the school bus, picking berries, providing bait to fishermen, sewing pyjamas and quilts, working as a chambermaid, doing laundry, and cooking.

After the Indian Act was amended in September 1951, women were finally allowed to become officially involved in band politics. Elsie, who believed that many changes should be made on her reserve, agreed to run for chief. She won in 1952 and became Chief Knott, leader of the 500 Mississaugas of Mud Lake Indian Band (now known as Curve Lake First Nation). She was thirty-one, eager to work with her five councillors to help the people on her reserve lead better lives.

Elsie served as chief from 1952 to 1962, and from 1970 to 1976. She gradually overcame her fear of public speaking. As she gained confidence in her role, she became more outspoken and adopted more radical ideas. Chief Knott successfully negotiated with the government for funding to improve services on the reserve. Forty-five houses were built, roads were upgraded, a daycare was constructed, new wells were dug, and more social services were provided.

Chief Knott organized community activities and tried to create greater awareness of First Nations culture, both on the reserve and in neighbouring areas. She revived the powwow, opened it to outsiders, and used the proceeds for Christmas hampers. She also organized Boy Scouts, Girl Guides, baseball teams, dances, and fish fries. She brought back traditional drumming and singing, and taught weekly Ojibway language classes. Elsie translated fourteen Christmas carols into Ojibway and helped host an Aboriginal hockey tournament involving sixty reserves. She encouraged children from the reserve to succeed in school even when others called them names and threw rocks at the school bus.

Elsie was also active in political activities at various levels. She served in the Union of Ontario Indians and was on the board of directors of the National Indian Brotherhood (now the Assembly of First Nations). The once mild-mannered girl expressed her opposition to the 1969 White Paper on Indian Policy by publicly burning a copy and dancing on the ashes.

Chief Elsie Knott was a respected leader who made significant achievements in her community and earned recognition across Canada.

She inspired many young people on her reserve to follow their dreams, including Judge Tim Whetung, who thanked her for driving him to school day after day. In 1975, International Women's Year, she was named one of twenty-five outstanding women in Ontario.

Quote:

"Nobody ever talked to me about a career. Women just got married."[2]

Captain Kool

Molly Kool
1916–2009

At twenty-three, she became North America's first female sea captain — and just the second in the world.

Courtesy of Jonnie-Anne Carlisle

Captain Molly Kool.

When Molly Kool qualified as a sea captain in 1939, it was considered so amazing that she was flown to New York to be interviewed on *Ripley's Believe It or Not!* Not only was it thought curious that a woman planned to command a vessel, but also that she was so beautiful that one observer compared her to Marilyn Monroe.[1] Another wrote, "Her eyebrows are shaped and arched, her lips lightly rouged, her blonde hair up in feminine curls. That's Miss Molly Kool ashore … but in her barge … she knows no fear."[2]

For a New Brunswick girl who had grown up by the sea, the choice of profession was obvious. It was her childhood dream. Myrtle Kool (she detested her birthname and legally changed it to Molly) was born in Alma, a small fishing village on the Bay of Fundy. From the time she was eight, Molly spent her summers on the water with her father, a Dutch sailor. She loved joining him on his sixty-four-ton scow as they hauled cargo along the bay.

During her schooldays, Molly excelled at mathematics, geography, and history. She loved poems about the sea. After high school, she worked as a full-time seaman on her father's schooner, the *Jean K* (named after her oldest sister). Eager to become his first-mate, she applied to the Merchant

Marine School in Saint John. Though she was initially refused admission, Molly persevered and eventually earned a mate's certificate.

She obtained a coastal master's certificate from the Merchant Marine Institute in Yarmouth, Nova Scotia, after waiting three years for permission to take the necessary exams.[3] (The Canadian Shipping Act was later modified to show that both genders could be accepted as shipmasters.) The newly minted Captain Kool was now qualified to command her own ship.

When her father became ill, Molly took over the *Jean K*. For five years Molly served as captain, transporting lumber, gypsum, and other goods in the Bay of Fundy — famous for treacherous tides — and the Gulf of Maine. The tenacious young woman survived the challenges of life on the Atlantic coast without the aid of radar or modern equipment. She steered the vessel with a chart and compass to guide her.

Despite initial opposition from male seafarers, Captain Kool earned the respect and admiration of all who met her. She coped with near shipwrecks, being dumped in the icy Atlantic and having to swim to safety, and close encounters with whales. When a Norwegian skipper tried to steal her berth in Moncton, the fearless Captain Kool threatened him with some salty language, a belaying pin, and legal action; she had to leap to the wharf when his steel-hulled freighter crashed into her scow.

Captain Kool's career ended abruptly in 1944 when a gas explosion and fire destroyed much of the *Jean K*. Though Molly initially planned to return to the sea, she fell in love with and married Ray Blaisdell. They settled in Maine.

When Molly died in 2009, her death was widely covered in both Canada and the United States — including the *New York Times*. She received praise from her contemporaries for having "the interior toughness of a hard-driving sea captain."[4] Throughout her life Molly retained her fondness for Alma, and was proud to attend the unveiling of a plaque erected there in her honour. After Molly's death, friends and family scattered her ashes in the Bay of Fundy. It was her final wish to have a captain's burial at sea.

The Captain Molly Kool Heritage Centre, a reconstruction of her modest childhood home, was developed in Fundy National Park as a memorial to the first woman sea captain in North America.

Quote:

"You can call me captain from now on."[5]

Castaway

Marguerite de la Rocque

1500s, exact dates unknown

A real-life Robinson Crusoe, she became a famous sixteenth-century heroine.

The exiled lovers and a servant on the Island of Demons.

Several hundred years before Daniel Defoe published his classic novel *Robinson Crusoe*, a young French noblewoman was cruelly abandoned on a remote island in the Gulf of St. Lawrence called Île des Démons. The courageous tale of Marguerite de la Rocque has inspired countless novels that romanticize the few accurate historical accounts.[1]

Marguerite de la Rocque was presumably born in France. She was co-seigneuress of Pontpoint along with Jean-François de la Rocque, a close relative who was probably her brother or uncle. She also had land in Périgord and Languedoc in southern France.

In 1542, Marguerite was bound for Canada. It was a time when a voyage from France to the New World meant adventure and unknown perils. La Rocque had convinced the spirited young lady to accompany him on an expedition to establish a colony in Canada. He hoped to recoup his dwindling fortune by discovering diamonds and gold.

Though the king of France, François I, had named La Rocque as lieutenant-general in Canada and provided a large grant, he still had

problems funding the expedition. He borrowed money, sold some of his property, and finally resorted to piracy on the high seas. There is also speculation that he persuaded Marguerite to contribute some of her wealth.

On April 16, 1542, the adventurers sailed from La Rochelle on three ships, carrying crew and a group of colonists comprised of ladies and gentlemen as well as some hardened criminals who had been forced to come along. The latter included thieves, murderers, and one assassin.

The ships sailed into what is now St. John's, Newfoundland, on June 8. Here they met up with explorer Jacques Cartier. But after leaving the city, trouble erupted as the ships proceeded to navigate the Gulf of St. Lawrence. It seems that La Rocque was enraged to discover that Marguerite had a lover onboard, and decided to leave her on an uninhabited island near the coast of Labrador as punishment. While the details of the incident are unclear, it seems that Marguerite, her lover, and a servant woman named Damienne were all abandoned on an island bearing the frightening name of Island of Demons.

La Rocque left the threesome with some guns and ammunition, food, clothing, and a copy of the New Testament. Some suggest that the ruthless adventurer was pleased to have an excuse to rid himself of Marguerite to avoid sharing his property or his expected riches.

The castaways managed to make a shelter on the rocky, inhospitable island, and by supplementing their provisions with edible plants and wild game, they survived the first harsh winter. About eight months after their arrival, however, Marguerite's lover apparently died, just before the birth of their baby. Shortly thereafter the servant also died. Sadly, Marguerite couldn't adequately nourish the infant and soon she had to bury her child as well.

Alone on the desolate isle for another year or so, the bereaved young woman somehow found the will to endure. It seems she still had enough ammunition to be able to shoot marauding wildlife, including a bear that was "as white as an egg."[2] After nearly two and a half years on the Island of Demons, Marguerite spotted some ships and lit a bonfire on the beach. A French vessel rescued the emaciated castaway, clad in tattered clothes, and carried her back to France in the fall of 1544. Little is known of her fate, though it seems she later became a teacher.

Her incredible story soon appeared in publications throughout France, beginning with accounts by King François I's sister, the Queen of Navarre (1558),[3] and André Thevet (1575). Marguerite was one of the earliest heroines in Canadian history, one who enthusiastically joined a colonial expedition but was instead forced to survive a horrific ordeal.

The chief pilot on the La Rocque expedition named Île de la Demoiselle after Marguerite in 1542, though it is believed that the actual island of her exile is one of the Harrington Islands in the Gulf of St. Lawrence.[4] In the small village of Harrington Harbour, Quebec, local lore links the heroic colonist to Marguerite's Cave, where she may have sought shelter while marooned.

Quote:

"The poor woman buried him [her husband/lover] in a grave which she made as deep as she could; the beasts, however, immediately got scent of it, and came to devour the body, but the poor woman, firing from her little dwelling with her arquebuse, hindered her husband's body from having such a burial."[5]

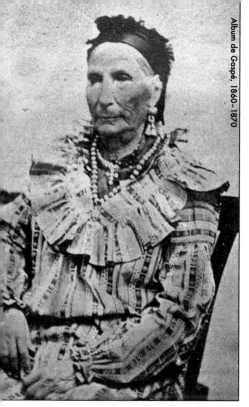

"The Woman Skilled at Needlework"[1]

Marguerite Vincent Lawinonkié

1783–1865

She ensured the survival of the Huron-Wendat by turning Native crafts into a big business.

Marguerite Vincent Lawinonkié.

Marguerite Vincent Lawinonkié was born in the Mohawk community of the Bay of Quinte, on the eastern shores of Lake Ontario, and raised in a dynamic family known for its involvement in politics, diplomacy, and defence.

At twenty-four, "the beautiful Huron girl"[2] married Paul Picard Hondawonhont in Jeune-Lorette, a Huron settlement near Quebec City. She remained in the region for the rest of her life. Though Marguerite gave birth to many children, the only survivor was her son, François-Xavier Picard.

During the early years of their marriage, Paul spent months at a time in the forest, trying to support his family. In his absence, his extremely intelligent and creative young wife turned her talent at handicrafts into an important source of income.

Marguerite became a renowned artisan and entrepreneur whose needlework was prized in Quebec and England. She learned to embroider moccasins with porcupine quills and moosehair, having mastered the art

of finely detailed, sophisticated embroidery practised by the Ursulines. Marguerite's skills enabled her "to embellish the thousands of trinkets sought by the curiosity of the English and the Americans and which they buy at its weight of gold."[3]

Taking advantage of the strong tourist market for Native curiosities, the Picards developed a thriving business. Their main product was snowshoes, but Marguerite also made mittens, moccasins, gloves, and coats. The family was reported to be rich and they lived in a comparatively fine house.

While the Picards prospered, many other Native peoples were facing hard times as settlers flooded the countryside. The traditional Huron lifestyle disappeared with deforestation and resource depletion. They needed a new source of livelihood and Marguerite provided it:

> [The Huron's] precarious condition of life aggrieved Lawinonkie, the mother of François-Xavier; and first, among the Huron women of Lorette, she attempted to rekindle the fire while the warriors and chiefs were away; she created a new industry.... One year when the hunters returned from their expedition, they each found in their home a full pot or boiler, which they had left empty.[4]

Marguerite fostered the development of an industry that used modern techniques and new materials for traditional handicrafts. She taught Huron women techniques for making and decorating garments and handicrafts, including moosehair embroidery and the use of natural dyes. By assigning duties and adapting traditional handicrafts to available materials and markets, Marguerite was able to increase handicraft production to meet the growing demand.

Through Marguerite's leadership in teaching techniques, Huron crafts became famous in the nineteenth century and a new Huron industry was born. The Picard business grew. Paul had men working to fill large government contracts for snowshoes, sleds, and toboggans for soldiers, while Marguerite supervised women to produce moccasins and crafts. Huron women gained a way to contribute to their family's survival and the growth of the community.

The people of Lorette prospered as more artisans were needed. In 1861, just one delivery of moccasins and snowshoes to Montreal brought in $1,200. By 1879, sixty of the seventy-six families in Lorette depended on needlework for income, and 30,000 pairs of moccasins and embroidered shoes were made a year for Montreal, Quebec City, Toronto, Kingston, and other markets.

One traveller, who visited the Picards when Marguerite was seventy-seven, described her as "an old Norna-like figure, wrapped in a large black shawl, and sitting silent and motionless by the fire." She was a woman who had seen "her family prosper and the spirit of industry spread increasingly among her compatriots."[5] Marguerite died at eighty-two and was buried in the chapel at the Jeune-Lorette Mission.

In 2008, the Historic Sites and Monuments Board of Canada designated Marguerite Vincent Lawinonkié (Picard) a national historic person because of the role she played in fostering both the development of the Huron handicraft industry and the entrepreneurial spirit that enabled her community's survival. Marguerite and Paul Picard's home in Wendake, Quebec, is now an interpretive and cultural centre. A few of her finest pieces of work are preserved in museums, including the headdress she made for her son, who became Grand Chief of the Huron-Wendat.

Quote:

"The woman skilled at needlework … knew how to earn a livelihood through her ingenuity. Paul, the hunter, the guide or the warrior, could leave without fear. All was well at home."[6]

The Girl of a Thousand Faces

Florence Lawrence

1886–1938

Fans loved Florence — even when they didn't know her name. She made history as the first movie star.

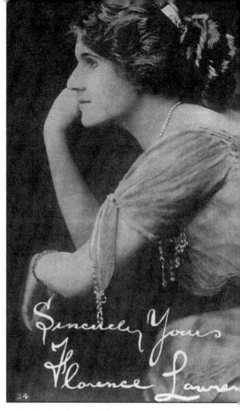

Florence Lawrence.

In the early years of silent movies, studios refused to reveal their actors' names, fearing that stardom would lead to demands for higher wages. Audiences nicknamed one of their favourite leading ladies the "Girl of a Thousand Faces." As one fan wrote, she was an exquisite delight, "whether comic, pathetic, dramatic, tragic or any other old thing, she simply took the rag right off. The power of expression that lay in her features was nothing less than marvelous."[18]

That girl was a Canadian performer named Florence Lawrence, petite with wavy blonde hair and expressive blue eyes. She was born in Hamilton, Ontario, on January 2, 1886, the daughter of the unlikely union between young vaudeville actress Charlotte "Lotta" Dunn and middle-aged carriage-builder George Bridgwood.

Florence began sharing the stage with Lotta by the age of two and was soon known as "Baby Flo, The Child Wonder Whistler."[2] She toured with Lotta's production company, Lawrence Dramatic Company, and Lotta changed both their surnames to Lawrence. By ten, Florence

Lawrence was a veteran actress with five full-time touring seasons, but her mother pulled her from the stage after George died suddenly. The family moved to Buffalo, New York, so they could live with her grandmother, Ann Dunn.

Florence began attending school, where she thrived in the stable environment. It is thought that she went to the Loretto Academy in Toronto as well as to a school in Buffalo. In addition to playing the violin and clarinet, the young tomboy loved horseback riding and other sports. Florence returned to vaudeville with her mother in 1906 — when she saw her first moving picture and became fascinated.

In 1907, Florence appeared in her first silent movie, *Daniel Boone,* which was produced in New York by Edison Studios. She performed in more than 250 movies, many of them short films shown in small nickelodeon theatres. Florence was the first woman in America to play the role of Juliet in the movies. She also made costumes and painted backdrops.

Florence was hired in 1908 as a leading actress at a film studio called Biograph, where her ability to perform stunts and tricks on horseback in Western movies was an asset. Florence jumped at the opportunity to join Biograph, especially at a weekly wage of $25 and no other duties. One of her most successful roles was that of Mrs. Jones in a series of slapstick comedies. Though actors were still working anonymously, audiences soon recognized their favourite actress, "The Biograph Girl," and began sending her fan mail.

Florence adored working with the talented director D.W. Griffith and became one of Biograph's most popular performers. When Carl Laemmle created IMP Company in 1910, he wanted to capitalize on Florence's popularity. Laemmle lured her to his studio by offering public recognition, publicity, and an impressive salary of $300 per week.[3]

Laemmle launched a clever publicity campaign, seeding rumours that the actress had been killed in a streetcar accident. He then arranged for Florence to make a public appearance in St. Louis. For the first time in the industry, the studio identified her by name. Newspaper articles with photos and biographical information followed, introducing fans to the actress said to be the most popular and highest-paid in America.[4]

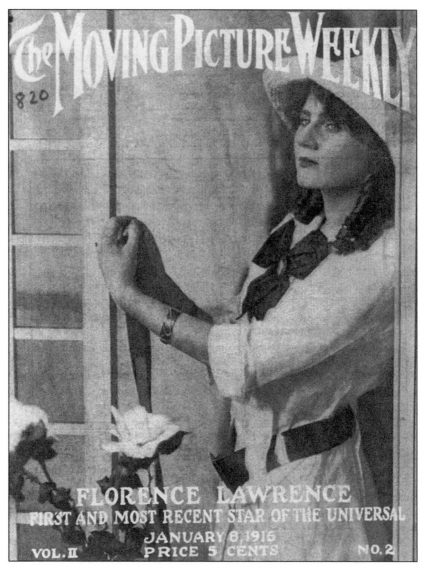

Florence Lawrence on a magazine cover, 1916.

When Florence's train pulled into St. Louis on March 25, 1910, she was mobbed. The crowd rushed to get a closer view of the woman they "instantly recognized as Miss Lawrence, their heroine,"[5] with a zeal usually reserved for famous explorers and presidents. She became the first movie star and revolutionized the film industry.

Florence continued to act in movies, but did not attain the fame

and fortune of fellow Canadian and rival Mary Pickford. Florence was one of the first women to own a production company, the Victor Film Company,[6] but her career suffered a major setback in 1914. She was supposed to carry a 175-pound man down a flight of stairs during a fire, but fell and injured her back. Some accounts indicate she was also badly burned while rescuing a co-star. The accidents derailed Florence's career, bringing her back pain, surgery, and medical bills.

She still loved to drive. As early as 1913, Florence had purchased an automobile. She began developing accessories to improve cars and made two significant inventions that she never patented. MIT recently featured Florence as Inventor of the Week, crediting her with inventing the first turn-and-stop-signal devices for automobiles.

Florence's first husband died in 1920. A second marriage ended in divorce, and a third marriage lasted only a few months, after she realized that her husband was an abusive alcoholic. In 1937, she was diagnosed with a rare bone-marrow disease that resulted in severe pain, anemia, and depression.[7] There was no cure. Florence committed suicide on December 28, 1938.

Thanks to the Motion Picture Relief Fund, Florence was buried in Hollywood Memorial Cemetery in Los Angeles. Her grave remained unmarked for many years, until an anonymous British donor bought a bronze marker in 1991. The inscription reads: "Florence Lawrence, The Biograph Girl, The First Movie Star."

Her once-famous face has been largely forgotten, except by film historians. Few of her films have been preserved. Author Kelly R. Brown, determined to ensure that her contributions to film were not lost forever, published a biography in 1999 so that "she will ... be remembered as she deserved to be."[8]

Quote:

"The moving picture business is trying on the nerves ... much more than theatrical work."[9]

The Healer

Marie-Henriette LeJeune-Ross

1762–1860

**She nursed Nova Scotia
pioneers even when she
was blind.**

Time and incomplete historical records have blurred legendary Marie-Henriette LeJeune's story. She was a gifted healer who served as midwife and nurse to early settlers in Cape Breton for at least sixty years, when no other medical aid was available. Her reputation was larger than life.

By the time this remarkable Acadian settled in Cape Breton in 1793 with her Scottish spouse, James Ross, she'd been exiled to France and outlived two previous husbands. Marie-Henriette LeJeune was born in Rochefort, France, after her Acadian parents, Joseph Lejeune and Martine LeRoi, had been deported from Cape Breton in 1758.[1]

The family returned to North America at the end of the Seven Years' War in 1763, but continued to be uprooted by wars and power struggles. They moved back to Little Bras d'Or in Cape Breton where they had settled in the first place, and stayed for eleven years before again being deported to France. Small in stature, with blue eyes and a dark complexion, eighteen-year-old Marie-Henriette wed widower Joseph Comeau, fifty-four. At the end of the American Revolution, the

Nova Scotia Economic and Rural Development and Tourism

Margaree Valley along the Cabot Trail on Cape Breton Island, Nova Scotia.

Acadian families were permitted to return to North America, and Marie-Henriette and her husband settled on the island of Saint Pierre.

Joseph drowned, making Marie-Henriette a widow at twenty-two. When the LeJeunes moved back to Little Bras d'Or, she married a cousin, but he also died. At thirty-one, the well-travelled Marie-Henriette settled down with third husband James Ross, and the couple had four children, two of whom survived. In 1800, they relocated to the North East Margaree Valley, where there was ample land for Ross's brothers to settle nearby. Marie-Henriette enjoyed a happy life with her third husband.

As a young adult, Marie-Henriette began nursing the sick and delivering babies. She also learned about medicinal plants. When smallpox threatened settlers, she treated the sick in a makeshift infirmary in a cabin in the woods. One of her descendants noted that "she knew the effects of vaccination and persuaded the inhabitants to allow her to vaccinate them. She used serum she brought from France in a small glass vial, and she renewed her supply with serum from the sores of the ill."[2]

Marie-Henriette's reputation spread, and settlers counted on her as a midwife and nurse. She travelled throughout the countryside by foot, horseback, or on snowshoes, armed with a pine torch to guide her at night and a loaded musket to fend off wildlife. She was known to have

shot at least one black bear and fought another with a fire shovel. The healer was renowned for her courage and determination, as well as her love of adventure and travel.

When Marie-Henriette lost her eyesight she was still committed to helping people who needed her services. She couldn't hit the trails on her own, so her relatives transported her in a modified wheelbarrow or a sled during the winter.

Marie-Henriette LeJeune Ross, known fondly as Granny Ross, died in 1860 at ninety-eight. The Cape Breton midwife and healer is still proudly remembered by her many descendants. She continues to be a popular figure in Nova Scotia folklore.[3]

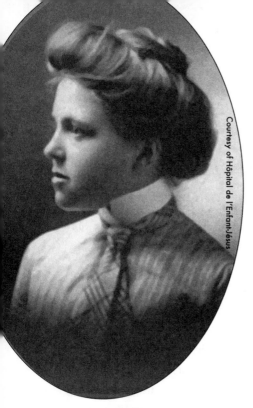

Courtesy of Hôpital de l'Enfant-Jésus

A Pioneering Pediatrician

Irma LeVasseur

1877–1964

One of the first women doctors in Quebec, she opened children's hospitals and became a leader in pediatric care in Canada.[1]

Irma LeVasseur, about twenty years old.

Four-year-old Irma wept when her beloved little brother Benjamin died. Infant deaths were not unusual at the time, when children under two weren't accepted in hospitals and one in four babies in Quebec didn't survive infancy. Irma's only remaining sibling was an older brother, Paul, who was mildly handicapped but showed a certain musical talent. This made her particularly sensitive to the special needs and gifts of such children.

Irma LeVasseur was born and raised in Quebec City. Her father had been forced to quit medical school due to financial problems, but as a man of many talents, he became a journalist, soldier, historian, accomplished musician, and prominent political and cultural figure. Irma's mother, singer Marie-Anne Phédora Venner, abandoned the family when Irma was ten. The little girl was inconsolable. But she had a dream: to become a doctor and care for needy children.

Just one problem: when Irma completed school, women weren't accepted at any francophone university in Canada. At seventeen she went

to study medicine at the University of Minnesota, where a friend of her father's had a successful medical career. He no doubt served as a mentor.

After six years of study, Irma graduated as a medical doctor and surgeon in 1900. She completed a two-year residency in New York City, where Irma worked with a prominent husband-wife team: neurologist Dr. Mary Jacobi and her husband, Dr. Abraham Jacobi, who was considered the father of pediatrics.

Dr. LeVasseur was eager to return home to practise medicine, but Laval University refused to admit women to the courses required for the provincial exams to practise medicine in the province.[2] The medical community, religious elites, and franco-Catholic society preferred women to be teachers or homemakers.

Irma appealed to the Legislative Assembly of Quebec and was licensed to practise medicine in 1903, becoming the first francophone woman to register as a doctor in Quebec. Unfortunately, this symbolic event didn't make it easier for other women to enter the profession. Though Bishop's College had accepted some women, McGill didn't admit females until 1918, the University of Montreal until 1924, and Laval until 1936.

Despite ongoing prejudice against female doctors, Dr. LeVasseur managed to have an exceptional career in her chosen field. She opened a care facility in Montreal called the Crèche de la Miséricorde where she and other doctors treated "illegitimate" children. Anxious to improve her pediatric skills, she spent two years in children's health institutions in France and Germany to learn about the latest advances in bacteriology and immunotherapy, including vaccinations and milk pasteurization.

On returning to Montreal, Dr. LeVasseur established a clinic for sick children, but felt there was a need to create a specialized hospital. Thanks to the support of a group of socially active women in the city, in 1907 she opened the facility that would become the Hôpital Sainte-Justine.[3] It was the first francophone hospital for children in Canada, and the beginning of pediatrics in Quebec. Justine Lacoste-Beaubien, after whom the hospital was named, noted her admiration for Dr. LeVasseur: "She was the instigator of our hospital…. I thank God for having placed me in the path of this remarkable woman."[4]

Dr. LeVasseur returned to the United States and worked for the New York City Board of Health from 1908–1914, and again from

1918–1920. During the First World War, she volunteered in Serbia. She spent much of her time treating soldiers on the front lines, burying the dead, and immunizing and treating the population in the midst of a typhus epidemic.

As enemy troops advanced, the indomitable doctor joined the Serbs' desperate retreat across the Albanian mountains. She survived, though an estimated 700,000 others died.[5] A colleague later commended Dr. LeVasseur's courage on the battlefields: "Deprived of any comforts in a country in which she did not understand the language, she remained smiling and silent. She was a woman of action who had an extraordinary amount of energy."[6]

After helping the Red Cross in Paris, Dr. LeVasseur worked in New York until her mentor, Dr. Jacobi, died. She then went back to Quebec City, where she was eager to establish another hospital for children. The Hôpital de l'Enfant-Jésus was incorporated in 1923. The following year she created a clinic called Hôpital des Enfants Malades. Concerned about children suffering from tuberculosis and congenital diseases, she convinced the women in the Ligue de la jeunesse féminine to found an institution for disabled children. It was not until 1935 that the École Cardinal-Villeneuve was created in Quebec City.

During the Second World War, Dr. LeVasseur worked as the medical officer for the recruiting office at the Quebec City Armoury. Her activities after that are uncertain. At eighty, she was forcibly confined to a mental hospital for eight months when neighbours complained about her living conditions. Irma eventually managed to convince authorities of her sanity. She died in January 1964, destitute and forgotten. It took another forty years before her name was even added to the LeVasseur family gravestone. In November 2008, journalist Serge Bouchard of L'actualité wrote an article, "When Forgetting Becomes Scandalous," about the amazing lack of recognition for such a notable historical figure.

In recent years she has been recognized by the naming of a mountain in Quebec, as well as with a commemorative plaque and an auditorium in the Hôpital de l'Enfant-Jésus, several streets, a school pavilion, a three-volume novel based on her life, and a scholarship created by the Quebec government. Quebec City paid tribute to this

remarkable physician with a bronze sculpture in 2009, and Montreal opened a park in 2010 named in her honour. In 2008, the Historic Sites and Monuments Board of Canada recognized Dr. Irma LeVasseur as a national historic person.

Quote:

"How many of these poor little creatures are destined for death by ignorance and negligence, by the absence of intelligent care, by poverty! ... We want our children treated, as in all other large cities, in a hospital where specialists will give free care each day to poor families who bring in their sick children."[7]

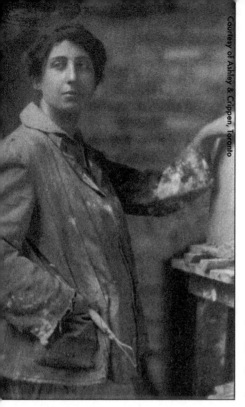

Frances Loring, 1912.

The Grande Dame of Canadian Sculpture[1]

Frances Loring

1887–1968

She brought brilliance and professionalism to Canadian sculpture, and opened doors for other artists.

Frances Loring was flamboyant, compelling, and charismatic, not to mention being a gifted sculptor with training in neoclassicism. When she settled in Toronto in 1911, at twenty-four, she had already spent five years experiencing the artistic wonders of Europe. Frances had studied sculpture in Munich, Paris, and Geneva. She arrived in Canada with much to contribute to a country where there was little interest in sculpture.

Frances was a privileged child, the daughter of mining engineer Frank Loring. She was born in a mining camp in Wardner, Idaho, but the adventurous family moved often. Successful more often than not, her father generously provided for his talented daughter and supported her artistic endeavours. Frances was just thirteen when she first experimented with clay in Geneva.

"Clay is so fascinating that once you start working with it you can't stop. That's when I started to be a sculptor,"[2] she said. After her early studies in Europe, Frances enrolled at the Chicago Art Institute in 1906. There she met an older student who would become her lifelong

companion: Florence Wyle. From 1909 to 1912, Frances tried to establish herself as a sculptor in New York. Her father paid for the Greenwich Village studio she shared with Florence.

Despite some initial success in New York, the women lost an important sculpting job after one of their teachers claimed that they were lesbians.[3] Frank Loring convinced his daughter that Canada was a land of opportunity, so Frances and Florence moved to Toronto, eventually establishing themselves in a home studio they shared for the remainder of their lives. Some thought it odd for two unmarried women to live together. Biographer Elspeth Cameron wrote that friends didn't believe they were lesbians, and that the true nature of their close relationship is unknown.[4]

With her impressive talent, Frances soon made her mark on Canadian sculpture. She preferred works on a grand scale, often architectural in style, with big themes. She loved climbing ladders to work on scaffolding, as when she sculpted a sixteen-foot figure of *Miss Canada* at Eaton's in Toronto in 1917. Wearing comfortable overalls and a smock, the attractive brunette worked twelve-hour days to complete the statue that symbolized brave young Canadian men and women.

Frances gained renown for her large public statues, such as the First World War memorial at Osgoode Hall in Toronto, which includes a dramatic seven-foot-tall Carrara marble statue. She also sculpted war memorials at St. Stephen, New Brunswick, and Galt, Ontario, *The Recording Angel* for the Parliament Buildings in Ottawa, and the Robert Borden monument on Parliament Hill.

Frances was a popular speaker. She gave many public presentations and lectures, as well as radio broadcasts, to encourage the appreciation of sculpture. She and Florence inspired young artists. Frances was one of the founders of the Sculptors' Society of Canada, as well as an organizer of the National Arts Council and the Federation of Canadian Artists.

Frances was one of Canada's most talented and respected sculptors. In 1954, she became the first sculptor and first woman to receive the University of Alberta's national award for "long and conspicuous service to the arts."[5] She was also awarded an honorary degree from the University of Toronto.

Frances died in 1968, just three weeks after Florence. They donated the Loring-Wyle Studio at 110 Glenrose Avenue to the Royal Canadian Academy of Arts. The academy eventually sold the property and directed the proceeds towards the purchase and display of works by aspiring sculptors. As specified by Frances and Florence's will, the profits from selling their remaining works went to the same fund.

The studio remains a private residence. A provincial government plaque at the site is a small tribute to the enormous role played by both Frances Loring and Florence Wyle in the development of Canadian sculpture. Frances's famous lions, which once graced the Toronto entrance to the Queen Elizabeth Highway, were moved away and most of their sculptures are now in storage.

Quote:

"Canada [has] the inferiority complex of a new country, and Canadians [are] afraid to trust their own judgment in matters of art.... A work of art [has] to be endorsed by London, Paris, or New York before Canadians would accept it."[6]

A New Woman

Laura Muntz Lyall
1860–1930

This great Canadian
Impressionist was a sensation
in France — becoming the
first female Canadian artist
to earn recognition abroad.

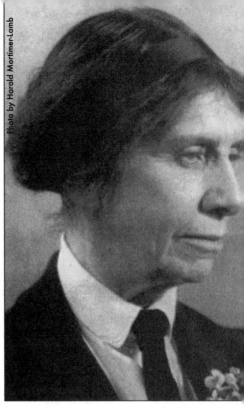

Laura Muntz Lyall, 1907.

Six-year-old Laura Muntz was so enthralled by an exhibit at London's Crystal Palace that her mother could hardly drag her away. The experience sparked Laura's passion for painting. Through incredible determination and perseverance, she became an independent professional artist who maintained a successful studio and had a teaching practice. Despite parental disapproval, sexism in the world of art, and the need to support herself, Laura Muntz evolved into what late-nineteenth-century society dubbed a New Woman — shattering traditional notions of women.[1] Believing it was too hard to devote yourself to both a family and art, she chose to be single.

Laura was born in a village near Warwickshire, England, to first cousins Eugene and Emma Muntz. In 1869, Laura's family immigrated to Canada, where her father soon failed miserably at farming in both the Lake Simcoe and Muskoka regions. While Laura's brothers were educated at private school, there is no indication that she was even tutored at home. In 1879, William Charles Forster, the drawing master at

the Hamilton Public Schools, spotted her sketching. Forster gave her the opportunity to study with him and live with his family.

It is not clear if Laura's parents were unable or unwilling to help her pursue an artistic career, but she was on her own in the male-dominated art world. Supporting herself by teaching and portrait commissions, Laura trained with William Cruikshank and Lucius R. O'Brien at the Ontario School of Art in Toronto and George Agnew Reid of the Central Ontario School of Art and Design. She also managed to spend three months in London, England, at the St. John's Wood Art School. In 1891, Laura became a member of the Ontario Society of Artists (OSA) and earned first prize for a painting she exhibited with the group.

Like many serious Canadian and American artists of her time, Laura was eager to develop her talent overseas. At thirty-one she went to France. She studied at the Académie Colarossi and worked in Paris from 1891 to 1898, struggling to support herself with a loan from her grandmother, various jobs, and selling paintings. Surrounded by the works of the great Impressionists, the industrious student quickly adopted open brushwork, natural light, and uplifting themes.

Laura's works from this period "remain among the most compelling and personal Impressionist-inspired works by a Canadian painter"[2] and earned her significant recognition abroad — the first Canadian woman to receive such acclaim. She exhibited regularly with the renowned Société des Artistes Français, earning a silver medal at the Colarossi and an Honorable Mention at the prestigious Paris Salon. Press coverage of her work included praise in the British *International Studio* and a feature illustration in the prestigious French publication *L'Illustration*.

During her years in France, Laura exhibited her work with the Royal Canadian Academy (RCA) and the Art Association of Montreal, as well as at the World's Columbian Exposition in Chicago. She also spent a number of summers teaching North American students in Holland, along with her friend Wilhelmina Hawley. After Laura returned to Toronto in 1898, the two women shared a studio and taught classes for several years. Laura was also the first woman to serve on the executive of the Ontario Society of Artists and the first invited to participate in an exhibition of the Canadian Art Club in 1909. At the time other Canadian women artists were not included in these male organizations.[3]

The Pink Dress, oil on canvas painted by Laura Muntz in 1897.

Laura actively worked as a professional artist until 1915, making a name for herself in Canadian art circles. In addition to teaching and maintaining a studio (usually in Toronto, but also in Montreal for a few years) she exhibited widely in Canada and the United States. In 1910, the National Gallery of Canada purchased one of her canvases: *A Daffodil*. Her preferred themes were women and children, a feminine subject that she painted with a masculine style. Laura regretted that she did not have more time for larger creative, allegorical works.

Laura faded into obscurity after 1915 when her sister, Ida, died. Laura married her brother-in-law, Charles W.B. Lyall (who was bored to tears by art), to manage his household and look after his eleven children. She was fifty-five at the time, and it wasn't until 1924 that the frustrated painter was able to resume her professional activities, including exhibiting at the prestigious British Empire Exhibition in Wembley. But she couldn't revive her career. She died in 1930, an unconventional woman who was once proclaimed by a leading artist as "the greatest painter in Canada, and the greatest woman painter on this continent."[4]

Quote:

"I've always wanted to paint, and still wish to paint — all day — quite simple, isn't it?"[5]

A Doukhobor Martyr

Anna Markova

1902–1978

She was passionate about family and faith — and forgiving of those who imprisoned her.

Anna Markova was finally permitted to emigrate from Russia to Canada in 1960 after enduring bitter hardship and persecution because of her Doukhobor beliefs. In a tearful reunion, she embraced the son she hadn't seen for thirty-two years. Anna became a highly respected and influential elder in the Doukhobor community in British Columbia.

Anna and her brother, Peter, were born in Russia to Anna Fyodorovna and Peter Petrovitch Verigin, peasants in a small village called Slavyanka. They belonged to a sect of Russian dissenters who lived by the slogan of "toil and peaceful life." Like other Doukhobors, they practised pacifism and rejected secular governments and formal churches, replacing the Bible with their orally transmitted psalms and hymns. And they were persecuted for their religious beliefs.

Anna's grandfather Peter Vasilievich Verigin (known as "the Lordly") was the Doukhobors' leader in Russia, but he'd been exiled to Siberia. In 1902, he was allowed to immigrate to Canada with 500 Doukhobors, joining the 7,500 who had already been permitted entry.

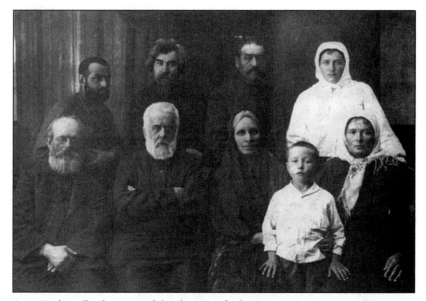

Anna Markova (back row at right) with group of Tolstoyans in Moscow, June 1928, prior to the departure of Anna's mother and son John Verigin (both at front right) for Canada.

In 1920, Anna married Ivan Semyonovitch Voykin, a young man who worked as a secretary for her father — leader of one of the groups of Doukhobors in the Caucasus area. Amid the turmoil of the Russian Revolution, Ivan was among a group of Doukhobor men who established a new settlement in the Don region. He died of pneumonia a month before Anna gave birth to their son, Ivan Ivanovitch.

The young widow and her child later joined her father's household in the Don. Her father wanted Anna's son to grow up with his surname, so he adopted the boy. Anna married Ivan Vasilievitch Markov and gave birth to her second son, Peter, in 1926.

That same year Anna's father was arrested as a dissident and sent to Kazakhstan. Later he was allowed to substitute exile for an exit visa to Canada. He wrote to Anna's mother, asking that she join him in Canada with their adopted son. Anna Markova's oldest child disappeared from her life.

In 1935, Anna Markova, her husband, and her brother were arrested. Innocent of any crime save being Doukhobors, the threesome were sentenced to ten years in labour camps. She was torn away from her

237

nine-year-old child: "Our son, Peter, was left to the mercies of fate since there were no close relatives who could take care of him."[1]

Anna, her husband, and brother suffered horrendous conditions in the labour camps, where millions died. They were separated and often knew nothing of the others. Anna was the only one of the threesome to survive. Her husband was shot in 1938 and her brother perished in 1942. Anna was moved from one camp to another, criss-crossing eastern Siberia.

Friends cared for Peter for the first nine years of her incarceration, but he was arrested in April 1944 on charges of being a pacifist and draft-dodger. He was taken directly into the Red Army and put on the front lines in the Second World War. Peter was killed in battle near Berlin in April 1945.

Anna wasn't liberated until 1947. She spent the next four years as a displaced person, earning money by doing housework. In May 1952, she was arrested again and sentenced to life-long settlement in another region. She was finally freed in 1954 after an amnesty was declared. Dispirited and in poor health, Anna felt "denuded, despoiled and dispossessed."[2]

Canadian Doukhobors appealed to Soviet leader Nikita Khrushchev and Anna was allowed to emigrate. She became the first Doukhobor since the 1920s to legally leave the U.S.S.R. for Canada.[3] After a tearful reunion with her son, honorary chairman of the Union of Spiritual Communities of Christ (USCC), Anna finally began a life in freedom in 1960.

Anna became an important figure in the Doukhobor community in Grand Forks, British Columbia. Eager to help preserve Doukhobor society and heritage, she organized and motivated women to work together. She supported efforts to build the Brilliant Cultural Centre and the creation of the Kootenay USCC Ladies Organization. Anna helped the less fortunate, shared her knowledge of Doukhobor history and philosophy, assisted the local choirs, and helped compile a hymn book.

Anna Petrovna Markova died after eighteen happy and fruitful years in Canada. One of the first Canadian Doukhobor social activists, she is still remembered as a visionary. The local newspaper noted, "She was zealous, but not a zealot, and a staunch advocate of enlightenment, family unity, spiritual and moral rebirth."[4]

Anna was buried in Verigin Memorial Park in Brilliant, British Columbia. Markova Road and the Anna Petrovna Markova Room in the Doukhobor Village Museum in Castlegar were named after her, and local singers dedicated an album of hymns to her. The film *Anna Markova: Forgiveness in Exile* documents the extraordinary life of a woman who remained true to her faith despite the hardships she experienced because of it.

Quote:

"I lost my two children: one I kissed goodbye to at the age of six as he left for Canada, and the other, by the whims of fate, at a few months past eighteen years of age, became the victim of such circumstances as makes it very, very hard for me to talk about."[5]

A Toppled Legal Heroine

Clara Brett Martin

1874–1923

She accomplished something no other woman in the British Empire had done. Become a lawyer.

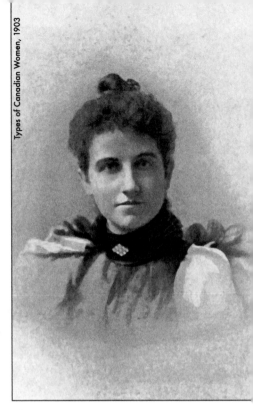

Types of Canadian Women, 1903

Clara Brett Martin.

Clara Brett Martin's achievement was exceptional for a time when doctors claimed that higher education was hazardous to the less robust sex. Physicians cautioned that serious study could even weaken the wombs of these frail creatures.

Clara didn't fall for those ideas, nor did her parents. The Martins believed in university education when fewer than one in 100 Canadians pursued post-secondary training: all twelve of their children spent at least some time in university. Clara signed up at Trinity College in Toronto in 1888, three years after women were admitted. She majored in mathematics and graduated with an honours B.A. at sixteen.

Clara dared to aspire to be a lawyer in the all-male legal system, when women couldn't yet vote or sit in provincial or federal legislatures. In 1891, she applied to the Law Society of Upper Canada, but was refused admission. When she took legal action to obtain access to the profession for women, some men opposed legislation became it would be "disastrous to the best interests of women."[1] Opposition leader

William Ralph Meredith also doubted that women would want to wear the unfashionable official robes worn by male litigators.

Due to the involvement of influential supporters such as suffragist Dr. Emily Stowe and Premier Sir Oliver Mowat, a law was passed in 1892 in Ontario permitting women to become solicitors. There was still grumbling in the Law Society, but members eventually allowed Clara to study law in 1893. She continued to face hostility and abuse — from the male lecturers who tried to embarrass her with sexual references, to fellow students who hissed when she entered the classroom. When Clara began articling, she switched firms after being treated miserably. But she persevered and placed first in her exams.

Clara was a solicitor but wanted to be a barrister as well. The legendary Lady Aberdeen, the National Council of Women, and the International Council of Women lobbied on her behalf. After MPP Bruce Wood introduced a motion to allow women to become barristers, there was vociferous debate about the dangers to homes and womanhood, but the bill eventually passed. The Law Society still refused to accept Clara.

The society gave in only after being pressured by Sir Oliver Mowat and some wealthy clients. At twenty-three, Clara was admitted to the Law Society as a barrister and solicitor on February 2, 1897. She was the first woman in the British Empire to become a full-fledged lawyer. Earning her Bachelor of Civil Law in 1897, she received her LL.B. in 1899.

Clara joined a Toronto firm and became a partner in 1901. In 1906, she established her own office, focusing on family law, wills, and real estate. She built a successful practice but seldom appeared in court because of the commotion her presence created. Clara owned her own home in a pleasant residential area of Toronto, plus seven row houses in Cabbagetown that she rented out.

Clara lectured frequently to women's groups and supported legal equality for married women. She lobbied for female suffrage, fundraising for day nurseries,[2] and the creation of a special court for women. A member of the Toronto Collegiate Institute Board and the Public School Board, Clara fought for a variety of causes, including meals for impoverished children. The energetic reformer never married.

Clara Brett Martin died suddenly from a heart attack in 1923, at forty-nine. Toronto newspapers praised her and she was later widely

recognized for her accomplishments. *The Canadian Encyclopedia* continues to credit her as a heroic trailblazer. In 1989, the new building housing the Ministry of the Attorney General in Toronto was named in her honour. At the reception that followed, a dramatic re-creation of her struggles brought many in the audience of 600 to tears.

In July 1990, an Ontario law professor published a letter that Clara had written in 1915 claiming that Jews were exclusively responsible for unethical real-estate practices in Toronto. Clara asked for legislative action. Though such racial prejudice was common at the time and Clara employed a Jewish woman as a secretary and bookkeeper, the lawyer's anti-Semitic beliefs quickly pushed her from her pedestal. She was vilified after the startling revelations were made public. The Ontario government removed Clara's name from the building that honoured her, the University of Toronto quickly cut references to the legal pioneer from its "Clara Brett Martin Workshop Series," and Osgoode Hall Law School abandoned its plans to name a new feminist institute after her.

Assessing Clara's change in status, legal historian Constance Backhouse suggested that we had been holding her "to a model of purity which will be met by very few — perhaps none in her own time, or today. This conception of a heroine as perfect and omniscient is binding, restrictive, and remarkably rigid."[3]

Jewish radical-lesbian feminist Lynne Pearlman, a lawyer who admired Clara Brett Martin's struggle, came to the difficult decision that she could not forgive her nor could she give her up as a role model: "I refuse to make a choice.... I feel as strongly about her struggle being honoured, not jettisoned, as I do about her anti-Semitism being exposed and denounced."[4]

Quote:

"If it were not that I set out to open the way to the bar for others of my sex, I would have given up the effort long ago."[5]

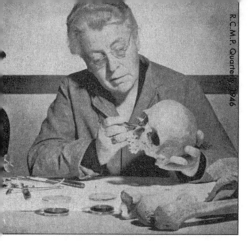

Dr. McGill in her laboratory.

The Sherlock Holmes of Saskatchewan

Frances Gertrude McGill

1877–1959

A brilliant forensic pathologist and one of the country's leading criminologists, she had a genius for solving mysteries.

The RCMP thought they had their man, until Dr. McGill investigated. After a young farmer was found shot in the head, the police arrested a neighbour. Dr. McGill's analysis eventually determined that despite the fact that the victim was shot with the accused's shotgun, and that the accused was covered in blood, the dead man had actually committed suicide by shooting himself and hiding the gun before dying. She also proved that the supposedly incriminating blood stains were not human, but from a wounded farm animal.

Dr. Frances Gertrude McGill was a pioneer in many ways. Born and raised on a family farm in Minnedosa, Manitoba, she taught school for several years to finance her university studies. She initially studied law, but switched to medicine and graduated at thirty-seven. Frances was a brilliant student, receiving the Dean's Prize and the Hutchinson Gold Medal for highest marks as well as a surgery prize.

After serving as the provincial bacteriologist in Saskatchewan, Dr. McGill accepted a job as provincial pathologist. In 1922, she

became the director of the provincial laboratory, where she focused on investigating suspicious deaths. The RCMP did not establish a crime lab until 1937, so Dr. McGill conducted all the forensic autopsies and related analyses for police forces and the RCMP in Saskatchewan. Frances had found her calling as a shrewd investigator with a talent for crime detection. Many called her the Sherlock Holmes of Saskatchewan.

Dr. McGill travelled thousands of kilometres to crime scenes across the province in all kind of weather. In 1934 alone, she made forty-three trips to investigate crimes. On one case she ventured as far north as the Arctic Circle. She was robust and strong, a woman who considered service to the RCMP her number one priority. Her male colleagues admired her "unboundless energy and invincible determination,"[1] and the fact that she would work to the point of exhaustion. Nobody ever doubted her dedication or that she could face the grisliest crime scene. In addition to her scientific expertise and investigative skills, Dr. McGill was admired for being a gifted communicator with a great sense of humour and a skilled horseback rider.

Dr. McGill successfully combined her knowledge of law and medicine in search of the truth, earning widespread renown for her meticulous investigations, shrewd detective work, and her unshakeable testimony as an expert witness in murder cases. She was difficult to cross-examine, and pointed in her remarks. "Ask sensible questions and I will answer them,"[2] she told one lawyer.

Though she retired as provincial pathologist in 1942, Dr. McGill continued to practise medicine. When the director of the newly created RCMP Crime Lab in Regina died in a plane crash the following year, she quickly stepped in to manage the lab temporarily. Dr. McGill lectured at the police college in Regina, teaching forensic medicine to a new generation of crime stoppers.

In 1946, the RCMP named Dr. Frances McGill the Honorary Surgeon to the RCMP, recognizing her dedication to the force. Well-known across Canada and highly esteemed, she contributed to the development of scientific analysis in crime cases.[3] She was an outstanding criminologist and forensic pathologist who demonstrated the importance of forensic medicine in criminal investigations.

Dr. Frances McGill died in Winnipeg in 1959, at eighty-one. Saskatchewan named McGill Lake, north of Lake Athabasca, in her memory.

Quote:

"Think like a man, act like a lady and work like a dog."[4]

The Lumberjack Who Made Movies

Dorothea Mitchell

1877–1976

The first single woman to be granted a homestead in Ontario, this indomitable pioneer reinvented herself time and time again.

Courtesy of the personal collection of Michel S. Beaulieu

Dorothea Mitchell at Silver Mountain, pre-1921.

Funny how childhood lessons and experiences mould an individual. Dorothea Mitchell's mother taught her two daughters to be fearless and independent. Mrs. Mitchell allowed them to ride half-wild ponies, swim in murky waters, climb cliffs, and learn carpentry from an undertaker. She taught the girls to dance and how to write stories. When Dorothea was twenty-seven she immigrated to Canada, confident that she was equipped with the abilities to "stay on top"[1] in even the most trying circumstances.

Dorothea Mitchell was born in Lancaster County, England, but grew up in Bombay, India. Her father travelled extensively, overseeing railway construction in the British Empire, and decided to have his family join him in the British Raj in the early 1880s. Dorothea enjoyed the luxurious lifestyle and freedom, becoming an adventurous spirit during the years in India. In 1894, the girls moved back to England because of Mrs. Mitchell's ill health. Three years later they received tragic news: Mr. Mitchell had died suddenly in India.

Dorothea and her sister, Vera, immediately became the breadwinners of the family, working as governesses. After years of drudgery, Dorothea decided to establish herself in Canada and then bring over her mother and sister. The solitary settler soon found employment in Toronto as an assistant manager in a hotel. She bought a rooming house, and earned extra money by teaching dancing and swimming. When it became clear that her mother was still not well enough to move to Canada, the adventurous Dorothea headed for the bush.

In 1909, Dorothea travelled about 1,400 kilometres west to Silver Mountain, Ontario, where she had accepted a job to be a companion to the wife of a superintendent in a mining camp. The tall, attractive redhead got a lot of attention as the only woman in the area between sixteen and forty. The mine closed, but Dorothea decided to stay on. Resourceful as always, she juggled jobs as station master on the Port Arthur–Duluth railway, postmaster, and manager of her own general store. In late 1910, Dorothea petitioned the Ontario government to be granted a free homestead.

After initial delays, the government claimed that unmarried women, weren't entitled to land grants. Dorothea refused to take no for an answer. After more than a year of letter-writing, appeals to the deputy minister of Lands and Forests, and the resubmission of her application when the first one mysteriously disappeared, the government reversed its decision. On July 29, 1911, Dorothea became the first single woman to be granted a homestead in Ontario.

The victory was bittersweet. The province refused to grant her the standard allotment of 160 acres; Dorothea recieved just seventy-nine. When she dared appeal the judgment, the government said that "not being a married women you are not strictly entitled to a free grant."[2] But at least thirty-four-year-old Dorothea was the proud owner of a homestead. By the time her mother and sister joined her, some land had been cleared and a hewed-log house awaited them.

Dorothea bought a sawmill in 1914 and hired some men to work for her. She managed an efficient operation and was actively involved in every aspect of the business, from scrambling up mountainsides in deep snow to filling in as engineer for three months and stoking the firebox with a cord and a half of wood per day. It was such hard work that she

lost thirteen pounds in the first two weeks. The workers knew that Miss Mitchell could handle any of the jobs in the mill and dubbed her the "lady lumberjack."[3]

Dorothea decided to retire from lumbering in 1921, moving to Port Arthur to join her sister. At forty-four she got involved in a variety of different business ventures. After enrolling in business college, she was soon teaching there and working as an accountant, eventually opening her own firm and selling real estate. She also starred in a play at the Lyceum Theatre in Port Arthur.

In 1929, Dorothea and her friends Fred Cooper and Harold Harcourt formed the Port Arthur Cinema Society after Fred bought a movie camera. Working out of Dorothea's office, the threesome created a silent movie called *A Race for Ties* — the first Canadian-made amateur feature-length film. She wrote the script, served as production manager, editor, actor, wardrobe manager, and director. The film's local popularity encouraged the friends to develop a second film, but their third production (a murder mystery entitled *The Fatal Flower*) had to be abandoned in 1930 due to lack of funds.

By 1930 both Dorothea's sister and mother had died. Dorothea, always eager for new challenges, bought an insurance agency, managed a volunteer agency during the Second World War, and signed up with the Red Cross overseas at sixty-three. Too old to ship out, Dorothea served with the organization in Canada and helped locate suitable homes for British Child Guests during the war.

In 1944, Dorothea began a new life in Victoria, British Columbia, where she became an active member of the Canadian Authors Association and the Victoria Amateur Movie Club. She put her considerable writing skills to good use by penning an autobiography. At ninety-two, Dorothea published *Lady Lumberjack*. She died in Victoria in 1976 after nearly 100 years of adventure.

Thanks to Lakehead University's Michael S. Beaulieu and Ronald N. Harpelle, Dorothea's remarkable autobiography was republished. A group of Thunder Bay film buffs went to considerable effort to complete the silent picture she was unable to finish so long ago. Seventy years after she worked on *The Fatal Flower*, the film was shown to an enthusiastic crowd.

Dorothea Mitchell (centre, with a black wig) on the set of *A Race for Ties*, 1929.

Quote:

"I, a mere female, was able to survive in what was certainly a man's world long before an executive in skirts had come to be a phenomenon that was accepted as only slightly unusual."[4]

The Trader

Sophie Morigeau

circa 1836–1916

She proved a woman's place could be on the trails of the rugged Rockies, thriving as a free trader.

Fort Steele Park interpreter Wynn Rower-Towers in the role of Sophie Morigeau.

Sophie Morigeau was tough. So tough that she amputated her protruding rib after an accident with a runaway horse and buggy — and hung up the piece in her cabin with a pink bow.

Sophie's career choice was as unusual as she was. Running a pack train in the borderlands of northwestern North American was risky business, but the fearless Métis was up to the challenge. Travelling alone in the mountains, fording raging rivers, camping in all kinds of weather, and confronting rival traders were familiar to Sophie, a child of the fur trade.

Catholic priest Father Modeste Demers baptized Sophie at the Jasper House trading post in 1838. She was raised in a large extended family of trappers and fur traders, primarily free traders. Her mother was Elizabeth Taylor, daughter of a Scotchman who settled in Red River and a Métis woman. Sophie's biological father was probably Patrick Finley, son of the famous Jocko Finlay who helped David Thompson set up trading posts. By the time Sophie was baptized, her mother was living with a Montreal-born

trader named François Baptiste Morigeau. Sophie grew accustomed to an itinerant lifestyle as her family moved from place to place when trading opportunities changed. She spent much of her childhood in the Upper Columbia area of the Kootenays, where her step-father was a free trader.

With increasing settlement and diminishing returns in fur trading, the Morigeaus moved to Fort Colville, where they could obtain free land. Sophie may have attended a mission school for a few years, though it seems she could not write. At sixteen, she wed trader Jean Baptiste Chabotte in a Catholic ceremony. For a mixed-blood girl it would have been considered a good match to marry a white man. By 1860, the marriage fizzled and Sophie was single again.

The marriage fizzled and Sophie was single again by 1860. She decided to remain independent, using Morigeau as her surname, though many men drifted through her life. According to one source, "[she] seldom lacked for masculine company if she so desired ... some outsmarted her and some merely tried, winding up extinct."[1]

Sophie became a free trader. As recounted by her great-grandniece, "Sophie Morigeau, scorning to lead the servile life of a squaw, and of most women who were even half white or red, initiated her own enterprise."[2]

When the Wild Horse Gold Rush broke out in 1863, Sophie was caught up in the excitement and headed north, chasing new opportunities as her family had always done. Being a Métis woman — at a time when gender and race often limited your prospects — didn't stop Sophie from running a pack train from Washington and Montana north to supply the miners. She was a regular visitor to Fort Steele, just a few miles from Wild Horse Creek.

The new Canadian-American border was no impediment. She roamed the north-south corridor known as the Tobacco Plains, which she had travelled throughout her life and where she had family members. Like the Morigeau and Finley men, Sophie was a sharp trader and turned a good profit. She did business with whites and Natives alike, presenting whatever side of her own racial heritage best suited the situation.

After Fort Steele closed down in 1870, Sophie returned to her childhood home in the Windermere Valley area of British Columbia to set up her own trading post. In 1872, she obtained 320 acres of land along Lower Columbia Lake. One of the first British Columbian women

who dared to claim land on their own,[3] Sophie operated her business from the homestead. She continued to trade along the Tobacco Plains corridor on both sides of the border until about 1880, when she moved south to the Eureka, Montana, area.

Sophie kept a good herd of cattle, as well as horses, on her new homestead and hired prospectors to find good mining sites. Never one to pass up a business opportunity, she decided to do some trading in Canada where the construction crews were building the transcontinental railway. She took her pack train to Golden, British Columbia, to sell contraband liquor she'd concealed under her goods. When the local suppliers chased her away, Sophie headed east to Calgary, where she made a big profit.

Sophie then stuck closer to her trading post on Tobacco Plains, where she died at eighty in 1916. She became a legendary figure on both sides of the border, a colourful character who stashed a box of gold coins under her mattress and wore a patch over her eye.[4] Well-liked, she helped those in need and served as a role model for youngsters she befriended. A marvel at adaptation, she was a daring trailblazer and a gracious hostess, serving her guests strawberries, cake, and whipped cream on a white tablecloth.

Sophie defied convention (and racial and sexual stereotypes) to became a successful businesswoman on the frontier. The remarkable Sophie Morigeau returns to the reconstructed Fort Steele each summer as a popular character in the park interpretive program.

Quote:

"Oh, [I] just cut a hole in the bottom of the box and hung 'er over the saddle horn."[5]

— Sophie's response when quizzed about how she managed to transport an entire wagon by pack train.

Kirkina Mucko at right, with Benjamin Butt, 1909.

A Labrador Legend

Kirkina Mucko

1890s–1970

Dr. Grenfell wept at the sight of her disability.[1] But Kirkina's life was full of courage and optimism continues to inspire.

Elizabeth Jefferies (later known as Kirkina Mucko) was about two years old when tragedy struck. After her Inuit mother went into labour with a second child, Elizabeth's father, Adam, left their isolated cabin on the coast of Labrador to find a midwife. The Scottish/Inuit trapper returned alone several days later, after being caught in a blizzard. To his horror, the cabin was freezing. His wife had given birth to a new baby, but couldn't manage to tend the fire in the wood stove. Two-year-old Elizabeth's legs had frozen and her feet had turned black. Gangrene had set in.

The only hope of saving the child's life was amputation. After stoking the fire, Adam grabbed his axe and chopped off both her legs below the knees, placing the stubs in a barrel of flour to soak up the blood. He carefully sewed up the wounds with caribou sinew and applied juniper bark ointment to prevent infection. Elizabeth survived, but her father drowned a few days later.[2]

Several years after the amputation, the famed medical missionary Dr. Wilfred Grenfell — who established hospitals, nursing stations, and

orphanages on the coasts of Labrador and northern Newfoundland — discovered Elizabeth. He was dismayed to see the four-year-old clumsily hobbling around on her severed limbs. Dr. Grenfell arranged for the child to undergo surgery on her protruding leg bones in Battle Harbour. The medical staff fitted the child (who'd been baptized as Kirkina) with artificial legs, suddenly bringing her a new world of opportunity.

When Dr. John McPherson, a physician at Battle Harbour, and his wife returned to New York, they took Kirkina along; she underwent additional surgeries while attending school. After Dr. McPherson transferred to a hospital in Mexico, Kirkina spent summer holidays with the family and received some education there. She was fluent in Spanish by the time she graduated from grade twelve.[3]

Kirkina travelled with Dr. Grenfell in the United States and Great Britain, recounting her heartbreaking story to help raise funds for the Grenfell Mission in Newfoundland and Labrador. Eventually, he set up a Kirkina Fund.

When Kirkina was nineteen, Mrs. McPherson died and the young woman returned to Labrador. She worked at the Grenfell Mission for several years. After marrying a French-Canadian Inuit trapper and fisherman named Adam Mucko, she settled in Rigolet. Like many other families in the area, they were poor. The challenge of raising their seven children became even more daunting when they couldn't afford replacement artificial limbs. Once she had outworn the prosthetics, Kirkina had no choice but to hobble around on her knees, protected only by leather pads.

Things got worse when the 1918 Spanish Flu pandemic hit the coast of Labrador. Adam Mucko died, as did three of the children. Three more died later of other illnesses. After burying most of her family, Kirkina began building a new life for herself and her daughter. She studied nursing and midwifery with Dr. Paddon at the mission hospital in St. Anthony, Newfoundland. After returning to Labrador, Kirkina travelled along the coast for three decades as a midwife — often without artificial legs.

In the fall of 1950, Kirkina went to St. John's Orthopedic Hospital to be fitted for new prosthetics, thanks to the donations of some pilots who'd heard about her predicament. After a week of therapy, she could walk again. "It's nice to have legs again, after being without them for 27 years."[4]

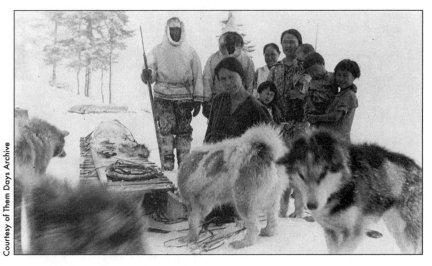

Courtesy of Them Days Archive

Kirkina Mucko, centre.

Kirkina continued to serve as a midwife and nurse in Labrador, spending her senior years in comfort with her daughter and family in Happy Valley-Goose Bay. The courageous woman who had encountered so much misfortune died in 1970. She was ever optimistic in facing adversity and hardship — an inspiration to those whose lives she touched. The province of Newfoundland and Labrador recognized Kirkina's heroism by including her in a series of twenty educational posters that profile people who have influenced the province's history and culture.[5] In 2010, the new women's shelter in Rigolet was named Kirkina House in her honour.

Quote:

"I was put in the world to do all I did, and to go through all I did. I had full and plenty and I never had any regrets."[6]

Born to Fly

Marion Orr

1916–1995

More than a great pilot,
she was one of the most
amazing women in the
history of Canadian
aviation.

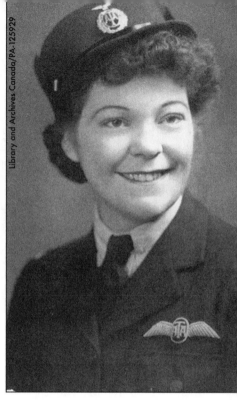

Marion Orr in England with the Air Transport
Auxiliary.

"I was always crazy about airplanes," Marion Powell Orr said. "I used to try and fly off the roof of the house in homemade contraptions."[1]

As a child in Toronto, Marion Powell regularly walked six miles to watch the planes at Barker Field. She read everything she could about flight, and stories of the legendary Amelia Earhart inspired her to succeed in the male-dominated world of aviation. Orphaned at fifteen, Marion had to quit school and work in a factory for $12 a week. Since flying lessons cost $9 an hour, it took six years of scrimping before she could sign up. Marion finally obtained her private pilot's licence on January 5, 1940.

She worked as an aircraft inspector for De Havilland in Toronto while working toward a commercial licence, which she received on December 12, 1941. Marion married her flying instructor, Doug Orr, but the marriage was short-lived.

Hired as manager and chief flight instructor by the St. Catharines Flying Club in 1942, Marion was the first woman in the country to operate a flying club. After a disastrous fire destroyed the planes and hangar, she

got work at Goderich Airport. Ever a trailblazer, Marion became the second Canadian woman to qualify as an air traffic control assistant.

During the Second World War, the young pilot was eager to take to the skies but was turned down by the Royal Canadian Air Force, even though inexperienced men were accepted. She was ecstatic when her friend Vi Milstead told her the Air Transport Auxiliary (ATA) was hiring women pilots to ferry military aircraft from factories to bases in the United Kingdom for the Royal Air Force. Along with three other Canadian women, Marion and Vi joined the ATA. Marion flew her first ATA flight on June 2, 1943.

Marion had the thrill of a lifetime when she flew the fastest and largest aircraft in the world in often dangerous conditions. She operated under visual flight rules (VFR) without radio facilities or instrument training. Marion flew most days of the two years she was stationed in Britain: up to eight flights and four or five different aircraft, including Mosquitoes, Hurricanes, and Spitfires, Marion's favourite. When she reluctantly left the ATA at the end of the war, the fearless pilot had flown about 700 hours on sixty-seven different types of military aircraft.

Struggling with emotional letdown following the war, Marion looked for new opportunities to fly. The banks refused to give her a loan, but she scraped together enough money to establish the Aero Flying School in Barker Field in 1949. The first woman in Canada to own a flying club, she trained in aeromechanics so she could maintain the planes herself. Desperate to build her business, she lived in her office for months and sold her car, most of her belongings, and any pop bottles she could find. She bought a Chipmunk aircraft for instrument training with the proceeds.

After Barker Field was sold, Marion established an airfield and flying school in Maple, Ontario. When anti-development residents passed a bylaw to block the airport after Marion had already spent $5,000 and built a runway, she drove to Ottawa to seek assistance from Prime Minister Louis St. Laurent. She convinced him to help, and Marion completed her airport, often by the light of her car headlights. The airport's grand opening in 1954 featured an air show with Marion and pilots Sally Wagner and Helen Hems flying Fleet Canucks. Reporters marvelled at "Canada's Only Woman Airfield Boss,"[2] marking another first for a Canadian woman. She soon had seven instructors and ten aircraft.

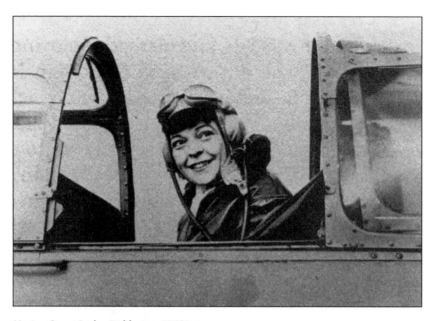

Marion Orr at Barker Field, circa 1950.

Exhausted by the strain of establishing her business and working eighteen-hour days to maintain it, Marion sold the airport and flying school several years later. She joined her sister in Florida. When flying lured her back to Canada, Marion became the first Canadian woman to earn a helicopter licence, in 1961, and then an instructor's licence. The pilot's flying days were put on hold after a helicopter engine failed, and her back was broken in the crash. Marion returned to flying after she recuperated and continued to teach until losing her licence in 1994. She died a year later, having flown more than 20,000 hours over fifty years.

Marion received many honours, including the Amelia Earhart Medallion for her contributions to aviation. She was also named to Canada's Aviation Hall of Fame, awarded the Order of Canada, and was among the pioneers honoured by Queen Elizabeth II at the dedication of the Western Canada Aviation Museum in 1984. A CBC documentary called *Airborne* pays tribute to the pioneer pilot who lived to fly and trusted airplanes more than people.

Quote:

"I felt so empty. It was as if my whole life was behind me. I knew I would never get near a military airfield again, never get a chance to fly those fast planes. I had all that experience and I knew that I couldn't put it to use in Canada."[3]

— Marion Orr's reflections after the Second World War.

A Fujin[1] Pioneer

Yoko Oya

1864–1914

She arrived with hope for a good life in Canada — and the courage to be the first Japanese woman to settle here.

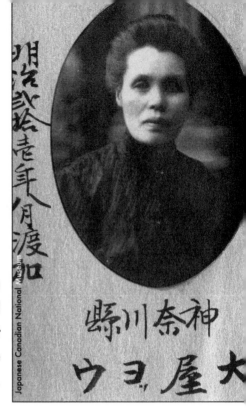

Yoko Oya.

Yoko Oya (née Shishido) was born in Kanagawa prefecture in Japan in 1864. As a twenty-three-year-old bride, she said goodbye to her family. She would never see most of them again. A nervous Yoko and her husband, Washiji Oya, boarded a CPR steamship — loaded with tea, silk, rice, mail, merchants, and Japanese workers — in Yokohama in 1887. They were bound for a new and unfamiliar world across the Pacific.

Washiji had seen Vancouver several years earlier while working on a ship that docked in the city. He vowed to return with a wife and build a life there. When Yoko walked down the gangplank in the scenic port of Vancouver, she became the first Japanese woman to immigrate to Canada. The young woman was likely anxious about settling in a country with a foreign language, laws, and customs.

It was an exciting time to start a new life, and Vancouver offered many opportunities for industrious new arrivals. Vancouver had 1,000 residents — only about a dozen Japanese — and the city was the Pacific terminus of the Canadian Pacific Railway. In fact, the first passenger train

arrived the same year as the Oyas. The couple settled near the Hastings Lumber Mill in what became known as Little Tokyo.

Washiji worked as a labour contractor at the Hastings Mill, and later built a general store and house on Powell Street. This was Yoko's new home, in a tree-covered area that was so low-lying that she had to wear rubber boots. She probably worked in their store, the first general store in the community. The Oyas initially felt welcome in their new homeland. But the year they arrived a white mob attacked a Chinese camp on False Creek, and the next year some whites smashed Japanese fishing boats.

Yoko gave birth to her first son, Katsuji Oya, in 1889. He was the first Canadian-born Japanese child, or Nisei. The following year she gave birth to her second son, Jiro. The Oyas must have been prosperous, as they sent both children to Japan to be educated. The boys returned to Little Tokyo, where Jiro managed the family store at 463 Powell Street until 1942.

There are few records about Yoko or the challenges she must have faced as an immigrant. Her younger sister, Kinuko Uchida, arrived in 1889, followed by another sister, Ima Suzuki, and Washiji's niece, Naka Sekine. The four Fujin pioneers supported one another. Though there are no recollections about Yoko, her experiences were probably similar to those of her sister, Kinu, as described by daughter Chitose:

> Like all pioneer wives, mother's life was one of hardship and work, full of ups and downs, mainly downs. She was the hub of the wheel which kept us all moving while she helped father every step of the way in all of his endeavours."[2]

Chitose also noted that her mother didn't know any English, and presumably Oyo didn't either. It was possible that they spent their days talking Japanese, having no contact with non-Japanese. By 1897, there was a weekly Japanese-language newspaper.

With increasing immigration from 1892 to 1894, white Vancouverites grew anxious about competition for jobs and some Japanese had to resort to begging. In 1899, Washiji and Yoko learned that city council had

decided to deny Japanese residents the right to vote. The following year Japan halted immigration to Canada, but a loophole in the legislation eventually resulted in a large influx of Japanese. By 1907 there were about 18,000 Japanese people in Canada.

The surge of immigrants triggered a large anti-Asiatic riot in Vancouver. We can only imagine Yoko's fear as a mob of white supremists swept through both Chinatown and Little Tokyo on September 7, 1907. The violent rioters smashed windows and damaged sixty homes and businesses on Powell Street.

The Japanese residents received $9,000 in compensation, but the prejudice against the immigrants remained. In 1909, Japan agreed to restrict emigration to only 400 people per year. We know nothing of how Oya felt about her unwelcoming homeland when she died in 1914, at forty-years-old. She was buried in Mountainview Cemetery.

Thanks to the grit and determination of pioneers such as Yoko Oya, Japanese immigrants established themselves in Canada. Yoko's niece, Chitose Uchida, was the first Japanese Canadian to graduate from the University of British Columbia.[3]

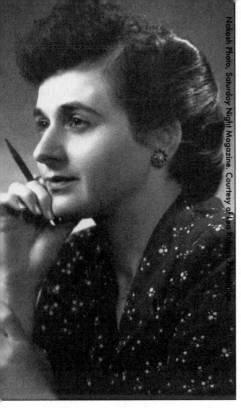

Walking the Picket Lines

Madeleine Parent

born 1918

Why did Quebec's Premier Duplessis, the Catholic church, and powerful textile companies try to stop this woman?

Madeleine Parent, at the time of her trial in 1947.

A heroine of the labour movement, Madeleine Parent organized strikes that improved workers' lives but antagonized those in power. She earned the wrath of the ruthless Maurice Duplessis, who tried to halt her work and had her arrested five times. In 1947, she was charged with seditious conspiracy. Convicted and sentenced to two years in jail, the committed union organizer and activist was never imprisoned. She was eventually acquitted in 1955.

Born into a middle-class family in Montreal, Madeleine attended the best schools. But even as a young student she began noticing the exploitation of servant girls and other class-based injustices. Madeleine went to McGill University to avoid the constraints of a religious institution. Eventually focusing on sociology, she became involved with a number of campus associations as well as with the militant student movement.

Despite opposition from professors, Madeleine invited feminist Thérèse Casgrain to lecture on the right of Quebec women to vote. Madeleine participated in numerous student protests and joined the

Civil Liberties Union. Following one of the meetings she met trade-union organizer Lea Roback, who mentored the younger woman and became a lifetime friend. After Madeleine graduated from university in 1940, she became a union activist to help the disadvantaged.

Madeleine fought to alleviate the horrendous working conditions in Quebec's cotton and woollen mills, where the predominantly female workforce often worked fifty-five-hour weeks and children as young as fourteen laboured for meagre wages. In 1942, she led the campaign to unionize workers at Dominion Textile plants in Montreal and Valleyfield. She partnered with fellow union activist Kent Rowley, who she later married, to organize the United Textile Workers of America (UTWA). By 1946 the pair led 6,000 cotton workers in a successful strike for a new contract.

The favourable outcome was an incredible achievement given the situation. The company spread rumours that Madeleine was a spy dropped off by a Soviet submarine on the Gaspé Peninsula in the war, and hoped that the story would be believed in the Cold War context. The provincial police hassled picketers, threatened the workers in their homes, protected scabs, and raided the union office. Parish priests conducted anti-strike masses and escorted scabs across the picket lines. In Valleyfield one night, 250 policemen arrived, armed with machine guns, to confront strikers and their families and doused them with tear gas. Rowley was jailed.

Violence erupted at the 1947 strike in Lachine, and Duplessis accused Madeleine and her husband of being communists. Duplessis ordered both be arrested and charged with seditious conspiracy. By postponing their second trial for years, he fostered lingering doubts about their integrity. An anti-Duplessis judge finally exonerated the pair.

Madeleine and Kent worked to develop independent Canadian unions after Quebec workers lost out in a deal arranged by Duplessis and Dominion Textile in 1952. That same year, the international office of the UTWA fired Madeleine based on the unfounded accusation that she was a communist.

The husband and wife duo founded the Canadian Textile and Chemical Union in 1952 and the Confederation of Canadian Unions in 1969. In addition to becoming a labour legend in Quebec, Madeleine also played a

key role in strikes in Ontario in the 1970s, such as the 1979 Purtex battle over surveillance cameras. After her husband died in 1978, Madeleine continued working for the union movement. She retired in 1983.

Throughout her life, Madeleine has been a reformer seeking social justice, particularly for women, new immigrants, and First Nations. She campaigned for pay equity and the right to abortions, and rallied feminists to support Mary Two-Axe Early's struggle to restore the Native rights to women who married non-Aboriginals. In 1972, Madeleine helped found the National Action Committee on the Status of Women (NAC) and served as the Quebec representative for eight years. In the 1990s, she worked for the NAC campaign assisting Bosnian and Croatian women in prisoner-of-war camps. Wherever there was a need for support, Madeleine was on the march: she joined the Bread and Roses March in 1995, the World March of Women in 2000, and protests against the North American Free Trade Agreement in 2001.

Madeleine continues to be an inspirational figure for activists and has been widely praised by her contemporaries. A documentary was made about her life. The Parent-Roback House in Old Montreal now houses Quebec organizations that promote women's rights. In recognition of Madeleine's outstanding contributions as a union leader, feminist, and social activist she received honorary degrees from a number of universities. As politician Monique Simard noted, "In a lifetime, one meets few characters like Madeleine ... someone who has confronted giants."[1]

Quote:

"Every labour battle teaches a worker how to fight. Nothing is ever completely lost."[2]

The Designing Nun

Esther Pariseau

1823–1902

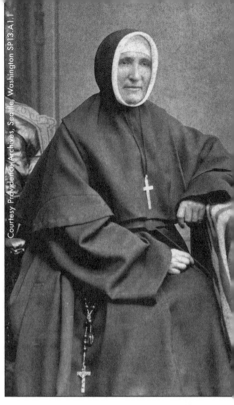

One of the first architects in the Northwest, Mother Joseph built hospitals, schools, and orphanages.

Mother Joseph of the Sacred Heart, circa 1882.

Clad in her black habit, seventy-seven-year-old Mother Joseph (born Esther Pariseau), climbed the ladder at the construction site in New Westminster every evening after the workers left.[1] Hammer in hand, she inspected the day's progress and scrutinized every detail. A perfectionist who demanded the best craftsmanship and finest artistry, she was known to tear up shoddy work and repair it herself. Mother Joseph expected nothing but the best at the Providence St. Genevieve Orphanage, the last building that she planned and supervised.

Recognized as one of the first architects of the Northwest, the Quebec-born nun designed and oversaw construction of more than thirty buildings in southern British Columbia, Washington, Montana, Idaho, and Oregon. In Canada, she founded and built St. Mary's Hospital in New Westminster (1886), St. Eugene Hospital in the Kootenays (1890), St. Paul's Hospital in Vancouver (1894), the St. Eugene Hospital in Cranbrook (1900), and the Providence St. Genevieve Orphanage in New Westminster (1900). Mother Joseph erected these buildings with

the Sisters of Providence, whose territory eventually included British Columbia, Alberta, and Yukon, as well as several northwestern states.

In 1856, Quebec-born Esther Pariseau was chosen to create a Catholic mission for the Sisters of Providence in Nesqually, Washington. Well-trained for life in the wilderness, the intelligent and industrious young woman had mastered traditional domestic tasks, as well as carpentry and woodwork. During her religious training, she'd gained experience in nursing, pharmaceuticals, candle-making, baking, and sewing.

Named the superior despite her youth, Mother Joseph of the Sacred Heart served in the West for nearly half a century. Throughout her career she dutifully reported back to the mother house in Montreal, where she occasionally travelled to purchase equipment, recruit more nuns, and fundraise. She also studied sculpture and statuary there.

Armed with deep faith and compassion, simple tools, and myriad skills, Mother Joseph ventured to the Northwest with four other missionary sisters. They survived a perilous journey of more than a month, covering 6,000 miles by land and sea via the Panama Canal before finally arriving at the mouth of the Columbia River.[2] The francophone nuns found themselves in a ramshackle settlement of Americans, French Canadians, and Natives. Under the able leadership of Mother Joseph the Sisters of Providence set to work to establish themselves and learn English. They provided health care, education, and social services to the community.

A decade later, Mother Joseph took on the responsibility for building and financing missions in both the Canadian and American West. In addition to assessing requests for new institutions, selecting and purchasing properties, negotiating with local authorities, drawing up plans, and supervising the construction, she also carved altars, columns, and statues for the new chapels. The intrepid architect and artisan travelled thousands of miles to meet the growing demand for her services.

Mother Joseph made many hazardous trips to mining areas, begging for nuggets and gold dust to help feed and shelter the needy. Neither packs of howling wolves nor aggressive grizzly bears could stop her. In 1874 or 1875, she and some sisters trekked to the Cariboo Mountains despite Bishop d'Herbomez's cautions. He begged God for a dozen Guardian Angels to protect them from all the dangers to which they surely would be exposed.[3] The group endured three rough days on the Fraser River

Vancouver Public Library: 5147

The original St. Paul's Hospital, built under Mother Joseph's direction in Vancouver, circa 1905.

and another four in ramshackle stagecoaches following narrow and winding trails above sheer cliffs, before finally reaching the mines there. After spending three weeks with the prospectors, Mother Joseph returned with a grand total of $10,000.

Mother Joseph of the Sacred Heart died in Vancouver, Washington, in 1902. There is a statue of her in the House of Representatives in the United States. Mother Joseph was probably the first female Canadian architect, practising her craft in the early days of the profession. She is often mentioned in association with the buildings she designed in Canada, where the Sisters of Providence still operate St. Paul's Hospital and St. Mary's Hospital.

Quote:

"How much more agreeable for me to remain at home. But with the large debt we still carry and the needs of the poor, the sick and the orphans pressing, it is with all my heart I leave my solitude, for the toilsome task of begging."[4]

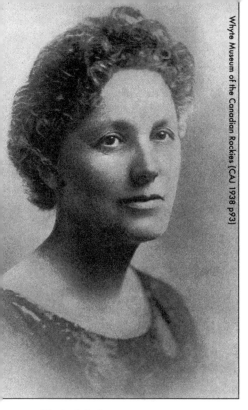

Mountain Pilgrim

Elizabeth Parker

1856–1944

A mountain climber she was not. But she co-founded the Alpine Club of Canada – in Winnipeg.

Elizabeth Parker.

Middle-aged Winnipeg journalist Elizabeth Parker was surveyor Arthur Oliver Wheeler's unlikely ally. The woman made his dream of creating a Canadian mountaineering club a reality, even though she admitted she only scaled peaks in her imagination.[1]

Elizabeth grew up far from the Rocky Mountains that would one day inspire her to become a conservationist. A Nova Scotia girl, she was born Elizabeth Fulton in Colchester County in 1856. After her mother died, her step mother raised her with a love of literature. Elizabeth attended normal school in Truro to become a teacher. She taught for a year before marrying Henry John Parker when she was eighteen.

The Parkers settled in Halifax, where Elizabeth took classes at Dalhousie University and got involved with literary groups. She gave birth to the couple's three children before the family moved to Winnipeg in 1892. While John worked as a railway clerk, Elizabeth continued attending literary readings. She stumbled into a new career after storming into the office of *Manitoba Free Press* to complain that the paper wasn't

providing adequate coverage of literary events.

The editor challenged her to write her own reports. Elizabeth began writing weekly (then daily) columns on books and authors. She worked for the newspaper as a journalist for nearly forty years. Readers from around the world corresponded with the journalist who signed herself as "The Bookman, A.L.O.W." (A Lady of Winnipeg), or "M.T." (her mother's initials). Elizabeth was also a social reformer and efficient organizer. She founded the Winnipeg Women's Canadian Club and played a key role in establishing YWCAs. But her true calling was in the mountains.

Elizabeth first experienced the splendour of the Rockies on a train trip in the late 1880s. She returned for a visit in the 1890s, along with a growing number of American and European adventurers who'd discovered the thrill of climbing mountains and exploring the region. In 1904, Elizabeth, who was never in good health, went back to improve her condition in the fresh mountain air and soak in the renowned Banff Hot Springs. During her eighteen months in the mountains, Elizabeth made an attempt to scramble up Cascade Mountain with some friends, though she was not a mountain climber.

When she read about A.O. Wheeler's idea to establish a Canadian chapter of the American Alpine Club, her patriotic fervour spurred her to write a scathing article. Wheeler had been trying to garner support for an all-Canadian organization for years. When Wheeler read the newspaper article by M.T., he contacted the *Manitoba Free Press*. He was surprised to discover the author was a woman.

Elizabeth and Wheeler joined forces to create a national alpine club that would encourage Canadians to discover the wonders of the mountain wilderness and make some of the first ascents of Canadian peaks. Elizabeth plunged into a campaign promoting the club, tirelessly writing articles and letters to influential Canadians. Wheeler acknowledged that her "cultured and forcible style of writing, her keen sense of vision and invariable accuracy of statement" led to their ultimate success.[2] In 1906, she organized the club's first meeting in Winnipeg. The members included some of the most famous climbers, guides, and outfitters in Canada. The Alpine Club of Canada (ACC) was formed on March 28, 1906, with A.O. Wheeler elected as president and Elizabeth Parker as secretary.

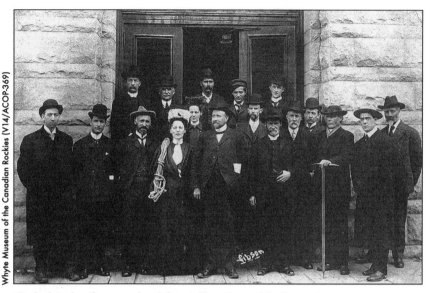

Whyte Museum of the Canadian Rockies (V14/ACOP-369)

Elizabeth Parker (front row, fourth from left) at Alpine Club of Canada meeting in Winnipeg, 1906. Daughter Jean Parker stands behind her.

Unlike its British counterpart, the ACC allowed women to join the organization. By 1907 there were 250 members, a third of whom were women; within a decade, half the members were female. With Elizabeth holding the pen, the new club established objectives of preservation, educating Canadians to appreciate their mountain heritage, promoting scientific study and exploration of Canada's alpine and glacial regions, as well as encouraging artistic endeavours in the mountains. Elizabeth ensured that women were allowed to wear the same climbing clothing as men, rather than being restricted by conventional clothing for ladies. She also edited the club's *Canadian Alpine Journal*, launched in 1907, writing many articles and imbuing the organization with her vision.

Elizabeth extolled the Canadian Rocky Mountains as a national asset, praising the spiritual and physical benefits of mountain climbing for both men and women — and to nation building. Elizabeth attended the first annual mountaineering camp in the Little Yoho Valley in the summer of 1906, when Canadians could use the services of the talented Swiss mountain guides for the first time.[3] Elizabeth housed the club's library in her Winnipeg home in the early years, and co-authored the ACC guidebook with Wheeler in 1912.

Elizabeth Parker was a journalist, conservationist, and mountain pilgrim. Her enduring legacy is the Alpine Club of Canada, a national organization with over 10,000 members, providing opportunities for mountain adventures in Canada and abroad. Elizabeth continued to support the ACC throughout her life. The ACC named the Elizabeth Parker Hut, situated near the spectacular Lake O'Hara in Yoho National Park, after her and noted: "As much as any single person, Elizabeth Parker was largely responsible for the formation of the Alpine Club of Canada, and this hut sits as a wonderful tribute to her efforts."[4]

Quote:

"... the Alpine club is a national trust for the defence of our mountain solitudes against the intrusion of steam and electricity and all the vandalisms of this luxurious, utilitarian age; for the keeping free from the grind of commerce, the wooded passes and valleys and alplands of the wilderness."[5]

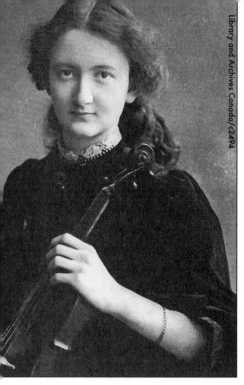

Lady of the Golden Bow[1]

Kathleen Parlow
1890–1963

Acclaimed as the world's greatest woman violinist, she captivated audiences around the globe.

Kathleen Parlow in St. Petersburg, circa 1905.

Kathleen Parlow was recognized as a prodigy at an early age. This remarkable musician performed with her famous Guarnerius violin on the major stages of the world. Playing from her enormous repertoire, she produced a big, pure tone that sounded as if she had a nine-foot bow.[2] According to renowned conductor and composer Sir Ernest MacMillan, "No Canadian performing artist enjoyed a more distinguished career."[3]

Born in Fort Calgary, where her father worked for the Hudson's Bay Company, she picked up the Cree language from her Native playmates before learning English. The little girl idolized her storytelling father, but Mrs. Parlow whisked the child out of the country when she discovered that her husband had been unfaithful and contracted tuberculosis. Despite his pleadings, Kathleen never saw her father again. He died of TB.

Kathleen was just four when she and her mother arrived in San Francisco. Her mother bought the young Kathleen a half-size violin. Her cousin, a professional musician who recognized her immense talent, was her first teacher. Kathleen played in her first concert at the age of six. She

soon began taking lessons with the gifted violinist Henry Holmes, thanks to the generosity of a wealthy lady who attended the first performance. By the time she was fourteen, Kathleen was travelling to Europe to train for a career on the stage.

With financial support from their church and a patron, Kathleen and her mother arrived in England on January 1, 1905. The young violinist performed with the London Symphony Orchestra and gave a concert at Buckingham Palace for the Royal Family. Kathleen was determined to study with Leopold Auer in St. Petersburg, but needed money. She daringly approached Lord Strathcona, High Commissioner for Canada, for a loan. Fortunately, Lord Strathcona had attended one of Kathleen's concerts and even told her that Canada was proud of her. He wrote Kathleen a generous cheque — and never accepted payment..

Though friends were aghast at Kathleen's decision to study in Russia, she and her mother travelled there in 1906. The Canadian musician became the first foreign student at the St. Petersburg Conservatory, and the only female in a class of forty-five. Auer remained her teacher, mentor, and adviser long after Kathleen completed her studies. Highlights of her training in Russia included the opportunity to work with the talented school director Alexander Glazunov, from whom she learned his "Concerto in A Minor."

Following a successful debut in Berlin in 1907, Kathleen began touring Europe as a virtuoso. She received high praise for the 375 concerts she performed between 1908 and 1915. The violinist also made a number of appearances in Norway before King Haakon and Queen Maud, who presented Kathleen with a diamond necklace. In Oslo she met the wealthy Einar Bjornson, who became a patron as well as a close friend. He gave her the remarkable violin, an instrument made in 1735 by Guarnerius del Gesù, that became her most treasured possession.

After Kathleen had studied and performed in Europe for five years, she took an important career step by touring in North America. Billed as one of the top-ranking violinists in the world, Kathleen gave concerts in Boston, Philadelphia, and New York. The very favourable reviews from critics included one following her performance with the New York Symphony Orchestra in 1911: "The gifts of this young girl are extraordinary.… In her performances she has not been judged as a

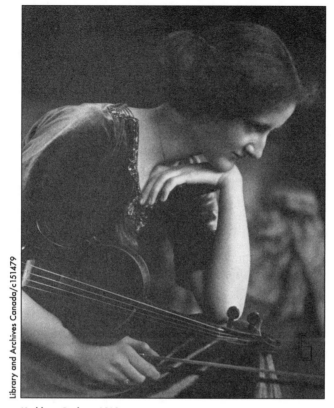

Library and Archives Canada/c151479

Kathleen Parlow, 1913.

woman but as an artist … the men in the profession have declared that she is today one of the phenomena of the musical world."[4]

Kathleen, accompanied by her mother as always, also toured Canada. The Parlows were especially pleased by the warm reception they received in Alberta. They were greeted by the premier and hosted by Senator James Lougheed and his wife, Isabella, for whom Kathleen's father had been a witness at their wedding. Calgarians were proud of the tall, slender young woman who had returned to her home town as an international celebrity. Kathleen noted in her diary that she was finally "[at] home."[5]

From 1912 to 1925 the Parlows lived in a house near Cambridge, England, which served as a base for touring Holland and Scandinavia, the United States, and Asia. Kathleen was thrilled with her adventures in the Far East, particularly the tour in China. "I had always longed to see

China and when I finally arrived I almost held my breath in fear lest the reality should not come up to my anticipation."[6] She was not disappointed — and the tour was a big success.

After suffering from a breakdown in 1927 and weary of low financial returns from touring, Kathleen focused on teaching and playing in a quartet. She lived in San Francisco and New York — teaching at the prestigious Julliard School of Music — before the Parlows decided they belonged back in Canada. Kathleen accepted an offer to teach at The Conservatory of Music in Toronto in 1941. She was soon performing with the Toronto Symphony Orchestra, giving concerts with the Canadian Trio, and then the Parlow String Quartet. In 1959, she was named head of the London, Ontario, College of Music.

Kathleen died in 1963 after a lifetime of devotion to music. Despite close relationships with a number of suitors, she never wed. Some relatives speculated that her domineering mother may have kept the men away. Kathleen earned international acclaim during her impressive career and helped students develop their skills. By willing her estate — primarily her famous violin — to the University of Toronto, she funded the Kathleen Parlow Scholarships to assist aspiring string players.

Quote:

"Music begins where love leaves off."[7]

Marie Anne Payzant during the siege of Quebec.

Prisoner of War

Marie Anne Payzant

circa 1711–1796

Her fight for freedom is a Canadian epic.

Marie Anne Payzant's life reads like legend, though the suggestion that she was General Montcalm's secret sister is a myth. The scarcity of historical facts about her has inspired wonderful fictional accounts of her life, and led her descendant Linda G. Layton to piece together the true story.[1]

It was May 8, 1756, near the fortified town of Lunenburg, Nova Scotia. The dogs began barking at midnight on the small island in Mahone Bay. Louis Payzant rushed to the door of his family's log cabin and fired his musket. As his wife Marie Anne ran to his side, he fell to the ground in a pool of blood, dead. Ten whooping warriors brandishing tomahawks bolted into the cabin. The terrified Marie Anne and her four young children watched in horror as one attacker ripped the scalp from Louis's head, attaching it to his belt as a trophy.

The Maliseet raiding party grabbed the dry goods that the murdered merchant was planning to sell, herded the remaining Payzants into canoes, and torched the buildings. The attackers killed the family's servant and her son, the young boy who had guided them to Payzant

Island to begin with. While it is not clear why the Maliseet spared Marie Anne and her children, they may have been surprised to hear them speaking French like the men who'd hired them and hoped their captives would fetch a good ransom.

Marie Anne must have rued the day the Payzants left their peaceful sanctuary in Jersey three years earlier. Both Marie Anne and her husband were middle-class Huguenots from Normandy, who fled France to escape religious persecution. Louis Payzant was a prosperous merchant when he escaped to the British-held island of Jersey, where the couple married in 1740.

The couple soon established themselves in their refuge. Marie Anne gave birth to seven children, though only four survived. When Louis learned that the British government was looking for several hundred Huguenots to settle in Nova Scotia, he was enticed by the opportunity for adventure and profit. The Payzants sailed into Halifax in the summer of 1753, settling initially in Lunenburg before moving onto their own island in 1756. They had only been there a few months when their dream of peace and prosperity was shattered by the raid.

The family had been caught in the war that Britain had just declared on France: the Seven Years' War would last from 1756 to 1763. The Marquis de Vaudreuil in Quebec had ordered attacks in Nova Scotia, and Father Charles Germain and Captain Deschamps de Boishebert incited their Native allies, the Maliseet, to attack the English colony. The Maliseet were encouraged to bring back prisoners and scalps in return for rewards like guns, brandy, and tobacco.

For at least four days, Marie Anne and her children endured a frightening trek from Payzant Island to Saint Anne's Mission in French territory. Ordered to lie flat in the canoes, the captives huddled together. The youngest son, Lewis, would later recall being treated cruelly. The captives ate berries, bread, or nothing. On arrival in Saint Anne's, they watched the Maliseet warriors celebrate their successful raids by dancing and drumming around their campfires.

The prisoners of war soon discovered their fate. The Maliseets adopted the four Payzant children and gave them new names. They were to be raised as Catholics. Marie Anne, fearful she would never set eyes on her children again, was sent to Quebec City, the capital of New France.

Marie Anne, who was about a month pregnant, was handed over to French authorities after surviving a gruelling nine-day journey to Quebec. It is not certain where she stayed during her four years of captivity in Quebec, but her biographer suggests the Ursuline Convent as one possibility. While authorities were probably surprised that the prisoners of war included a bourgeoisie woman from France who could write her name, they were displeased to discover she was a Huguenot.

When Marie Anne pleaded with Bishop Pontbriand to be reunited with her children, he demanded that she convert to Catholicism. With no other options, she reluctantly signed the necessary papers on December 8, 1756. Just after Christmas, at forty-five, she gave birth to her last child: Louise Catherine Payzant. The baby was baptized in the Roman Catholic cathedral.

Marie Anne was reunited with her four older children in Quebec the following summer. At Bishop Pontbriand's suggestion, the adoptive parents were threatened with the refusal of absolution if they didn't give up the children. While it is not known if Marie Anne was able to live with all of her children in Quebec, at least she had the comfort of knowing they were nearby and safe. John attended the seminary and Jesuit college, and the other boys may have, too.

Marie Anne and the children were excited when they spotted British ships arriving in June 1759, and John actually witnessed the Battle of the Plains of Abraham. After the British defeated Montcalm, the Payzants suffered through chaos and food shortages following the war. They weren't able to sail away from Quebec until the ice broke up in the spring of 1760.

At fifty-one, Marie Anne was finally free again — free to live her life where and how she wanted, and practise her religion without fear of prosecution. She returned to Nova Scotia with her family and eventually settled in a new Protestant community in Falmouth where she obtained a 500-acre farm as well as other land grants. Forever haunted by their memories of murder and captivity, the children began the new challenge of learning English and living in an unfamiliar culture.

Unable to manage a farm with her children, Marie Anne married an Irishman named Malachi Caigin. The marriage was not successful, and she was separated from the tavern owner by the time he was murdered in

a barroom brawl in 1776. When Marie Anne died two decades later, she had enjoyed many years of living on the farm at Falmouth with her son, Lewis, and his large family.

Quote:

"Our curate of Quebec, undersigned, received the abjuration of the Religion Prétendice-Reformée and the profession of the Catholic, Apostolic and Roman Religion given by Dlle [Demoiselle] Anne Noget ... and given to her absolution of the blame incurred by the heretical profession ..."[2]

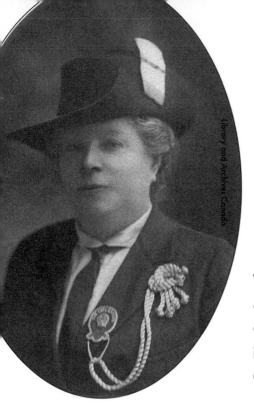

Guiding Light

Lady Mary Pellatt

1858–1924

The first chief commissioner of the Girl Guides of Canada, she was a pioneer in the development of the Guiding movement.

Lady Pellatt, first commissioner of the Girl Guides of Canada.

In 1922, Lady Pellatt received the Silver Fish. As any Girl Guide knows, this honour is the highest award in Guiding. Lady Mary Pellatt was so dedicated to the movement that she was buried in her Girl Guide uniform — with local Girl Guides forming a Guide of Honour at her funeral.

Mary Dodgson was born in Toronto in 1858 and attended Bishop Strachan School. She married a Kingston financier and soldier named Henry Pellatt, who was knighted for his service to the Queen's Own Rifles of Canada. Major-General Pellatt, who made a fortune through railway and hydro investments, spent $3.5 million building a castle for his family: Casa Loma. The medieval-style castle was the largest private residence in Canada and the first to have an elevator.[1] This was built to transport Mary's wheelchair, to which she was often confined due to complications from diabetes and arthritis.

Lady Mary was shy but led an active social life. She was always immaculately dressed, in long flowing dresses and large hats adorned with flowers. The Pellatts enjoyed entertaining in their fantasy castle,

which had ninety-eight rooms adorned with the country's largest private art collection.[2] Mary was fond of hosting tea parties in the conservatory, which featured exotic plants from around the globe.

Lady Pellatt was a professional volunteer who organized the Queen's Own Chapter, Imperial Order Daughter of the Empire, and served as first regent. She belonged to the War Memorial Club, the Toronto Women's Musical Club, the Women's Art Association, the Women's Canadian Club in Boston, and the St. James' Cathedral Women's Club. Lady Pellatt was also a life patron of the National Council of Women.

On July 24, 1912, Agnes Baden-Powell, the creator of the Girl Guide movement, named Lady Pellatt chief commissioner of the Canadian Girl Guides. She toured the country promoting the movement. With 250 companies of guides already formed, she began working with a group of prominent women to create a headquarters for them in Canada. Despite some opposition to what some perceived as an Amazon Cadet Corps, the Girl Guide movement spread. Lady Pellatt opened the headquarters in Toronto in December 1912, and the following spring began hosting guiding rallies and other events at Casa Loma.

About 250 Girl Guides attended the first rally in 1913. The girls roamed throughout the castle, exploring the conservatories, climbing to the top turret, and sipping tea in the Palm Room. There was dancing and marching outside on the lawn, with refreshments served in large tents, as well as educational activities like first aid training. Lady Pellatt also arranged skating parties for the Girl Guides in the winter.

In 1913, Lady Pellatt began working with the Canadian National Exhibition so the Girl Guides could participate in the Women's Day Activities at the fair. After the outbreak of war in 1914, she encouraged the Guides to send clothing, toys, and books to children in Belgium. The Girl Guides contributed to worthy causes throughout the First World War, sending 16,700 pairs of boots to France in 1918.

By the time the Canadian Girl Guides Association was incorporated by an Act of Parliament in 1917, the Guiding movement was well established. In May 1919, Lady Pellatt welcomed scouting and guiding leaders Lord and Lady Baden-Powell and organized a special Guide rally at Casa Loma for the empire's chief guide. When His Royal Highness, the Prince

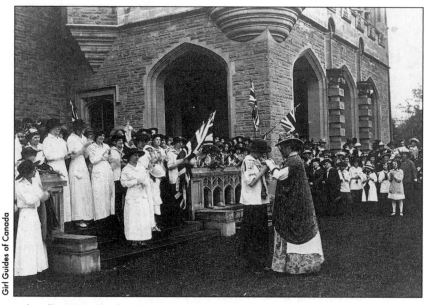

Girl Guides of Canada

Lady Pellatt presenting the Silver Fish at a gathering of Girl Guides, Casa Loma, 1915

of Wales visited the Parliament Buildings in Toronto that August, Lady Pellatt gave the welcome address on behalf of the Girl Guides of Canada.

In 1921, Lady Pellatt helped create the Rangers for Senior Guides. She also made her last public appearance as chief commissioner at the Brownie Revel in High Park. That year the Guiding movement included 17,500 Guides and 1,000 Brownies across the country. Lady Pellatt died in 1924, distraught at being forced out of Casa Loma after the Pellatt fortune disappeared.

Quote:

"The girls will be mothers of our citizens by-and-by. We must train them for womanhood and citizenship. That is the purpose of the Movement. Who said it meant unsexing? It is not an imitation of the Boy Scout Movement; for there is no militarism in it. It is purely a women's scheme."[3]

Granny Yip

Nellie Yip Quong
1882–1949

Bold and outspoken, she fought for Chinese immigrants struggling to survive racial hostility.

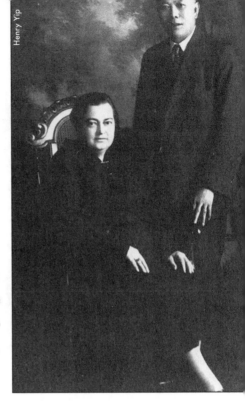

Henry Yip

Nellie Yip Quong and her husband, Charles Yip Quong.

Nellie Yip Quong could cuss and scold in any of five Chinese dialects. Or skillfully deliver a baby in Vancouver's Chinatown while offering comforting words in Chinese to the new mother. And in perfect English she fearlessly challenged the injustices immigrants faced, as when she convinced the Vancouver General Hospital to stop keeping all non-Caucasian patients in the basement. A white woman from New Brunswick, Nellie earned the respect and admiration of Vancouver's Chinese community.[1]

Nellie Towers was born in Saint John. She received a private education in the United States and taught English in New York City. There she fell in love with Charles Yip, a Chinese jeweller from Vancouver. Their 1900 wedding tore apart her family and severed her connection to the Roman Catholic Church. Neither would accept what was deemed a scandalous union, at a time when interracial marriages were rare.

After brief stints in New York and Vancouver's Chinatown, the couple moved to China for a few years. Nellie, an amazing linguist,

became fluent in Cantonese. She also learned four regional dialects and some Mandarin. When the pair returned to Vancouver in 1904, the young woman continued studying at a Chinese school operated by her husband's uncle, Yip Sang. Despite racial prejudice, Charles and Nellie were happy. As a merchant, he was among the Chinese elite, but also looked after the household cooking and gardening.

For more than thirty years, Nellie Yip Quong provided her adopted community with health and social services that were not available in a society that was openly hostile toward the Chinese. Her impressive language skills enabled her to communicate with the diverse Chinese populations. Nellie was a competent and trusted midwife, delivering babies for about 500 Chinese-Canadian women. The Chinese Benevolent Association of Vancouver hired her as the first public health nurse for the Chinese population. Granny Yip, as she was fondly known, also arranged care for the elderly, brokered adoptions, and served as a foster mother for many children. Unable to have children, Nellie and her husband adopted a daughter, Eleanor.

Nellie's understanding of Euro-Canadian society enabled her to serve as a bridge between it and the Chinese community. She served as an interpreter and helped people in disputes with landlords, immigration officials, and employers. Nellie also translated during court cases. She became an outspoken advocate of Chinese rights, never shying away from using her quick wit and acid tongue. She worked with many organizations, including the Anglican Good Shepherd Mission, the Chinese Benevolent Association, and the United Church in Chinatown.

Always ready to challenge racism, she once demanded that the owner of the White Lunch restaurant remove a sign that said, NO INDIANS, CHINESE OR DOGS ALLOWED.[2] He did.

Nellie used her position as a professional Caucasian woman with a respected Chinese husband to improve the Chinese community's living conditions. In 2008, the Historic Sites and Monuments Board of Canada designated Nellie Yip Quong a national historic person, recognized for providing health and social services to Chinese immigrants in their own language and advocating for her adopted community. She is still remembered in some community folklore and literature.

Quote:

"I have given up a whole lot to know my husband's people and it took a long time to win their confidence.... Oh I tell you it was often distressing."[3]

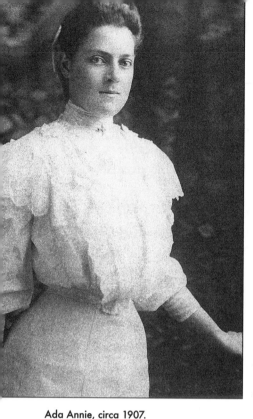

Cougar Annie

Ada Annie Rae-Arthur

1888–1985

She cleared forests, she trapped, she shot cougars. A typical Canadian pioneer.

Ada Annie, circa 1907.

As a young woman Ada Annie Jordan was bold and beautiful, with piercing blue eyes. She would need every ounce of her strength — and courage — to survive the horrific ordeals ahead.

Ada Annie was born in California, the daughter of a wandering Brit who'd married his housekeeper. The domineering George Jordan took his family from continent to continent, from the United States to England, South Africa, Lloydminster, Winnipeg, and finally Vancouver. Ada Annie endured a lonely childhood due to frequent moves that separated her from friends and favourite pets.

Taught to shoot when she was just seven, Ada Annie became a crack shot while they lived in South Africa. As a teenager, she learned shorthand and typing in Johannesburg, and trapping skills from her father in Lloydminster. By the time the family moved to Vancouver, he'd become a veterinarian, so Ada Annie helped out and also worked as a stenographer.

Ada Annie married a charming Scot named William (Willie) Rae-Arthur in 1909. The young couple began raising a family in Vancouver,

where Willie worked as a clerk for the Canadian Pacific Railway. Ada Annie's hopes for a happy marriage vanished as it became clear that Willie was an alcoholic and an opium addict. In spring 1915, the Rae-Arthurs and their three children moved far from the temptations of Vancouver's opium dens and Willie's boozing buddies. They settled in one of the most remote areas of the west coast of Vancouver Island, at the head of Hesquiat Harbour.

After journeying up the coast by steamer, the young family paddled to shore in a canoe with all of their luggage. They lugged their belongings through massive cedars to a log cabin in the wilderness. Ada Annie was pregnant, but she began the immense task of clearing the land with a mattock and axe. While Willie contributed somewhat to settling the family in their isolated home, he was a city-boy out of his element. He got lost if he stepped a few feet off a trail.

The couple spent the remainder of their lives in Boat Basin, struggling to feed and cloth their growing family. Ada Annie gave birth to eight more children, three of which died. In a desperate effort to sustain the family, she worked from dawn to dusk clearing the forest to make space for a garden. With the children's help, she eventually cleared seven acres and planted a large potato patch, vegetable garden, and fruit trees.

Ada Annie created a beautiful garden in the rainforest. She planted a wide variety of plants with seeds ordered from catalogues. Growing everything from exotic trees to shrubs and flowers, she developed a nursery business and shipped out produce. Dahlias were her specialty, and she had up to 200 varieties. Unfortunately, her business never brought in much money.

Ada Annie also raised a variety of animals. She had as many as 100 chickens at a time, as well as fifty goats, dozens of rabbits, ducks, geese, and black pigs. She tried raising guinea pigs and mink, and sold the furs. When times were tough, she shot wild cattle to feed the many hungry mouths. She also established a small store and a post office, which was approved only after considerable wrangling with authorities. Despite her best efforts, the children sometimes had nothing but porridge to eat morning, noon, and night.

Ada Annie would stop at nothing to look after her family. She once carried a sick child on her back down the rugged coast,

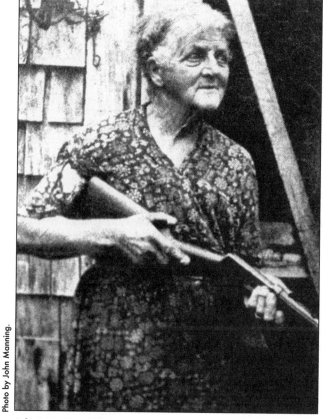

Photo by John Manning.

Ada Annie Rae-Arthur.

spending the night in a cave before reaching help. She shot anything that killed or threatened her livestock, including at least seventy cougars and about eighty black bears. She gained widespread renown as a cougar hunter, earning her the nickname Cougar Annie. Money from the pelts helped pay for supplies and building materials. In 1955, Cougar Annie earned $400 from selling the skins of the ten cougars she shot that year.

Despite gifts and money from Willie's sister in Scotland, there wasn't enough to provide well for their children. In 1922, a land inspector was appalled by the living conditions, even though Ada Annie tried to homeschool the children. The three eldest were forcibly removed from the home, and a fourth was taken later. The children spent up to five years at school in Vancouver, living at the Children's Aid Home. The family couldn't see one another during this period, but was eventually

reunited, and the younger children were allowed to receive their education at home.

After Willie drowned in the summer of 1936, Cougar Annie placed ads in the *Western Producer* and the *Winnipeg Free Press* to find a new man, with mixed results. She outlasted three more husbands, including two who beat her and tried to steal her money. One gentlemen suitor, Robert Culver, spent time at Boat Basin but couldn't cope with the isolation. He continued to write her affectionate letters throughout his life.

In later years the fiercely independent Cougar Annie was determined to remain on her land despite being almost completely blind. She still had no electricity or running water. This courageous pioneer died at ninety-seven and her ashes were scattered on Cougar Annie's Garden. Years later the garden was reclaimed by new owner Peter Buckland, and the Boat Basin Foundation is determined to preserve it. Cougar Annie's exploits are still legendary on the West Coast.

Quote:

"BC Widow with Nursery and orchard wishes partner. Widower preferred. Object matrimony."[1]

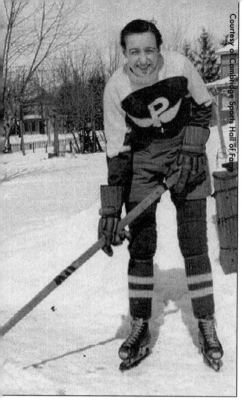

Courtesy of Cambridge Sports Hall of Fame

She Shoots, She Scores

Hilda Ranscombe

1913–1998

A hockey heroine of the 1930s, she opened doors for other women.

Hilda Ranscombe.

The crowd roared when Hilda Ranscombe scored on future NHLer Terry Sawchuck in 1946. According to one veteran hockey player, "They saw the greatest female hockey player score on the boy who would become the game's greatest goaltender."[1] Hilda skated with dazzling speed and looked invincible with puck and stick.[2]

If you assume that hockey is a man's game played only recently by women, think again. Lord Stanley's daughter first played in an organized hockey game at Rideau Hall in 1889. There were skilled women hockey players during the golden age of women's sports in the 1920s and 1930s — when hockey great Hilda Ranscombe shone. She was the best in Canada, maybe even the best in the world.

Born in Doon, Ontario, Hilda was a natural athlete. She excelled at baseball and tennis, as well as hockey, which she began playing on the frozen Grand River with a group of girls. They formed a team and called it the Preston Rivulettes, eventually moving their games indoors to an unheated arena. With Hilda as captain, the Preston Rivulettes became

the most famous women's hockey team in Canadian history.

The team played its first game in February 1931. The team's extraordinary success soon attracted media coverage and fans across the country. During the 1930s, the team played 350 games, and lost only three. The Rivulettes won the Ontario title ten times, the eastern Canadian championships six times, and the Lady Bessborough Trophy — the equivalent of a national championship, created in 1935 — six times. More than 6,000 cheering fans attended their 1935 two-game series against Winnipeg when the Rivulettes won the national title. Such incredible success wouldn't have been possible without Hilda Ranscombe.

"Hilda was 80 per cent of the team … without her they wouldn't have won what they won,"[3] recalled Sam Collard. Dependable, determined, and disciplined, she never swore or lost her cool in the heat of the game. But she was a terror on ice, the leading scorer and the fastest female skater in the country. Her skills were comparable to, or even surpassed, her male counterparts. Former NHLer Carl Liscombe admitted that when he played with Hilda on the Grand River she played better than most of the boys, including himself.

Hilda was also a strong and inspirational leader, appreciated for her warm personality and sportsmanship. She served as mentor to her teammates. This was particularly important when many of the new recruits were a decade younger than her and the other founding members. Hilda was always patient when helping younger players. With her leadership the Preston Rivulettes gained national recognition and established high standards for women on the ice.

Hilda and her teammates had big dreams. There was even talk of going to the Olympics. The Rivulettes were invited to play in Europe on a tour that would include London, Paris, Amsterdam, Brussels, and Switzerland, but the Second World War forced the cancellation of the trip. The Preston Rivulettes disbanded in the early 1940s due to lack of funds. Most of their cherished trophies, pucks, photographs, and memorabilia were housed in the Preston Arena, which tragically burned to the ground.

Hilda worked in the insurance industry. She continued playing hockey and coached the Preston Trianglettes, mentoring a new generation of female hockey players in the 1960s. When Hilda took her team to the

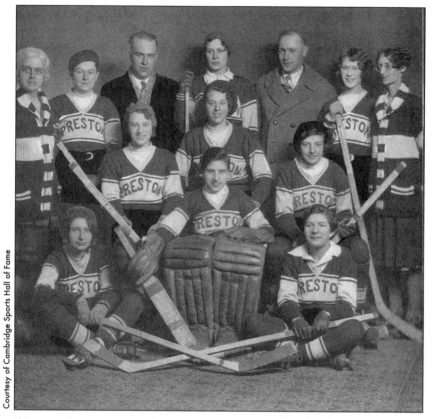

Courtesy of Cambridge Sports Hall of Fame

The Preston Rivulettes, with Hilda Ranscombe at far right on the second row.

Lipstick Hockey Tournament in 1969, she was praised as the greatest female hockey player of the century. The Trianglettes presented Hilda with a trophy recognizing her contribution to ladies hockey.

In her later years, Hilda remained active despite suffering from multiple sclerosis and losing her legs to diabetes. The modest hockey star wept with joy when inducted into the Cambridge Sports Hall of Fame in 1998. She died that same year.

"Preston's own female version of Wayne Gretzky"[4] was never inducted into the Hockey Hall of Fame, despite recommendations from the Cambridge Sports Hall of Fame. As Carly Adams points out, inductions to the Hall "reinforce a gendered hierarchy of athletic accomplishment over the past century," and the exclusion of women such as Hilda "suggests to the public that women have not made significant athletic accomplishments in hockey and are therefore unworthy of recognition."[5]

The lack of official recognition cannot erase the impact that Hilda had on women in hockey. N. Getty, a veteran goalie, was among those who thanked the elderly lady for opening doors that enabled her to play hockey. Her last words to Hilda were, "When I skate, you skate with me."[6] The great one smiled.

Quote:

"We were supposed to go to Europe to play but then the war came and our boat was sunk. We never went."[7]

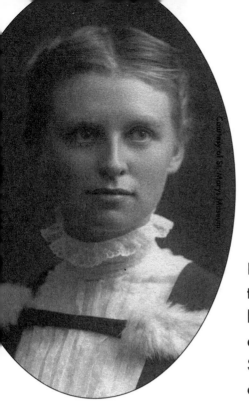

Courtesy of St. Mary's Museum.

The Prospector

Kathleen Rice
1883–1963

Her fierce determination to mine, trap, and fend for herself in the wilds shocked, and sometimes horrified. She embodied a new type of woman.

Kathleen Rice.

In the summer of 1928, news spread that a woman prospector was mining a rich strike of copper pyrite in northern Manitoba. The press marvelled that Kathleen Rice was competing in a sphere thought to belong to men alone. "This surely must complete the gamut of woman's entry into world activities," noted one newspaper.[1]

Kathleen Rice was hailed as the first woman prospector. She was an exceptionally courageous and capable young woman, determined as well as self-sufficient. Not only was she a homesteader, hunter, trapper, canoeist, and all-around outdoorswoman, the successful prospector, self-taught geologist, and miner was also a trained teacher and mathematician. Plus she was stunning, a statuesque woman of six feet with blonde hair and piercing blue-green eyes.

Kathleen was born in St. Marys, Ontario, in 1883. Her father taught her how to hunt and shoot, and shared his abandoned dreams of adventures on the frontier. As her grandfather, Samuel Dwight Rice, had founded a college for women, Kate was raised to believe in the

importance of education for women. She graduated from the University of Toronto, where she studied mathematics, physics, and astronomy.

Kathleen taught math in Ontario, Alberta, and Saskatchewan. While vacationing in the Rockies she developed sufficient climbing experience to earn membership in the Alpine Club of Canada. Eager for new adventures, she convinced her brother, George, to stake a homestead with her near The Pas, Manitoba, in 1913. George had no interest in farming but she needed him to obtain the 160-acre homestead. He soon returned east.

The independent homesteader spent the winter of 1913 — alone except for her dogs — shooting partridges and snaring rabbits. Though Kathleen developed the land, she lost interest in farming after hearing stories of mineral discoveries in the North. She pored over geology books and learned about prospecting. In 1914, she headed out on her first prospecting trip alone, travelling by dogsled to stake a claim on the Sturgeon-Weir River.

During the next fourteen years, the adventurous Kathleen honed her prospecting skills. She became an expert trapper, hunter, and canoeist, but knew her own limitations and hired men to assist her in prospecting, packing supplies, or building cabins. Her prospecting eventually led her to Herb Lake, where she moved onto an island that now bears her name.

Kathleen began actively exploring Rice Island, but it wasn't until eight years later that she finally struck copper, nickel, and zinc. She soon had a crew of ten men blasting, digging, and drilling. After news of the deposits brought a small stampede of prospectors and miners, developers began making her offers. Kathleen also found feldspar on Walrus Island, and was one of the first prospectors to locate vanadium.

Kathleen revealed little about her personal life to the curious reporters who wrote about her amazing exploits, such as running rapids in her canoe without getting a drop of water inside, or protecting herself from a pack of wolves by lighting a fire. Conscious of her reputation, Kathleen didn't reveal her secret: her nights in the wilderness weren't quite as lonely as they imagined. Back in 1914, she'd moved into prospector Dick Woosey's cabin. He was an ex-soldier whose wife returned to Britain shortly after she set eyes on Canada. He and Kathleen were business partners (and probably lovers) until he suddenly died in 1941.

Courtesy of St. Marys Museum

Kathleen Rice with dogsled, in northern Manitoba.

She continued to live in their cabin on Rice Island after his death. Locals called her the Lady of the Lake. After years of isolation, Kathleen buried her mining fortune — estimated at $45,000 — and checked herself into a mental institution in Brandon, Manitoba. Far from crazy, she died in 1963 in Minnedosa, Manitoba.

Dr. R.C. Wallace, a mining expert who knew Kathleen, identified her as one of the most competent prospectors.[2] Other contemporaries praised her as a "champion of the doctrine that there is no weaker sex ... living a rare romance in the wilds of wildest northern Manitoba."[3] This pioneering prospector and miner has been identified as one of the notable women geologists in Canadian history,[4] but isn't widely remembered.

Quote:

"If women could understand the thrills of prospecting there would be lots of them doing it.... No woman need hesitate about entering the mining field because she is a woman — it isn't courage that is needed so much as perseverance."[5]

From Slavery to Freedom

Marie Marguerite Rose

circa 1717–1757

She was just another piece of property for most of her life, but has become a symbol of strength and dignity.

From 1713 to 1758 there were about 400 slaves in the French colony of Île-Royale (now Cape Breton, Nova Scotia), mostly in Louisbourg.[1] Among them was Marie Marguerite Rose, a remarkable woman who survived nearly twenty years as a slave before gaining her freedom and becoming a successful tavern owner. Right next door to the home of the man who once owned her.

Marie Marguerite Rose was captured by slave traders in Guinea and transported across the Atlantic to the bustling seaport of Louisbourg. In 1736, naval officer Jean Loppinot bought her for an unknown price, possibly branding her with a hot iron as the French were known to do. Marie Marguerite was baptized with a name selected by her owner and introduced to Roman Catholicism. She was probably illiterate and left no records of the horrors she would have experienced as a slave, so it is not known if she was physically or mentally abused.

At this time there were about 1,500 people in Louisbourg, including fifty slaves. Like many female slaves, Marie Marguerite was expected

Marie Marguerite Rose survived the British attack on Louisbourg, 1745.

to work in the family home every day except Sundays and holy days of obligation. She cooked all the meals, washed the clothes, and scrubbed the floors. She gave birth to a son, Jean-François, whose father is unknown. As the son of a slave, the boy was automatically enslaved and worked in the Loppinot house with his mother.

Marie Marguerite's son died when he was thirteen and she had no other children. When she was about thirty-eight, the longtime slave somehow managed to secure her freedom. It's possible that she was purchased by Jean Baptiste Laurent, the Native man she married on becoming free. Both her emancipation and mixed marriage were exceptional.

Marie Marguerite went into business with her husband. The newlyweds stayed in Louisbourg and rented a building, where they lived and ran a tavern. It is astonishing that the former slave was able to open a popular business, attracting clientele from the fort. When she died suddenly on August 27, 1757, Marie Marguerite was not quite forty and had enjoyed just two years of freedom. She was buried in the Fortress of Louisbourg.

The goods she left were valued at £274 — a rare accomplishment for a freed slave. Her belongings give us a window into her new life.[3] She had an extensive collection of used clothing and a pair of half-made woollen stockings. Her other possessions were balls of handmade soap, an

iron, supplies for dyeing clothes, six pounds of sugar, and a cookbook, no doubt prized even though she was likely unable to read it. Marie Marguerite also left a thriving vegetable garden.

In 2008, the Historic Sites and Monuments Board of Canada selected Marie Marguerite Rose as a national historic person because of her unique role as a slave who managed to secure not only freedom, but also married a Native man and owned a business. Today the Fortress of Louisbourg is a popular national historic site in Nova Scotia, the largest reconstructed eighteenth-century French fortified town in North America. In 2009, Parks Canada launched a new Slavery Tour at the fortress — a tour that highlighted the historical significance of heroine Marie Marguerite Rose.

The Lady of Cataraqui

Madeleine de Roybon d'Allonne

circa 1646–1718

She became the first European woman in present-day Ontario to own land.

Madeleine de Roybon d'Allonne was among the more than 800 *Filles du Roi* shipped by Louis XIV as brides for the lonely men of New France. She was one of the few young women who didn't marry in the colony,[1] presumably because she was romantically involved with a famous explorer. René-Robert Cavelier de La Salle, governor at Fort Frontenac and the man who claimed the Mississippi River basin for France, was murdered before they could marry.

Madeleine was born in France at Montargis. She was in Quebec by September 1678 when La Salle returned from a trip to France. Later that year she accompanied him to Fort Frontenac (now Kingston). Their love affair endured through his many trips and sent rumours flying as far as France.

Madeleine loaned La Salle 2,141 livres on August 24, 1681, to finance his explorations. As governor, he granted her a seigneury nearby at Cataraqui. Thirty-five-year-old Madeleine developed her property over the next six years, clearing the land, building a house and barns, acquiring farm animals, planting vegetables and grain, and establishing a trading post.

Madeleine de Roybon d'Allonne was among the *Filles du Roi* (Daughters of the King), depicted in this early-twentieth-century watercolour.

After La Salle returned to the fort in 1683, Madeleine accompanied him to Quebec. He then sailed to France. Since he was still unable to pay back the loan, the adventurer signed a document ensuring that she would maintain possession of her house and property. She returned to Cataraqui, where she lived until receiving the shocking news that he'd been murdered in March 1687 during an expedition in Texas.

Throughout her years at Fort Frontenac, Madeleine witnessed the ongoing hostilities between the French and Iroquois. A few months after La Salle's death, the commander at the fort, fearing Native attacks, pleaded with the seigneuress to seek safety at her home. She refused. More than 1,000 Iroquois warriors attacked the fort and a group of braves, led by Chief Black Kettle, descended on Madeleine's land. They forced her to stand, wearing the chief's headdress, on a stump and watch as they destroyed her home.

The Iroquois took Madeleine prisoner, transporting her to the village of Onondago (in New York). After nearly a year of captivity, she was finally freed thanks to negotiations by the English governor of New York. Mlle d'Allonne arrived safely in Montreal in July 1698. Now in her early fifties, she faced a life without the man she loved, the money

she'd loaned, her land, and everything she'd worked so hard to build. She lived the remainder of her life in Montreal, despite repeated efforts to return to her seigneury.

After Montreal authorities challenged the legitimacy of her grant, the feisty lady (now sixty) set sail for France in 1706 to plead her case with the king. Though she returned to New France with a letter acknowledging her rights to the seigneury, the governor and intendant remained intent on keeping her out of business. She submitted an eloquent plea to the intendant in 1707, but he still refused to allow her to transport goods. Never giving up, Madeleine sent her final petition to France in 1717.

She died in Montreal in 1718 before receiving word that the Council of Marine in France had decided to grant her a pension. She was buried in an unmarked grave near the Notre-Dame de Montréal.

Madeleine de Roybon d'Allonne continues to be celebrated as an important figure in Franco-Ontarian heritage and the history of Kingston. A school was named after her, a provincial heritage sign recognizes her contributions to Ontario, and the former Township of Kingston's coat of arms included her image. In 2009, officials at Fort Frontenac purchased a rare historic document that had turned up in New York — the deed by which La Salle had granted Madeleine her seigneury.

Quote:

"… she had started off with the intention of re-claiming her establishment, which she was prevented from doing, and arrested, and her effects seized.… In her present fear and just apprehension in which she finds herself, she has recourse to you."[2]

The Other Klondike Kate

Katherine Ryan

1869–1932

Yukon Archives, E.J. Hamacher collection ACC78/28 #55

Among the first women to tackle the all-Canadian route to the Klondike, she became a special constable for the North-West Mounted Police.

Kate Ryan with her nephews.

If you've heard of Klondike Kate, you're probably thinking of the seductive dance hall girl entertaining miners in Dawson City — a notorious American performer called Kitty Rockwell.

Katherine Ryan, the other Klondike Kate, grew up in the Irish community of Johnville, New Brunswick, where she farmed potatoes with her siblings. When the boy who was courting her suddenly announced that his mother had convinced him to become a priest, Kate immediately revealed she, too, had plans. She would head west.

In 1897, Kate was working as a nurse in Vancouver when the city went wild with gold fever: news had arrived of a major gold strike in the Klondike. She decided to go north to seek her fortune, choosing an all-Canadian route. To meet government requirements to carry enough supplies for a year in the North, Kate used most of her savings to purchase the long list of food and gear from the Hudson's Bay Company. In addition to provisions such as 150 pounds of bacon and 400 pounds of flour, she purchased work boots, a mackinaw, and a Winchester rifle.

Kate Ryan joined the gold seekers in 1898. One of the first women to tackle the rough Stikine Trail, she took a steamer to the port of Wrangell, Alaska. On discovering the many challenges getting herself and her supplies to the Canadian boundary, the solitary adventurer shrewdly arranged to travel with the North-West Mounted Police in return for cooking their meals.

By early spring 1898, Kate was back in Canada at Dewdney Camp, where the NWMP had an outpost and customs station for the stampeders hoping to travel through northern British Columbia to the Klondike. Alone again, she continued her journey up the frozen Stikine River by dogsled. But Kate and thousands of other eager prospectors were stranded when they reached Glenora. The promised wagon road, narrow-gauge railway, and steamboats that were to provide easy transportation to the Yukon were not ready.

When a town appeared overnight to serve about 3,000 stampeders, Kate used a $5 gold piece to buy space for a restaurant in a new hotel. The Glenora Restaurant, her first business, prospered in 1898. After a nearby gold strike practically emptied the settlement, Kate sold her business and moved to Telegraph Creek. She hit the Teslin Trail on horseback in the fall.

Nearly six feet tall and sturdy, Kate Ryan cut a striking figure as she and her pack train made their way along the Stikine River. The young woman wore a type of culotte skirt she'd modified for riding and her favourite straw hat, adorned with blue flowers. When she reached the shores of Teslin Lake to catch a steamer to the Yukon, there were no boats running. Faced with the dismal prospect of spending the winter there, Kate went to Atlin where she knew her friend Reverend John Pringle was camped.

Kate wintered in Atlin. In the spring of 1899, she was finally able to continue north. By the time she reached Caribou Crossing, her final trek into the tent city at Whitehorse, Yukon, was a breeze after her wilderness travels. She was ready to settle down and moved into a twelve-by-sixteen-foot cabin, one of the first wooden buildings in town.

Kate became a successful businesswoman and prominent community leader. She opened a popular restaurant called Klondike Kate's Café and obtained a Free Miner's License, earning money through claims and

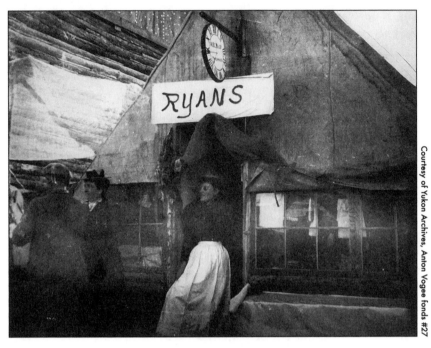

Kate Ryan (second from left) at her restaurant in Glenora, 1898.

investments in mines. In 1900, Kate became the first NWMP "woman special" to assist with female prisoners. She was later appointed a special constable to the NWMP, and was responsible for searching female passengers and their luggage to ensure no gold was smuggled out of the Yukon. Kate once found two large gold nuggets hidden in a lady's chignon.

Kate was one of the first directors of the North Star Athletic Club, the meeting place for many social and sporting events in Whitehorse. The popular young lady befriended a quiet bank clerk who secretly wrote poetry. His name was Robert Service. Kate and other locals shared their gold rush stories with the aspiring writer. Occasionaly, Kate borrowed a typewriter so she could help him with his work.

The warm-hearted, affable, and efficient Kate also generously provided her nursing skills at no charge. During the First World War, she raised more money for the war effort than any other individual in the Yukon, and the prime minister sent her a letter of thanks. Kate was also a political activist with the Yukon Women's Protective League, which demanded voting rights for women. She was a busy single

parent and raised some of her nephews after their mother died. When Kate made a visit to her hometown in 1901, she was astounded to learn that people on the outside were fascinated by her exploits and knew her as Klondike Kate.

After several decades in the Yukon, she moved to Stewart, a small mining town on the coast of British Columbia. In 1922 *Maclean's* interviewed her for a story they titled "The Woman Called Klondike Kate." She died in 1932. Katherine "Klondike Kate" Ryan was buried in Vancouver. The RCMP provided an honour guard at her funeral, with the RCMP providing an honour guard in tribute to her service with the NWMP. In 1990, author T. Ann Brennan published a book about a woman she called *The Real Klondike Kate*.[1]

Quote:

"I gradually became more and more obsessed with the desire to live and have my being where things were made by God. In other words I had a hunger to make my abode where the works of Nature, and not that of man, abounded."[2]

Lady Overlander

Catherine Schubert

1835–1918

by Emily Zheng, Winner of the Dundurn essay contest for students

She walked across Canada, becoming the first European woman to enter British Columbia over land.

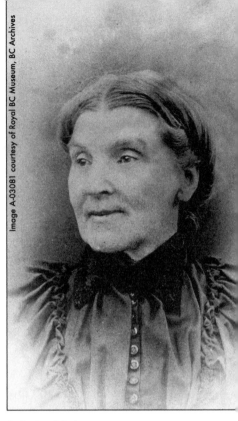

Catherine Schubert.

When the group of Overlanders first realized that a woman was coming on their journey, they were outraged. Shopkeepers, craftsmen, and merchants alike, they had all left their families behind to cross Canada. Their destination? The Cariboo, in search of gold.

This was no trip for any woman, let alone the three kids in tow. But Catherine Schubert was not just any woman. She was determined to accompany her husband, and keep the family together, no matter how far they had to go.

Catherine was no stranger to hard work. She was born in Ireland, the youngest of nine children. At sixteen, she sailed across the Atlantic to the United States. She worked as a maid until she met and married Augustus Schubert, a German carpenter, in 1855. Upon their marriage, Catherine opened a grocery store. However, an economic depression forced the family to move north. They settled in Fort Garry.

In 1858, miners discovered gold in Cariboo, British Columbia. A pack of gold-seeking men were bent on following the overland route to

the West. Augustus Schubert decided to join them. Catherine refused to be left behind.

Many of the men, who were initially shocked that a woman was coming along, eventually warmed to Catherine. Her hard work, determination, and loving nature won them over. Plus, she provided a much-needed woman's touch to the group of rough men.

Over the prairies, they walked on: hundreds of men and one woman. The hardships they faced were almost unimaginable. They had to carry months of provisions, as well as mining equipment. They camped out in the open air, rain or shine, and feared for their lives whenever a far-off howl could be heard. The sea of prairie seemed like it would never end.

However, the monotonous prairie was a vacation compared to what was about to cross the Overlanders' path: the Rocky Mountains. The travellers had to leave their pack animals at the foot of the mountains, carrying only the essentials on their backs. They crept over treacherous tracks and floated down dangerous rivers. Some men were lost to the elements. It's hard to picture how Catherine could have done it, holding onto three small children.

When the team of Overlanders decided to split up upon entering British Columbia, the Schuberts joined the group going down the Thompson River. It was safer than the Fraser. This proved to be a wise choice, because they had a secret. Catherine was pregnant. She was already in her fourth month when they set out from Fort Garry, thinking that the baby wouldn't come until they reached the Cariboo. However, the journey had taken longer than anticipated.

Catherine went into labour while riding a raft down the Thompson River. Once ashore, she successfully delivered a baby girl. The Schuberts called their baby Rose. She was the first girl of European heritage to be born within British Columbia.

The Schuberts eventually made it to the gold rush. Augustus never struck it rich, though. In 1881, he gave up hopes of gold. Instead, the family bought a farm in their newfound homeland and prospered there. Catherine had two more children.

Augustus died in 1908. His widow moved to Armstrong, British Columbia. She was an important part of the community there until her death in 1918.

Catherine Schubert had accomplished something great, and her name is forever etched in the books of history. But it was not her exceptional courage or wit that got her there. It was simply determination, endurance, and the ultimate love for her family.

May Sexton.

A Foremother of Equality

May Sexton

1880–1923

How could it be such a big deal to demand technical education for women? She wasn't seeking their right to become engineers or scientists — just classes to learn sewing and home economics.

New Brunswick–born May Best belonged to the class of 1902, receiving a B.Sc. from the prestigious Massachusetts Institute of Technology. A student of "striking intellectual ability,"[1] she graduated with high honours in chemistry and began working as a researcher at General Electric in Schenectady, New York.

If she had aspirations of a scientific career, May's hopes and dreams died with her. Aside from one blurry photograph printed in her obituary, all her personal papers, photos, and memorabilia seem to have been destroyed.[2] The life of May Best Sexton — prominent social activist, feminist, and war worker — can only be pieced together from public sources.

Edna May Williston Best was born in Shediac, New Brunswick, in 1880. After her father died, she moved to Boston in 1892 with her sister and mother. After graduating from high school in Boston, May enrolled at MIT, where she began dating an American student, Frederic H. Sexton. They married on her twenty-fourth birthday, and soon moved to

Halifax where he'd accepted a position teaching mining engineering and metallurgy at Dalhousie University.

In 1907, Frederic Sexton received an appointment as founding principal of the Nova Scotia Technical College and became director of technical education for the province. May's career took second fiddle. She gave birth to their son, Whitney, in 1906, and daughter, Helen, in 1908. Devoted to improving women's lives, she became active in many organizations in Halifax, including the Ladies Music Club, Local Council of Women, Imperial Order Daughters of the Empire, Red Cross, Nova Scotia Equal Franchise League, and Halifax Playgrounds Commission.

Recognized as "a born leader, magnetic, full of enthusiasm in all good,"[3] May was skilled at project management, fundraising, and public advocacy. She gave presentations to legislators, delivered lectures, and wrote newspaper articles. May also worked for improvements to public health, care of the mentally handicapped, inclusion of "edifying moving pictures" in schools,[4] classes on food preparation and nutrition, the enfranchisement of women, and their right to sit on school boards.

She challenged male legislators who saw no need to include women:

> Frankly, we think it partakes of the nonsensical for women to claim that there are any points, hygenic or otherwise, connected with the management of children in schools which the men of the Board … cannot understand and appreciate as well as these would-be lady members.[5]

One of May's major preoccupations was technical training for women, including establishing an industrial school. She lobbied unsuccessfully for a facility that would enable females to enter the workforce as dressmakers, seamstresses, milliners, and domestics. However, a few classes were introduced in Halifax to educate women in various trades. During May's lifetime, the notion of women in fields such as engineering was a distant possibility at the Technical College, where it was not until 1958 that a woman graduated (in chemical engineering).

At the outbreak of the First World War, she proposed a province-wide agency to coordinate the provision of hospital supplies by the

Red Cross. As chair of the work committee, May supervised work parties where women assembled and packaged everything from surgical dressings and bandages to pneumonia jackets. Articulate and charming, she gave patriotic lectures throughout the province to finance the Red Cross initiatives — and made a significant contribution to raising $1 million.

May organized volunteers to meet hospital vessels in the port of Halifax during the war and played a key role in establishing the first convalescent home in the country, which provided vocational training for returning soldiers. May's war effort left her exhausted and suffering from kidney disease. Though she was able to enjoy a European vacation with her husband in 1921, May was forced to withdraw from public life after 1918 — the year that women in Nova Scotia finally won the vote.

May was someone who would "prefer to wear out rather than to rust out."[6] Just forty-three when she died in 1923, May left behind a daughter still in high school and a son preparing for college exams. There was a flood of tributes to a "brilliant woman who devoted herself and her splendid ability unselfishly to work for the public weal."[7] An enormous crowd — including the lieutenant governor of Nova Scotia, the premier, and the chief justice — attended the funeral of the highly esteemed activist at her home.

The Nova Scotia Advisory Council on the Status of Women recognized May Sexton as one of the province's Foremothers in Equality. In 2011, Dalhousie University created the May Best Sexton Scholarship for Women in Engineering.[8]

Quote:

"What we need ... is an Industrial School for Girls. Each year a large number of girls are obliged to leave the public schools at the ages between 13 and 17 and go to work.... They have no trade, no resource, and no chance to learn a trade as boys have."[9]

From Montreal to MGM

Norma Shearer

1902–1983

She refused to let heavy thighs, short stature, and a drooping eyelid stop her from becoming a superstar.

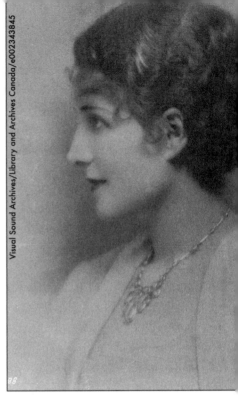

Norma Shearer, 1920.

"Where are all the Norma Shearers of the world?"[1] lamented the famed director Alfred Hitchcock. Actress Norma Shearer was once Hollywood's ultimate leading lady.

From the mid-1920s until her retirement in 1942, Norma was the Queen of MGM, the top studio in Hollywood. The talented actress played groundbreaking roles, depicting bold women who could sizzle with sex appeal while maintaining their respectability. She appeared in more than thirty films and won a Best Actress Oscar for the film *The Divorcee* (1930). Norma received five other Academy Award nominations.

As a child in Montreal's exclusive Westmount district, Norma Shearer studied dance and piano. She loved horseback riding and attending special events, like a vaudeville show featuring the Dolly Sisters, who inspired her dream to become an actress. Norma's privileged lifestyle suddenly vanished when her father's construction business failed after the First World War. Her parents separated, and her mother, Edith, moved her daughters into a dingy boarding house.

Edith decided to move the family to New York to try their luck in motion pictures, but they needed cash to get there. With $400 from selling Norma's piano and another $30 from selling their dog, the threesome arrived in New York in January 1920. They lived in a squalid room while Edith worked as a clerk and the girls tried to find acting parts. Norma met Florenz Ziegfeld and D.W. Griffith, but both directors told the seventeen-year-old that she had no future in showbiz: she was too short and had a dumpy figure, crooked teeth, heavy legs, and a cast in her right eye that made her look cross-eyed.

Norma refused to give up. She continued looking for work and used some of her dwindling savings to consult an eye specialist. In the summer of 1920, she got a big break, landing her first feature role in a silent movie called *The Stealers*. By 1923, Louis B. Mayer Productions (which soon merged with other studios to become Metro-Goldwyn-Mayer) in Los Angeles hired the determined actress. She made a successful transition to talkies, beginning with the smash hit *The Trial of Mary Dugan*. The increasingly confident and skillful Norma Shearer became the queen of the talkies and one of the most popular actresses in the world.

Physical fitness was extremely important to the naturally athletic young star. Norma swam and played tennis, as well as exercised vigorously at a fitness studio nicknamed The Torture Chamber. She strived to maximize her best attributes and camouflage the rest with costume designer Adrian's help. But she could never overcome the anguish of her family secret: serious mental illness which affected her sister, father, and eventually her mother.

In 1927, Norma married Irving G. Thalberg, a brilliant young producer who later became a vice-president at MGM. The powerful couple played key roles in MGM's impressive growth, as Norma transformed into an elegant and sophisticated movie star. The versatile and talented actress gave one of her best performances in the gripping anti-Nazi film *Escape* (1940), and starred in many other dramas, comedies, and historical films. The glamorous star played opposite famous leading men, including Clark Gable, Tyrone Power, Robert Montgomery, and Leslie Howard.

The Thalbergs had two children. When the couple married, Norma knew she'd married a fragile genius who wasn't expected to have a long life. He had a weak heart, and had two heart attacks before dying at

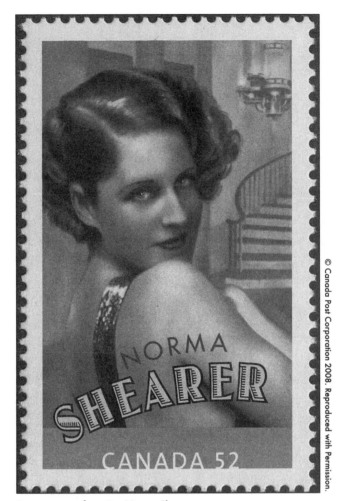

Postage stamp featuring Norma Shearer.

thirty-seven. Thirty-two-year-old Norma proved to be a formidable opponent in the ensuing legal struggle to retain her shares in MGM. She starred in several more films, including *Marie Antoinette* and *The Women*, but retired from acting in 1942. She married ski instructor and real-estate promoter Martin Arrougé (and was one of the first stars to have a pre-nuptial agreement). After her death in 1983, she was buried beside her first husband in Forest Lawn Cemetery in Los Angeles.

Norma Shearer was inducted into Canada's Walk of Fame in 2008. That same year Canada Post honoured the silver screen star by issuing a commemorative stamp in its Canadians in Hollywood series. Memories

of the determined actress faded after the 1940s. With recent TV and DVD releases of some of her forgotten films, a new generation of film buffs is discovering the legacy of the Queen of the Lot.

Quote:

"Scarlett O'Hara is going to be a difficult and thankless role. The part I'd like to play is Rhett Butler."[2]

— Norma's explanation of why she turned down a starring role in
Gone with the Wind.

The Girl from God's Country

Nell Shipman

1892–1970

The first lady of Canadian filmmaking brought us heroines who defeated villains. And rescued the men.

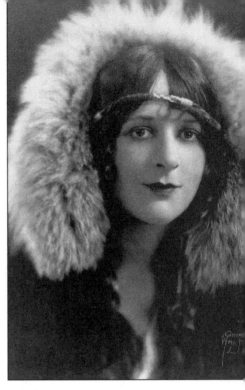

Nell Shipman.

Nell Shipman's stunt double was pregnant and terrified of leaping thirty feet into whitewater while filming *Baree, Son of Kazan* in 1918. The film's star didn't mind tackling the river herself. In fact, she relished the outdoor exploits her roles frequently required in silent movies of the early twentieth century. Nell jumped. She passed out from the shock of the icy water but was hauled safely to shore.

Nell also wrote screenplays, directed, and produced. She was the first Canadian woman to make a feature film, and one of the few Canadians to produce silent movies.[1] Many of her films were outdoor adventures featuring the Canadian wilds: God's country. She was a pioneer of shooting primarily on location rather than in studios. Nell's films often featured some of the animals from her own zoo, including both domestic and wild animals, such as her famous bear Brownie, wolves, a cougar, elk, and a skunk. She trained them herself, and advocated the humane treatment of animals in movie-making.

Nell grew up in Victoria, British Columbia, as Helen Foster Barnham.

The family moved to nearby Seattle when she was twelve, and the young girl studied acting and music. At thirteen she won a role in a vaudeville show and toured with Paul Gilmore's company. Her mother sometimes accompanied the young girl on the road. Nell performed on stages across North America, travelling from California to New York City and Alaska. She followed this vagabond lifestyle for most of her life.

By eighteen Nell had become the fourth wife of Canadian film producer and impresario Ernest Shipman, a charming man twenty-one years her senior. They moved to Hollywood, where she began acting in short films. Nell gave birth to their son, Barry, in 1912, and plunged into scriptwriting. She sold screenplays to Universal, Selig, and Vitagraph, and published one as a novel. In 1914, she directed her first film.

In 1916, Nell's career took off. She wrote the screenplay for the successful production of *God's Country and the Woman*, based on a novel by James Oliver Curwood. Nell also played the role of the heroine, gaining renown as the "girl from God's country" — a parka-clad beauty snowshoeing in the frozen North. She had become a star.

Nell was hired as screenwriter and lead actress for a follow-up film, and her husband signed on as producer. He convinced businessmen in Calgary to finance the film, which was released in 1919 as *Back to God's Country*. The investors were not disappointed. The melodrama earned them a 300 percent profit, becoming the most successful Canadian silent film in history. It grossed more than $1.5 million and added to Nell's fame.

Much of *Back to God's Country* was filmed in northern Alberta near Lesser Slave Lake. Some scenes were filmed at 60 degrees below zero. The leading man, Ronald Bryan, caught pneumonia and died during shooting, and manager Bert Van Tuyle had to have some fingers amputated after suffering frostbite. It was all part of the challenge of making a movie in the Great White North, a setting that Nell loved.

Nell often played the heroine in the wilderness: the strong, athletic woman who canoed on wild rivers and shot villains. Her independent heroines rescued themselves, as well as the men. Nell always saved the day.

Samuel Goldwyn offered Nell a lucrative seven-year contract that would have made her a wealthy and famous woman. She turned it down in 1917, opting to follow her dream of becoming a successful independent filmmaker. Nell didn't want any interference in her films.

She paid a high price for the decision.

Nell divorced Ernest in 1920 and launched Nell Shipman Productions the following year. She continued to write, direct, produce, and star in her own films, including *The Girl from God's Country* in 1921. Some were produced at her remote camp-studio in Priest Lake, Idaho, where she moved in 1922 with her son and her new partner, Bert Van Tuyle.

The emergence of the major Hollywood studios made it increasingly difficult for independent filmmakers to operate. Nell's company went bankrupt in 1924. She separated from Bert and moved to New York. Unlucky in love, she married several more times and gave birth to twins in 1926 while living in Spain with then-husband Charles Ayers.

Nell was involved in a few more films, writing the story for 1935's *Wings in the Dark*, starring Cary Grant and Myrna Loy. She is credited in as many as thirty films, though some have been lost. She continued to write throughout her life, penning novels and magazine articles as well as scripts. Always trying to revive her movie career, she still had an agent sending out her proposals when she was seventy-five. Nell died alone and broke at seventy-nine, while living in the desert of Cabazon, California.

She left behind volume one of an unpublished autobiography. Thanks to Professor Tom Trusky from Boise State University, who spent years ensuring Nell's legacy was preserved, both the autobiography and a collection of her letters were published. The latter showed an enduring attachment to Canada, as in a 1963 letter about her hopes of getting "back home" to make movies.[2]

In *The Girl from God's Country*, author Kay Armatage calls Nell Shipman a pioneer of both Canadian and American cinema. Armatage notes that Canadian scholars have neglected Nell because she worked in the United States, while American scholars consider her Canadian.

Quote:

"I did not like the way they dressed their contract players. This was in the period of curly blondes with cupid's bow mouths…. This long-legged, lanky, outdoors gal, who usually loped across the silver screen in fur parkas and mukluks, simply gagged at such costuming. And had the nerve to refuse it."[3]

Angela Sidney.

Tagish and Tlingit Tales

Angela Sidney
1902–1991

She devoted her life to preserving the language, dances, traditions, and stories of her people — and passing them on to a new generation.

When Angela Sidney died in 1991, she was a beloved and respected Tagish Elder of the Deisheetaan (Crow) Nation. Awarded the Order of Canada in 1986 for her significant contributions to preserving Native cultural heritage, she was the first woman from the Yukon to receive this honour. The humble lady proudly showed her photo of the ceremony in Ottawa at which Governor General Jeanne Sauvé presented her medal.[1]

Born near Carcross in the southern Yukon, she was given the English name Angela after an adoring prospector said she looked like an angel. She was also given the Tlingit name Stóow and the Tagish name Chʼóonehteʼ Ma because of her mixed ancestry: her father was Tagish and her mother was Tlingit.

Angela spent much of her life trapping, hunting, and fishing with her family. As a child, she occasionally attended school at the Anglican mission in Carcross, but spent most of her time participating in her community's traditional lifestyle. She grew up speaking both Tagish and Tlingit, and learned some Tahltan, Southern Tutchone, and Kaska, as

well as English. Angela loved hearing old Tagish and Tlingit stories from her mother and other relatives.

During Angela's lifetime, many of the cultural traditions of the First Nations in the Yukon were threatened by the influx of outsiders, first during the Klondike Gold Rush and later the construction of the Alaska Highway. She witnessed first-hand some of the effects of the rush as close relatives (including Kate Carmack and Skookum Jim) were in the party that struck gold on Bonanza Creek. At fourteen Angela wed twenty-eight-year-old George Sidney at the encouragement of her parents. She was first married simply in the custom of her people and later — at the insistence of her former teacher — in a formal ceremony in an Anglican church.

During the first winter of their marriage, Angela and George — whom she called Old Man — shared a twelve-by-fourteen-foot tent with her parents to save on wood. While Old Man was off working as a section hand on the Yukon White Pass Railway, Angela played: "I still felt like a kid even though I was living with Old Man — I was just like a child then!"[2]

Old Man was proud when his teenage bride once surprised him by catching some gophers and cooking them for supper. Pregnancy soon brought an end to Angela's childhood when she was fifteen. "I got in family way 1917. Gee, isn't that lucky? I was lucky I never got like that before!"[3]

She gave birth to seven children, but four died. Angela noted that when labour began the expectant mother would go to a camp behind the family house and hold on to a stick driven into the ground. After the birth the mother was given Hudson's Bay tea. They would hang the afterbirth of a boy in a tree for a Canada Jay to eat (so the boy would become a good hunter), and bury the afterbirth of a girl in a gopher den (so the girls became expert at catching gophers). Such traditions disappeared as missionaries and settlers moved in.

Angela wanted to make sure that her children and other First Nations people didn't lose their customs, history, legends, songs, or language. In the mid-1970s, she began recording and sharing the rich cultural knowledge she'd been gathering. She published Taglit and Tlingit stories in a number of books, including *My Stories Are My Wealth* (1977) and *Tagish Tlaagu* (1982). Other books documented Tagish and Tlingit place

names, as well as six generations of her family history. Angela spent many years collaborating with linguists and anthropologists Catharine McClellan and Julie Cruikshank, who helped her record traditional knowledge. Without Angela's devotion, much of the Tagish and Tlingit traditionals would have been lost.

By the time Angela Sidney died at eighty-nine, she was a renowned historian and storyteller, and the last of her people who spoke fluent Tagish. Her legacy includes the Yukon Storytelling Festival and the invaluable oral and written records of her community. Angela's death was mourned with a traditional potlatch in Carcross. Ch'óonehte'Ma Stóow is fondly remembered as a noble and generous woman.

Quote:

"I have no money to leave for my grandchildren. My stories are my wealth."[4]

Woman of the Paddle Song

Charlotte Small

1785–1857

Across the continent's rivers, mountains, and trails, she travelled farther than any other woman of her time[1] — and supported David Thompson as he mapped a nation.

Courtesy of photographer Ross MacDonald

Statue of David Thompson and Charlotte Small, Invermere, British Columbia.

The exploration party crossed and recrossed the foaming white swells in the Blaeberry River, clinging to their horses to avoid being swept away. Surveyor David Thompson was attempting to open a new route for fur traders across the Rocky Mountains. All the adventurers survived the harrowing ordeal, including the lone woman and her three small children.

Today she is recognized as a national historic person (more than eighty years after her husband received the same honour), a remarkable Aboriginal woman whose Cree language and many skills were essential to her husband's explorations during fur-trading days. She was commemorated with Thompson in a statue unveiled in Invermere, British Columbia, in 2003, and historians continue to try to piece together her story. Who was this woman?

Her name was Charlotte Small, born in 1785 at Île-à-la-Crosse, Saskatchewan. Her father, Patrick Small, was a senior partner in the North West Company before he retired to England in 1791, leaving behind his Native "country wife" and their three young children.

Though Charlotte's father left when she was just six, she benefited from the legacy of his last name. Charlotte's life was soon entwined with fur trader, explorer, and surveyor David Thompson, a poor boy who became one of the greatest geographers in North America.

"This day married Charlotte Small,"[2] Thompson wrote on June 10, 1799. In a simple ceremony attended by her mother and sister, thirteen-year-old Charlotte wed David Thompson, twenty-nine, at Île-à-la-Crosse. In the following years the couple journeyed across the continent as he explored and mapped for the North West Company by horseback, birchbark canoe, and on foot. Their children would frequently be lulled to sleep by the song of canoe paddles dipping into the waters of Canada's lakes and rivers. During the early years of their marriage, Charlotte travelled at least 20,000 kilometres,[3] from the headwaters of the Columbia River in the West to Montreal. She covered at least three and a half times more ground than the famous American explorers Lewis and Clark.

"My lovely Wife is of the blood of these people, speaking their language, and well educated in the English language; which gives me great advantage,"[4] wrote Thompson. Charlotte's knowledge, skills, and experience living on the land helped her husband immeasurably. She helped him communicate and maintain relationships with Natives. Charlotte also played a pivotal role in obtaining food and shelter and making clothing and equipment.

Thompson retired in 1812, moving east to Rupert's Land with Charlotte and their five children. They had eight more children there, all recorded in the family Bible.

David and Charlotte had their children baptized in the St. Gabriel Street Church in Montreal. The couple also formally wed there, as David demonstrated his devotion to the love of his life. Far from the woods and streams of her youth, Charlotte lived the next forty-five years in what was a strange new world. From the 1820s on, the couple faced poverty as David documented his travels and completed maps of what would become Canada and the United States.

No picture of Charlotte exists, just testimony from her grandson that she was about five feet tall, wiry, and active, with black eyes and almost copper-coloured skin. She left no written records of her

thoughts and dreams. Her husband's few personal remarks in his writings and the family Bible reveal his sensitivity, yet he shared little about the family.

Charlotte and David spent their last days living with daughter Eliza and her family near Montreal. The couple spent many evenings outside watching the stars, perhaps remembering their many starlit nights camped in the wilderness. The modest woman who explored North America extensively died just a few months after her companion of fifty-eight years. She was buried with him in Mount Royal Cemetery in Montreal.

Her gravestone reads: "Charlotte Small Thompson, Beloved Wife of David Thompson, September 1, 1785–May 4, 1857. Woman of the Paddle Song."[5]

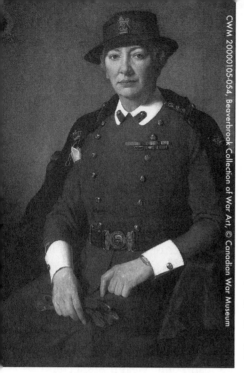

The Colonel

Elizabeth Smellie

1884–1968

She served in two world wars, built the Canadian Women's Army Corps, and led the Victorian Order of Nurses for decades.

Colonel Elizabeth Laurie Smellie C.B.E., R.R.C., L.L.D.

In 1944, nurse Elizabeth Smellie became the first female to be ranked colonel in the Canadian Army — a milestone for women in Canada.[1] Colonel Smellie was an impressive leader, courageous and committed to her country and the nursing profession. She was a model of self-sacrifice, recognized as an energetic and efficient administrator.

So how did Beth Smellie of Port Arthur become a colonel? Despite her father's objections, she pursued a nursing career and graduated from the internationally recognized John Hopkins Training School for Nurses in Baltimore. After the outbreak of the First World War, Elizabeth enlisted in the Canadian Army Nursing Service in January 1915 and soon set sail for Europe.

Nursing Sister Smellie served in both England and France. In addition to caring for the sick and wounded, she did transport duty. She was mentioned in dispatches in 1916 and in 1917. King George V awarded her the Royal Red Cross for exceptional service in military nursing. By the end of the war, she'd become the assistant to the army's

matron-in-chief, Edith C. Rayside. Elizabeth continued studying at Simmons College in Boston, where she completed the Public Health Nursing Course. Back in Canada, she became the assistant director of the School for Graduate Nurses at McGill University.

Elizabeth was later appointed superintendent of the Victorian Order of Nurses (VON) in Canada, a position she held from 1923 to 1947, except for four years during the Second World War. Under her leadership the VON expanded, becoming a strong national organization providing home-nursing services across the country. She received the CBE (Commander of the Most Excellent Order of the British Empire) from King George V in 1934. In 1938, she was awarded the Mary Agnes Snively Medal for outstanding leadership in nursing.

Elizabeth worked with the World Health Organization.[2] The Rockefeller Foundation also sought her expertise, sending her on a twelve-country tour to study maternal welfare. She also became a fellow, and later the first vice-president, of the American Public Health Association.

Elizabeth rejoined the army in the Second World War. Named matron-in-chief of the Royal Canadian Army Medical Corps, she served from 1940 to 1944. She was also called up to organize and administer the Canadian Women's Army Corps (CWAC), which was created in 1941 in response to the demands of women who wanted to support the armed forces in an official capacity. The following year military authorities finally agreed to integrate the organization into the Canadian Army. Demonstrating her superior leadership skills during the Second World War, Elizabeth was promoted to colonel in 1944.

Under the management of Colonel Smellie (and then Joan Kennedy), CWAC proved to be what military historian C.P. Stacey has called "a triumphantly successful experiment."[3] During a five-year period, more than 20,000 Canadian women served in CWAC, showing the possibilities for integrating women in the Canadian military.[4]

Colonel Smellie returned to the VON after the war, retiring in 1947. She was highly respected by her colleagues, who noted her charming personality and ability to work well with everyone. In 1960, Field Marshall Viscount Montgomery presented her with the Red Chevron award for her contributions to military nursing. Along with humanitarian Pauline Vanier, Elizabeth is featured on a stamp issued by Canada Post

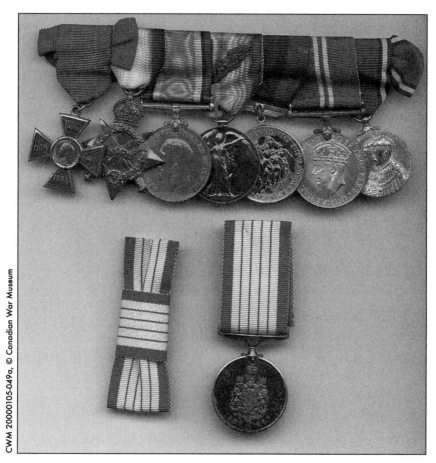

CWM 20000105-049a, © Canadian War Museum

Some of Colonel Smellie's medals.

in 2000. The University of Western Ontario gave this Canadian heroine an honorary doctorate of law, and the government of Ontario erected a historical plaque in her hometown of Thunder Bay.

Quote:

"… to nurse, the hands cannot be divided from the head and the heart."[5]

Bringing Ballet to Canada

Lois Smith

1929–2011

Canada's first prima ballerina entranced audiences – and inspired a new generation of dancers.

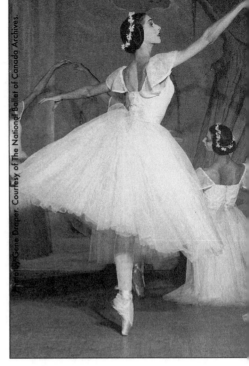

Lois Smith in *Les Sylphides*, November 1951.

When Lois Smith died on January 22, 2011, in Sechelt, British Columbia, newspapers across the country covered her passing. Though Lois was far from a household name, according to dance critic Max Wyman, "She gave ballet to the country.... Not a bad legacy, you know."[1]

Born in the Vancouver suburb of Burnaby in 1929, Lois was a poor kid who never dreamed of dancing until a neighbour suggested she try ballet. The girl was incredibly agile because her father had been teaching her gymnastics. But her parents couldn't afford ballet lessons. Her older brother Bill, who worked at a shoe factory, offered to pay for classes. At ten, Lois began taking classes at the British Columbia School of Dancing in Vancouver. Despite her teachers' encouragement, she had to drop out in less then a year when Bill lost his job.[2]

Family finances improved when Lois was fifteen. She eagerly took lessons with the Ballet Russe–trained Rosemary Deveson, who had a studio on top of the stately Georgia Hotel. Rosemary encouraged her to train seriously, so Lois dropped out of Templeton High School

and paid for her daily lessons by demonstrating for other classes. At seventeen she landed a job with Theatre Under the Stars, performing in summer musical presentations in Vancouver's Stanley Park for five years. "We were paid almost nothing," Lois remembered. "Fifteen dollars a week to start."[3]

Since there were few opportunities in Canada for talented and ambitious young dancers, Lois supplemented her summer work by performing with the Civic Light Opera, an American group that put on musicals in Los Angeles and San Francisco. She also danced in *Song of Norway* and *Oklahoma!* with an American touring company. Lois fell in love with a handsome dancer from Winnipeg, David Adams, who joined her as one of the two leading dancers in *Oklahoma!* They married in 1949.

When Celia Franca created a national and professional ballet company in Toronto, she invited David Adams, with whom she had danced in London, to join the troop. She agreed to hire Lois based on David's recommendation and a photograph. Lois was a bit tall for a ballet dancer, lacked extensive training, and had never danced in a professional ballet company. But Celia gambled on her potential: "with her beautiful legs and feet, natural classical line, and zeal she was destined to become our first principal ballerina."[4]

From the first exhibition performance in 1951 of the company that become the internationally acclaimed National Ballet of Canada, Lois Smith and David Adams were unofficially presented as the star dancers. They lived up to the great expectations. With intensive training from Celia Franca, Lois worked incredibly hard to develop technical skills such as speed, agility, and attack to expand her naturally expressive abilities and lyrical quality. She became Canada's first and foremost ballerina and a major audience draw.

During the difficult first years of the National Ballet, Lois faced a host of challenges. She gave birth to her only child, Janine, shortly before being invited to join the company. David's parents stepped in to care for the baby. The company was struggling to survive, so Lois and David literally laboured for love rather than money. During their first winter in Toronto, the young couple lived rent-free with other dancers in a large house, burning newspapers for heat.

Lois practised for long hours in makeshift studios, including drafty ramshackle rooms above a feed and grain store. The dancers never practised with the orchestra or with sets and lighting. During tours in Canada and the United States — scheduled between late fall and early spring — the company was often caught in blizzards. On a western tour in 1952, they gave a performance in Calgary after stepping off the train they'd been on for three days and two nights. When Lois danced outdoors at the Canadian National Exhibition grandstand show in Toronto that year, she could hardly keep her balance in a vicious wind and rain storm.

Everyone danced through the difficulties, dedicated to building a thriving national ballet company. Because there was no free medical care, the dancer's injuries sometimes didn't receive the best medical attention. Lois once had to dance with a cracked rib; there was no understudy. She was forced to quit the National Ballet in 1969 due to a knee injury; David had already left to dance in England in 1964, resulting in the end of the marriage.

Lois played a variety of roles during her eighteen years with the National Ballet. She delighted audiences with her leading roles in *Giselle, La Sylphide, Coppelia, Cinderella*, and *Sleeping Beauty*. A versatile performer, Lois also appeared on the television show *The Wayne & Schuster Hour* in 1963 in a sketch called *The Swan Lake Murder Case*.

Elegant and extremely talented, "she defined Canadian ballet for a long, long time,"[5] Max Wyman noted. Lois was idolized by aspiring ballet dancers like prima ballerina Karen Kain, for whom Lois "was a continuous source of inspiration" and "paved the way for all of us."[6]

The beloved ballerina established the Lois Smith Dance School in Toronto. It was eventually incorporated into the Performing Arts Program at George Brown College for which she was the chairman. She also choreographed productions for CBC Television, the Winnipeg Opera Company, and the Canadian Opera Company. In 1988, she moved to the Sunshine Coast in British Columbia, where she created another dance school and continued to perform occasionally.

Lois Smith received the Order of Canada in 1998 for her contribution to Canadian dance. Fans remember her as "the Canadian ballerina."[7]

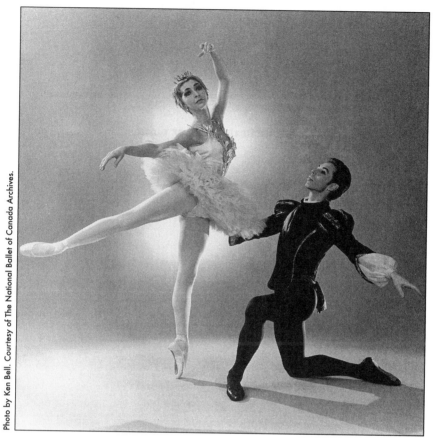

Photo by Ken Bell. Courtesy of The National Ballet of Canada Archives.

Lois Smith and Earl Kraul in *Swan Lake*, 1967.

Quote:

"What makes a prima ballerina? It is hard to say. I know I was fortunate to have the right kind of body for ballet, but I knew I had to work, and work hard."[8]

The Conductor Who Built a Great Symphony Orchestra

Ethel Stark

born 1916

She rebelled against sexism on the symphony stage and helped usher in podium feminism[1] by founding and conducting the Montreal Women's Symphony Orchestra.

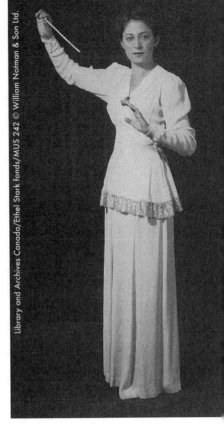

Ethel Stark.

It was 1940 and women in Quebec had finally won the right to vote. But women were usually excluded from professional symphony orchestras and struggled to earn respect as classical musicians. Ethel Stark dared to start an all-woman orchestra in Montreal and mount the podium as conductor. "We were a strong current in the rising tide that would sweep away the barriers to women musicians," she remembered.[2]

A Montreal native, Ethel was a brilliant violinist, a fine pianist, and an inspirational teacher. She was the first Canadian to win a fellowship at the prestigious Curtis Institute in Philadelphia, and was the only woman to sign up for Artur Rodzinski and Fritz Reiner's conducting classes. In 1934, while playing with the Curtis Symphony Orchestra, she was the first Canadian woman soloist on a program broadcast across the United States. She founded the New York Women's Chamber Orchestra in 1938.

Ethel started the Montreal Women's Symphony Orchestra (MWSO) after an amateur violinist named Madge Bowen asked her to direct some female string players. Ethel said she was only interested in working with a full orchestra, so Madge recruited more women. Since female musicians were generally considered suited for piano or strings, only a couple of the young women who signed up could play the flute; none could play wind or brass. Some were keen to learn new instruments, so the work began.

The women, most of them workers with little spare money, overcame many hurdles with the help of Montrealers who donated old instruments, loaned rehearsal space, and helped teach them. After scrounging to repair instruments and buy chairs, the musicians practised in basements, lofts, and churches. Nobody got paid. Ethel poured her energy into moulding the women into an orchestra and demanded nothing but the best from them. "If she heard wrongdoings, she could roar like a lion," one musician recalled.[3]

With Ethel as conductor, the MWSO gave its first concert on July 29, 1940, in front of the Mount Royal Chalet. Thousands turned out to see Canada's first all-female orchestra. One of the first of its kind in the world, the MWSO was composed of eighty women and performed for more than a quarter of a century. In 1947, they were proud to become the first Canadian orchestra to play at New Carnegie Hall — a performance lauded by New York critics. The MWSO also played in Toronto and London, but had to decline offers to perform in Europe, the Soviet Union, and Japan due to lack of funds. After decades of surviving without regular financial support, the volunteer orchestra disbanded in 1960. But the company's success helped women establish themselves in other orchestras.

Ethel was the first Canadian woman to gain international renown as a conductor. She performed as a guest conductor in Canada, the United States, Israel, and Japan. She also founded the Ethel Stark Symphonietta (1954) and the Montreal Women's Symphony Strings (1954–1968). Ethel appeared as violinist or conductor in at least 300 radio programs broadcast throughout North America and Europe.

Ethel earned much of her living as a violin teacher. She taught at the Catholic University of America in Washington as well as at the Provincial Conservatory of Music in Montreal and Concordia University. She received many accolades for her accomplishments,

including the Order of Canada, the Order of Quebec, the Queen's Golden Jubilee Medal, the Canada 125 Medal, Fellow of the Royal Society of Arts in England, and an honorary doctorate of law from Concordia. Heartbroken by the theft of her cherished eighteenth-century violin in 1990, she never played again.

"It is irreplaceable," she said. "People just don't realize that for 40 years, six to eight hours a day, seven days a week, that violin was under my chin. I gave it my heart and soul and it responded in kind."[4]

Ethel was a groundbreaker, opening doors for other female professional musicians and conductors. She raised the status of women in music by providing them with an opportunity to perform — and demonstrating herself that women could be great violinists and conductors. While Ethel didn't experience overt discrimination during her career, sexism was more evident in the opportunities that never came: "Where were the people to say, 'Let's take her and send her on tour as a guest conductor?' "[5]

Quote:

"We had a great success. Now I can't believe our nerve."[6]

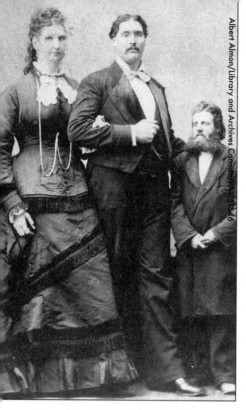

Walking Tall

Anna Swan

1846–1888

When her height seemed a disability, she capitalized on the opportunity to earn a living and demonstrate her talents as a performer.

Anna Swan with her husband Martin Van Buren Bates, and an unidentified man of normal height, circa 1878–88.

Anna Swan's grandmother told her to "stand tall, lass, and be proud of your highland ancestry."[1] These words guided Anna as she faced the challenge of being almost eight feet. By twenty-two, she weighed 350 pounds.

A woman who struggled to function in a world made for much smaller people, Anna survived and eventually thrived. She earned the respect and admiration of friends, family, co-workers, and an adoring public. Even Queen Victoria was a supporter.

Anna was a normal-sized baby born to Scottish parents in Mill Brook, Nova Scotia, in 1846. She towered over her peers from an early age, and had a hard time joining childhood games. Her family couldn't afford the extra costs of special clothing and furniture for their large daughter. They reluctantly accepted an acquaintance's invitation to raise money by touring the province with four-year-old Anna. She was exhibited as "The Infant Giantess," and adults paid a dollar to see her, children fifty cents.

Already standing five feet four inches when she started school, Anna was teased and taunted about her size. She was soon too big to sit at the

family dinner table, so she had to sit on the floor with a special table of her own. By fifteen, Anna stood seven feet.

She'd grown tired of touring country fairs and wanted to pursue her dream of becoming a teacher. In 1861, Anna moved to Truro, where she enrolled in teachers' college and stayed with an aunt. Extremely depressed by the stares and personal questions asked by strangers, the teenager soon begged her father to take her home.

Anna's unusual size came to the attention of the showman Phineas T. Barnum. From the early 1840s until it burned down twice in the 1860s, he operated Barnum's American Museum, a combination museum, zoo, aquarium, theatre, and lecture hall in New York City. As many as 15,000 people a day visited the attractions, which featured people with physical anomalies. Author Robert Bogdan notes in his book *Freak Show* that these performances are now considered despicable and cruel, exploitive and demeaning, but brought fame and fortune to many of the performers.[2] Such was the case for Anna.

After receiving a number of offers from Barnum, Anna and her parents negotiated acceptable terms. Eager to continue her education, the teenager would have a private tutor three hours a day for three years and earn $23 a week in gold (later, $1,000 per month) — an enormous amount of money for the time.[3] She would also study voice and piano. Worried about possible exploitation, the Swans travelled to New York with Anna, and her mother stayed for a year. Throughout her career Anna sent money home.

Anna enjoyed spacious living quarters with luxurious, oversized furniture. A seamstress created beautiful gowns for her, including a dress made from 100 yards of satin and 50 yards of lace. Billed as "Big Ann," she was the only known giantess in the world. She played the piano, read poetry, and recited from plays. Increasingly self-confident, Anna enjoyed talking to the crowds and working with a family of other performers. Her close friends included Charles Sherwood Stratton (the dwarf, General Tom Thumb) and his wife, Lavinia Warren (also a dwarf), as well as Millie and Christine McCoy (Siamese twins).

Barnum treated Anna with respect and noted that "she was an intelligent and by no means an ill-looking girl and during the period she was in my employ she was visited by thousands of people."[4] Anna liked her employer, and considered him "a fine, jolly man with a clever sense of

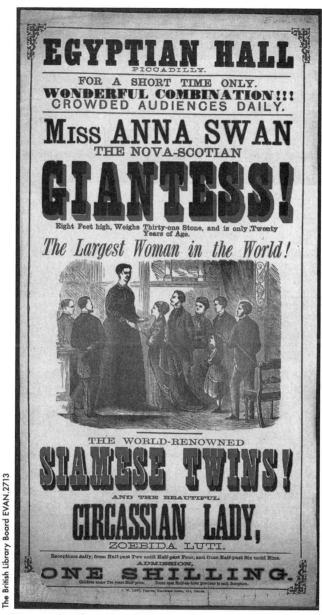

A poster describing Anna Swan, circa 1871.

humour."[5] She accompanied him on a European tour in 1863 when she met Queen Victoria and visited her ancestors' Scottish homeland.

When fire destroyed Barnum's American Museum in 1865, Anna was nearly burned to death. She was too large to escape through a window,

but eighteen men hoisted her out of the burning building by block and tackle. Anna decided to pursue her career independently. In 1871, while travelling to Europe with the Ingalls Troupe, she fell in love with Captain Martin Van Buren Bates, a well-known giant from Kentucky. The happy pair got engaged during their Atlantic voyage, and when they performed for Queen Victoria, she took an interest in their upcoming nuptials.

At the queen's invitation, Anna and Captain Bates were married in the Royal Parish of St. Martin-in-the-Fields. Anna wore a gown presented to her by Queen Victoria, and both the bride and groom sported gold watches they'd received as gifts from the monarch. The queen also gave Anna a diamond-cluster ring. An engraving in *The London Telegraph* depicted the tallest married couple in the world on their wedding day.

The newlyweds settled on a farm near Seville, Ohio, living in a special house with fourteen-foot ceilings and customized furniture. They were regulars at the Seville Baptist Church where Anna also taught Sunday school. The kind-hearted Nova Scotian was well-loved and admired in the community, where she enjoyed quilting bees and charity work.

The couple's two children died at birth. Both babies were abnormally large, and the labour and delivery were agonizing for Anna. Their son, thirty inches long, weighed twenty-three and a half pounds. Anna and Martin were both severely depressed after losing their children.

Anna Swan Bates died of tuberculosis in 1888 at forty-two, leaving behind an impressive estate valued at $40,000. The Anna Swan Museum in Nova Scotia pays tribute to this extraordinary woman, and there is a small monument to the Nova Scotia Giantess in New Annan.

Quote:

"I hate being different from others."[6]

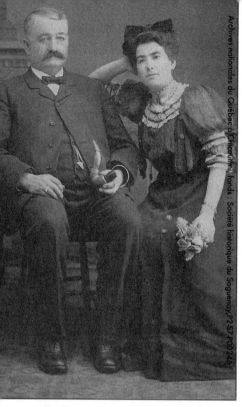

The Sourdough from Lac-St-Jean

Émilie Tremblay

1872–1949

One of the first white women to cross the Chilkoot, she scaled the pass years before the gold rush.

Émilie Tremblay and her husband Pierre-Nolasque, circa 1905.

"Thanks to God the profession of explorers has not been, even in the North, the lot of men alone,"[1] the adventurous Émilie Tremblay said. The spunky francophone spent her honeymoon on a 5,000-mile journey from Quebec to the Klondike, where her new husband had struck gold.

Émilie was born in St-Joseph-d'Alma, and lived in Chicoutimi and then New York state as a child. Émilie Fortin married Pierre-Nolasque "Jack" Tremblay in a Catholic church on December 11, 1893. She was twenty-one and thrilled to set out for the wilderness with the love of her life, despite her relatives' fears. After crossing the content by rail the newlyweds took a steamer to Juneau, then began their trek over the Chilkoot Pass with three First Nations packers.

Émilie thrived on the challenges of the journey, even after she was caught in an avalanche on the Dyea Trail. Once they reached Lake Bennett, their party camped for several months to build boats. They survived rough water on the lake, the treacherous rapids at Miles Canyon, then ice floes and sandbars on the Yukon River. Émilie prided herself on

cooking good meals for the men, surprising them with omelettes and cookies made using seagull eggs. She would later reflect that "this first trip down the Yukon River remains in my memory, full of romance, joy and love. There was nothing like it in all the world."[2]

The Tremblays' destination was Miller Creek. Their first home was a filthy one-room cabin, complete with a pole encrusted with black tobacco spit. They scrubbed the place and made furniture. There were no other women in the isolated mining camp, but Jack had a crew of men to help. Émilie, who spoke only French, began studying English grammar books so she could talk to the miners. She also cooked for them, and treated everyone to a sumptuous meal that Christmas: roast caribou, stuffed rabbit, King Oscar sardines, boiled brown beans, dried potatoes, sourdough bread, and prune pudding. After surviving a long, dark winter, she began growing lettuce and radishes on a rooftop garden.

In the fall of 1895, the Tremblays headed south to visit their families. It was meant to be a quick visit, but they ended up nursing Émilie's mother until she died. It wasn't until spring 1898 that the couple managed to head back north, too late to stake the best claims in the Klondike. Émilie and Jack initially settled on Bonanza Creek and prospected on various claims until 1913, but never struck it rich. They then moved to Dawson City, living above the dry goods shop that Émilie operated for thirty years as Madame Tremblay's.

Émilie Tremblay was a prominent businesswoman who was devoted to helping others in her community, from delivering babies to organizing bazaars for the church. She welcomed missionaries, widows, and travellers into her home, and raised her niece. During the Second World War, she knitted 263 pairs of socks for soldiers. Émilie also founded the Ladies of the Golden North, served as president of the Yukon Women Pioneers, and became a lifetime member of the Imperial Order of the Daughters of the Empire.

Émilie Tremblay died in 1949. The Saguenay Museum holds the medals she was awarded for community service. In 1985, the first francophone school in Yukon was named in honour of this heroine of the North. Madame Tremblay's store is still a well-know building in Dawson City, where it is a recognized federal heritage building within a national historic site commemorating the Klondike Gold Rush.

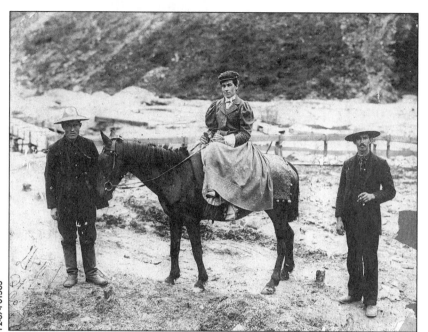

Archives nationales du Québec à Chicoutimi, fonds: Société historique du Saguenay, P2-S7-P01563

Émilie Tremblay on Eldorado Creek, 1898.

Quote:

"I needed a lot of courage to face and endure that kind of life. But, thank God, I had it and I was never homesick or downhearted."[3]

Mountain Woman

Mary Schäffer Warren

1861–1939

The most famous female explorer in the Canadian Rockies, she literally put Maligne Lake on the map. Then made sure it was protected within Jasper National Park.

Mary Schäffer Warren in the Rocky Mountains.

Prospectors were startled to find a couple of women camped in the wilderness at Tête Jaune Cache, British Columbia, in 1908. The *Edmonton Bulletin* later reported on the shocking discovery that "The women had no husbands, brothers or other encumbrances, along with them, and needed none." And just as surprising, "They are described as anything but masculine in appearance."[1]

The female adventurers were two Quaker friends from Philadelphia. Mary (née Sharples) Schäffer and Mollie Adams were wealthy women searching for the "great un-lonely silence of the wilderness."[2] After the completion of the Canadian Pacific Railway in 1885, a steady stream of tourists headed west each summer. Mary had first visited the Rockies and Selkirks in 1888, at twenty-six, travelling with friend and fellow artist Mary Vaux. At Glacier House, the CPR hotel in Rogers Pass, Mary Sharples met the charming Dr. Charles Schäffer, a Philadelphia medical doctor and amateur botanist twenty-three years her senior. She returned to the mountains the following year as his bride.

The couple spent each summer in the mountains until Dr. Schäffer died in 1903. Mary then worked with a curator at the Academy of Natural Sciences in Philadelphia to compile a book of Dr. Schäffer's botanical materials and her impressive photographs and watercolours. *The Alpine Flora of the Canadian Rocky Mountains* was published in 1907.

Mary Schäffer continued her summer excursions. Year after year Mary and her friend Mollie Adams had watched enviously as men headed out on expeditions from Lake Louise. One day the duo decided they could cope with the hardships of exploration as well as men. They hired mountain guides to teach them to ride horses and camp and began exploring more as their confidence grew.

In 1907, with Billy Warren as their guide, the women rode out of Lake Louise on a four-month pack trip. Nine-tenths of Mary's friends and relatives thought she was crazy, and the others just listened to her plans patiently.[3] The pack train headed north to the headwaters of the Athabasca and North Saskatchewan Rivers, though Mary's "real object was to delve into the heart of an untouched land, to tread where no human foot had trod before."[4] They searched, without success, for a legendary lake known to the Stoney Nation as Chaba Imne (or Beaver Lake). When the disappointed adventurers rode back into Lake Louise that fall, poet Rudyard Kipling was astounded to spot "two women, black-haired, bare-headed, wearing beadwork squaw-jackets, and riding straddle."[5]

In 1908, Mary and Mollie continued their search for the lake with their guides Bill Warren and Sid Unwin and two other camp helpers. The party travelled north to Poboktan Pass, then, after crossing Maligne Pass, they found the mystery lake. The ladies were the first white women to see what Mary named Maligne Lake. For three days the group explored the shimmering turquoise lake on a small raft. Through the raft's cracks, they could see icy blue waters below.

As the explorers passed through the lake's narrows, they suddenly saw the spectacular southern end of the lake encircled by peaks cradling glaciers and icefields. At 27.5 kilometres in length, Maligne Lake is the largest glacial-fed lake in the Canadian Rockies. Mary named many of the surrounding mountains: Mounts Warren and Unwin for the guides, Mount Mary Vaux for her friend, and Mounts Samson and Leah for the

Stoney and his wife who'd provided a rough map to the lake. Her Stoney friends referred to Mary as *Yahe-Weha*, "Mountain Woman."

During the winters, Mary entertained audiences in Philadelphia with lectures featuring hand-tinted lantern slides. She would be introduced as "the little explorer, who lives among the Rocky Mountains and the Indians for months at a time, far, far in the wilderness."[6] Mary also wrote many articles about her travels, and her popular book *Old Indian Trails of the Canadian Rockies* was published in 1911. That same year she returned to Maligne Lake at the Geological Survey of Canada's request to conduct an official mapping of the lake using a magnetic compass. She was influential in the successful lobby to ensure Maligne Lake was included within Jasper National Park.

The explorer settled permanently in Banff in 1912, marrying her longtime love Billy Warren. Mary died in 1939, and though her husband was about twenty years younger, he survived her by only four years.

Mary was an accomplished naturalist, writer, public speaker, photographer, and artist. She inspired others to visit the Canadian Rockies, and was an original member of both the Trail Riders of the Canadian Rockies and the Alpine Club of Canada. She was also a member of the Royal Geographical Society, the Association for the Advancement of Science, and the Academy of Natural Sciences in Philadelphia.

In Yoho National Park, Mary Lake, Schäffer Lake, and Mount Schäffer are tributes to the explorer and her first husband. Tourists in Jasper can take guided cruises on Maligne Lake and hear about her adventures, hike along the Mary Schäffer Loop trail, or camp in the Mary Schäffer Campground. Visitors to Banff can stroll by the heritage home at 117 Grizzly Street, where she and her devoted guide Billy Warren lived.

Quote:

"… there are some joys you will never feel, there are heart thrills you can never experience, till, with your horse you leave the world, your recognized world, and plunge into the vast unknown."[7]

Maud Watt.

The Angel of Hudson Bay

Maud Watt
1894–1987

As the beaver in northern Quebec disappeared, the Cree starved. Maud set out on an incredible journey to create a beaver preserve.

Maud Watt was an adventurer, an explorer, and a skillful negotiator said to be as persuasive as the Angel Gabriel.[1] Once a legendary figure in the Canadian North, the pioneering conservationist was referred to as the "Angel of Hudson Bay."[2] But has she been forgotten?

Born on the Gaspé, Maud Maloney was the tenth child in a family of fourteen. Her Irish father worked as a fisherman, carpenter, and boat builder, while her mother, Elizabeth Poirier, managed the hectic, yet happy household. Maud could bake bread as well as hunt hares and ptarmigan and use Morse code. After the family settled at Mingan, Quebec, the young girl attended classes at the nearby convent. Fluent in French and English, she learned Latin and also picked up some Montagnais.

When Maud was twenty-one, she married a young Scotsman named James Watt, a clerk for the Hudson's Bay Company (HBC). He'd been offered a job as subdistrict manager of Fort Chimo on Ungava Bay. The newlyweds were soon Arctic-bound on the icebreaker *Nascopie*. Their honeymoon began a lifetime of adventure in the North.

Eager to visit as much of the country as possible, Maud charmed the captain into allowing them to stay aboard for the planned circuit to Baffin Island and Hudson Bay. During the trip, she scampered over rocky shores, picking Arctic flowers and meeting the Inuit. The fun-living Maud also played poker on the ship, noting that she "lost and won cars, pianos, and jewels enough to cover the Queen of Sheba."[3]

From her first days in Fort Chimo, Maud welcomed the Natives into her home and treated them respectfully, unlike many of the HBC employees and their wives. The Watts were caring and compassionate, genuinely concerned about the welfare of those who traded with the company. When the supply ship didn't appear for three years, the Watts made a gruelling 800-mile journey from Fort Chimo to the St. Lawrence for help.

When the Watts arrived at Sept-Îles months later, they found the Quebec-bound steamer already full. A gentleman kindly offered them his stateroom. The chance meeting would prove helpful, as Maud's admirer was the Honourable L.A. Taschereau, future premier of Quebec.

In 1919, James was reassigned to Rupert House on James Bay. It had been one of the most productive beaver-trapping areas in the world, but was receiving only a few thousand beaver skins the year the Watts arrived. The numbers plummeted each year, and Rupert House was operating at a loss. With few beaver available, the Cree were suffering. It was one of their major food sources and they needed to trade the furs to survive.

In 1928–29, Rupert House received only four beaver skins. Many Cree were starving. James Watt suggested the creation of a beaver farm to provide steady production of beavers, but the HBC ignored his desperate pleas. When two men told James they'd found an occupied beaver lodge, he used his own money to buy the live beaver so they could live in the wilderness. He also convinced the local Cree that leaving the beaver to reproduce would eventually result in a sustainable resource. James continued paying Natives to guard the beavers, but his credit was running out and threat of poaching grew. By the third year, there were more than 200 beaver.

Though it was mid-winter, the Watts decided they had to act immediately. They decided to ask the Quebec government to set aside some of its territory as a beaver preserve. The government wasn't likely to be receptive, and James would probably be fired for abandoning his

post. Plus, he couldn't speak French. Maud decided to travel to Quebec City immediately to plead on behalf of the Natives of northern Quebec.

It was sixty below zero when Maud set out on dogsled, with two skilled men and her children (aged three to six) bundled up in bearskins. After an arduous journey by sled, foot, and finally train, the group arrived in Quebec about a month after departing. Maud met with the deputy minister of the provincial fisheries department, Louis A. Richard; she calmly asked for a large reserve, offering a token payment of $10. After subsequent meetings and considerable negotiation, Premier Taschereau and his cabinet approved her audacious request.

Maud returned with a lease from the Province of Quebec for 7,200 square miles of territory to be used as a beaver reserve. She served as proprietor of the Rupert House Preserve, but the Watts couldn't finance the venture indefinitely. Eventually, the Hudson's Bay Company took over the lease. By 1940 there were over 4,000 beavers, and licensed hunters could trap within the preserve, according to a quota system. The Rupert House Preserve became a model for other beaver preserves across Canada.

When James died of pneumonia in 1944, Maud lost both the love of her life and her home. A few days after his death she climbed into a float plane to fly south, but Maud's heart stayed in Rupert House. She later returned to set up a bakery. She also built the J.S.C. Watt Memorial Community Hall and adopted several Cree children.

During Maud's lifetime, she received a number of honours in recognition of her devotion to improving the lives of the First Nations of northern Quebec. In 1952, the Province of Quebec appointed her official warden of Rupert House, providing her with authority, a badge, and a modern two-storey house. She was the first female game warden in the province.[4] The Beaver Club in Montreal, the historic association of wealthy fur traders, presented her with a golden trophy. The well-dressed and elegant Maud, speaking in classic French, charmed the members with her gracious acceptance speech.

Maud was awarded the Order of Canada in 1971. She died in Ottawa in 1987 but was buried in Rupert House near her beloved James, in the land that she called home. In March 2009, Radio-Canada broadcast a program about Maud Watt in a series about remarkable people who have been forgotten.

The Beaver, March 1943.

Maud Watt with sleigh.

Quote:

"… here I am standing on a hilltop with a jewelled world at my feet — and healthy and happy — with an appetite no millionaire could buy — and not a worry in the world."[5]

— Maud Watt describing her view near Ungava Bay.

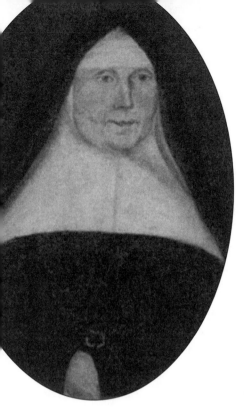

From Captive to Mother Superior

Esther Wheelwright

1696–1780

She was once a devout Puritan girl. But her dedication to Catholicism helped save the Ursulines after the fall of New France.

Mother Esther Marie-Joseph de l'Enfant-Jésus, circa 1763.

In the summer of 1703, Esther Wheelwright was seven years old, a happy child on the American frontier. The daughter of prominent pioneers Colonel John Wheelwright and Mary Snell, she was born and raised in Wells, Massachusetts. The Wheelwrights were influential Puritans; Colonel Wheelwright served as a judge, town clerk, and councillor.

On August 21, 1703, hundreds of Abenaki warriors and French forces raided the community of Wells, torching buildings, killing twenty-two, and kidnapping seven, including Esther. The terrified child joined sixty-eight captives from other nearby communities. The raiding party forced the prisoners to march north on an incredible 200-mile journey through forests and swamps. After about a week, Esther and the other surviving captives arrived in the Abenaki village of Norridgewock, near the Kennebec and Androscoggin Rivers, in New France.

An Abenaki family adopted Esther, who was in "an impenetrable gloom."[1] She laboured in the fields with her adoptive family and was trained in Catholicism by a Jesuit priest. She attended Sunday Mass and

catechism class before being baptized a Catholic as Marie-Joseph. Esther soon lost her English vocabulary and became fluent in Abenaki. When her new family moved to a St. François mission (south of Trois-Rivières) in 1705, young Esther paddled canoes and portaged on snowshoes like everyone else.

Once the Wheelwrights learned that their daughter had survived, they appealed to the governor of Massachusetts for her release. The powerful and persuasive Father Vincent Bigot in Quebec eventually managed to convince Esther's Abenaki parents to release her in a prisoner exchange. She was sent to Quebec after five years of captivity. Esther was welcomed into the splendid home of New France's Governor Vaudreuil.

Despite the Wheelwrights' continued efforts to have their daughter released, they never saw her again. She had made a strong impression on Father Bigot, who was confident that the young captive had great potential as a convert. Father Bigot devoted himself to Esther's education and advancement.

He enrolled Esther in the boarding school run by the Ursulines in Quebec and she decided to join the order. She took her vows on April 12, 1714, as Esther Marie-Joseph de l'Enfant-Jésus and began an extraordinary career with the Ursulines. Esther became principal of the boarding school, then mistress of the novices, before being elected as the first English-born Mother Superior of the Ursulines in Quebec on December 15, 1760. After 1772, she served as assistant superior until 1778, then zelatrice until her death in 1780.

Esther accepted the keys to the convent at one of the most challenging times in the Ursulines' history. The British conquest of French forces in North America had left the monastery in shambles. Refugees and British soldiers sought shelter there. The Ursulines were in debt and had no income. The boarding school was closed and their traditional patrons had fled or lost their fortunes. Ties with the Mother House in France were broken, and Esther and the sisters feared for the order's survival.

Esther became Mother Superior in the midst of hostilities between the British military and the conquered population. She used her excellent diplomatic skills to demonstrate that the Ursuline order was beneficial to the new colony. Among her many influential English patrons was the

writer Frances Moore Brooke, who incorporated Esther in her book *The History of Emily Montague*, the first Canadian novel.

Esther maintained contact with her relatives over the years, and her English background and family connections helped her build important relationships with the English colonists. She was able to place English students in the boarding school, rent out rooms to ladies, and establish a lucrative business selling holy objects, convent art, fresh produce, and jams. The unlikely Mother Superior from Wells saved the Ursulines from extinction while serving in the most powerful religious position that a woman of her day could hold.

Esther's story has long been familiar to historians of New France, and the Wheelwright family has cherished the memory of the lost child who became a famous Ursuline. For eight generations the only existing portrait of her was handed down in the Wheelwright family through members named Esther. In more recent times, her creative relatives have honoured her memory. Director and producer Penny Wheelwright released the documentary *Captive — The Story of Esther* in 2004, and author Julie Wheelwright spent several decades researching her 2011 book *Esther*.

Quote:

"Thus you see, my lovely Mother, the impossibility there is of complying with the desire you have of my return to you. It hath been always an infinite trouble to me to resist the desire that you and my Dear Father have so often repeated in times past."[2]

The Unforgettable Madam Mayor

Charlotte Whitton

1896–1975

Charlotte Whitton, 1935.

The first female mayor in a major Canadian city, she was a flamboyant trailblazer for women in public life.

Charlotte Elizabeth Hazeltyne Whitton was born in 1896 to a family of modest means in Renfrew, Ontario. She excelled in school, motivated by her mother's advice: "Charlotte Elizabeth, you'll have to make the best use of the brains you've got for you've neither a face nor a figure."[1]

Sixteen-year-old Charlotte was inspired by the mock election in history class at school, and raced home to share her dream of becoming a federal cabinet minister. Her usually placid father fumed at the preposterous idea, because "like rugby, politics was for the boys and men."[2] He did, however, believe in the value of education. During the First World War, the ambitious young woman attended Queen's University on scholarships, excelling at both academics and hockey. Her hopes for a career in public service grew when women won the right to vote in federal elections in 1918, the year she graduated with an M.A.

Charlotte became a social worker, working tirelessly for two decades on child protection and family welfare in Ottawa. From 1920 to 1941, she was a driving force behind the Canadian Council on Child Welfare (CCCW),

which became a strong national organization. Charlotte led the way to making social work a profession rather than a volunteer activity. Under her leadership, the CCCW worked to protect handicapped, illegitimate, and immigrant children, and improve child welfare legislation and the juvenile justice system. The CCCW also conducted valuable research, published reports, held conferences, compiled a directory of child welfare agencies, and worked with federal and provincial authorities across Canada.

A tireless activist, Charlotte lectured across North America. She served on the League of Nations' Child Welfare Committee for more than a decade. During the Great Depression, Prime Minister R.B. Bennett hired her to investigate the distribution of unemployment relief. She also wrote countless articles for newspapers, magazines, and journals, and hosted a popular television show called *Dear Charlotte*.

During the 1940s, Charlotte continued fighting for the public good. After alleging that babies were being smuggled out of Alberta for sale in Ontario and the United States, she was charged with conspiracy to commit criminal libel. When the charges were dismissed, and a Royal Commission in 1949 confirmed her report, one writer congratulated Charlotte and compared her to Joan of Arc.

Charlotte was in her fifties when she became the mayor of Ottawa. In 1950, she was elected to city council as controller, thanks to strong support from many women's groups. She stepped into the position of mayor the following year. "While men groaned and women gloated, Charlotte Whitton took up the municipal reins."[3] When one alderman suggested that a particular topic might be offensive to a woman, she quickly reassured him, "Whatever my sex, I'm no lady."[4]

She served for nine years, 1951–1956 and 1960–1964. Colourful and controversial, she was an outspoken mayor known for many stormy confrontations with her opponents. She once threatened to hit a man who made a sexist remark. After leaving the mayor's chair, she became an alderman until retiring in 1972, at seventy-six. Charlotte encouraged other women to become active in politics and championed women's equality standing firm on her conservative notion that married women shouldn't work outside the home. Her bold personality, controversial views, and wit frequently made her the focus of attention, putting Charlotte in the headlines for more than half a century.

Who is it?

She rules the roost where a majority of men rule Canada. Turn to page 46 to see who this young lady grew up to be.

Charlotte Whitton at age five, in a teaser for an article about her in *Maclean's*, 1956.

Charlotte was named a Commander of the British Empire (1934), and awarded the Jubilee Medal (1936) and the Coronation Medal (1937). She also received several honorary degrees. She died in 1975, but people still speculated on her legacy and sexual orientation.

Charlotte's racism raised concerns about how she is remembered. She frequently expressed her anti-Semitic views in important discussions of immigration, which influenced government decisions to restrict the entry of Jewish refugees. Determined to preserve the Anglo-Canadian

character of the country, she voiced her racist objections to the immigration of Ukrainians, Asians, and other ethnicities.[5]

Though anti-Semitism was common at the time, Bernie Farber of the Canadian Jewish Congress pointed out that "[the] difference with Charlotte Whitton is she acted on her anti-Semitic views ... she damned Jewish children."[6] Ruth Klein of B'nai Brith Canada commented that "[the] Charlotte Whitton controversy forces us to re-evaluate the standards we use to choose our national heroes and heroines.... People's prejudices and the actions they take should be taken into account when we assess their enduring legacy. The negatives cannot just be overlooked."[7]

Charlotte donated her personal papers to Library and Archives Canada, stipulating that the box of letters written by longtime companion Margaret Grier be sealed for fifteen years longer than the rest. The couple, who had a very close and affectionate relationship for about thirty years, lived together until Margaret died of cancer. The opening of the box in January 1999 caused a sensation.

After her partner's death, Charlotte had written, "Oh! Mardie, Mardie, Mardie, how can I go on? Ours wasn't love; it was a knitting together of mind and spirit; it was something given to few of God."[8] While some historians doubt a lesbian relationship,[9] others believed that they "obviously had a wonderfully physical relationship."[10]

Charlotte Whitton continues to be remembered as an influential feminist, journalist, social worker, and politician.

Quote:

"Whatever women do they must do twice as well as men to be thought half as good. Luckily it's not difficult."[11]

A Great Human Dynamo[1]

Mona Wilson
1894–1981

A heroic nurse for a new century, she made a difference.

Mona Wilson.

"Come wind, snow, rain or sleet, and any hour of the day or night, often standing for hours in the freezing cold waiting for the port and starboard lights of the rescue ships to loom out of the blackness of the harbour, I was always on the pier to meet the survivors."[2]

The woman on the dock at St. John's was nurse Mona Wilson, ready to care for shipwrecked sailors and soldiers. During the Second World War, the port was home to the Newfoundland Escort Service, which guided convoys of supply ships across the Atlantic. Mona and her volunteers looked after 500 survivors of vessels attacked by German submarines, and 5,000 more men who landed after disasters.

Nicknamed the "Florence Nightingale of Newfoundland,"[3] Mona served as Red Cross Assistant Commissioner for Newfoundland from 1940 to 1945. The resourceful and dedicated nurse organized a system to effectively meet the survivors' needs, as well as those of men stationed in Newfoundland and Labrador. Backed by an army of volunteers, she served three hospitals in St. John's as well as others in Gander and

Botswood. She established the Caribou Hut hostel in St. John's and ensured emergency supplies reached those in need, even sending warm clothing by dogsled to an isolated base and dropping food by parachute to a snowed-in troop train. Mona earned the Office of the Order of the British Empire for her wartime service.

Mona was born in Toronto, the daughter of upper-middle-class parents who believed in public service and gave their children the best education. She graduated as a nurse from the prestigious John Hopkins Hospital in Baltimore in 1918. Mona was anxious to work overseas, but the Canadian Army Medical Corps turned her down because she hadn't trained in Canada. The newly minted nurse was soon accepted by the United States Army Nursing Corps, administered by the American Red Cross.

Mona and some of her nursing friends were sent to Siberia in 1919. She worked in Vladivostok before being posted to Albania and then Ragusa (now Dubrovnik), where she helped some of the 30,000 refugees. Reassigned to Montenegro, she cared for children in an orphanage, participated in mobile clinics, and trained women in public-health nursing. Mona received a number of awards for her work overseas, including the Foreign Service Certificate (Siberia), Red Cross Certificate (Balkans), a gold medallion (Italian Red Cross), and the Order of the Day (White Russians).

After returning to Canada in 1922, Mona enrolled in the new public-health nursing program at the University of Toronto. Following her graduation, she became the chief Red Cross nurse in Prince Edward Island, which was still relatively isolated. It wasn't until 1931 that a department of health was established in the province, with Mona named as director of Public Health Nursing. She ably developed nursing services in Prince Edward Island from 1923 until she retired in 1961.

Mona was one of the most important women in Prince Edward Island.[4] She built public-health programs that affected nearly everyone in the province. Despite resistance, Mona managed to change the belief that illness was the will of God, bringing acceptance of the many public-health services she introduced. She created inoculations, tuberculosis care, and preventative education programs, and promoted dental hygiene, assistance for crippled children, and better sanitation in schools.

Mona also found time to help set up the Zonta Club, a professional women's club, and a Girl Guides troop. After her retirement, she travelled around the globe. Though Mona had many beaus, she never wed. Historian Douglas O. Baldwin speculated that society's requirement for a married woman to give up her career could have been a factor in her decision.[5]

Mona was an excellent administrator and a leader in public-health nursing in Canada. Her nursing division became Prince Edward Island's provincial health department. She received the highest international recognition in nursing, the Florence Nightingale Award, and was named Island Woman of the Century in 1967. The Historic Sites and Monuments Board recognized Mona as a person of national historic significance. The Mona Gordon Wilson Building, where she once worked in Charlottetown, was named in her honour.

The engraving on Mona Wilson's gravestone recognizes her lifetime dedication to nursing: "She Answered Every Call."[6]

Quote:

"There were all kinds of disabilities — dislocated hips, tubercular bones, rickets, knocked knees, spinal curvatures.... This was one of the most tragic scenes I had ever witnessed and that night I wept into my pillow."[7]

— Mona's memories of a clinic for crippled children.

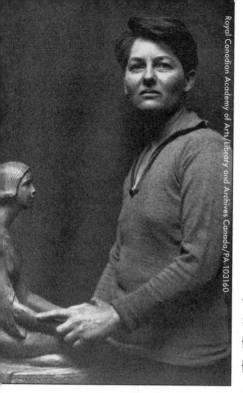

Florence Wyle, 1930.

The Sculpting Life on Glenrose

Florence Wyle
1881–1968

A powerful force in Canadian sculpture, She became the first woman sculptor to gain full membership in the Royal Canadian Academy.

Florence was born in Trenton, Illinois, in 1881. As a child, she was a tomboy who loved playing on the farm and helping wounded animals. She also liked to draw pictures. When Florence's puritan father gave her $500 for her education, she decided to become a doctor. Mr. Wyle wasn't amused when his daughter discovered art was her greater love and became a sculptor.

In 1903, Florence enrolled at the Art Institute of Chicago, where her instructors included Laredo Taft and Charles J. Mulligan. She fell deeply in love with Mulligan and kept his picture at her bedside for decades.[1] Most of her fellow students were women, eager to pursue an occupation previously closed to the fairer sex. Among them was another aspiring American sculptor named Frances Loring, who would become her lifelong friend. The two young women began sharing a studio in New York in 1911. Florence's career looked promising, and several of her works were shown at the National Academy to good reviews.

Several years later, thirty-year-old Florence joined Frances and moved to Toronto. They eventually moved into an old church on

Glenrose Avenue. When they first arrived in the city, there were few Canadian sculptors, and the other female one wasn't as talented as "The Girls."[2] Their home became a haven for artists and musicians, who had to bring treats for the pets. Members of the Group of Seven — after whom Florence and Frances named their chickens — as well as rich art patrons dropped by. Though the couple was usually poor, they were always generous to young art students. For more than five decades, the home would serve as what artist A.Y. Jackson called "the hub of culture in Toronto."[3] The women's unconventional lifestyle shocked the doyens of society.

The unusual residence also served as headquarters for the Sculptors' Society of Canada, which the pair helped create in 1928. The organization helped raise Canadian sculpture's profile at home and abroad, and nurtured a group of aspiring sculptors. There was considerable opportunity to achieve distinction in the relatively small community of Canadian sculptors. Despite male domination, Florence became one of the best sculptors in the country. Sculpture was her life.

University anatomy classes and neoclassical training helped Florence shape her respect for depicting the human body accurately. The sculptor worked in bronze, wood, and plaster, bringing together naturalism and realism. She depicted adults and children as well as animals and nature, creating serene and intimate pieces. Female nude torsos were among her best works, but she also created some large memorials.

During the First World War, she sculpted some small bronze statues of female war workers, which the National Gallery purchased for display in 1918. In 1927, the federal government commissioned her to document the West Coast's decaying totems with sketches and models. Florence's sculpture also included busts of artists A.Y. Jackson and F.H. Varley, as well as a sculpted tombstone for Dr. Frederick Banting. She was prolific, praised for her frequently exhibited works, and the recipient of many commissions. Florence was awarded the Coronation Medal in 1953. She was also a poet, and published a book of her work in 1958.

Though contemporary sculpture later overshadowed Florence's work, sculptors such as Alan Jarvis acknowledged The Girls' contribution: "The art of sculpture in Canada has been something of a poor cousin compared to painting. That it has survived at all, much is owed to two

distinguished sculptors, who are also two great women, Frances Loring and Florence Wyle."[4] When Florence died on January 14, 1968, the press hailed her as one of Canada's great sculptors.

Florence Wyle's memorial to Edith Cavell can still be seen at Toronto General Hospital and some of her hundreds of other works are held by the National Gallery of Canada, the Art Gallery of Ontario, and the War Museum in Ottawa; whether they are displayed is another question. A tiny Toronto park, so small it is called the Loring-Wyle Parkette, is a modest tribute to Florence and her partner. Historian Elspeth Cameron's book about The Girls played an important role in ensuring that their contributions to the development of professional sculpture in Canadian are not completely forgotten.

Quote:

"Young sculptors … dare to flout the things nature does so well. They don't know anatomy. A knowledge of anatomy gives vitality, vigour to sculpture."[5]

Fighting the Gigantic Crime of Crimes[1]

Letitia Youmans
1827–1896

She built the first Dominion-wide women's group, leading a movement to stop the evils of drunkenness.

Letitia Youmans.

Like Mothers Against Drunk Drivers, Letitia Youmans tried to stop alcohol abuse. At the helm of the Women's Christian Temperance Union (WCTU) in Canada, she pleaded for home protection. Sister Youmans didn't see it as advocating for women's rights, but remonstrating against woman's wrongs, claiming "for every wife the right to have a sober husband, and a sober son, and a comfortable home for herself and children."[2]

Letitia Youmans was born in a log cabin near Cobourg, Ontario, in 1827. John Creighton had great expectations for the new baby, naming her after a generous estate owner in Ireland who had befriended him when he was a lad. Letitia proudly trudged off through the forest to school at four years old. Despite the family's modest means, the girl was well-dressed in a pretty blue-and-white calico dress with a bonnet, carrying a brightly painted lunch basket with bread and butter, as well as an egg.

Letitia's Methodist family strongly believed in abstaining from alcohol. When she was a schoolgirl, a teacher taught her class about the

evils of alcohol abuse and the importance of temperance. Letitia happily signed a pledge of abstinence. Her devotion to the cause was reinforced by the ravages of alcohol in her community: inebriated men brawling until one died, families left destitute by drunken fathers, drunks scrounging for whiskey. Her most impressive temperance lesson was the horrific discovery of a dead drunk, whose corpse was swarming with maggots.

Letitia studied at both the Cobourg Ladies' Seminary and the Burlington Academy. While teaching at the Picton Academy[3] she met and married her soulmate, Arthur Youmans. The widower with eight children owned a farm, as well as some mills. Letitia lived on the farm for eighteen years, devoting herself to being a good mother and wife.

After the children were raised, the Youmans moved to Picton. Letitia had always wanted to do good in the world[4] and her observations of the towns' alcohol-related problems fuelled her passion to join the anti-booze crusade. Letitia directed her energy into what she considered a holy cause, abstinence and prohibition.

Letitia taught Sunday school and educated children about temperance. She created the non-denominational Band of Hope, a youth group in which members pledged not to use alcohol, tobacco, or bad language. In 1874, Letitia participated in an inspirational meeting of a new national WCTU in Chautauqua, New York, conducted by women. It was the first time in her life that she'd heard a lecture by a woman.

Back in Picton, Letitia Youman established a WCTU group, the second in Canada, to promote temperance through legislation that would prohibit the sale of alcohol. Letitia and the other women risking their reputations by being so bold, decided to petition the town council to stop granting liquor licences to grocery stores. Letitia was a reluctant speaker, but she became a powerful voice for temperance across Canada and abroad.

With growing confidence, Letitia marched on. She was invited to speak at a temperance meeting in Cobourg in 1875, and stunned her audience by delivering a rousing one-hour presentation — without a single note. Sister Youmans travelled widely despite failing health, addressing five or six audiences a week in Ontario to reach at least 15,000 potential converts. Supporters hailed the impressive orator for her "zealous and self-denying labors."[5]

Left to right: Frances Willard (president, United States WCTU), Margaret Bright Lucas (president, British WCTU) and Letitia Youmans (president, Canadian WCTU), 1886.

Letitia was elected president of Ontario'sWCTU, with other WCTUs established across Canada as a result of her fiery speeches. When her efforts resulted in a national WCTU in 1885, she was named president and remained the honorary president until her death. She took her campaign across the country, from British Columbia to New Brunswick

and Prince Edward Island, and discussed her views with Prime Minister John A. Macdonald.

Letitia also represented the WCTU internationally, travelling more extensively after her husband died and she moved to Toronto in 1882. She visited England and Scotland as the Canadian temperance spokesperson, and spoke frequently in the United States. She participated in a presentation to the Maryland Senate and enjoyed a private interview with President Rutherford B. Hayes's wife, Lucy, at the White House. Letitia was an admirer and close friend of American temperance leader Frances Willard, who praised her Canadian counterpart as an electrifying speaker and remarkable leader.

Forced to retire after being seized by a severe case of inflammatory rheumatism in August 1988, Letitia was bedridden. She documented her heroic story in an autobiography entitled *Campaign Echoes*.

Letitia was the inspirational founder of the original White Ribbon Movement in Canada, named after the WCTU's emblem. By the turn of the century, the WCTU was the largest national, non-denominational women's group in the country, with nearly 10,000 members. Prohibition laws were passed across Canada, but were short-lived. Historian T.A. Crowley suggested that the association Letitia built provided an important forum for Canadian women to discuss issues, and the opportunity to work together later to obtain the vote.[6]

Letitia Youmans is commemorated by a government of Ontario historic plaque at her grave in Glenwood Cemetery, Picton.

Quote:

"These Christian nations have actually instituted a system by which it is a legitimate branch of business to deal out liquid death and distilled destruction."[7]

Notes

Introduction

1. Constance Backhouse, "Clara Brett Martin: Canadian Heroine or Not?" *Canadian Journal of Women and the Law*, Vol. 5, No. 2 (1992): 273.
2. See the stories of Dr. Leone Farrell, Dr. Irma LeVasseur, and Florence Lawrence in this book.
3. Andrew Cohen, "Don't Be Shy, Honour Ourselves," *Ottawa Citizen*, August 5, 2003.
4. Lindsay E. Rankin and Alice H. Eagly, "Is His Heroism Hailed and Hers Hidden? Women, Men, and the Social Construction of Heroism," *Psychology of Women Quarterly*, Vol. 32, No. 4 (2008): 414–22.
5. Greg Spurgeon to Merna Forster, November 10, 2009.
6. As of March 31, 2011. There were also three couples designated.
7. Dianne Dodd, "Canadian Historic Sites and Plaques: Heroines, Trailblazers, The Famous Five," *CRM: The Journal of Heritage Stewardship*, Vol. 6, No. 2 (Summer 2009).

Mary Electa Adams

1. Alexandra Mosquin, "Mary Electa Adams," Historic Sites and Monuments Board of Canada Submission Report — Person, 2003-33, 1095.
2. Nathanael Burwash, *The History of Victoria College* (Toronto: Victoria College Press, 1927), 56.
3. John G. Reid, "Mary Electa Adams," DCB, *www.biographi.ca*.

Sally Ainse

1. Alan Taylor, *The Divided Ground* (New York: Alfred A. Knopf, 2006), 400.
2. *Ibid.*, 401.
3. John Clarke, "Sarah Ainse," DCB, *www.biographi.ca.*
4. Sarah Ainse to David W. Smith, March 26, 1794, in Taylor, 401. Ainse may have had others write letters for her, then she signed with her totem.

Maud Allan

1. Judith R. Walkowitz, "The 'Vision of Salome,'" *The American Historical Review*, Vol. 108, No. 2: 338.
2. Philip Hoare, *Oscar Wilde's Last Stand* (New York: Arcade, 1998), 77.
3. "A New Canadian Dancer," *London Observer*, 1908.
4. Amy Koritz, *Gendering Bodies/Performing Art* (Ann Arbor: The University of Michigan Press, 1995), 2.
5. Walkowitz, 363, 337–76.
6. *Ibid.*, 343.
7. Felix Cherniavsky, *The Salome Dancer* (Toronto: McClelland & Stewart, 1991), 291.
8. *Ibid.*, 194.

Elizabeth Arden

1. Lindy Woodhead, *War Paint: Madame Helene Rubinstein & Miss Elizabeth Arden* (New Jersey: John Wiley & Sons, 2003), 4, 23.
2. Alfred Allan Lewis and Constance Woodworth, *Miss Elizabeth Arden* (New York: Coward, McCann & Geoghegan, Inc., 1972), 34.
3. Woodhead, 94.
4. *Ibid.*, 95.
5. *Ibid.*, 2, 6.
6. *Ibid.*, 229.
7. *Ibid.*
8. *Ibid.*, 209.
9. Barbara C. Eastman, "Women Entrepreneurs: The Role Has Models," *Canadian Woman Studies*, Vol. 3, No. 4 (1982): 94.
10. Ron Shillingford, *History of the World's Greatest Entrepreneurs* (The History of the World's Greatest, 2010), 275.

Helen Armstrong

1. Bob Waters, *Four Generations That Walked the Walk* (Pittsburgh: Dorrance Publishing Co., 2010), 20.
2. Paula Kelly, "Looking for Mrs. Armstrong," *The Beaver*, June–July 2002: 21.
3. Waters, 37.
4. Mary Horodyski, "Women and the Winnipeg General Strike of 1919," *Manitoba History*, No. 11, March 1986: 28–37.
5. Paula Kelly, producer, *The Notorious Mrs. Armstrong*, Buffalo Gal Pictures, 2001.
6. Waters, 39.

Elizabeth Bagshaw

1. Charlotte Gray, "Elizabeth Catharine Bagshaw," *CMA Journal*, Vol. 124 (January 15, 1981): 211.
2. "Dr. Elizabeth Bagshaw Role in Birth-Control Clinic Aroused Ire in 1932," *Globe and Mail*, January 7, 1982.
3. Mark McCurdy, director, *Doctor Woman: The Life and Times of Dr. Elizabeth Bagshaw*, National Film Board, 1978.
4. Frances Rooney, "Elizabeth Bagshaw, M.D., An Interview," *Makara*, Vol. 2, No. 3 (May 1977): 28–29.

Mary "Bonnie" Baker

1. Lois Browne, *Girls of Summer* (Toronto: HarperCollins, 1992), 163, 183.
2. *Ibid.*, 35.
3. *Ibid.*, 117.
4. *Ibid.*, 61.
5. *Ibid.*, 44.
6. M. Ann Hall, *The Girl and the Game* (Peterborough: Broadview Press, 2002), 125.
7. Browne, 164.
8. Dawn Walton, "Canadian Ball Star Gave U.S. Someone to Cheer," *Globe and Mail*, December 22, 2003.
9. Browne, 35, 193.

Catherine and Mary Barclay

1. Allan Connery, "Mary Belle Barclay," *Calgary Herald*, October 7, 2000, and Evelyn Edgeller, *Mary Belle Barclay* (Calgary: Detselig Enterprises Ltd., 1988), 75–79.

2. Doris Anderson believed Catherine Barclay started the first such exchange. See Doris Anderson, "The Teacher Who Changed My Life," *Toronto Star*, December 10, 1988.
3. Jocelyn Sara, "Personality of the Week: E. Catherine Barclay," n.d.
4. Canadian Hostelling Association, *Fifty Years of Canadian Hostelling* (Calgary: Detselig Enterprises Ltd., 1988), 6.
5. *Ibid.*, 7.
6. Anderson.
7. Debra Cummings, "Cadillac of Hostels Opens in Banff," *Vancouver Sun*, May 2, 1998.

Frances Barkley

1. Beth Hill, *The Remarkable World of Frances Barkley* (Sidney: Gray's Publishing, 1978), 18.
2. Captain Walbran, "The Cruise of the Imperial Eagle", *Victoria Times Colonist*, March 2, 1901.
3. Londa Schiebinger, "Jeanne Baret: The First Woman to Circumnavigate the Globe," *Endeavour,* Vol. 27, No.1 (March 2003).
4. Hill, 171–84.
5. Roger Evans, *Somerset's Forgotten Heroes* (Dorset: Dovecotte Press, 2004), 19–23.
6. Hill, 83.

Robertine Barry

1. Sergine Desjardins, *Robertine Barry: La femme nouvelle* (Trois-Pistoles: Éditions Trois-Pistoles, 2010), 318–19, 323.
2. Lisette Lapointe, "Robertine Barry: la rebelle," *La Gazette des femmes*, Vol. 20, No.1: 14–15.
3. Desjardins, 247.
4. *Ibid.*, 321–22.
5. *Ibid.*, 15–16.
6. *Ibid.*, 337.

Abigail Becker

1. Cheryl MacDonald, *Abigail Becker: Angel of Long Point* (Nanticoke: Heronwood Enterprises, 2008), 4, 47.
2. "Abigail Becker, Life Saver, Dead," *New York Times*, March 24, 1905.
3. Rev. R. Calvert, *The Story of Abigail Becker* (Toronto: William Briggs, 1899), 14.

4. *The Century Illustrated Monthly Magazine*, Vol. XXX (May–October 1885): 800–02.
5. Calvert, 13–20.
6. John G. Whittier, "The Heroine of Long Point," *Atlantic Monthly*, May 1869.
7. *Ibid.*

Margret Benedictsson

1. Norma Thomasson to Merna Forster, February 1, 2011.
2. Dianne Dodd, "Margrét Jónsdóttir Benedictsson (1866–1956)," Historic Sites and Monuments Board of Canada Submission Report — Person, 2008-69, 6, 9.
3. "The Icelandic Emigration," Iceland National Broadcasting Service, *http://servefir.ruv.is*.
4. Mary Kinnear, "The Icelandic Connection: Freyja and the Manitoba Woman Suffrage Movement," *Canadian Woman Studies*, Vol. 7, No. 4 (1986): 25–28.
5. *Ibid.*
6. Ryan Eyford, "Lucifer Come to New Iceland: Margret and Sigfus Benedictson's Radical Critique of Marriage and the Family," Presentation at Canadian Historical Association, 2007: 16.
7. Anne Brydon, "The Icelandic Fjalkona," in Pauline Greenhill and Diane Tye, eds., *Undisciplined Women: Tradition and Culture in Canada* (Montreal and Kingston: McGill and Queen's University Press, 1997), 99–100.
8. Kinnear: 26.

Myra Bennett

1. H. Gordon Green, *Don't Have Your Baby in the Dory!* (Montreal: Harvest House, 1974), 9.
2. *Ibid.*, 50.
3. *Ibid.*, 133.
4. The play, written by Robert Chafe, was a production of Theatre Newfoundland Labrador.
5. Trevor Bennett to Merna Forster, 2011.
6. Green, 16, and modification from Trevor Bennett to Merna Forster, April 23, 2011.

Mary Bibb

1. Afua Cooper, "Black Women and Work in Nineteenth-Century Canada West: Black Woman Teacher Mary Bibb," in Peggy Bristow, ed., *We're Rooted Here*

and They Can't Pull Us Up (Toronto: University of Toronto Press, 1994), 146.
2. Owen Thomas, "Mary and Henry Bibb," Historic Sites and Monuments Board of Canada Submission Report — Person, 2002-22, 7.
3. Cooper, 160.
4. *Ibid.*, 157.
5. Thomas, 833.

Georgina Binnie-Clark

1. Georgina Binnie-Clark with introduction by Sarah A. Carter, *Wheat and Woman* (Toronto: University of Toronto Press, 2007), 300.
2. *Ibid.*, 300.
3. *Ibid.*, l.
4. *Ibid.*, lii.
5. *Ibid.*, xv.
6. *Ibid.*, xli.

Lucie Blackburn

1. Karolyn Smardz Frost, *I've Got a Home in Glory Land* (Toronto: Thomas Allen Publishers, 2007).
2. *Ibid.*, 11.
3. *Ibid.*, 207–08, 221–33.
4. *Ibid.*, 252–53.
5. *Ibid.*, 264–66.
6. *Ibid.*, 353.
7. *Ibid.*, 95.

Fern Blodgett

1. Olive Roeckner, "Pioneer Canadian Wireless YLs," *Radio Amateurs of Canada, www.rac.ca.*
2. Fern Sunde, "Mrs. 'Sparks,'" *Canadians at War, Reader's Digest*, Vol. 1 (1939/45): 287.
3. Roeckner.

Esther Brandeau

1. B.G. Sack, *History of the Jews in Canada*, Ralph Novek, trans. (Montreal: Harvest House, 1965), 8.
2. *Ibid.*, 9.

3. Sharon McKay, *Esther* (Toronto: Penguin Canada, 2004); the theatrical piece is *Ribcage: This Wide Passage.*
4. Gaston Tisdel, "Esther Brandeau," DCB, *www.biographi.ca.*

Rosemary Brown

1. This was Rosemary Brown's campaign slogan in her 1975 run for leadership of the federal NDP Party. Rosemary Brown, *Being Brown* (Toronto: Random House, 1989), 180.
2. Brown, 86.
3. *Ibid.*, 133–34.
4. *Ibid.*, 141.

Jennie Butchart

1. Dave Preston, *The Story of Butchart Gardens* (B.C.: Highline Publishing, 1996), 21.
2. *Ibid.*, 26.
3. *Ibid.*, 42–43.
4. *Ibid.*, 107.
5. *Ibid.*, 191.
6. Alexandra Mosquin, "The Butchart Gardens," Historic Sites and Monuments Board of Canada Submission Report — Place, 2004-30, 30.
7. *Ibid.*, 28.
8. Preston, 28.

Ethel Catherwood

1. Ron Hotchkiss, *The Matchless Six* (Toronto: Tundra Books, 2006), 61.
2. Tom Levine, *Evening Telegram* in Hotchkiss, 147.
3. Floyd Conner, *The Olympics' Most Wanted* (Dulles: Brassey's, 2001), 37.

Victoria Cheung

1. Jiwu Wang, *"His Dominion" and the "Yellow Peril"* (Waterloo: Wilfrid Laurier University Press, 2006), 46.
2. R.D. Gidney and W.P.J. Millar, "Medical Students at the University of Toronto, 1910–40: A Profile," CBMH/BCHM, Vol. 13 (1996): 37.
3. Helen G. Day and Kenneth J. Beaton, *They Came Through* (Toronto: United Church of Canada), 8.
4. Deborah Shulman, "From the Pages of Three Ladies: Canadian Women

Missionaries in Republican China" (MA Thesis, Concordia University, 1997).
5. Day and Beaton, 2.
6. *Ibid.*, 3.
7. Donna Sinclair, "Victoria Cheung," *Touchstone*, Vol. 11, No. 3 (1993): 42.

Helen Creighton

1. Ian Sclanders, "She's Collecting Long Lost Songs," *Maclean's*, September 15, 1952: 54.
2. Helen Creighton, *A Life in Folklore: Helen Creighton* (Toronto: McGraw-Hill, 1975), 1.

Charlotte and Cornelia De Grassi

1. Bill Brioux, "Degrassi: School More of a Grind Than Ever," *Toronto Star*, July 17, 2010.
2. Leonard Wise and Allan Gould, *Toronto Street Names* (Willowdale: Firefly Books, 2000), 74.
3. Charles Sauriol, *Remembering the Don* (Scarborough: Consolidated Amethyst Communications Inc., 1981), 74.
4. W.L. Mackenzie, *Head's Flag of Truce* (1853) in W. Stewart Wallace, "The Story of Charlotte and Cornelia De Grassi," *Transactions of the Royal Society of Canada*, 1941, 151.
5. Wallace, 149.
6. Florence Schill, "Cornelia, 13, Gallant Spy in 1837 Rebellion," *Globe and Mail*, January 15, 1954.
7. Wallace, 152.

Demasduit

1. Obituary of W.E. Cormack, *London Times*, September 14, 1829, in Ingeborg Marshall, *A History and Ethnography of the Beothuk* (Montreal and Kingston: McGill-Queen's University Press, 1996), 220.
2. Ingeborg Marshall, Presentation to Newfoundland Historical Society, *www.mun.ca* (accessed September 19, 1996).
3. *Ibid.*
4. Anonymous, *Mercantile Journal*, May 27, 1819 in Marshall.
5. David Smyth, "Demasduit and Shanawdithit," Historic Sites and Monuments Board of Canada Submission Report — Person 2000-15, 605–06.
6. *Ibid.*, 610.

Flora MacDonald Denison

1. This is how Flora described herself. Deborah Gorham, "Flora MacDonald Denison," in *A Not Unreasonable Claim*, Linda Kealey, ed. (Toronto: The Women's Press, 1979), 51.
2. Michele Lacombe, "Songs of the Open Road: Bon Echo, Urban Utopians, and the Cult of Nature," *Journal of Canadian Studies* (1998).
3. Gorham, 51.
4. Ramsay Cook and Michele Lacombe, "Flora MacDonald (Denison) Merrill," DCB, *www.biographi.ca.*
5. Philippa Schmiegelow, "Canadian Feminists in the International Arena," *Canadian Woman Studies*, Vol. 17, No. 2: 85.
6. Gorham, 58.
7. *Ibid.*, 59.
8. Janice Fiamengo, *The Woman's Page* (Toronto: University of Toronto Press, 2008), 175.

Viola Desmond

1. "Negress Alleges She Was Ejected from Theatre," *Halifax Chronicle,* November 30, 1946.
2. Constance Backhouse, *Colour-Coded* (Toronto: University of Toronto Press, 2001), 245.
3. *Ibid.*, 271.
4. "Interview with Wanda Robson," in Backhouse, 267.
5. Backhouse, 226–71.
6. "Negress Alleges She Was Ejected from Theatre."

Pauline Donalda

1. Ruth C. Brotman, *Pauline Donalda: The Life and Career of a Canadian Prima Donna* (Montreal: The Eagle Publishing Co., 1975), 4.
2. *Ibid.*, 17.
3. *Ibid.*, 110.
4. *Ibid.*, 31–32.

Onésime Dorval

1. Diane P. Payment, "Onésime Dorval: 'la bonne demoiselle,'" *Saskatchewan History* (May 2003): 32.
2. Obituary in *StarPhoenix*, 1932.

3. Author translation of quote in "Onésime Dorval," Musée Virtual Francophone de la Saskatchewan.

Allie Vibert Douglas

1. Patrick Vibert Douglas to Merna Forster, October 14, 2010. Her surname was changed from Vibert to Douglas by deed poll in 1914 to recognize the role of the Douglas family.
2. Benjamin F. Shearer and Barbara S. Shearer, eds., *Notable Women in the Physical Sciences* (Westport and London: Greenwood Press, 1997), 73.
3. *Ibid.*, 74.
4. "CFUW Heroine of the 1940s," *www.cfuw.org*.

Mary Two-Axe Early

1. Her last name can be found spelled Early as well as Earley, but her son confirmed that the former is correct.
2. Huguette Dagenais and Denise Piché, *Women, Feminism and Development* (Montreal/Kingston: McGill-Queen's University Press, 1994), 431.
3. Wayne Brown, "Mary Two-Axe Earley: Crusader for Equal Rights for Aboriginal Women," *Electoral Insight*, November 2003.
4. *Ibid.*
5. Janice Kennedy, "A Century of Wrong Put Right," *Ottawa Citizen*, July 6, 1991.
6. Ken MacQueen, "Mary Two-Axe Earley's Final Victory," *Calgary Herald*, August 24, 1996.
7. Brown.

Sarah Emma Edmonds

1. Sylvia Dannett, *She Rode with the Generals* (New York: Thomson Nelson & Sons, 1960), 24.
2. *Ibid.*, 47.
3. Sarah Emma Edmonds, *Soldier, Nurse and Spy* (DeKalb: Northern Illinois University Press, 1999), 18.
4. Dannett, 213.
5. Elizabeth D. Leonard, *All the Daring of the Soldier* (New York: W.W. Norton & Company, 1999), 172.
6. Elizabeth D. Leonard "Introduction" in Sarah Emma Edmonds, *Soldier, Nurse and Spy*, xiii, and DeAnne Blanton, "Women Soldiers of the Civil War," *Prologue*, Spring 1933.
7. Edmonds, 5.

Leone Norwood Farrell

1. Rita Daly, "Toronto's Unknown Polio Soldier," *Toronto Star*, April 17, 2005.
2. *Ibid.*
3. Paul Engleman, "Polio's Unsung Hero," *Rotary Canada* (April 2010).
4. Daly.
5. Harry Black, *Canadian Scientists and Inventors* (Markham: Pembroke Publishers, 2008).
6. Daly.
7. Dr. Leone Farrell, "Medical Research by Non-Medical Graduates," Panel Discussion for Women's Club, 1959, Sanofi Pasteur Archives (Toronto).

Faith Fenton

1. Sandra Gabriele, "Gendered Mobility, the Nation and the Woman's Page," *Journalism*, Vol. 7 (2006), 174–96.
2. Jill Downie, *A Passionate Pen* (Toronto: HarperCollins, 1996), 101.
3. *Men and Women of the Day* (1898) in Downie, 3.
4. Downie, 281.
5. *Ibid.*, 2.
6. *Ibid.*, 295.

Joan Bamford Fletcher

1. The Cinema Guild, promotional page for "Women of Courage: Untold Stories of WWII."
2. "Award for Woman Who Led Japs," *The Straits Times* (Singapore), November 10, 1946.
3. Ruth Wright Millar, *Saskatchewan Heroes & Rogues* (Regina: Coteau Books, 2004), 140.
4. The Cinema Guild.
5. Millar, 141.

Lillian Freiman

1. Brigitte Violette, "Lillian Bilsky Freiman (1885–1940)," Commission des lieux et monuments historiques du Canada rapport au feuilleton — personne, 2007-35, 5.
2. *Ibid.*, 13, and Lawrence Freiman, *Don't Fall off the Rocking Horse* (Toronto: McClelland & Stewart, 1978), 38–39.
3. Gerald Tulchinsky, *Branching Out: The Transformation of the Canadian*

Jewish Community (Toronto: Stoddart, 1998), 44, cited in Violette, 11.
4. Canadian Jewish Congress Archives.
5. *Hadassah* is the Hebrew name for the bibilical heroine Esther.
6. Violette, 14.
7. Gerald Tulchinsky, *Taking Root: The Origins of the Canadian Jewish Community* (Toronto: Lester Publishing Ltd., 1992), 202.
8. Bernard Figler, *Lillian and Archie Freiman Biographies* (Montreal: Northern Printing, 1962), 149.

Alexandrine Gibb

1. M. Ann Hall, "Alexandrine Gibb: In 'No Man's Land of Sport,'" *International Journal of the History of Sport* 18: 1, 151.
2. "Leader in Girls' Sport Movement," *Toronto Star Weekly*, March 31, 1928, in Hall: 149.
3. L. Marsh, "With Pick and Shovel," *Toronto Daily Star*, September 8, 1934, in Hall: 163.
4. Hall: 156.
5. *Ibid.*: 168.
6. Bruce Kidd, "Forgotten Foremother: Alexandrine Gibb," *CAAWS Action Bulletin*, Winter 1994.
7. A. Gibb, "No Man's Land of Sport," May 1, 1937, 17, cited in Hall: 155.

Hilwie Hamdon

1. Richard Asmet Awid and Marlene Hamdon, *Through the Eyes of the Son — A Factual History About Canadian Arabs* (Edmonton: Accent Printing, 2000).
2. Daood Hamdani, *In the footsteps of Canadian Muslim Women* (Canadian Council of Muslim Women, 2007), 6.
3. Andrea Lorenz, "The Women Behind the Al Rashid," *Legacy*, November 1988–January 1999 (Alberta Online Encyclopedia).
4. Don Thomas, "Muslims Mark a Century of Faith in Canada," *Edmonton Journal*, May 3, 1999: B3.
5. Awid and Hamdon.

Hattie Rhue Hatchett

1. Paula McCooey, "That Sacred Song," *Ottawa Citizen*, November 11, 2002: C1.
2. Richard George Stewardson, "Hattie Rhue Hatchett (1863–1958)" (MA Thesis, York University, 1994), 51.

3. *Ibid.*, 40, 266, 267.
4. *Ibid.*, 62.
5. McCooey.
6. *Ibid.*
7. Hattie Rhue Hatchett, "That Sacred Spot."

Satinder Hawkins

1. Vaughn Palmer, "Cancer Crusader Sindi Hawkins Made a Difference," *Vancouver Sun*, September 22, 2010.
2. Notes from Seema Ahluwalia to author, April 2011.
3. Official Report of the Legislative Assembly (British Columbia), Vol. 6, No. 20: 5615.
4. Jonathan Fowlie, "Former Liberal MLA Sindi Hawkins Loses Cancer Battle," *Vancouver Sun*, September 21, 2010.
5. Broadcast on *www.castanet.net.*, September 22, 2010.

Prudence Heward

1. Natalie Luckyj, *Expressions of Will: The Art of Prudence Heward* (Kingston: Agnes Etherington Art Centre, 1986), 61.
2. Evelyn Walters, *The Women of Beaver Hall* (Toronto: Dundurn Press, 2005), 49.
3. See the biography of her grandmother, Eliza Jones, in this book.
4. A.K. Prakash, *Independent Spirit: Early Canadian Women Artists* (Buffalo/ Richmond Hill: Firefly, 2008), 100.
5. Walters, 47.
6. *Ibid.*, 51.
7. Canadian Painting in the 1930s, *www.gallery.ca.*

Esther Hill

1. "New Trail Blazed by a Varsity Girl," *Globe and Mail*, June 3, 1920.
2. "Breaking Barriers by Building," *The Gazette*, August 5, 2000.
3. Annmarie Adams and Peta Tancred, "Designing Women: Then and Now," *The Canadian Architect*, Vol. 45, Iss. 11 (Nov. 2000): 16–17. See also Annmarie Adams and Peta Tancred, *Designing Women: Gender and the Architectural Profession* (Toronto: University of Toronto Press, 2000).
4. "Marjorie Hill," International Archive of Women in Architecture: Biographical Database, Virginia Tech, *www.lumiere.lib.vt.edu.*

Lotta Hitschmanova

1. This is the title of a documentary film about Lotta Hitschmanova, produced by Peter Lockyer.
2. Clyde Sanger, *Lotta* (Toronto: Stoddart Publishing Co. Ltd., 1986), 254.
3. The oats were developed by breeder Dr. Vernon Burrows, who was inspired by Lotta's work.
4. USC Canada has an excellent website with many resources about Lotta Hitschmanova, where you can also hear her voice again. See *www.DrLotta.ca.* USC Canada website, *www.usc-canada.org.*

Helen Hogg

1. Christine Clement and Peter Broughton, "Helen Sawyer Hogg," *RASC Journal*, Vol. 87, No. 6.
2. Judith L. Pipher, "Helen Sawyer Hogg," *Publications of the Astronomical Society of the Pacific*, Vol. 105, No. 694: 1371.
3. Judith Knelman, "Helen Hogg," *Graduate: The University of Toronto Alumni Magazine*, Vol. XIII, No. 1.
4. Pipher, 1372.
5. Althea Blackburn-Evans, "Helen Hogg — Great Discoverers," *EDGE Magazine*, Winter 2000.
6. Benjamin F. Shearer and Barbara S. Shearer, eds., *Notable Women in the Physical Sciences* (Westport: Greenwood Press, 1997), 193.

Ann Hulan

1. George Coggeshall, *History of the American Privateers* (New York: Putnam, 1861), 60.
2. *Ibid.*, 4.
3. Edwards Wix, *Six Months of a Newfoundland Missionary's Journal* (London: Smith, Elder and Co., Cornhill, 1836), 193
4. W.E. Cormack, *Narrative of Journey Across the Island of Newfoundland in 1822* (London/Toronto: Longmans, Green and Company, 1928).
5. *Cultural Connections Resource, Of Character: Newfoundland and Labrador*, 2008.
6. Wix, 194.

May Irwin

1. Eve Golden, *Golden Images: 41 Essays in Silent Film Stars* (Jefferson, NC: McFarland & Company, 2001), 60.

2. In Golden, 56, there is a quote from May Irwin indicating she was eleven at the time of the audition. Though her birth year is usually indicated as 1862, recent research in the Canadian Census shows it could be 1861.
3. Lewis Clinton Strang, *Famous Actresses of the Day in America* (Boston: L.C. Page and Company, 1899), 174.
4. See "May Irwin to Head Laughter Bureau," *New York Times*, September 18, 1915, and "May Irwin's Play Anew: Improved Production Launches Suffrage Week at the Park," the *New York Times*, September 28, 1915.
5. Charles Foster, *Stardust and Shadows: Canadians in Early Hollywood* (Toronto: Dundurn Press, 2000), 15.
6. *The Heroes* (Toronto: McClelland & Stewart Limited, 1967), 78.

Eliza M. Jones

1. Henry J. Morgan, *Types of Canadian Women Past & Present* (Toronto: William Briggs, 1903), 181.
2. Faith Berghuis Collection, Jones Family Files.
3. S. Lynn Campbell and Susan L. Bennett, "Eliza Maria Harvey," DCB, *www. biographi.ca*.
4. Mrs. E.M. Jones, *Dairying for Profit; or, The Poor Man's Cow* (Montreal: John Lovell & Son, 1892), Preface.

Frances Kelsey

1. Linda Bren, "Frances Oldham Kelsey: FDA Medical Reviewer Leaves Her Mark on History," *FDA Consumer* magazine, March–April 2001.
2. Gardiner Harris, "The Public's Quiet Savior from Harmful Medicines," *New York Times*, September 13, 2010.
3. Bren.
4. "Dr. Frances Kathleen Oldham Kelsey," National Library of Medicine, *www. nlm.nih.gov*.
5. Harris.
6. See, for example, Ian E.P. Taylor, "Censuring the Scientists," *CPJ/RPC*, Vol. 141, No. 2 (2008): 69, and *The Current*, CBC Radio, July 27, 2010.
7. Harris.
8. Bren.

Lady Sara Kirke

1. Peter E. Pope, *Fish into Wine* (Chapel Hill: University of North Carolina Press, 2004), 438.

2. Robert W. Sexty and Suzanne Sexty, "Lady Sara Kirke: Canada's First Female Entrepreneur or One of Many?" Administrative Sciences Association of Canada — Annual Conference 2000, Vol. 21, Part 24, 29.
3. Petition of the Merchant Adventurers of Plymouth, England, to the Council of State, circa 1650, Winthrop Papers, VI, 4–6, in Pope, 437.
4. CATA Alliance, *www.cata.ca* (accessed August 13, 2009).
5. Sexty and Sexty, 28.

Muriel Kitagawa

1. Muriel Kitagawa, *This Is My Own* (Vancouver: Talonbooks, 1985), 31.
2. Kitagawa, 21.
3. *Ibid.*, 184–85.
4. "The News from the Ethnic Press," *The Vancouver Sun*, October 26, 1998.
5. "Reflections on Anniversary of an Apology," *The Toronto Star*, November 17, 2008.
6. Kitagawa, 250.

Elsie Knott

1. Cora Voyageur, *Firekeepers of the Twenty-First Century: First Nations Women Chiefs* (Montreal and Kingston: McGill-Queen's University Press, 2008), 28.
2. *Ibid.*, 29.

Molly Kool

1. "Fearless Captain Molly Kool," *King's County Record*, August 30, 1978.
2. Aida Boyer McAnn, "Kool is the Word for Molly," *The Star Weekly*, June 3, 1939.
3. Donal Baird, *Women at Sea in the Age of Sail* (Halifax: Nimbus Publishing, 2001), 215.
4. "Fearless Captain Molly Kool."
5. Molly Kool to Jean Kool, Canadian National Telegram, April 19, 1939, Visitor Centre in Alma, New Brunswick.

Marguerite de la Rocque

1. For an in-depth analysis of the many versions of the story see Arthur P. Stabler, *The Legend of Marguerite de Roberval* (Washington: Washington State University Press, 1972).
2. Stabler, 15.
3. *Ibid.*, 3.

4. *Ibid.*, 25–27, 71–77.
5. Walter K. Kelly, translator, *The Heptameron of Margaret, Queen of Navarre* (London: Published for the trade, n.d.), 510.

Marguerite Vincent Lawinonkié

1. A.N. Montpetit, "Paul Tahourenche, Grand-chef des Hurons," *L'Opinion publique*, Montreal, January 23, 1879: 40, in Jean Tanguay, "Marguerite Vincent Lawinonkié, 'The Woman Skilled at Needlework,'" Commission des lieux et monuments historiques du Canada rapport au feuilleton — personne, 2007-29-A, 1.
2. Anonymous, "Marguerite Vincent Lawinonkié." Commission des lieux et monuments historiques du Canada formulaire de demande — personne, 2000-42, 2153.
3. Tanguay, 11.
4. *Ibid.*, 12.
5. *Ibid.*, 3.
6. Montpetit, 40, in Tanguay, 11.

Florence Lawrence

1. Kelly R. Brown, *Florence Lawrence, The Biograph Girl: America's First Movie Star* (Jefferson, NC: McFarland & Company, 1999), 49.
2. "Florence Lawrence," Inventor of the Week Archive, MIT, *www.web.mit.edu.*
3. At the time, Mary Pickford was earning $5 a day at Biograph; two years later she would be earning $200 per week with David Belasco. See Brown, 53–54.
4. *Ibid.*, 53.
5. *Ibid.*, 56.
6. *Ibid.*, 79.
7. *Ibid.*, 144.
8. *Ibid.*, xii.
9. *Ibid.*, 58.

Marie-Henriette LeJeune-Ross

1. Jackson, Elva E., "The True Story of the Legendary Granny Ross," *Nova Scotia Historical Review*, Vol. 8, No. 1 (1988).
2. Elva E. Jackson, "A Legend Reconsidered," *Cape Breton's Magazine*, Issue 37: 41–42.
3. Lois Kathleen Kernaghan, "Marie-Henriette Lejeune", *DCB*, *www.biographi.ca.*

Irma LeVasseur

1. France Parent, "Irma LeVasseur (1877–1964)," Commission des lieux et monuments historiques du Canada rapport au feuilleton – personne, 2007-10, 3. LeVasseur was the first female to be licensed by the College of Physicians of Quebec, and is considered by Parent to be the first female French-Canadian doctor in Quebec. Female physicians such as Charlotte Ross, Grace Ritchie-England, and Maud Abbott (whose father was French Canadian) had already practised medicine in the province.
2. *Ibid.*, 9. This was required since she had not graduated as a doctor in Quebec.
3. *Ibid.*, 21.
4. Carlotta Hacker, *The Indomitable Lady Doctors* (Toronto: Clarke, Irwin & Co. Ltd.), 174.
5. *Ibid.*, 176.
6. Albiny Paquette, "Irma LeVasseur (1877–1964)," in Album-souvenir 1923–1963 (Quebec City: Hôpital de l'Enfant-Jésus, 1964), 62, in Parent, *Résumé*, 3.
7. Irma LeVasseur to Françoise (Robertine Barry), *La Patrie*, April 18, 1907.

Frances Loring

1. Elspeth Cameron, *And Beauty Answers: The Life of Frances Loring and Florence Wyle* (Toronto: Cormorant Books, 2007), 293.
2. *Ibid.*, 18.
3. *Ibid.*, 73.
4. *Ibid.*, 6–9.
5. *Ibid.*, 281.
6. *Ibid.*, 212.

Laura Muntz Lyall

1. Elizabeth Mulley, "Women and Children in Context: Laura Muntz and the Representation of Maternity" (Doctoral Thesis, McGill, 2000).
2. Paul Duval, *Canadian Impressionism* (Toronto and London: McClelland & Stewart, 1990), 50.
3. Mulley, 125–26.
4. *Saturday Night*, June 7, 1913, cited in Mulley, 2.
5. *Ibid.*, 85.

Anna Markova

1. "An Interview with Anna Petrovna Markova," *Mir* (1979): 6.

2. *Ibid.*: 8.
3. George Woodcock and Ivan Avakumovic, *The Doukhobors* (Toronto: Oxford University Press, 1968), 358.
4. Koozma J. Tarasoff, *Spirit Wrestlers: Doukhobor Pioneers' Strategies for Living* (Ottawa: Legas, 2002), 114.
5. "An Interview with Anna Petrovna Markova," 6.

Clara Brett Martin

1. "Clara Brett Martin," DCB, *www.biographi.ca*.
2. Constance Backhouse, "Clara Brett Martin: Canadian Heroine or Not?" *Canadian Journal of Women and the Law*, Vol. 5, No. 2 (1992): 265.
3. *Ibid.*: 276.
4. Lynne Pearlman, "Through Jewish Lesbian Eyes: Rethinking Clara Brett Martin," *Canadian Journal of Women and the Law*, Vol. 5, No. 2 (1992): 329, 348.
5. *Buffalo Express*, 1896.

Frances Gertrude McGill

1. Joe L. Salterio, "Frances G. McGill, M.D.," *RCMP Quarterly*, Vol. 12, No. 1 (1946): 32.
2. *Ibid.*: 32.
3. Jim Churchman, "Initio," *RCMP Quarterly*, Vol. 38, No. 3 (1972): 21.
4. "Dr. Frances Gertrude McGill," Celebrating Women's Achievements, Library and Archives Canada, *www.collectionscanada.gc.ca/women/002026-417-e.html* (accessed April 24, 2010).

Dorothea Mitchell

1. Michel S. Beaulieu and Ronald N. Harpelle, eds., *The Lady Lumberjack* (Thunder Bay: Centre for Northern Studies, 2005), 106.
2. *Ibid.*, xiii.
3. *Ibid.*, xi.
4. *Ibid.*, 108.

Sophie Morigeau

1. Jean Barman, "Sophie Morigeau: Free Trader, Free Woman," in *Lives of Aboriginal Women of the Canadian Northwest and Borderlands*, edited by Sarah Carter and Patricia A. McCormack (Edmonton: Athabasca University Press, 2011), 188.

2. *Ibid.*, 184.

3. *Ibid.*, 186.

4. Carol S. Ray, "Sophie Morigeau: Trading Across the Boundaries" (MA Thesis, University of Wyoming, 2001).

5. Barman, 189.

Kirkina Mucko

1. Earl B. Pilgrim, *The Day Grenfell Cried* (St. John's: DRC Publishing, 2007), 148.

2. There are many versions of the story, and the details differ. See for example Wilfred Thomason Grenfell, *A Labrador Doctor* (Bibliobazaar, 2007), 245, and Harry Paddon, *The Labrador Memoir of Dr. Harry Paddon* (Montreal/Toronto: McGill-Queen's University Press, 2003), 73.

3. Cassie Brown, "Kirkina Mucko," *The Daily News*, April 23, 1964.

4. *The Twillingate Sun*, October 21, 1950.

5. *Cultural Connections Resource, Of Character: Newfoundland and Labrador,* 2008.

6. Brown.

Marion Orr

1. Shirley Render, *No Place for a Lady* (Winnipeg: Portage & Main Press, 2000), 11.

2. *Ibid.*, 142.

3. *Ibid.*, 125.

Yoko Oya

1. *Fujin* means woman in Japanese.

2. Roy Ito, *Stories of My People: A Japanese Canadian Journal* (Hamilton: Promark Printing, 1994).

3. Jorgen Dahlie, "The Japanese in B.C.: Lost Opportunity?" *BC Studies*, No. 8, (1970–71): 5.

Madeleine Parent

1. Andrée Lévesque, *Madeleine Parent: Activist* (Toronto: Sumach Press, 2005), 128.

2. *Ibid.*, 70.

Esther Pariseau

1. Sister Mary McCrosson, *The Bell and the River* (Palo Alto: Pacific Books, 1957), 258.
2. *Ibid.*, 106.
3. *Ibid.*, 224.
4. Letters of Mother Joseph, June 11, 1876, Providence Archives, Seattle.

Elizabeth Parker

1. Pearl Ann Reichwein, "Guardians of the Rockies," *The Beaver*, Vol. 74, No. 4 (1994).
2. *Ibid.*
3. R.W. Sandford, *High Ideals: Canadian Pacific's Swiss Guides 1899–1999* (Canmore: The Alpine Club of Canada & Canadian Pacific Hotels, 1999), 21.
4. Alpine Club of Canada website, *www.alpineclubofcanada.ca* (accessed November 10, 2010).
5. Elizabeth Parker, "The Alpine Club of Canada," *Canadian Alpine Journal*, Vol. 1, No. 1 (1907): 3–8.

Kathleen Parlow

1. This was her nickname.
2. "Parlow, Kathleen," *Encyclopedia of Music in Canada, Second Edition* (Toronto: University of Toronto Press, 1992).
3. Maida Parlow French, *Kathleen Parlow: A Portrait* (Toronto: Ryerson Press, 1967), vii.
4. *Ibid.*, 40–41.
5. *Ibid.*, 38.
6. *Ibid.*, 86.
7. *Ibid.*, 64.

Marie Anne Payzant

1. Linda G. Layton, *A Passion for Survival* (Halifax: Nimbus Publishing, 2003).
2. Cited in Layton, 74–75.

Lady Mary Pellatt

1. Bill Freeman, *Casa Loma: Toronto's Fairy-Tale Castle and its Owner, Sir Henry Pellatt* (Toronto: James Lorimer & Company, 2005), 21.

2. *Ibid.*, 17.
3. Girl Guides of Canada Collection, National Office, Toronto.

Nellie Yip Quong

1. Dianne Dodd, "Nellie Yip Quong," Historic Sites and Monuments Board of Canada Submission Report — Person, 2007-70.
2. *Ibid.*, 9.
3. Hilda Hellaby, *Hilda Hellaby's Story and Poems* (Whitehorse: Anglican Churchwomen of Christ Church Cathedral Parish, 1983), in Dodd, 7.

Ada Annie Rae-Arthur

1. Margaret Horsfield, *Cougar Annie's Garden* (Nanaimo: Salal Books, 1999), 113.

Hilda Ranscombe

1. Mary McGuire letter, February 15, 1999. Ranscombe Scrapbook. Cambridge Sports Hall of Fame.
2. Based on a quote from Bobbie Rosenfeld, Ranscombe Scrapbook.
3. Ranscombe Scrapbook.
4. *Cambridge Times*, February 2, 2001: 21.
5. Carly Adams, "Invisible Female Athletes: Creating a Place for the Preston Rivulettes in Canadian Sport History," *Skating into the Future: Hockey in the New Millennium I & II Conference Proceedings* (University of New Brunswick, 2004).
6. Comment by N. Getty on January 7, 2011, to a blog post by Joe Pelletier, March 17, 2009. *http://greatesthockeylegends.com.*
7. Ranscombe Scrapbook.

Kathleen Rice

1. "What's Next?" *The Globe*, July 18, 1928.
2. "Ontario Girl Winning Out as Pioneer and Prospector," *Toronto Daily Star*, January 28, 1928.
3. *Ibid.*
4. Barbara L. Sherriff and Shelley Reuter, "Notable Canadian Women in the History of Geology," *Geoscience Canada*, Vol. 21, No. 3.
5. Bessie G. Ferguson, "First Woman Prospector 'Swings On Her Own Gate,'" The University Of Manitoba Archives, Mss 162, Box 1, Folder 1.

Marie Marguerite Rose

1. Ken Donovan, "Slavery in Louisbourg," *The Huissier*, July 9, 2009. There were also about 4,000 slaves in Quebec and Ontario.
2. Alain Gelly, "Marie Marguerite Rose (vers 1717–1757)," Commission des lieux et monuments historiques du Canada rapport au feuilleton — personne, 2007-12.
3. Kenneth Donovan, "Slaves in Ile Royale, 1713–1758," *French Colonial History*, Vol. 5 (2004): 33–34.

Madeleine de Roybon d'Allonne

1. Yves Landry, "Les filles du roi émigrées au Canada au XVIIe siècle," *Histoire, économie et société*, Vol. 11, Issue 11-2 (1992): 201.
2. H.C. Burleigh, "Ontario's First Lady," *Historic Kingston*, Vol. 14 (1966): 73.

Katherine Ryan

1. T. Ann Brennan, *The Real Klondike Kate* (Fredericton: Goose Lane Editions, 1990).
2. "The Woman Called Klondike Kate," *Maclean's*, December 15, 1922.

May Sexton

1. "The Late Mrs. Sexton," December 1923.
2. Lois K. Yorke to Mary P. Bentley, September 20, 2001, Yorke Files re: Sexton, Nova Scotia Archives and Records Management.
3. "Mrs. F.H. Sexton Passes on After Acute Suffering," *The Halifax Herald*, December 15, 1923.
4. Minutes, Local Council of Women (Halifax), February 19, 1914.
5. "Women on the School Board," *Acadian Recorder*, March 20, 1911.
6. "Mrs. F.H. Sexton," *Acadian Recorder*, December 17, 1923.
7. "City Mourns Passing of Brilliant Woman," *The Morning Chronicle*, December 15, 1923.
8. See *http://giving.dal.ca/maybestsextonscholarship*.
9. Mary Sexton, "Halifax Should Make a Move Towards Providing Industrial Education for Girls," *The Evening Mail*, November 28, 1908.

Norma Shearer

1. Gavin Lambert, *Norma Shearer* (New York: Alfred A. Knopf, 1990), 4.

2. Stephen J. Spignesi, *The Official Gone with the Wind Companion* (Plume, 1993), 10.

Nell Shipman

1. Kay Armatage, *The Girl from God's Country* (Toronto: University of Toronto Press, 2003), 3.
2. Letter from Nell Shipman to Hye Bossin, in Tom Trusky, ed., *Letters from God's Country, 1917–1970* (Boise, ID: Boise State University, 2003).
3. Nell Shipman, *The Silent Screen and My Talking Heart* (Boise, ID: Hemingway Western Studies Series, 1987), 46.

Angela Sidney

1. Julie Cruikshank, *Life Lived Like a Story* (Vancouver: University of British Columbia Press, 1990), 24.
2. *Ibid.*, 115.
3. *Ibid.*, 128.
4. *Ibid.*, 36.

Charlotte Small

1. Jennifer S.H. Brown, "Charlotte Small (1785–1857)," Historic Sites and Monuments Board of Canada Submission Report — Person, 2007-13, 14, 16.
2. Cited in Aritha van Herk, "Travels with Charlotte," *Canadian Geographic*, July–August 2007.
3. Andreas N. Korsos, research compiled by S. Leanne Playter, 2006, in "Mocassin Miles: The Travels of Charlotte Small 1799–1812," in Brown, 4 and figure 1.
4. David Thompson, "Travels," unpublished manuscript, iii, 34a, circa 1847, in Brown, 11
5. Photo of gravestone, *http://davidthompsonthings.com/CHARLOTTEgrave.html.*

Elizabeth Smellie

1. John Murray Gibbon and Mary S. Mathewson, *Three Centuries of Canadian Nursing* (Toronto: Macmillan, 1947), 273.
2. Obituaries, "Miss Elizabeth L. Smellie," *Canadian Medical Association Journal*, Vol. 98 (June 8, 1968): 1120.
3. Barbara Dundas and Dr. Serge Durflinger, "The Canadian Women's Army Corps, 1941–1946," Canadian War Museum, *www.warmuseum.ca* (accessed in 2008).

4. *Ibid.*
5. Mary R. MacLean, "Colonel Elizabeth Smellie," Thunder Bay Historical Museum Society *Papers & Records*, Vol. 3 (1975): 18.

Lois Smith

1. John Mackie, "Lois Smith 'Gave Ballet to the Country,'" *Vancouver Sun*, January 25, 2011.
2. See background in "The Life and Times of Lois Smith OC," Dance Collection Danse Archives.
3. Herbert Whittaker, *Canada's National Ballet* (Toronto and Montreal: McClelland & Stewart, 1967), 63.
4. Ken Bell and Celia Franca, *The National Ballet of Canada* (Toronto: University of Toronto Press, 1978), 24.
5. Mackie.
6. *Ibid.*
7. Kaija Pepper, "Canada's First Prima Ballerina Joined National Ballet Sight Unseen," *Globe and Mail*, February 5, 2011.
7. Whittaker, 62.
8. *Ibid.*, 67.

Ethel Stark

1. The term "podium feminism" is used by Arthur Kaptainis, "Putting Down the Spatula Picking up the Baton," *The Gazette*, March 9, 1991.
2. "Woman Musicians Set the Pace for the Future," *The Gazette*, November 19, 1995.
3. John Kalbfleisch, "Pioneering Violinist, Conductor Blazed Trail for Women," *The Gazette*, February 2, 2003.
4. "Cherished 18th-Century Violin Stolen," *The Gazette*, June 20, 1990.
5. Arthur Kaptainis, "Pioneer Likes a Challenge: Violinist and Conductor Ethel Stark Founded a Women's Symphony," *The Gazette*, April 24, 2010.
6. Lou Seligson, *Canadian Jewish News*, n.d.

Anna Swan

1. Anna Swan Museum at the Creamery.
2. Robert Bogdan, *Freak Show* (Chicago: University of Chicago Press, 1990), viii.
3. Confirmed by Dale Swan, email to author, July 11, 2010.
4. Phyllis R. Blakeley, *Nova Scotia's Two Remarkable Giants* (Windsor, NS: Lancelot Press, 1972), 10.

5. Shirley Irene Vacon, *Giants of Nova Scotia* (Lawrencetown Beach, NS: Pottersfield Press, 2008), 29.
6. *Ibid.*, 20.

Émilie Tremblay

1. Jennifer Duncan, *Frontier Spirit: The Brave Women of the Klondike* (Toronto: Doubleday Canada, 2003), 101.
2. *Ibid.*, 88
3. *Ibid.*, 90.

Mary Schäffer Warren

1 "An Early Jasper Tea Party," *Edmonton Bulletin*, n.d.
2. Mary T.S. Schäffer, *Old Indian Trails of the Canadian Rockies* (New York: Putnam's, 1911), 3.
3. *Ibid.*, 13.
4. *Ibid.*
5. Rudyard Kipling, *Letters of Travel (1892–1913)*, Project Gutenberg, *www.gutenberg.org/files/12089/12089-h/12089-h.htm* (accessed January 23, 2010), Chapter 16.
6. Schäffer, 15.
7. *Ibid.*, 16.

Maud Watt

1. William Ashley Anderson, *Angel of Hudson Bay* (New York: Dutton, 1961), 177.
2. *Ibid.*, 15.
3. Maud Watt, "Nascopie Honeymoon," *The Beaver*, March 1938: 23.
4. Quebec, Débats de l'assemblée (June 13, 2007), Vol. 40, No. 20 (M. Claude Béchard), *www.assnat.qc.ca/Fra/38legislature1/Debats/journal/ch/070613.htm#_Toc169593877.*
5. Anderson, 81.

Esther Wheelwright

1. Julie Wheelwright, *Esther: The Remarkable True Story of Esther Wheelwright* (Toronto: HarperCollins Publishers, 2011), 56.
2. "Copie d'une lettre de Soeur Wheelwright de l'Enfant-Jésus," AMUQ, cited in Wheelwright, 181.

Charlotte Whitton

1. Roger Morier, "Style and Substance: The Career of Charlotte Whitton," *Canadian Women's Studies*, Vol. 3, No. 1 (1981): 67.
2. Charlotte Whitton, "Will Women Ever Run the Country?" *Maclean's*, August 1, 1952: 17.
3. P.T. Rooke and R.L. Schnell, *No Bleeding Heart: Charlotte Whitton a Feminist on the Right* (Vancouver: University of British Columbia Press, 1987), 151.
4. *Ibid.*, 143.
5. *Ibid.*, 69–71.
6. Sammy Hudes, "The Controversial Legacy of Charlotte Whitton," *IsraelNationalNews.com* (accessed August 20, 2010).
7. *Ibid.*
8. Catherine Lawson, "Whitton in Love," *Ottawa Citizen*, February 23, 2005.
9. Rooke and Schnell, 37, 57–62. The book was written prior to release of Charlotte's letters to Margaret Grier.
10. Lawson.
11. Rooke and Schnell, 2.

Mona Wilson

1. A description of Mona Wilson from W.J.P. MacMillan, the onetime minister of health for Prince Edward Island, in Dianne Dodd, "Mona Gordon Wilson," Historic Sites and Monuments Board of Canada Submission Report — Person, 2007-53, 7.
2. Douglas O. Baldwin, *She Answered Every Call* (Charlottetown: Indigo Press, 1997), 228.
3. Dodd, 10.
4. Baldwin, x.
5. *Ibid.*, 159–60.
6. *Ibid.*, 299.
7. *Ibid.*, 168.

Florence Wyle

1. Elspeth Cameron, *And Beauty Answers: The Life of Frances Loring and Florence Wyle* (Toronto: Cormorant Books, 2007), 57, 359.
2. *Ibid.*, 77, 101, 122.
3. *Ibid.*, 337.
4. *Ibid.*, 332.
5. Kay Kritzwiser, *Globe Magazine*, April 7, 1962.

Letitia Youmans

1 A phrase Letitia used, Letitia Youmans, *Campaign Echoes: The Autobiography of Mrs. Letitia Youmans* (Toronto: William Briggs, 1893?), viii.

2. *Ibid.*, 207.

3. She worked for Mary E. Adams, see page 23.

4. Youmans, 59.

5. *Ibid.*, 173.

6. T.A. Crowley, "Letitia Creighton," DCB, *www.biographi.ca.*

7. Youmans, 263.

Selected Bibliography

Books and Reports

Adams, Annmarie, and Petra Tancred. *Designing Women: Gender and the Architectural Profession*. Toronto: University of Toronto Press, 2000.

Anderson, William Ashley. *Angel of Hudson Bay: The True Story of Maud Watt*. New York: E.P. Dutton & Co., 1961.

Armatage, Kay. *The Girl from God's Country: Nell Shipman and the Silent Cinema*. Toronto: University of Toronto Press, 2003.

Awid, Richard Asmet, and Marlene Hamdon. *Through the Eyes of the Son — A Factual History about Canadian Arabs*. Edmonton: Accent Printing, 2000.

Backhouse, Constance. *Colour-Coded: A Legal History of Racism in Canada 1900–1950*. Toronto: University of Toronto Press, 2001.

Baldwin, Douglas O. *She Answered Every Call: The Life of Public Health Nurse Mona Gordon Wilson (1894–1981)*. Charlottetown: Indigo Press, 1997.

Bataille, Gretchen M., ed. *Native American Women: A Biographical Dictionary*. New York & London: Garland Publishing, 1993.

Beaulieu, Michel S., and Ronald N. Harpelle, eds. *The Lady Lumberjack: An Annotated Collection of Dorothea Mitchell's Writings*. Thunder Bay: Centre for Northern Studies, 2005.

Bell, Ken, and Celia Franca. *The National Ballet of Canada: A Celebration*. Toronto: University of Toronto Press, 1978.

Binnie-Clark, Georgina. *Wheat and Woman*. Toronto: University of Toronto Press, 2007.

Black, Harry. *Canadian Scientists and Inventors: Biographies of People Who Have Shaped Our World*. Markham: Pembroke Publishers, 2008.

Blakeley, Phyllis R. *Nova Scotia's Two Remarkable Giants*. Windsor, NS: Lancelot Press, 1972.

Brennan, T. Ann. *The Real Klondike Kate*. Fredericton: Goose Lane Editions, 1990.

Brotman, Ruth C. *Pauline Donalda: The Life and Career of a Canadian Prima Donna*. Montreal: The Eagle Publishing Co., 1975.

Brown, Kelly R. *Florence Lawrence, The Biograph Girl: America's First Movie Star*. Jefferson, North Carolina, and London: McFarland & Company, 1999.

Brown, Rosemary. *Being Brown: A Very Public Life*. Toronto: Random House, 1989.

Browne, Lois. *Girls of Summer: In Their Own League*. Toronto: HarperCollins Publishers Ltd., 1992.

Calvert, Rev. R. *The Story of Abigail Becker, the Heroine of Long Point*. Toronto: William Briggs, 1899.

Cameron, Elspeth. *And Beauty Answers: The Life of Frances Loring and Florence Wyle*. Toronto: Cormorant Books, 2007.

Campbell, John. *The Mazinaw Experience: Bon Echo and Beyond*. Toronto: Natural Heritage Books, 2000.

Canadian Hostelling Association. *Fifty Years of Canadian Hostelling*. Calgary: Detselig Enterprises, Ltd., 1988.

Carter, Sarah, and Patricia A. McCormick, eds. *Lives of Aboriginal Women of the Canadian Northwest and Borderlands*. Edmonton: Athabasca University, 2011.

CATA Alliance. *www.cata.ca* (accessed August 13, 2009).

Cherniavsky, Felix. *The Salome Dancer: The Life and Times of Maud Allan*. Toronto: McClelland & Stewart, 1991.

Chinese Canadian National Council, Women's Book Committee. *Jin Guo: Voices of Chinese Canadian Women*. Toronto: Toronto Women's Press, 1992.

Clarke, David. *The Butchart Gardens: A Family Legacy*. Victoria: The Butchart Gardens Ltd., 2003.

Coggeshall, George. *History of the American Privateers, and Letters-of-marque*. New York: Putnam, 1861. *www.mun.ca/rels/native/beothuk/beo2gifs/texts/HOW19b.html* (accessed July 8, 2010).

Colony of Avalon. *www.colonyofavalon.ca* (accessed September 12, 2009).

Cooper, Afua P. "Black Women and Work in Nineteenth-Century Canada West: Black Woman Teacher Mary Bibb." In *We're Rooted Here and They Can't Pull Us Up: Essays in African Canadian Women's History*, edited by Peggy Bristow, 143–170. Toronto: University of Toronto Press, 1994.

Cormack, W.E. *Narrative of a Journey Across the Island of Newfoundland in 1822*. London/Toronto: Longmans, Green and Company, 1928.

Creighton, Helen. *A Life in Folklore: Helen Creighton*. Toronto: McGraw-Hill, 1975.

Cruikshank, Julie. *Life Lived Like a Story: Life Stories of Three Yukon Native Elders*. Vancouver: University of British Columbia Press, 1990.

Dannett, Sylvia. *She Rode with the Generals: The True and Incredible Story of Sarah Emma Seelye, alias Franklin Thompson*. New York: Thomas Nelson & Sons, 1960.

Day, Helen G., and Kenneth J. Beaton. *They Came Through*. Toronto: United Church of Canada.

Desjardins, Sergine. *Robertine Barry: La femme nouvelle*. Trois-Pistoles: Éditions Trois-Pistoles, 2010.

Dictionary of Canadian Biography. Toronto: University of Toronto Press, circa 1987.

Downie, Jill. *A Passionate Pen: The Life and Times of Faith Fenton*. Toronto: HarperCollins, 1996.

Duncan, Jennifer. *Frontier Spirit: The Brave Women of the Klondike*. Toronto: Doubleday Canada, 2003.

Duvall, Paul. *Canadian Impressionism*. Toronto: McClelland & Stewart Inc., 1990.

Edgeller, Evelyn. *Mary Belle Barclay: Founder of Canadian Hostelling*. Calgary: Detselig Enterprises Ltd., 1988.

Edmonds, Sarah. *Memoirs of a Soldier, Nurse and Spy: A Woman's Adventures in the Union Army*. DeKalb: Northern Illinois University Press, 1999.

Fiamengo, Janice. *The Woman's Page: Journalism and Rhetoric in Early Canada*. Toronto: University of Toronto Press, 2008.

Freeman, Bill. *Casa Loma: Toronto's Fairy-Tale Castle and its Owner, Sir Henry Pellatt*. Toronto: Lorimer, 2005.

French, Maida Parlow. *Kathleen Parlow: A Portrait*. Toronto: Ryerson Press, 1967.

Gorham, Deborah. "Flora MacDonald Denison: Canadian Feminist." In *A Not Unreasonable Claim: Women and Reform in Canada, 1880s–1920s*, edited by Linda Kealey. Toronto: The Women's Press, 1979, 47–70.

Green, H. Gordon. *Don't Have Your Baby in the Dory! A Biography of Myra Bennett*. Montreal: Harvest House, 1974.

Hacker, Carlotta. *The Indomitable Lady Doctors*. Toronto: Clarke, Irwin & Company Ltd., 1974.

Hall, M. Ann. *The Girl and the Game: A History of Women's Sport in Canada*. Peterborough: Broadview Press, 2002.

Hamdani, Daood. *In the Footsteps of Canadian Muslim Women 1837–2007*. Canadian Council of Muslim Women: 2007.

Hill, Beth. *The Remarkable World of Frances Barkley, 1769–1845*. Sidney: Gray's Publishing Ltd., 1978.

Hoare, Philip. *Oscar Wilde's Last Stand: Decadence, Conspiracy, and the Most Outrageous Trial of the Century*. New York: Arcade Publishing, 1998.

Hotchkiss, Ron. *The Matchless Six: The Story of Canada's First Women's Olympic Team*. Toronto: Tundra Books, 2006.

Horsfield, Margaret. *Cougar Annie's Garden*. Nanaimo: Salal Books, 1999.

Howley, J.P. *The Beothuks or Red Indians: The Aboriginal Inhabitants of Newfoundland*. Cambridge: Cambridge University Press, 1915.

Ito, Roy. *Stories of My People: A Japanese Canadian Journal*. Hamilton: Promark, 1994.

Jones, Mrs. E.M. *Dairying for Profit; or, The Poor Man's Cow*. Montreal: John Lovell & Son, 1892.

Kitagawa, Muriel. *This Is My Own: Letters to Wes & Other Writings of Japanese Canadians, 1941–1948*, edited by Roy Miki. Vancouver: Talonbooks, 1985.

Koritz, Amy. *Gendering Bodies/Performing Art: Dance and Literature in Early Twentieth-Century British Culture*. Ann Arbor: The University of Michigan Press, 1995.

Lambert, Gavin. *Norma Shearer: A Life*. New York: Alfred A. Knopf, 1990.

Layton, Linda G. *The Passion for Survival: The True Story of Marie Anne and Louis Payzant in Eighteenth-Century Nova Scotia*. Halifax: Nimbus, 2003.

Leonard, Elizabeth D. *All the Daring of the Soldier: Women of the Civil War Armies*. New York: W.W. Norton & Company, 1999.

Lévesque, Andrée, ed. *Madeleine Parent: Activist*. Toronto: Sumach Press, 2005.

Luckyj, Natalie. *Expressions of Will: The Art of Prudence Heward*. Kingston: Agnes Etherington Art Centre, 1986.

MacDonald, Cheryl. *Abigail Becker: Angel of Long Point*. Nanticoke: Heronwood Enterprises, 2008.

Macpherson, Susan, ed. *Encyclopedia of Theatre Dance in Canada*. Toronto: Dance Collection Danse, 2000.

Marshall, Ingeborg. *A History and Ethnography of the Beothuk*. Montreal and Kingston: McGill-Queen's University Press, 1996.

McCrosson, Sister Mary. *The Bell and the River*. Palo Alto: Pacific Books, 1956.

McFarlane, Brian. *Proud Past, Bright Future: One Hundred Years of Canadian Women's Hockey*. Toronto: Stoddart, 1994.

Millar, Ruth Wright. *Saskatchewan Heroes & Rogues*. Regina: Coteau Books, 2004.

Mitchinson, Wendy. "The WCTU: 'For God, Home and Native Land': A Study in Nineteenth-Century Feminism." In *A Not Unreasonable Claim: Women and Reform in Canada 1880s-1920s*, edited by Linda Kealey, 151–67. Toronto: The Women's Press, 1979.

Morgan, Henry J. *Types of Canadian Women Past & Present*. Toronto: William Briggs, 1903.

Neufield, James. *Power to Rise: The Story of the National Ballet of Canada*. Toronto: University of Toronto Press, 1996.

Patton, Brian, ed. *Tales from the Canadian Rockies*. Edmonton: Hurtig Publishers, 1984.

Pilgrim, Earl B. *The Day Grenfell Cried*. St. John's: DRC Publishing, 2007.

Pope, Peter E. *Fish into Wine: The Newfoundland Plantation in the Seventeenth Century*. Chapel Hill: University of North Carolina Press, 2004.

Prakash, A.K. *Independent Spirit: Early Canadian Women Artists*. Buffalo/ Richmond Hill: Firefly, 2008.

Preston, Dave. *The Story of Butchart Gardens*. Victoria, BC: Highline Publishing, 1996.

Render, Shirley. *No Place for a Lady: The Story of Canadian Women Pilots 1928– 1992*. Winnipeg: Portage & Main Press, 2000.

Rooke. P.T., and R.L. Schnell. *No Bleeding Heart: Charlotte Whitton, A Feminist on the Right*. Vancouver: University of British Columbia Press, 1987.

Sack, B.G. *History of the Jews in Canada*. Translated by Ralph Novek. Montreal: Harvest House, 1965.

Sandford, R.W. *High Ideals: Canadian Pacific's Swiss Guides 1800–1999*. Canmore, AB: The Alpine Club of Canada & Canadian Pacific Hotels, 1999.

Sanger, Clyde. *Lotta and the Unitarian Service Committee Story*. Toronto: Stoddart Publishing Co. Ltd., 1986.

Sauriol, Charles. *Remembering the Don: A Rare Record of Earlier Times Within the Don River Valley*. Scarborough, ON: Consolidated Amethyst Communications Inc., 1981.

Savigny, Mary. *Bon Echo: The Denison Years*. Toronto: Natural Heritage Books, 1997.

Schäffer, Mary T.S. *Old Indian Trails of the Canadian Rockies*. New York: G.P. Putnam's Sons, 1911.

Shearer, Benjamin, and Barbara S. Shearer, eds. *Notable Women in the Physical Sciences: A Biographical Dictionary*. Westport, ON: Greenwood Press, 1997.

Sidney, Angela. *Tagish Tlaagu: Tagish Stories*. Whitehorse: Council of Yukon Indians and Government of Yukon, 1982.

Smardz Frost, Karolyn. *I've Got a Home in Glory Land: A Lost Tale of the Underground Railroad*. Toronto: Thomas Allen Publishers, 2007.

Spring, Joyce. *Daring Lady Flyers: Canadian Women in the Early Years of Aviation*. Lawrencetown Beach, NS: Pottersfield Press, 1994.

Stabler, Arthur P. *The Legend of Marguerite de Roberval*. Washington: Washington State University Press, 1972.

Stacey, Robert, and Stan McMullin. *Massanoga: The Art of Bon Echo*. Manotick, ON: Penumbra Press, 1998.

Strang, Lewis Clinton. *Famous Actresses of the Day in America*. Boston: L.P. Page and Company, 1899.

Takata, Toya. *Nikkei Legacy: The Story of Japanese Canadians from Settlement to Today*. Toronto: NC Press Limited, 1983.

Tarasoff, Koozma J. *Spirit Wrestlers: Doukhobor Pioneers' Strategies for Living*. Ottawa: Legas, 2002.

Taylor, Alan. *The Divided Ground: Indians, Settlers, and the Northern Borderland of the American Revolution*. New York: Alfred A. Knopf, 2006.

Tulchinsky, Gerald. *Taking Root: The Origins of the Canadian Jewish Community*. Toronto: Lester Publishing Ltd., 1992.

Vacon, Shirley Irene. *Giants of Nova Scotia: The Lives of Anna Swan and Angus McAskill*. Lawrencetown Beach, NS: Pottersfield Press, 2008.

Voyageur, Cora. *Firekeepers of the Twenty-First Century: First Nations Women Chiefs*. Montreal and Kingston: McGill-Queen's University Press, 2008.

Walters, Evelyn. *The Women of Beaver Hall*. Toronto: Dundurn, 2005.

Wang, Jiwu. *"His Dominion" and the "Yellow Peril."* Waterloo, ON: Wilfrid Laurier University Press, 2006.

Waters, Bob. *Four Generations That Walked the Walk*. Pittsburgh: Dorrance Publishing Co., 2010.

Wheelwright, Julie. *Esther: The Remarkable True Story of Esther Wheelwright*. Toronto: HarperCollins, 2011.

Whittaker, Herbert. *Canada's National Ballet*. Toronto: McClelland & Stewart, 1967.

Wild, Marjorie. *Elizabeth Bagshaw*. Markham, ON: Fitzhenry & Whiteside, 1984.

Wix, Edwards. *Six Months of a Newfoundland Missionary's Journal*. London: Smith, Elder and Co., Cornhill, 1836.

Woodhead, Lindy. *War Paint: Madame Helena Rubinstein & Miss Elizabeth Arden*. Hoboken, NJ: John Wiley & Sons, 2003.

Wyman, Max. *Dance Canada: An Illustrated History*. Vancouver: Douglas & McIntyre, 1989.

Youmans, Letitia. *Campaign Echoes: The Autobiography of Mrs. Letitia Youmans*. Second Edition. Toronto: William Briggs; Montreal: C.W. Coates; Halifax, S.F. Huestis; 1893?

Periodicals

Adams, Annmarie and Petra Tancred. "Designing Women: Then and Now." *The Canadian Architect*, Vol. 45, Iss. 11 (November 2000): 16–17.

Anderson, J.W. "Beaver Sanctuary." *The Beaver*, June 1937: 8–11.

Backhouse, Constance. "Clara Brett Martin: Canadian Heroine or Not?" *Canadian Journal of Women and the Law*, Vol. 5, Iss. 2 (1992): 263–79.

Backhouse, Constance. "Response to Cossman, Kline, and Pearlman." *Canadian Journal of Women and the Law*, Vol. 5, Iss. 2 (1992): 280–97.

Backhouse, Constance. "To Open the Way for Others of My Sex: Clara Brett Martin's Career as Canada's First Woman Lawyer." *Canadian Journal of Women and the Law*, Vol. 1 (1985): 1–41.

Betcherman, Lita-Rose. "Clara Brett Martin's Anti-Semitism." *Canadian Journal of Women and the Law*, Vol. 5, Iss. 2 (1992): 263–79.
Blackburn-Evans, Althea. "Helen Hogg: Great Discoverers." *EDGE Magazine*, Winter 2000.
Blanton, DeAnne. "Women Soldiers of the Civil War." *Prologue* 25 (Spring 1993): 27–33.
Bren, Linda. "Frances Oldham Kelsey: FDA Medical Reviewer Leaves Her Mark on History." *FDA Consumer* magazine, March–April 2001.
Brown, Wayne. "Mary Two-Axe Earley: Crusader for Equal Rights for Aboriginal Women." *Electoral Insight*, November 2003.
Burleigh, H.C. "Ontario's First Lady." *Historic Kingston*, Vol. 14 (1966): 67–77.
Churchman, Jim. "Initio." *RCMP Quarterly*, Vol. 38, No. 3 (July 1972): 20–25.
Cossman, Brenda, and Marlee Kline. "And If Not Now, When?": Feminism and Anti-Semitism Beyond Clara Brett Martin." *Canadian Journal of Women and the Law*, Vol. 5, Iss. 2 (1992): 298–316.
Denmark, D.E. "James Bay Beaver Conservation." *The Beaver*, September 1948: 38–43.
Donovan, Kenneth Joseph. "Slaves in Ile Royale, 1713–1758." *French Colonial History*, Vol. 5 (2004): 25–42.
Fladeland, Betty. "New Light on Sarah Emma Edmonds, Alias Franklin Thompson." *Michigan History* 47 (1963): 357–62.
Gabriele, Sandra. "Gendered Mobility, the Nation and the Woman's Page: Exploring the Mobile Practices of the Canadian Lady Journalist, 1888–1895." *Journalism*, Vol. 7 (2006): 174–96.
H.A. "In Memoriam: Mary Warren." *Canadian Alpine Journal* 27: 108–10.
Hall, M. Ann. "Alexandrine Gibb: In 'No Man's Land of Sport.'" *International Journal of the History of Sport*, Vol. 18, Issue 1 (2001): 149–72.
Harrington, Michael Francis. "Ann Hulan: A Newfoundland Pioneer." *Atlantic Advocate*, January 1981: 39–41.
Hudes, Sammy. "The Controversial Legacy of Charlotte Whitton." *IsraelNationalNews.com*, August 20, 2010.
Jackson, Elva E. "A Legend Reconsidered." *Cape Breton's Magazine*, Issue 37: 41–52.
Jackson, Elva E. "The True Story of the Legendary Granny Rose." *Nova Scotia Historical Review*, Vol. 8, No.1 (1988): 42–61.
Kinnear, Mary. "The Icelandic Connection: Freyja and the Manitoba Woman Suffrage Movement." *Canadian Woman Studies*, Vol. 7, No. 4: 25–28.
Knelman, Judith. "Helen Hogg." *Graduate*, the University of Toronto Alumni Magazine, Vol. XIII, No. 1 (October 1985).
Lacombe, Michele. "Songs of the Open Road: Bon Echo, Urban Utopians, and the Cult of Nature." *Journal of Canadian Studies*, Summer 1998, Vol. 33, Iss. 2.

Lapointe, Lisette. "Robertine Barry: la rebelle." *La Gazette des femmes*, Vol. 20, No. 1: 14–15.

Lorenz, Andrea W. "Canada's Pioneer Mosque." *Saudi Aramco World*, Vol. 49, No. 4 (July/August 1998).

MacLean, Mary R. "Colonel Elizabeth Smellie." Thunder Bay Historical Museum Society *Papers & Records*, Vol. 3 (1975): 16–18.

Martin, Robert. "The Meteoric Rise and Precipitous Fall of Clara Brett Martin." *Inroads*, Iss. 21 (Summer 2007).

Morier, Roger. "Style and Substance: The Career of Charlotte Whitton." *Canadian Woman Studies*, Vol. 3, No. 1 (1981).

"Passing of a Doukhobor Martyr" and "An Interview with Anna Petrovna Markova." *Mir*, May 1979, No. 17: 3–23.

Payment, Diane P. "Onésime Dorval: 'la bonne demoiselle.'" *Saskatchewan History*, Vol. 55, 1 (May 2003): 31–35.

Pearlman, Lynne. "Through Jewish Lesbian Eyes: Rethinking Clara Brett Martin." *Canadian Journal of Women and the Law*, Vol. 5, Iss. 2 (1992): 317–49.

Pipher, Judith L. "Helen Sawyer Hogg. *Publications of the Astronomical Society of the Pacific*, Vol. 105, No. 694 (December 1993): 1369–72.

Reichwein, Pearl Ann. "Guardians of the Rockies." *The Beaver*, Vol. 74, Iss. 4 (August/September 94).

Reynolds, Mac. "Mrs. Butchart's Famous Gardens." *Maclean's*, September 15, 1952: 16–17 and 36–38.

Rooney, Frances. "Elizabeth Bagshaw, M.D.: An Interview." *Makara*, Vol. 2, No. 3 (May 1977): 27–30.

Salterio, Joe L. "Frances G. McGill, M.D." *RCMP Quarterly*, Vol. 12, No. 1 (July 1946): 25–32.

Scandlers, Ian. "She's Collecting Long Lost Songs." *Maclean's*, September 15, 1952.

Schäffer, Mary T.S. "The Finding of Maligne Lake." *Canadian Alpine Journal* 4 (1912): 92–97.

Schmiegelow, Philippa. "Canadian Feminists in the International Arena." *Canadian Woman Studies*, Vol. 17, No. 2: 85–87.

Sexty, Robert W., and Suzanne Sexty. "Lady Sara Kirke: Canada's First Female Entrepreneur or One of Many?" Administrative Sciences Association of Canada — Annual Conference 2000, Vol. 21, Part 24: 22–30.

Sinclair, Donna. "Victoria Cheung." *Touchstone*, Vol. 11, No. 3 (1993): 37–43.

Sunde, Fern. "Mrs. 'Sparks.'" *Canadians at War* (1939/45), Vol. 1: 287.

Wallace, W. Stewart. "The Story of Charlotte and Cornelia De Grassi." *Transactions of the Royal Society of Canada*, 1941: 147–53.

Watt, Maud. "Nascopie Honeymoon." *The Beaver*, March 1938: 18–26.

Watt, Maud. "Rupert's March of Time." *The Beaver*, June 1938: 22–26.

Watt, Mrs. J.S.C. "The Long Trail." *The Beaver*, March 1943: 46–50.

Watt, Mrs. J.S.C. "The Long Trail — II." *The Beaver*, June 1943: 16–19.

Walkowitz, Judith R. "The 'Vision of Salome:' Cosmopolitanism and Erotic Dancing in Central London, 1908–1918." *The American Historical Review*, Vol. 108, No. 2 (April 2003): 337–76.

Whittier, John G. "The Heroine of Long Point." *Atlantic Monthly*, May 1869.

Whitton, Charlotte. "Will Women Ever Run the Country?" *Maclean's*, August 1, 1952.

Newspapers

Major newspapers in Canada and the United States

Unpublished Sources

Anonymous. "Marguerite Vincent Lawinonkié." Commission des lieux et monuments historiques du Canada formulaire de demande — personne, 2000-42.

Brown, Jennifer S.H. "Charlotte Small (1785–1857)." Historic Sites and Monuments Board of Canada Submission Report — Person, 2007-13.

Cambridge Sports Hall of Fame
 Hilda Ranscombe Scrapbook

Dodd, Dianne. "Margrét Jónsdóttir Benedictsson (1866–1956)." Historic Sites and Monuments Board of Canada Submission Report — Person, 2008-69.

Dodd, Dianne. "Mona Gordon Wilson (1894–1981)." Historic Sites and Monuments Board of Canada Submission Report — Person, 2007-53.

Dodd, Dianne. "Nellie Yip Quong (1882–1949)." Historic Sites and Monuments Board of Canada Submission Report — Person, 2007-70.

Eyford, Ryan. "Lucifer Comes to New Iceland: Margrét and Sigfús Benedictson's Radical Critique of Marriage and the Family." Presentation at Canadian Historical Association, 2007.

Faith Berghuis Collection
 Jones Family Files

Fort Steele Archives

Gelly, Alain. "Marie Marguerite Rose (vers 1717–1757)." Commission des lieux et monuments historiques du Canada rapport au feuilleton — personne, 2007-12.

Hamdani, Daood. "Muslim History of Canada: Pre-Confederation to the First World War." Toronto: Keynote address at launch of Tessellate Institute, April 27, 2008.

Mosquin, Alexandra. "The Butchart Gardens, Victoria, British Columbia." Historic Sites and Monuments Board of Canada Submission Report — Place, 2004-30.

Mosquin, Alexandra. "Mary Electa Adams." Historic Sites and Monuments Board of Canada Submission Report — Person, 2003-33.

Mulley, Elizabeth. "Women and Children in Context: Laura Muntz and the Representation of Maternity." Doctoral Thesis, McGill University, 2000.

Parent, France. "Irma LeVasseur (1877–1964)." Commission des lieux et monuments historiques du Canada rapport au feuilleton — personne, 2007-10.

Ray, Carol S. "Sophie Morigeau: Trading Across the Boundaries." M.A. Thesis, University of Wyoming, 2001.

Shulman, Deborah. "From the Pages of Three Ladies: Canadian Women Missionaries in Republican China." M.A. Thesis, Concordia University, Montreal, 1996.

Smith, Lois. "The Life and Times of Lois Smith OC," Dance Collection Danse Archives.

Smyth, David. "Demasduit and Shanawdithit." Historic Sites and Monuments Board of Canada Submission Report — Person, 2000-15.

Stewardson, Richard George. "Hattie Rhue Hatchett (1863–1958)." M.A. Thesis, York University, 1994.

Tanguay, Jean. "Marguerite Vincent Lawinonkié, "The Woman Skilled at Needlework." Commission des lieux et monuments historiques du Canada rapport au feuilleton — personne, 2007-29-A.

Thomas, Owen. "Mary and Henry Bibb." Historic Sites and Monuments Board of Canada Submission Report — Person, 2002-22.

University of Manitoba Archives and Special Collections
Elizabeth Dafoe Library
Kathleen Rice Fonds

Acknowledgements

I'd like to express my appreciation to everyone who contributed to this book.

To my husband Glen Purdy and sons Gavin and Lawren, thanks for providing input throughout the production of this publication, managing the household in my absence, and cheering me on. Glen spent countless hours scanning and printing historical images, burning CDs, removing a nasty computer virus, and coming to the rescue whenever technology threatened the project!

I'd like to extend a special thanks to journalist Angela Mangiacasale, who kindly volunteered to edit my manuscript and devoted her considerable expertise to the task. To Dr. John Lutz (University of Victoria history professor), I owe a big thanks for reviewing texts depicting Aboriginal women and British Columbians. Both reviewers provided very helpful comments and corrections. Any errors are my own.

Thanks to the many readers who encouraged me to write a second volume about Canadian heroines, and also offered suggestions of women to be featured. I greatly appreciated the ideas and material sent to me, and regret that I wasn't able to include everyone and everything. Many archivists, historians, authors, researchers, artists, and relatives of women featured in this book also provided material that enriched the final product.

I would particularly like to thank the following individuals and organizations for their assistance: Trevor Bennett; Leigh Beauchamp

Day; Marjory Hind; Brandy Dunnebacke, Kristin Schachtel and Sally Passey (Fort Steele); Seema Ahluwalia; Amy Bowring (Dance Collection Danse); Dr. Michael S. Beaulieu; Stephen Mostad (Office of the Lieutenant Governor, Nova Scotia); artist Gary Alphonso (*www.i2iart.com/Gary_Alphonso*) and Shelley Brown; Irene Ellenberger (Lea Roback Foundation); Blair Newby (Chatham-Kent Black Historical Society); Ryan Eyford; Norma Thomasson; Lois K. Yorke; National Association of Japanese Canadians; Dale Swan (Anna Swan Museum at the Creamery); David Menary and the Cambridge Sports Hall of Fame; Soeur Huguette Michaud (l'Hôpital de l'Enfant-Jésus); David E. Hogg; Patrick Vibert Douglas; Karen Hamdon; Canadian Council of Muslim Women; Faith Berghuis (Falklands Farm); Koozma J. Tarasoff; Linda G. Layton, author of *A Passion for Survival* (available at *www.nimbus.ns.ca*); John Payzant; Mark Heine; David Jenkins; Ross MacDonald; Parks Canada; Pauline Gill; Max Finkelstein; Chris Tibelius for suggesting Lady Pellatt; David Rain (USC, Canada); Ed Two-Axe Early and Rosemary Two Rivers; Linda Reid (Japanese Canadian National Museum); Olive Roeckner; Adrienne Neville (The National Ballet of Canada); Rita Rose and Anne Taylor (Curve Lake First Nation); Scott Gillies (Eva Brook Donly Museum and Archives); Sanofi Pasteur – Toronto; Lou Seileri (Casa Loma); Vernon Russell (Girl Guides of Canada); Emily Cartlidge (St. Marys Museum); Butchart Gardens; Canadian Jewish Congress; Buxton National Historic Site and Museum; and Kelly Candaele.